SPIRIT BEINGS AND SUN DANCERS

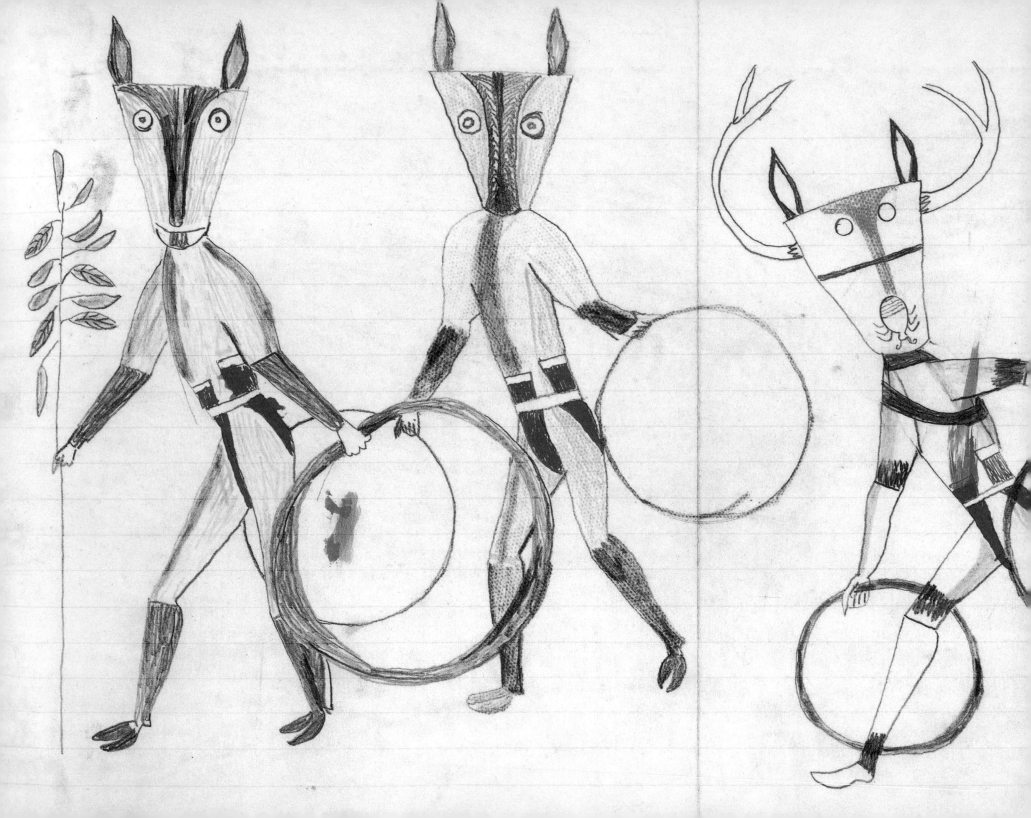

SPIRIT BEINGS
AND SUN DANCERS

Black Hawk's Vision of the Lakota World

JANET CATHERINE BERLO

FOREWORD BY ARTHUR AMIOTTE
INTRODUCTORY NOTE BY EUGENE V. THAW

GEORGE BRAZILLER ❊ PUBLISHER
in association with
THE NEW YORK STATE HISTORICAL ASSOCIATION

First published in 2000 in the United States of America by George Braziller, Inc.,
in association with the New York State Historical Association

Copyright © 2000 by George Braziller, Inc.

Black Hawk's drawing book is held by the Eugene and Clare Thaw Collection at the Fenimore Art Museum,
New York State Historical Association, Cooperstown, New York (accession no. T614).

Photography of Black Hawk's images is by John Bigelow Taylor, New York.

For information, please address the publisher:
George Braziller, Inc.
171 Madison Avenue
New York, New York 10016

Library of Congress Cataloging-in-Publication Data
Berlo, Janet Catherine.
 Spirit beings and sun dancers : Black Hawk's vision of the Lakota world/Janet
Catherine Berlo ; forewords by Arthur Amiotte and Eugene V. Thaw.—1st ed.
 p. cm.
 Includes bibliographical references and index.
 ISBN 0-8076-1465-3 (hardback)
 1. Sans Arc art—South Dakota—Cheyenne River Indian Reservation—History. 2. Indian
ledger drawings—South Dakota—Cheyenne River Indian Reservation—History. 3. Sans Arc
Indians—Social life and customs. 4. Black Hawk, ca. 1832–ca. 1890. I. Title.
 E99.S217 B47 2000
 978.3'54—dc21 00-042913

Design by POLLEN
Map by Rita Lascaro
Printed in Hong Kong

FIRST EDITION

Our children can not forget their own people, and when the older people tell them of the time when the Lakotas moved across the land as free as the winds and no one could say to them "go here or stay there"; of the times when men did not labor and sweat to stay in one place; of the times when to hunt the buffalo and keep the tipi was all the care there was; of the times when brave men could win respect and renown on the warpath—then they sing the Indian songs and would be as the Lakotas were and not as the white men are.

—Red Cloud, 1903

CONTENTS

FOREWORD

NATIVE STUDIES scholars, art historians, artists, anthropologists, and western historians familiar with the multidisciplinary and interdisciplinary approaches necessary to comprehend the complexity of any Native American tribe and its art will appreciate the arduous task Janet Catherine Berlo has undertaken in this volume.

It is the first of its kind to explore in such detail the drawings of one individual artist of the Northern Plains, Black Hawk. Berlo approaches this work as Art with a capital A rather than merely as ethnography, as so many others have. Her detailed research, based on the classic anthropological literature, and her inspired synthesis of her own personal expertise with that of Lakota interviewees and scholars, are surely a landmark in Native American art historical scholarship. Moreover, Berlo has paid close attention to the perspectives of Native people themselves.

In this last century, Native people moved, through formal education, into positions of empowerment and influence. Recently, Native scholars have focused on the reappraisal of our tribal histories; we have proposed that an alternative model for examining the evolution of tribal visual arts is essential if a more complete and enlightened interpretation is to explain why these forms and their creators ought to be deemed significant.

Thankfully, the days of merely labeling a work of Native American art in a museum with a brief caption have long gone by the wayside. Formerly, such a label would contain information such as the tribe from which it was collected, the medium, and the approximate date it was made or collected. The artist, if mentioned at all, was usually listed as anonymous. Native and non-Native scholars have sought to apply new criteria and have performed exhaustive

research to further explicate the universal significance of these forms, once considered mere quaint and archaic artifacts. Janet Berlo has been, and continues to be, a pioneer in efforts to move beyond the old model.

History and the cultural matrix are vital first considerations in any study. Native cultures of the Northern Plains, their traditions and arts, have been colored and altered by historical and chronological forces, mainly the presence of Euro-American people on this continent. The influence of non-Indian materials, technology, and social interaction is as integral to the artistic development of Native arts as indigenous creativity, skill, and cultural continuity of style and technique. Here on the Northern Plains, the period over which these changes occurred spans approximately 250 years. This time span coincides with the westward advancement of the forces of Manifest Destiny.

Of specific interest during these 250 years are several overlapping periods, each typified by similar art forms, styles, techniques, and media, and each giving rise to innovative and synthetic forms. Through contact with non-Indians, new elements are incorporated, reconfigured, and altered to suit the aesthetic sensibilities of the indigenous maker. These periods of Native art history can be divided into several phases: precontact; contact; early postcontact; full contact and confrontation; early reservation confinement (the period from which Black Hawk's work emerges); adaptation to sedentary reservation lifestyles; reservation-based and distant acculturation-based educational programming; emerging non-Indian fine arts styles and media by Indian artists; and local, regional, and national fine arts participation by Indian artists.

While these periods may seem arbitrary and perhaps unconventional, most scholars and Native art historians rely upon them for a variety of purposes: dating; identifying what a form is; determining where it was made or collected; identifying the media and style, according to tribes or individuals; determining the gender of the artist or the person for whom it was made; and, finally, identifying an individual artist—a most significant development and the very subject of this volume.

Black Hawk was an Itazipco (or Sans Arc) Lakota; he lived on the Cheyenne River Sioux Reservation and worked in the early reservation period, about 1880. He used the new medium of pencil and ink on paper, in a style adapted from the earlier tradition of narrative painting on hide, practiced by men. In the introduced medium of ledger art we see the emergence of a new art form. Yet the content of the drawings is purely Lakota, based on an ancient tradition. Most significant here is how the tribal worldview—the individual and collective psyche—permeates and threads itself into forms, images, and symbols portrayed by Black Hawk. These become visual manifestations of cultural continuity and are distinctly characteristic of "Lakota-ness." Yet, in totality, they have become contemporary Native Art.

Berlo's lengthy analysis of Black Hawk's work (as opposed to the cursory descriptions such works of art usually receive) and her cross-referencing with works by other Lakota artists (Black Hawk's contemporaries, forebears, and descendants) enhance our understanding and appreciation of the meaning of the drawings. This attests to Berlo's mastery of the lesser known corpus of Northern Plains ledger and muslin art; it also provides readers with a more expansive and thus more complete and accurate vision of cultural cohesiveness and continuity at a time in history when Lakota people were under great duress and our cultural traditions in danger of being lost.

Because Black Hawk was also a spiritual practitioner, any presentation of his work would not be complete without delving into the metaphysical, spiritual, and mysterious dimensions of Lakota thought. In addition to being a fine exemplar of the Northern Plains graphic art tradition, his drawings are powerful icons with hierophantic qualities. While this would be daunting to some, Berlo's treatment of Black Hawk's drawings highlights her acuity, bravery, and impressive command of both the classic literature and contemporary scholarly works of comparative religion and ethnography now being published by Native scholars. Lakota artist–holy men knew that the sacred and profane, the animate and inanimate, are worlds without distinct boundaries. In her elucidation of these potent drawings, Berlo has sensitively paid credence to this hallmark of Lakota art.

In the summer of 1995, as corecipients of a Getty Senior Collaborative Grant, Janet and I traveled nearly two thousand miles by pickup truck over the South Dakota and North Dakota landscape to view and collect data on Northern Plains ledger art in various museums, tribal communities, and archives. I was greatly moved by Janet's energy and dedication to leaving no stone—or page—unturned. On a hot summer day we stood on the high, dry grass ridges overlooking Bridger, Red Scaffold, and Cherry Creek (the communities where Black Hawk lived on the Cheyenne River Sioux Reservation); the prairie wind and the occasional heat waves rising from the earth evoked the sounds and actions of nineteenth-century people at their daily tasks near their isolated log houses. One could almost hear dogs barking and the sound of a creaking wooden wagon pulled by a team of horses returning from the trading post where some little drawings had been sold to buy sugar, coffee, and flour, or kerosene for the lamps. I am familiar with such scenes from my own childhood nearly sixty years ago on the Pine Ridge Reservation, and so it's not difficult to empathize with the life of Black Hawk. I had known similar old men as a child and could understand Janet's quest to understand more about his work and to make it available to the world and especially to other Native people.

An eminent art historian with interest and expertise in the arts of numerous regions of the indigenous Americas, Janet Berlo is a prolific and insightful scholar and a courageous, dedicated, and generous advocate of Native art and Native people. On behalf of the Lakota people, I thank her for this fine contribution to the history of indigenous American art.

ARTHUR AMIOTTE

INTRODUCTORY NOTE

I WAS A COLLECTOR of master drawings of most European schools—from Mantegna to Picasso—before I ever became aware of American Indian art. However, once I plunged deeply into collecting Indian cultural objects, I could not remain unaware of Indian drawings for long.

In Santa Fe, where my wife and I had resettled in the 1980s, several Indian art dealers had stocks of so-called ledger drawings framed, hanging on the walls, and for sale individually. At first, I was disdainful of them, refusing to buy any, since I felt that, in the world of works on paper, they could not compare with my master drawings from the European tradition. I was also upset by the merchandising aspect of this art-dealing activity. For higher profit and wider distribution to their clients, dealers habitually dismembered every complete ledger book they could obtain. In some cases, they at least produced reasonable facsimiles to record the original appearance of the book.

Eventually, I woke up to the appeal of these remarkable drawings and realized that they were made for purposes different from those for which my beloved old master drawings were created. I could now see that their pictographic style was a storytelling language related to aboriginal rock art, to painted hides, and even to Paleolithic cave art. It was too late for me to go back and select the best sheets from most of the books that had been dismembered in my collecting years, but I was able to purchase from a friend an anthology, which he had made—not necessarily the very best but a respectable group of separate drawings from a number of different ledger books.

At the very moment I realized how foolish I had been, a book of drawings finer than any I had ever before seen appeared for auction in New York. Naturally, I tried to get it, but the bidding soared far above what anyone had expected. In the end, I was the underbidder,

losing to Alexander Acevedo, a prominent New York dealer in this field. I was, of course, heartbroken. But fate gave me a second chance. Jonathan Holstein, a good friend among the dealers who had helped me build my collection, came to commiserate with me. He felt that the only way Acevedo could recoup economically would be to break up the book and sell it page by page. He interceded for me, and I was able to acquire the Black Hawk book for my collection at the Fenimore Art Museum with the promise to Acevedo that it would never be broken up.

Notwithstanding the relationship to ancient pictographs, ledger drawings are works of art that can be approached and understood through traditional methods of art historical analysis, as they have been applied to most of the world's art traditions. In the case of Black Hawk, and in many other cases, we know the names of individual masters. In this volume, in fact, we have one of the few art historical monographs devoted to the work of a single American Indian artist of the historical period. This is a development long awaited in this field, dominated until recently by an ethnographic approach that has been unconcerned with artistic quality or individual personality.

Admirably displaying an interdisciplinary approach that remains grounded in the traditional methods of stylistic and iconographic analysis, which are fundamental to the discipline of art history, Janet Berlo presents here substantial research on Black Hawk and the Lakota world he depicts. Her work brings this important American Indian artist the wider audience he deserves.

EUGENE V. THAW

IN THE AUTUMN of 1994, a remarkable book of seventy-six Lakota drawings was offered for sale at Sotheby's auction house in New York City.[1] At the time, I was working with Lakota artist and scholar Arthur Amiotte on a study of Plains graphic arts. I immediately flew to New York, where Ellen Taubman, then vice president of Sotheby's and head of the Department of American Indian Art, graciously allowed me to examine the book for hours and photograph all of its pages. Arthur and I pored over these images, discussing them over the next year, as we traveled to museums, archives, and Native communities throughout the West. We recognized this corpus as a stellar artistic achievement, deserving of further study and full publication.

Within a month of its sale at Sotheby's, the Black Hawk drawing book found a home at the Fenimore Art Museum, in Cooperstown, New York, thanks to the generosity of the collector Eugene V. Thaw.

Gilbert T. Vincent, the director of the Museum at that time, allowed the book to be exhibited in two venues of my traveling exhibition, "Plains Indian Drawings 1865–1935: Pages from a Visual History." Visitors to The Drawing Center in New York City in the fall of 1996 and to the Art Gallery of Ontario in the fall of 1997 were able to see at least one page of Black Hawk's remarkable book. And in several diverse publications I published a few images from the artist's oeuvre,[2] most often the arresting "Dream or Vision of himself changed to a destroyer and riding a Buffalo Eagle" (see pl. 2), which graces the jacket of this volume.

But from the moment I held Black Hawk's bound drawings in my hands in October 1994, I knew that I wanted to see it published in a full-color edition, with an accompanying text on Lakota art and culture. *Spirit Beings and Sun Dancers* is the realization of that dream.

The chapters that follow merely crack open the door to the complex and eloquent world known to Black Hawk and his contemporaries. I have endeavored to present a narrative that is accessible to a nonscholarly audience interested in Native American life, art, and thought. But because it is equally important that this book make a contribution to the ever-growing discipline of Native American art historical studies, a great deal of supporting data and scholarly documentation has been included in the lengthy footnotes. Each section of the text opens with a quotation, usually from a Lakota speaker, in order to acknowledge the primacy of the Native voice—as well as the Native vision.

My remarks are by no means definitive—nor is the commentary of anyone who was not a part of that world 120 years ago. Nevertheless, it is my hope that this book will serve as a starting point for many Lakota interpretations of these drawings in the future. It is also my hope that *Spirit Beings and Sun Dancers* will introduce Black Hawk to all who are interested in Native history and fine arts in general, and most especially to those who are of Plains Indian heritage. Just as the artworks of Amos Bad Heart Bull and Red Hawk influenced the generation of Native artists and intellectuals who came of age in the 1960s,[3] assuring them that Lakota cosmology, art, and history extend back many generations in time, so, too, will these seventy-six remarkable drawings remind Lakota people that before the ethnographies of their culture were written by outsiders, Black Hawk inscribed his own visual ethnography in a form that is still eloquent and accessible today.

Indeed, fifty years before the Oglala Lakota holy man Black Elk (1863–1950) narrated to John Neihardt his stories and visions, made famous in the book *Black Elk Speaks,* Black Hawk, a member of the Sans Arc Lakota band, sat down with pens and paper and drew the history, ceremonial practices, and cosmology of the Lakota. Some of what he drew was remarkably consistent with what Black Elk described some five decades later. Although Black Hawk was making these drawings on commission to an outsider—the trader at the Cheyenne River Sioux Agency—the act of making them, and perhaps of narrating his history to friends and family members as he did so, was an act of resistance at a time when Lakota ways were under assault from the U.S. government, missionaries, and settlers.

In the summer of 1995, Arthur Amiotte and I showed color photocopies of the Black Hawk drawings to Lakota elder Darlene Young Bear (now deceased), who, like Black Hawk, was from the Cheyenne River Sioux Reservation. As she looked intently at the depictions of ceremonial practices, Mrs. Young Bear exclaimed poignantly, "There's a lot of information in these pictures that people could use. . . . We could use these to help remember." I hope that this book will serve as a contribution to that process of remembering.

✳

I AM GRATEFUL that a wrong turn in the Metropolitan Museum of Art in the spring of 1999 brought the publisher George Braziller face-to-face with some glorious Plains Indian drawings on temporary display there. His curiosity about this artistic genre led him to me, and his support for this project has been unwavering ever since. A Getty Senior Collaborative Grant (1994–96) and a National Endowment for the Humanities Fellowship (1994–95) allowed me to conduct extensive research on Plains Indian drawing traditions, which laid the groundwork for this project. A grant from the John Simon Guggenheim Memorial Foundation (1999–2000), supple-

mented by research leave from the University of Rochester, provided me with the opportunity to complete the manuscript for this book.

I am grateful for Arthur Amiotte's intellectual companionship during the two years of our Getty grant and for the conversations we had with numerous museum curators, tribal elders, and members of Native communities. Discussions with a number of other colleagues have enriched my thinking on the subject of this book, among them Ted J. Brasser, Christina Burke, Robert G. Donnelley, Candace Green, Gerald McMaster, Imre Nagy, Martin Sage, Joyce Szabo, and Colin Taylor. I am particularly grateful for an afternoon that Bill Holm generously spent with me discussing the details of Crow iconography and clothing. Similarly memorable was a conversation with equestrienne India Frank, in which we discussed Black Hawk's scenes of horsemanship. Cyril Reade and Marc Leger, my research assistants during the final months of manuscript preparation, were particularly helpful in locating arcane bibliographic references. Arthur Amiotte, Gilbert T. Vincent, Sherry Brydon, Kate Kane, and Kristin Dowell read the penultimate draft and offered many useful suggestions. In preparing the bibliography, Kristin Dowell did her usual meticulous job.

I am grateful that the following Lakota people took time to consult with Arthur Amiotte and me on this project in South Dakota during the summer of 1995: Jim Picotte, director of the Lakota Cultural Center in Eagle Butte; Darlene Young Bear, an elder from the Red Scaffold district; and Russ McClure, superintendent of the Cheyenne River Sioux Reservation, and his staff members Sue Ella High Elk and Charlene Anderson.

As always, my work is informed by ten years' worth of conversations on Native American art history with my dear friends and esteemed colleagues Aldona Jonaitis and Ruth Phillips. Sherry Brydon, curator of the Thaw Collection at the Fenimore Art Museum, has been helpful in many ways throughout this project, facilitating inspection of the original book and providing her own insights about its style and iconography. Gilbert T. Vincent, now president of the New York State Historical Association and Farmers' Museum, has been enthusiastic about my work on the Black Hawk drawings since 1995. I am grateful for his guidance in seeing this book to press.

I am grateful to Mary Taveras, production editor at George Braziller, Inc., for expertly shepherding my manuscript through the process from proposal to bound book. Graham Harles, copyeditor extraordinaire, did a superb job tying up all the loose ends in the manuscript, as did proofreader Richard Gallin. I am grateful to all of them for taking the kinks out of my prose. Stewart Cauley and Molly Ackerman-Brimberg of Pollen Design are responsible for the elegant look of the book.

I have come to rely upon the support and unstinting enthusiasm that my husband, Bradley D. Gale, shows for all my scholarly and creative endeavors. Once again, I was not disappointed. To this project, however, he also brought the discerning eye and scientific knowledge of a former paper conservator and rare-book binder, helping with the analysis of the physical condition of the book that appears in appendix 1.

My greatest thanks go to the art collector Eugene V. Thaw, whose purchase and donation of Black Hawk's drawing book to the Fenimore Art Museum prevented it from being broken up and sold on the art market page by page. When art dealer Jonathan Holstein

told him, "This is one of the world's great works of art, and it belongs in a museum," Gene accepted the challenge. Without *your* vision, Gene, the world would not have had a proper appreciation of Black Hawk's full vision. Thank you.

Finally, in honor of the Lakota people and their enduring culture, George Braziller has generously agreed to send compli-mentary copies of this book to fifteen tribal schools and colleges on the Great Plains. Twenty percent of my earnings from this book will be donated to support the educational programs at Red Cloud Indian School at Pine Ridge, South Dakota.

Mitakuye oyasin.

BLACK HAWK AND THE LAKOTA WORLD

*The bay horse said to me: "Behold them, your horses come dancing." I looked around
and saw millions of horses circling around me—a sky full of horses. Then the bay
horse said, "Make haste." The horse began to go beside me and the forty-eight horses
followed us. I looked around and all the horses that were running changed into buffalo,
elk, and all kinds of animals and fowls and they all went back to the four quarters.*

—Black Elk[1]

IN THE LAKOTA language, the word *hanbloglaka* can be translated as "vision talk," that is, relating orally one's experiences in the spirit world, or as "the language of the spirits."[2] In Lakota tradition, the personal vision, rather than culturally established dogma or doctrine, is the essence of one's spiritual life. By means of *hanbloglaka* one recounts one's spiritual history, which serves as the foundation upon which other acts are predicated.

In the famous Lakota narrative, *Black Elk Speaks,* Black Elk presents his vision (it occurred in 1872, when he was only nine) as the cornerstone upon which all subsequent actions and activities of his life rest. In the vision, he goes to the world of "the Grand-fathers," the ancestral spirits who guide the Lakota nation. There, in the most visually dramatic moments of Black Elk's complex narrative, he sees herds of spirit horses neighing and bucking, causing the world to shake with thunder, lightning, and wind.[3]

A person who had such a vision might present it to the people by means of a public ritual performance. In nineteenth-century

Lakota life, if such a person were male, and had artistic aptitude, he might present it through drawings—on tipis, on hide robes, or, by the last third of the nineteenth century, on drawing paper. The Lakota artist Black Hawk experienced such a personal vision and recorded it the same way countless generations of Lakota historians and artists before him had—by drawing it.

Pictorial narratives have an ancient lineage on the Great Plains. In earlier centuries men recorded dreams, visions, and historical actions in petroglyphs and pictographs on rocky escarpments. More recently, the bison-skin robes and painted hide shirts for which nineteenth-century Plains warriors are famous demonstrate these artists' keen interest in recording autobiographical details in pictographic form.[4] Black Hawk's book of drawings opens with two images that were revealed to him in a Vision Quest (see pls. 1, 2). Like Black Elk's vision, it, too, concerns powerful horselike beings that fly through the sky. But as the subtitle of this book, *Black Hawk's Vision of the Lakota World*, emphasizes, it is not only the spiritual vision that is important for subsequent generations to understand but also Black Hawk's vision of his world as he lived it. In seventy-six drawings, later amassed in a leather-bound book, Black Hawk recorded scenes from Lakota ceremony, including the Sun Dance, the female puberty ceremony, and many animal transformation masquerades. He chronicled the history of warfare between the Lakota and their bitter enemies, the Crow. Yet paradoxically, he also drew some of the finest extant images of Crow ceremonialism. He recorded scenes of buffalo hunting recalled from his youth, as well as animal illustrations so scientifically precise that they serve as the finest indigenous exemplars of nineteenth-century natural history drawings.

In contrast to some of his cohorts, he apparently chose not to record images of the rapid changes and willful destruction of Lakota life wrought by the U.S. government during the last third of the nineteenth century. Unlike some drawing books of the era, we see no images of white soldiers or log houses. While elements of non-Native culture appear in his drawings (carbines and rifles, trade cloth, and the like), they do so as elements fully incorporated into a Lakota world.

Black Hawk may have been deliberately turning his back on the upheavals that were rending traditional life as he had known it as a young man. He may have decided that it was more important to record the people, animals, and objects that made up a Lakota world. While many questions remain about Black Hawk and his artworks, this book offers a first glimpse of one Lakota man and his pictorial record of traditional life, ceremony, and spirituality. All of his known drawings are included here in full color, so that they can be studied and interpreted by others. This book represents an initial attempt to place one man's eloquent visual legacy into a Lakota universe—a universe that still flourishes today, despite the best efforts of an interloping civilization to extirpate it through whatever means necessary: military, religious, economic, or educational.

This chapter introduces nineteenth-century Lakota life, thought, and art and places Black Hawk and his Sans Arc band of Lakota within that world. It looks in some detail at the history of Lakota graphic arts and considers Black Hawk's place within that tradition. Chapter 2 examines his works of art in groups, according to their subject matter. Drawing upon historical and contemporary Lakota ethnography, as well as traditional art historical

tools such as stylistic and iconographic analysis, I interpret the meanings of these images. In the third chapter, I suggest some interpretive strategies for understanding the drawings, not only within the realm of Lakota life at one particular historical moment, but also within the realm of intercultural circulation of knowledge and images. I also briefly examine the trajectory of Lakota life and art since Black Hawk's time. Finally, two appendices discuss the physical condition of the bound book and its drawings, and the historical documentation that was passed down through the generations of the family of William Edward Caton, the man who commissioned these drawings from the artist.

Art and Culture in the Nineteenth Century

When the Lakotas came from the middle of the world they were one as a people and made but one winter camp and kept but one council fire. After a time some did not return to the winter camp and when they did associate with the original camp they maintained their council fire, so they were called tonwan *[village] because they thought they had power sufficient to be independent. Then others did so until there were seven* tonwan, *or seven council fires, when the people all associated. While these people were independent of each other, they were friends, so they called themselves* Dakoda, *or friends [Lakota in the Teton dialect] and they were allies against all others of mankind.*

—James Walker[5]

LAKOTA PEOPLE TODAY reside mainly on several reservations in South Dakota, but their history is one of migration and adaptation to various environments and situations. Until recently, they were better known by the names the U.S. Army and anthropologists called them a century ago: the Sioux, the Dakota, the Teton Sioux, or the Western Sioux. The nomenclature is confusing: while all Lakota are Sioux, not all Sioux are Lakota, and today most people of the Western or Teton Sioux prefer to be called Lakota, for the language they speak.[6] The Lakota group is composed of seven bands, called in Lakota *oceti* for "council fires" or "fireplaces": the Oglala, Sicangu (or Brulé), Hunkpapa, Minneconjou, Itazipco (or Sans Arc), Oohenunpa (or Two Kettle), and Sihasapa (Blackfeet).[7]

From sources as diverse as archaeology, ethnohistory, Jesuit narratives, the memoirs of trappers and traders, and the pictographic histories of Lakota people themselves, scholars have pieced together a picture of the migration of Sioux peoples and their development into the culture we recognize from the nineteenth century.[8] In the seventeenth century, the ancestors of the Lakota probably lived in the tall-grass prairies west of the Mississippi River in what is now Minnesota. Over the next decades, they seem to have pushed westward toward the Missouri River area, in part because of pressures by their Algonkian neighbors, and later by the inexorable movement of non-Native peoples westward from the Great Lakes and farther east. The Lakota, in turn, pressed other groups even farther west or south—the Omaha and Arikara, for example, and later the Kiowa and Crow.

During these years, as scholar George Hyde has written, they transformed themselves "from little camps of poor people afoot in the vast buffalo plains into seven powerful tribes of mounted Indians."[9] They obtained guns from European traders and horses from other Indian nations. Through means of this powerful duo—the gun and the horse—they became the equestrian warrior culture familiar to us from the nineteenth century. But it

was not population pressures alone that caused the western migration of the Lakota. The rewards of the fur trade—access to guns and trade goods in exchange for beaver pelts—were a powerful incentive. For their own needs, the Lakota depended increasingly upon the buffalo, for the sturdy and plentiful buffalo was a source of meat, fuel, clothing, artistic materials, shelter, and tools (see pls. 56, 57, 58, 59).

According to indigenous pictorial records, the Lakota reached the Black Hills (in present-day western South Dakota) around the time that a new independent nation was being formed in Philadelphia—1776. The Black Hills became so fundamentally important to the Lakota that today some Lakota think of this site as their ancestral place of origin, from which they migrated and to which they returned.[10] This vast tract of forested land became a refuge for the Lakota in the nineteenth century. It is a place of quiet majesty, a setting where one might contemplate all that is *wakan* (sacred, mysterious); indeed, many Lakota have gone and continue to go there for personal Vision Quests. For a nomadic people, it was a source for fresh water and abundant game. Its dense, tall conifers were good for making long, straight lodgepoles for tipis. Its quiet canyons sheltered Lakota bands from harsh winter storms and from the predations of their enemies.

In the first half of the nineteenth century, the Lakota had to contend principally with trappers and traders and with the occasional U.S. military or scientific expedition. By the 1840s, wagon trains of white families began making their way west: some came in search of land in California or Oregon; others, like the Mormons, came in search of religious freedom. By 1848, when the California Gold Rush was under way, many came in search of riches. One newspaper correspondent at Fort Kearney (in what became Nebraska Territory in 1854) noted that by mid-June 1849, more than five thousand wagons had passed through that region just since the start of that spring, giving some indication of the amount of traffic in a region formerly used by small bands of hunters and large herds of game.[11] These settlers and travelers disturbed the great buffalo herds that had become central to the Lakota way of life. Just as trappers and traders had zealously sought beaver pelts in earlier decades to supply fashion's demands in New York and Paris, buffalo robes became prized items of trade by midcentury. Both Indian people and whites decimated the great herds by overhunting and wastefulness.[12]

While the early history of Sioux peoples and their migrations and alliances is both confused and confusing, what is important for our purposes is that by the early nineteenth century the Lakota had emerged as the great and powerful warriors of the Northern and Central Plains. Historian Richard White has suggested that their power grew, in part, because they increased in population during the nineteenth century, unlike most other Plains tribes, who experienced a dramatic decrease in their numbers. The Lakota were less affected by the great cholera, measles, and smallpox epidemics than were some of the sedentary tribes on the Upper Missouri, for example.[13]

Throughout the nineteenth century, the Lakota and their Cheyenne allies fought repeatedly with Pawnee, Crow, and other groups over control of resources in the area around the Platte River, thus institutionalizing these tribes as traditional enemies. This enmity is evident from Lakota pictorial arts and winter counts (pictographic calendars of historical events). These repeatedly record clashes with warriors from those ethnic groups (see pls. 39–55; for a rare truce, see fig. 7). So it was logical that when the Lakota and

Cheyenne battled the U.S. military, Crow and Pawnee scouts were eager to side with the U.S. Army against their traditional foes.

Less emphasized than their role as implacable warriors, especially by earlier writers, is the fact that the Lakota lived in a well-functioning society in which individuality, bravery, and freedom were prized, as were generosity, humility, and group solidarity. Lakota people typically identified themselves not only by their band ethnicity (Oglala, Sans Arc, etc.), but also by the smaller residential units or camps to which they belonged. Lakota social organization was fluid and flexible, with people moving to other camp circles or bands because of marriage, death, or other personal circumstances. Camps were organized and controlled by chiefs and a male governing council.[14] Individual camps would come together into a larger camp circle for annual gatherings like the Sun Dance or other occasions having to do with hunting or ceremony. An elaborate social etiquette for proper behavior was developed and institutionalized. Fraternal warrior societies and sororal artistic guilds imposed structure and order on daily life.

Artistic accomplishments were highly valued. Men's arts, usually made to highlight their exploits in war and the hunt, included pictorial narrative paintings on animal hides used in clothing, on painted tipis, and on shields and drums. They also produced pictographic historical records known as *winter counts*, which used individual glyphlike symbols as mnemonic devices to recall important events of last winter and the winter before that (with "winter" essentially marking a year), stretching back dozens of years.

While men's culture of warfare, and the arts associated with it, received the lion's share of attention in the early literature, women's creativity was central to Lakota life as well. Women were

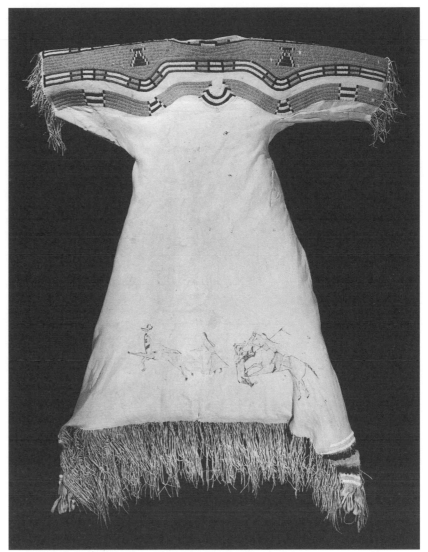

FIGURE 1 Beaded buckskin dress owned by Pretty White Cow, ca. 1875. State Historical Society of North Dakota, Bismarck (L641)

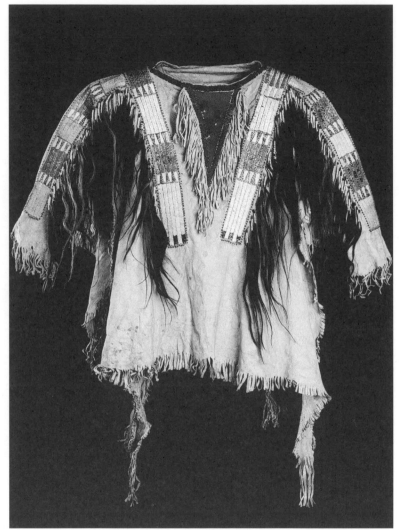

FIGURE 2 Man's quilled antelope-skin shirt adorned with hair locks, ca. 1870. Eugene and Clare Thaw Collection, Fenimore Art Museum, Cooperstown, New York (T64). Photograph by John Bigelow Taylor

accomplished hide tanners, who processed the hides from men's hunting expeditions and turned them into goods for sale or for use in both men's and women's arts. Women painted abstract designs on robes and on luggage and ornamented all of the goods of daily and ceremonial life with fine quillwork and beadwork (figs. 1, 2).[15]

While men gained status through military societies, women's prestige grew according to their artistic accomplishments. They belonged to quillwork and beadwork guilds, which taught them the techniques and customs of their particular artform. Like male warriors, who would recall their exploits while seated with a group of cohorts around a fire, women also publicly validated their artistic achievements. Rattling Blanket Woman recalled the year when, during the summer Sun Dance camp, she challenged other women to come sit in a circle and recount their finest works.[16] Each woman was given a stick for every item she had quilled. The women with the four highest tallies were seated in places of honor and were served food before all the others. The tallies, or "quilling coups," were recorded on the tipi liner of the Red Council Lodge, along with men's military achievements.

Like many other Amerindian peoples, Lakota believe that dreaming is a noble way to receive sacred knowledge (as will be discussed further in the next section). So for women, the art of quillwork is imbued with a sacred legitimacy by its origin in a dream. A supernatural figure named Double Woman appeared to a young woman in a dream and taught her how to use porcupine quills for artistry. Before that, according to the Lakota, no one knew that such items had a practical or aesthetic value. After her sacred dream, this young woman requested a tipi, a porcupine, and a prepared buffalo hide. She went out in search of natural dyes of red, blue, yellow, and black.

She entered her tipi and worked alone, emerging only for meals. She plucked the porcupine quills, separated them according to length, and dyed them. Eventually, she invited one of her friends into the tipi and shared with her the techniques of this new art. Together they quilled an entire buffalo robe, then prepared a feast, and invited many other women. They sang songs and explained quillwork and other secrets Double Woman had shared with the young woman. For this reason, the Lakota say, quillwork is a sacred art.[17]

Just as a dream engendered this sacred art form, it is also said that if a woman dreams of Double Woman she will excel at art, producing fine quillwork of unsurpassed quality.[18] According to some sources, the Double Woman dreamer herself would have extraordinary powers:

> She could do the quill or beadwork on one side of a pair of moccasins, place it against the blank one, sit on it, sing the song, and both would be done. Or she could even just put the quills between the moccasin blanks, sit on them, sing the song, and it would be finished.[19]

Lakota people believed that menstruating women had power that could interfere with other sorts of power within the community. So women withdrew to isolated tipis during their periods. The seclusion imposed during menstruation was considered a perfect time to engage in artistic pursuits. A woman in a menstrual tipi would be waited on by her older female relatives who would encourage her to enjoy this period of relaxation and use it to perfect her skills in quillwork and beadwork.[20] During a girl's first seclusion, her mother would ceremonially instruct her in quilling and moccasin making. As one Lakota recalled, "Even though she had learned quilling before, the girl must quill continuously for four days. If she does this,

she will be good with the awl; if she does not, she will never be industrious."[21] Other ceremonies performed after a young woman's first menstrual seclusion would further ensure that she had the traits of industry and generosity (see chapter 2, pp. 57, 59–63).

For both men and women, the making of artwork often followed upon a dream or vision. Lakota people created a culture that valued private individual religious experience—the Vision Quest—as well as public affirmation of that experience in group ritual and ceremony.

Cosmology and Religious Practice

I am bringing something so the people will live.

—White Buffalo Woman[22]

THE LAKOTA MARK a pivotal event in the formation of their history not by the writing of a document, like the Declaration of Independence, nor by the winning of a certain territory in a war, but by the giving of a mysterious gift. This salutary event in ancient history was the appearance of White Buffalo Woman, who brought Lakota people the Sacred Pipe.

As recounted in the story, two young men were out hunting, when a beautiful young woman appeared before them. One was so taken with her physical attributes, that he approached, intent upon raping her. When his companion next looked up, the man who had held such evil desires was reduced to a pile of bones.[23] The virtuous young man brought the young woman to his community, where she told the people, "I am bringing something so the people will live."

She came from the Buffalo Nation, it is said, to bring gifts to the Lakota. Most of these gifts concerned ceremonial procedures and fundamental modes of correct behavior. She taught people how to perform the handful of core rituals that then became central to Lakota religion, among them the Vision Quest, the Sun Dance, the Hunka Ceremony, the Spirit-Keeping Ceremony, and the Buffalo Ceremony, many of which Black Hawk depicts in his drawings. She also gave them a material object to symbolize the Lakotas' profound bond with the sacred mysteries of the universe: the Sacred Buffalo Calf Pipe, along with instructions on methods of smoking willow bark and tobacco as a means of prayer. As she left the camp, she transformed into a white buffalo calf. Since that time, whenever an albino buffalo calf is born, it is revered by the people. The Sacred Pipe that was so mysteriously delivered to the Lakota is also highly revered and has been handed down through the generations within the Sans Arc community—Black Hawk's band—on the Cheyenne River Sioux Reservation.

With this story, Lakota people account for their fundamental social structure, which is shaped by ceremony and ritual obligation. All Lakota histories—both oral and pictorial—commemorate the coming of White Buffalo Woman. In winter counts it is sometimes shown as having happened in antiquity. Battiste Good, a Lakota making his records on paper in the 1880s based on earlier sources, places the coming of White Buffalo Woman around A.D. 1000 (that is, in mythic time, in time immemorial, long before the memory of any Lakota people, or even in the memory of their direct ancestors).[24]

Many of the details of Lakota ceremony are presented more fully in chapter 2, in the analysis of Black Hawk's drawings, but a few more remarks on Lakota cosmology and spirituality will help set the stage for that discussion. Central to the Lakota understanding of the cosmos is the concept of *Wakan Tanka* (the great mystery, or the great unknowable). Christian Lakota would use this term in reference to God, but in traditional spirituality, it is the cumulative life force of the universe—all that is incomprehensible to mere humans. Other aspects of the universe (thunder, lightning, earth, rock, water, and so forth) are described in terms of personified forces.

These forces, however, cannot be reduced to the simplistic idea of god of thunder, or god of wind, as has sometimes been described. Personifying these forces is simply a way to speak of them easily, for metaphor is more readily understood than abstraction. These forces were observed to have an energy that is long lasting. Energy can move between different realms, and human individuals can tap into these energy forces and channel them: that is the function of much art and all ceremony. Terms of human relationship are often used to name these forces (*tunkasila*, the grandfathers, for example) or to indicate the deep kinship among humans, animals, and the forces of nature (which in the Western tradition are divided between animate and inanimate, a meaningless distinction in Lakota thought). Color, numerical, and directional symbolism are important as well, as will become evident in the discussion of individual drawings. Events and objects often occur in multiples of four, in honor of the four directions.

Unlike Christianity, Lakota religion has no great body of standardized dogma. A great deal of spiritual experience stems from the direct encounter an individual might have with things that are *wakan* (sacred, mysterious); this happens through an individual Vision Quest. There are, however, various categories of ritual specialists, both male and female. Some have knowledge of herbal medicine, while others specialize in particular curing ceremonies. Some hold

encyclopedic knowledge about proper protocols for conducting ceremonies like the Sun Dance or the Buffalo Ceremony. Others are simply recognized as particularly holy or powerful people. So the term *medicine man* is a rather simplistic designation for a variety of ritual specialists. William Edward Caton, who commissioned Black Hawk's drawings, states that Black Hawk was "Chief Medicine Man of the Sioux" (see appendix 2). Still, we don't know what kind of ritual practicner Black Hawk was. The only evidence we have is Caton's simple, and perhaps hyperbolic, statement. Surely it was more likely that Black Hawk was recognized as a powerful spiritual figure principally among the Sans Arc division of the tribe.

Black Hawk: An Artist of the Sans Arc People

1815/16: Itazipco kin titanka otipi. *The Sans Arcs lived in an earth lodge.*

—White Bull[25]

BLACK HAWK was a member of the Sans Arc division of the Lakota. Their name, French for "Without Bows," is a literal rendering of the Lakota name *Itazipco.* They are not as well known to the outside world as some of the other divisions or "fireplaces" of the Lakota, like the Oglala or Hunkpapa, whose famous warriors and battles have captivated people's imaginations for more than one hundred years. Their unusual name comes from a story passed down in winter counts like that held by White Bull. A fourteen-year-old orphan, so poor that he didn't even have a bow and arrows, nevertheless valiantly fought his enemies by striking them with a stick. To honor him, his proud grandmother sang, "My

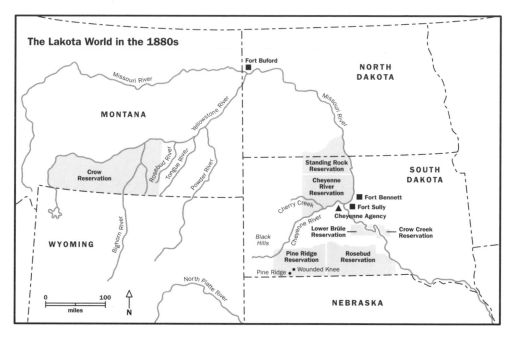

The Lakota World in the 1880s

grandson struck the enemy / yet he had no bow." His band, then, took the name Itazipco, "Without Bows."[26]

To my knowledge, no in-depth history of the Sans Arc band has been written, though many details can be gleaned from other histories of the Lakota in general, or of events at the Cheyenne River Sioux Reservation in specific.[27]

Many non-Indians have heard of the Pine Ridge Reservation in southwestern South Dakota, or its neighbor to the east, Rosebud. But less well known is the Cheyenne River Sioux Reservation in north-central South Dakota, bordered on the east by the Missouri River and on the south by the Cheyenne River, for which it is named (see map). All of these lands, and more, were originally part of the Great Sioux Reservation established by the Fort Laramie Treaty of

1868. This territory was supposed to extend from the Missouri River westward, to encompass all of what is today western South Dakota. (Subsequent congressional acts and laws subdivided, weakened, and diminished this great tract of land.) In reaction to the wars waged with the Sioux in the 1860s, the Fort Laramie Treaty stipulated that if Indians settled at permanent locations, renouncing warfare, they would be given agricultural equipment to help transform them into farmers, a pursuit that nineteenth-century Anglo-Americans saw as inherently more worthwhile than hunting and foraging. Indians living in settlements would also be given annuities of food.

To make this plan manageable, General William S. Harney subdivided the Great Sioux Reservation into smaller agencies. Headquarters for the Cheyenne River Agency were established on the west bank of the Missouri River, about seven miles south of the mouth of the Cheyenne River. Several bands of Lakota—the Minneconjou, Sans Arc, Two Kettle, and Blackfeet—were combined at this agency. Some of their sub-bands had lived in this region for a couple of generations.

The first twenty-five years of the Cheyenne River Sioux Agency were chaotic, at best.[28] During the 1870s, many Indian people continued to try to live a migratory, free existence, despite the constraints of the reservation system, which were tightening inexorably around them. Census and ration records from this decade show dramatic fluctuations in population—ranging from a few hundred to a few thousand. An 1869 survey of Indians at Fort Sully (a few miles south of where the agency headquarters would be established the following year) estimated fifteen hundred Sans Arc in residence there (one thousand of them described as "hostile" and five hundred as "peaceful").[29]

During the summer, the young and the healthy would travel to better hunting lands or go on war expeditions farther north and west against the Crow and other enemies, including the U.S. Army. Records indicate that members of the Sans Arc band traveled with Minneconjou along the North Platte and Powder Rivers (an arc that ranges from what is today eastern Montana and eastern Wyoming to western Nebraska). Some attended the 1867 Sun Dance on the Powder River, at which many bands gathered. Along with Oglala, Minneconjou, and other Lakota bands and their Cheyenne allies, some Sans Arcs had a camp circle at the huge Sun Dance encampment of 1876, right before the Battle of Little Big Horn. Some surrendered at the Spotted Tail Agency (near Pine Ridge) in April 1877.[30]

A number of Sans Arc *tiyospaye* (smaller residential groups that constituted the band) traveled widely, coming to the agency only to bring furs and skins to the trader. Others were reported to be intractable, opposed to agricultural schemes, and even to government annuity payments made to Indians residing on the reservation. Theodore Koues, an agent at the Cheyenne River Agency, wrote the following in his report to the Commissioner of Indian Affairs in August 1872:

> The Indians, Two Kettles, Minneconjouxs, Sans Arcs, and some Blackfeet Sioux are divided into friendly and hostile groups. The friendly are contented and evince a desire to adapt themselves to civilized pursuits. They have about 250 acres in cultivation and are on both sides of the Missouri and along it for 50 miles. This entails great labor but is better from a standpoint of possible depredations from the Hostiles. About 70 log houses have been built and before winter, it is believed, there will be 100. With the exception of plowing and hauling all work is done by the Indians. The hostiles, more numerous than the friendlies, visit the agency once a year in the spring, although small

parties come in from time to time for short stays. This year perhaps 50 lodges have come in and settled near the agency and started some small agriculture. The construction of the Northern Pacific [railroad] has however rekindled their old animosity and checked their tendency to follow the friendlies in agricultural pursuits.[31]

As Koues's report indicates, some people settled near the agency, expecting the government to fulfill its promise of providing food, arable land, and education for their children. Some built log houses and proceeded to farm. Others started businesses selling wood to fuel the steamboats that plied the Missouri River, for the lands along the river were rich with cottonwood trees.

A military installation (later named Fort Bennett) was erected at the Cheyenne River Agency in 1870. Cottonwood log buildings chinked with mud were erected within a stockade, providing lodgings for soldiers, a laundry, a hospital, supply depots, and an independently run trading post. Goods for subsistence and annuity payments to the Indian residents were shipped by steamboat up the Missouri, which was navigable usually from April through November. The fort fronted on the riverbank for the easy unloading of supplies from boats. But the site chosen was unstable bottomland; the powerful waters immediately began cutting away at the shore and threatening the structures. The agency was moved north in 1872, and farther north again a few years later, after buildings were inundated by a flash flood in 1876. Many agency records, including early census books and reports of annuity issues, were lost in that flood.[32]

In early 1876, after months of unrest because of unlawful exploration and mining in the Black Hills (which were supposed to belong to the Lakota in perpetuity, according to the treaty of 1868), the U.S. government was edgy about further Indian uprisings. The Commissioner of Indian Affairs directed that no arms or ammunition be sold to Indians at the agency. While this may have limited the supply of arms to the "hostiles," who were on the move outside of easy agency jurisdiction, it also meant that agency Indians could not hunt the antelope and small game that supplemented their meager and inconsistent supply of rations.

The Battle of Little Big Horn, on June 25, 1876, was the last decisive victory by Lakota and Cheyenne warriors against the U.S. Army. Custer had drastically overestimated his troops' capabilities to fight the combined forces of a great encampment of Oglala, Minneconjou, Hunkpapa, and Sans Arc Lakota, and some Cheyenne, whose combined warriors probably outnumbered the army soldiers five to one. In the weeks after the battle, one of the trader's assistants at the agency noted that the Indians suddenly had real money (rather than trader's scrip) with which to purchase their supplies. It was surmised that the money came from the pockets of more than two hundred dead army soldiers on the battlefield of Little Big Horn, who had been paid shortly before embarking upon their final military engagement.[33]

In autumn of 1876, the power of the U.S. government came down inexorably upon the Indians at the Cheyenne River Agency: they were told that until they signed an agreement relinquishing the Black Hills, no more rations would be issued. Moreover, the Seventh Cavalry and other infantrymen came to the Cheyenne River and Standing Rock Agencies to embark upon a systematic program to "disarm and dismount." Each adult male was allowed to keep just one horse; all other horses and all firearms were confiscated and the horses sold off the reservation.[34] This was a bitter situation for a people who traditionally measured their wealth in horses.

Life in the late 1870s continued to be difficult for all Lakota, both those who had resigned themselves to reservation life, as well as those who resisted. Some bands had retreated to Canada, to avoid submitting to agency authority. Other families struggled to farm and raise livestock. As at other agencies, an Indian police force was formed at the Cheyenne River Agency to help maintain order. Then, in 1878, William Edward Caton arrived to take over the trading post.

Very little is known about this man who commissioned the drawings from Black Hawk. It was Caton's daughter who, in a note found taped to the inside cover of Black Hawk's book, provided the information that he was appointed as trader in 1878 (see appendix 2 for the full text). Among the documents deposited at the National Archives from the Cheyenne River Sioux Reservation is a trading license issued to Caton on May 7, 1882. Trading licenses were renewed annually, so he was still there, four years after his initial appointment.[35] How long he stayed is not known. Whether he was, in fact, "held in high esteem by the Indians" (as his daughter alleged in the documents passed down with the drawing book) is not known, but his actions are telling: if he indeed paid Black Hawk fifty cents in credit at the store for each drawing, this amounted to thirty-eight dollars. While this amount may seem inconsequential according to modern standards, it was a considerable sum of money in 1880.[36] In the same year, in Leavenworth, Kansas (the closest place to South Dakota for which price statistics are available), a pound of roasted coffee cost twenty cents, a pound of molasses was seventy-five cents, a pound of soap cost six cents, and a pound of fresh beef steak cost nine cents.[37] A comparison of laborers' wages is instructive as well. In 1880, a carpenter or blacksmith earned approximately $2.25 per day, while a teamster in Dakota earned $1.92 per day.[38]

This, then, is the backdrop against which Black Hawk, a man about whom we also know very little, made his drawings during the harsh winter of 1880–81. A search of Black Hawk's name in government records reveals more about his identity.[39] To Indian people of the Great Plains in the late nineteenth century, the compulsion of the U.S. government to commit to paper all of the tedious details of daily life must have seemed odd. Why did white men insist on recording names before they would allow food to be distributed or people to travel? For the historian working more than a century later, however, the benefits are clear: traders' ledgers listing purchases like molasses, wagons, or flour, and military and governmental rosters listing not only census data but also people to whom beef or ration tickets had been issued, or those given passes to leave the agency, provide a remarkable record for tracing Native individuals, many of whom otherwise lived in a preliterate world in the 1870s and 1880s.

Beginning in 1868, when Article 10 of the Fort Laramie Treaty stipulated that Indian agents must make exact censuses of Indians, there grew a voluminous chronicle of names. Many of the original U.S. government census ledgers still exist in the National Archives, Central Plains Region, in Kansas City, Missouri. To page through these handwritten ledgers, discovering many famous names, is to have Lakota history come alive via the proper Victorian penmanship of their scribes. As with other pre-twentieth-century historical documents, women's individual histories are, of course, often obliterated. Their names are not necessarily listed; often only those of heads of households can be traced reliably. Some statistical records come alive in other ways, occasionally giving a glimpse of the sense of humor of the Indian men being counted, some of whom clearly

relieved the tedium of standing in line by providing vulgar, slangy names to the agents, who dutifully translated and recorded them.[40]

By the time that individual land allotments were registered, the files grew thicker. Birth, death, and probate records begin to multiply at the very end of the nineteenth century. Today, however, in most tribal offices, such records are customarily closed to all but descendants of the individual in question, for reasons of privacy. This paper trail sometimes makes it possible to retrieve at least the sketchy outlines of biographical data on individuals who were not otherwise famous enough in the eyes of the dominant society of their time to have made it into official chronicles. The records on Black Hawk are, unfortunately, scanty. Caton's family documents, handed down with the drawing book, tell us only that Black Hawk was chief medicine man of the Sans Arc band (see appendix 2).[41] The documents of the Cheyenne River Sioux Reservation proved more fruitful.

As mentioned above, many early records were destroyed in the flood of 1876. But documents at the National Archives, Central Plains Region, in Kansas City, do show some tantalizing traces of Black Hawk's existence in the 1880s. Annuity and goods disbursement records from September 1880 record that he purchased a wagon. He is listed as a member of the Sans Arc band (corroborating the laconic data in the Caton family records). There is also a record of there being four members in his family.[42] During the 1880s, there are records of a pair of overalls issued to Black Hawk as part of his annuity payment. Sometimes he made larger purchases: a bedstead, a cow or two, a cooking stove.[43] From these items we can deduce that, like many Lakota in the 1880s, Black Hawk probably lived in a log house, for which he needed a bedstead, and that he and his family were raising a few animals, struggling to eke out an existence.

Black Hawk apparently received no tribal land allotment, for no official agency records exist for him at the Cheyenne River Sioux Reservation offices in Eagle Butte, South Dakota. Arthur Amiotte suggested that we search for descendents as some oral histories might still maintained within the family, just as there are within his own family concerning his great-grandfather, the noted artist Standing Bear. Records do exist for two individuals named John Black Hawk who lived at that agency at the end of the nineteenth century. At that time it was not uncommon for government officials to give patronymic names to children; thus, Black Hawk would have been the surname recorded on official documents for the children of Black Hawk and any wife, along with a Christian first name. The first John Black Hawk in the records, however, born in 1852, was not Black Hawk's son; he is listed as the son of Winifred Horn and Henry Crane. The second John Black Hawk, born in 1862, was the son of a man named Black Hawk and a woman named Hollow Horn Woman. In his file, it states that his parents came from the Cherry Creek district.[44] John Black Hawk had only one child, a male named Harry Poor Dog, born in 1880. Though married four times, Poor Dog had no children of his own and died in 1970. Poor Dog's foster son, who had no children either, died in 1956. Black Hawk, it seems, has no descendents.

The last record at the Cheyenne River Sioux Reservation of Black Hawk himself seems to be in 1889, when he is listed in a census of adult males as being fifty-eight years old.[45] After this last mention, his name does not appear again in the records, suggesting that he may have died shortly thereafter. Although nothing certain is known of Black Hawk's death, there are some suggestive clues.

The Cherry Creek district, where Black Hawk lived, was, in the late 1880s, a bastion of traditionalists and "hostiles," as they were often called in U.S. government documents (see pp. 146–47). Many members of Big Foot's band at Cherry Creek (mostly made up of Minneconjous), practiced the Ghost Dance religion at the end of the 1880s; many of these practitioners died at Pine Ridge, in the Massacre at Wounded Knee, on December 29, 1890. Among Big Foot's followers killed at Wounded Knee was a man named Black Hawk. According to one account, he was seventy-seven at the time of his death—almost twenty years older than the Black Hawk listed in the Cheyenne River records. Nevertheless, this could be the artist Black Hawk, for the name of the man I suggest was his son, Birds Are Afraid, and the name of his wife, Hollow Horn Woman, also appear in the roster of individuals present at Wounded Knee.[46] These details are tantalizing but inconclusive. As historians of the Wounded Knee Massacre have pointed out, there are numerous inaccuracies and conflicting records, arising not only from confusion and lack of information but also from the Lakota custom of having more than one name, or the problem of names being translated imprecisely.[47]

Because Black Hawk's name does not appear in Cheyenne River records after 1889, and because an individual named Black Hawk is listed among Big Foot's followers killed at Wounded Knee, I suggest that the life span of the artist of these drawings was about 1832 to about 1890. A birth date circa 1832 would mean Black Hawk was approximately fifty when he drew his visions and scenes from Lakota life and ceremony. For a nineteenth-century Lakota, the age of fifty was a time past the busyness of making a family and the business of making war. It was a time for reflection and contemplation; a time when older men turned their attention to making art, to record the experiences of their youth and the encyclopedic knowledge of their maturity.

The Lakota Drawing Tradition

He stood pointing his carbine at me and I was afraid but I charged him and ran him down. He fired at me but missed. It was lucky for me. This was a hard fight, the hardest I ever fought, but finally I overpowered him.

I have had this in my memory for a long time. Now I have shown it to you, friend. Many of the Dakotas and the white men saw me do this and know me, my friend.

—Chief White Bull[48]

WHITE BULL WROTE these words to Usher Burdick in 1931, explaining a drawing he made expressly for this North Dakota lawyer. White Bull chose to illustrate one of the notable war exploits of his youth. Even in 1931 he drew it in the way his forebears had been drawing for well over one hundred years.

The pictorial tradition as practiced by men on the Great Plains encompassed both history and autobiography. Men painted their war exploits on their own hide shirts and buffalo robes, thus memorializing their history in a public fashion. Traditionally, these pictographs were almost stenographic, conveying only the most concise details of subject and action. The finest early examples are from the Upper Missouri River area, most of them probably Mandan. Only a couple Lakota examples of painting on hide survive from the early nineteenth century.[49]

When European and Euro-American artists such as Karl Bodmer, George Catlin, and Rudolph Kurz traveled to the American West beginning in the 1830s, they shared their materials with their Plains colleagues, helping to start a new trend—drawing on paper using pens and pencils, and drawing in a more naturalistic and detailed style. In subsequent decades, most male artists on the Great Plains tried their hand at these new materials, often drawing in cast-off notebooks and ledgers, giving rise to the term *ledger drawings,* which, strictly speaking, refers only to those works rendered in lined account books. But *ledger drawing* has become a shorthand (if somewhat inaccurate) term characterizing all drawings done on paper.[50] In fact, many late-nineteenth-century drawings, especially those commissioned by outsiders, were often executed on drawing paper, in small artists' tablets, in fine, unused notebooks of unlined paper, or on ordinary writing paper, like Black Hawk's drawings.[51]

Presumably the Lakota, like other Plains Indians, had occasional access to paper, pencils, pens, and colored inks from the beginning of the nineteenth century, when they came into steady contact with traders. Nevertheless, the earliest securely dated drawings that are indisputably Lakota date from 1870. There is, however, a series of drawings of undetermined date by a Lakota artist named Swift Dog (ca. 1845–1925) that exhibits a style of representation earlier than that seen in the 1870 drawings, one more akin to an older, hide-painting tradition.[52] In the drawing illustrated here (fig. 3), Swift Dog depicts himself on a horse-capture raid. In his right hand he holds leads to three horses, which are drawn facing the left side of the page. The action moves from right to left, as it does in most hide paintings, as well as most drawings on paper. No ground line is depicted, but the horses are stacked, as if to suggest depth in space. Swift Dog has

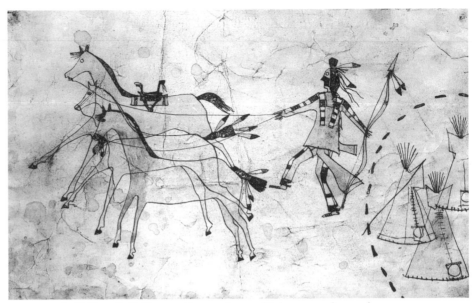

FIGURE 3 Swift Dog, *Swift Dog stealing ponies*, 1870? Ink, watercolor, and crayon on paper, 8¼ x 13½ in. (21 x 34.3 cm). Collection of Mark Lansburgh, Santa Fe

drawn the horses in X-ray style, so that all parts of the horses behind the first one are visible. Unlike some ledger artists who calculated the gaps they had to leave in a horse's outline in order to create a more realistic overlapping effect, Swift Dog worked with a free, sure line, unconcerned about the overlapping outlines of his figures. This gives his work a transparency and immediacy that is very pleasing to the eye. Narrative detail is provided by an indication of locale at right: Swift Dog shows evidence of his daring, for he has captured these horses not in a skirmish out on the open plains, but from right within the enemy camp.

The earliest securely dated Lakota drawings, done in 1870, are by a Hunkpapa Lakota named Four Horns, who proudly drew the

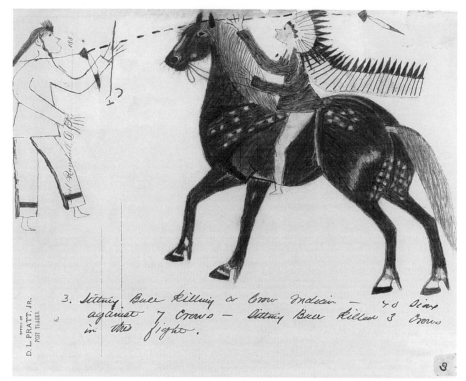

3. Sitting Bull killing a Crow Indian — 40 bians against 7 Crows — Sitting Bull killed 3 Crows in the fight.

D. L. PRATT, JR.,
POST TRADER.

FIGURE 4 Sitting Bull, *Sitting Bull killing a Crow Indian*, 1882. Pencil and crayon on paper, 8½ x 10¼ in. (21.6 x 26 cm). Buffalo Bill Historical Center, Cody, Wyoming (40.70.3)

evident in Swift Dog's and Four Horns's drawings continue, with some modifications, to be important in the Lakota drawing tradition: for example, the lack of concern for situating the figures in any landscape or background, the simple linear style, and the focus on readily recognizable iconographic detail to identify figures and their actions.

The Swift Dog drawings were held within the artist's family until the 1930s. Men routinely executed drawings for themselves and for circulation among their friends and cohorts; they would use such drawings as *aide-mémoire* in evening oratory, around the campfire. But by the 1870s and 1880s it was becoming increasingly common for works to be made for sale to outsiders as well. Four Horns's drawings, for instance, were collected by U.S. Army surgeon James Kimball in 1870, at Fort Buford in Dakota Territory. Sitting Bull made some drawings of his own, now lost, at the same time; his only surviving ones postdate his 1881 surrender to the U.S. government. In 1882, he made drawings for Daniel Pratt, the trader at Fort Randall, and for Lieutenant Wallace Tear, who said that Sitting Bull "made these pictures for me to show his gratitude for blankets and clothing furnished his children last winter before the government supply of clothing for his band arrived."[54] And of course Black Hawk made his drawings at the behest of Caton, the trader at the Cheyenne River Agency during the winter of 1880–81. Traders often developed special friendships with particular Indians, and it is not uncommon for drawings to have come into non-Native possession in this way.

Sitting Bull's drawing (fig. 4) depicts him killing a Crow Indian, a common theme in Lakota art, for the Crow were their bitter enemies (see pp. 90–111 in chapter 2). In his work, human figures

exploits of his nephew Sitting Bull on the pages of discarded U.S. Army roster sheets.[53] To show that he was not recording his own feats, but those of another man, Four Horns assiduously included a large pictograph of a seated buffalo connected by a line to the main protagonist in each picture. Except for this meticulously rendered name glyph, his style is somewhat sketchy and impressionistic, although details of clothing and headgear are included to help identify the protagonists and their actions. Many traits

retain the relatively flat, sketchy quality seen in Four Horns's and Swift Dog's works. The horse in this drawing, however, is quite rounded, with a sense of three-dimensional modeling. Matthew Stirling notes that the German journalist and artist Rudolf Cronau made Sitting Bull's acquaintance in 1881 and "spent some time teaching him how to draw."[55] But of course Sitting Bull was an accomplished artist long before this date. We know that Four Horns's drawings of 1870 were based on now-lost originals done by Sitting Bull himself. A more likely explanation for the relationship between Cronau and Sitting Bull is that these two artists, from radically different cultural and artistic traditions, shared their diverse styles and materials, much as Bodmer and Catlin had done with other Plains artists some decades before, and as Kurz did at Fort Union in the 1850s.

Occasionally, anecdotes concerning these meetings between artists of different cultures suggest that the Plains men involved were curious and intrigued by the artistic customs of these strangers, and that most considered themselves artist-colleagues, not students. For example, Kurz recalled in his diary in 1852, "While I was sketching this afternoon, the Sioux visited me. He brought two interesting drawings. He was not satisfied with my work; he could do better. Forthwith I supplied him with drawing paper."[56]

The scope of Lakota pictorial narrative expanded during the 1880s, perhaps for two reasons. That decade was an era of great hardship on Lakota reservations; it is not surprising that some men used their artistry as a means of making money. Secondly, not only was the outside audience interested in a fuller picture of Plains culture, but the men making drawings were engaged in an act of cultural remembrance and validation at a time when their culture was under siege. There are no better examples of this than the drawings of Black Hawk.[57]

In addition to depicting Lakota war exploits in seventeen drawings (see pls. 39–55), Black Hawk also drew scenes of spiritual visions (see pls. 1, 2), courtship (see pls. 24, 25, 26), and social dancing (see pls. 27, 28, 29). Numerous drawings document traditions—ceremonial and social practices that were changing or were under attack by outside forces (see pls. 3–21).

Black Hawk was a master of coloration and patterning, as seen in his rows of human figures (see pls. 27, 28, 29). He also had a meticulous eye for detail, describing (with both line and color) beadwork, jewelry design, fringe, feather, and fabric (see, for example, pls. 7, 22, 29, 32). In his drawings of mounted combat, he ably conveyed the various movements of a well-trained war pony (see pls. 44, 46).

Having recently emerged from obscurity, Black Hawk's book of seventy-six drawings now stands as the most complete visual record extant of Lakota ceremonial imagery. It is also the earliest known example of a Lakota artist chronicling in a series of interrelated works not simply personal history, or the military history of his cohorts, but a larger view of ceremonial life.[58] His drawings of the Sun Dance, animal dreamers dances, visionary experiences, and the puberty ceremony (see pls. 1–21), and even the ceremonial practices of his Crow enemies (see pls. 30–34), are superb artistic studies of indigenous life, rendered with far more knowledge and accuracy than most of those by outsiders like Catlin or Bodmer. Black Hawk's drawings are noteworthy not only for their excellence of execution but also for their profound underlying spiritual and artistic vision.

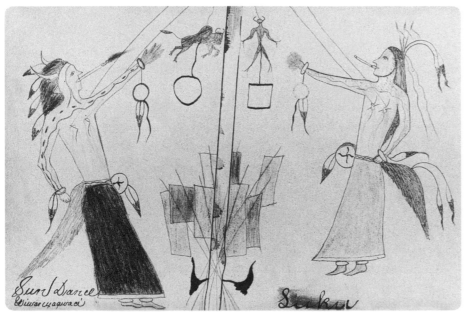

FIGURE 5 Artist unknown, Sun Dance, ca. 1890. Colored pencil and ink on paper, 5¾ x 9 in. (14.6 x 22.9 cm). Founders Society Purchase, The Detroit Institute of Arts (81.233). Photograph © 1998 by The Detroit Institute of Arts

The impulse toward making a visual record of ceremonialism became more common later in the 1880s and in the 1890s; during this period, other artists also turned their attention to the depiction of ceremonial vignettes. This required an expansion in stylistic vocabulary, as artists endeavored to pictorialize subjects that had not been part of the traditional repertory. In figure 5, for example, an unknown artist has drawn the ceremonial climax of the Sun Dance. Two men have pierced their chests with small wooden pegs and attached themselves to the sacred Sun Dance pole. The artist has drawn the pole with its circle of cloth banners at its base, the rawhide figures of man and buffalo attached to the pole, and the skin straining away from the pierced flesh of the ritual celebrants (for further discussion of the Sun Dance, see pp. 38–44). In common with most Lakota drawings of this era, the action still takes place without benefit of ground line or background.

In the works of this era, we are witnessing the beginning of a pictorial autoethnography, in which artists begin to set down a record not just of their feats of personal bravery but many aspects of cultural practice. Artists were fulfilling a dual purpose in making these evocative images of Lakota ceremonialism. It was an act of remembering and reconstituting the most sacred activities of traditional life. Yet artists also sold these miniaturized memories, so it became, as well, an act engendering cross-cultural understanding—reaching out to convey some essential bits of information about Lakota identity.

Another artist working in the 1880s was Sinte, a Lakota probably from Pine Ridge, who made a series of drawings when he accompanied Cronau on a tour of European cities. Some of Sinte's drawings fall well within the pictorial conventions established by previous generations. He drew himself on horseback, for example, charging his enemies. Yet Sinte not only depicted himself as a mounted warrior, he also attempted a frontal self-portrait and drew Western-style buildings, accurately mapping the Pine Ridge Agency as it existed in the 1880s.[59] Like Black Hawk's drawings, Sinte's works reveal the 1880s to be a time of expansion of subject matter and stylistic conventions for Lakota artists. Both Sinte and Black Hawk, for example, drew highly descriptive nature studies of animals, an unusual subject for Indian artists of this era (see pp. 117–41; see pls. 60–76).

Sinte's drawing of a bugling male elk whose call has mesmerized the female elk who trots behind him (fig. 6) is not only a study

in descriptive science but also a reference to Lakota ceremonialism. In front of the male elk is a hoop, attached by a thin line to a pictographic head of a man. The man is trying to harness the love medicine of this animal for his own use (for further discussion of elk love medicine, see pp. 56–57). Artists like Black Hawk and Sinte moved comfortably between traditional representations of mounted warriors, nature studies, and (in Sinte's case) a rendering of a modern town with almost cartographic accuracy. This is important to note, for many Native artists, past and present, move comfortably between traditional and more contemporary styles.

In contrast to the experiments in style and subject matter ventured by Sinte and Black Hawk, some artists continued the established tradition of memorializing exploits in warfare in simple compositions showcasing a Lakota hero and his adversary. A good example of this is a book acquired from Red Hawk at Pine Ridge, South Dakota, in 1891, shortly after the Massacre at Wounded Knee. Its 116 drawings in several artists' hands depict the war exploits of seventeen men. The example illustrated here (fig. 7) is one of just two showing peaceful negotiations with the Crow. On horseback is a Lakota named Holy Standing Buffalo (identified in the inscription above his head in both Lakota and English). He carries a rifle and bow and arrows. On foot, a Crow man approaches, carrying a handgun. Between them, a row of horse tracks and a peace pipe suggest that this is a truce among a group larger than just these two individuals. The artist (whether Red Hawk himself or a cohort is unknown) provides detailed information about the clothing and accoutrements of each man.[60] He is less interested in facial features or hands, which are sketchily indicated. This work was probably executed in the 1880s. While captivating in its free, gestural

FIGURE 6 Sinte, Elk Medicine, 1886. Graphite and paint on paper, 4⅓ x 8⁷⁄₁₆ in. (11 x 21.5 cm). Department of Library Services, American Museum of Natural History, New York (50.2100)

quality, especially in the rendering of the horse, in many ways it is far less artistically accomplished than Black Hawk's drawings of the same decade.

Black Hawk's seventy-six drawings are the most complex, subtle, and sophisticated body of Lakota graphic art in existence today. But from 1890 to 1913, a Lakota artist was engaged in a project of far greater scope and magnitude. Amos Bad Heart Bull (1869–1913) systematically drew in a large ledger he had purchased for that purpose. By the time of his death, he had completed some 408 drawings, ranging from early history of the Lakota and a record of their traditional ceremonialism to chronicles of the Battle of Little Big Horn, the Ghost Dance, the murder of Sitting Bull, and the Massacre at Wounded Knee.[61] Before undertaking this work, Bad Heart Bull had executed a winter count. According to Helen Blish, whose thorough study of his work remains a landmark of scholar-

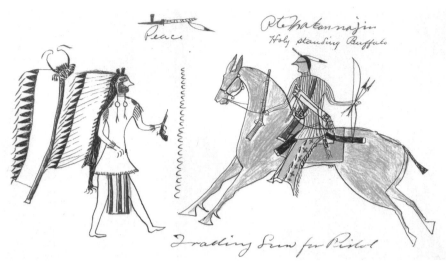

Peace

Pte Wakannajin
Holy standing Buffalo

Trading Gun for Pistol

FIGURE 7 Red Hawk and others, Holy Standing Buffalo negotiating a peace treaty with a Crow Indian, from Red Hawk's ledger book, 1880s. Ink and crayon on paper, 7½ x 12¼ in. (19.1 x 31.1 cm). Milwaukee Public Museum (2063)

ship in Lakota studies, it was while working on the winter count that the artist "realized the quantity of materials that was being left untouched—the battles, rituals, ceremonies, and various activities and interests that were not being recorded and yet were vitally significant in the life of the people."[62]

Bad Heart Bull rendered a panoptic view of Lakota life, with details painstakingly conveyed both artistically and in inscriptions written in Lakota (with an occasional name written in English). As Blish points out, it is significant that Bad Heart Bull did not undertake this epic work for any tribal archive or for tribal elders; this was not an "official" Lakota history. Equally significant is the fact that it was not made at the behest of any anthropologist or collector who desired a record of Lakota life. It was a personal achieve-

ment that satisfied Bad Heart Bull's own vision of what it meant to be an artist and historian.[63]

In terms of his artistic capabilities, Bad Heart Bull moved easily from large-scale epic scenes of warfare to miniature, maplike renderings, as well as to intimate depictions of courtship and ceremony. He chronicled warfare between the Lakota and the Crow during the 1850s, 1860s, and 1870s, in addition to their adaptation to farming and ranching in the 1880s and 1890s.[64] Bad Heart Bull experimented with new modes of representation, fearlessly tackling three-dimensionality, back and three-quarter views, and aerial perspective. His work is dynamic and vigorous. Bold in its conception of the sweep and detail of Lakota history, it stands as an unparalleled achievement in the history of Native American art.

In the drawing illustrated here (fig. 8), Bad Heart Bull depicts one moment in the retreat of Major Marcus A. Reno and his men during the Battle of Little Big Horn in 1876, a subject to which he devoted nearly three dozen drawings.[65] In this image, one soldier, stripped of his uniform, lies dead in the middle ground on the right. Above and below him, mounted Lakota lead away cavalry horses, some drawn in difficult head-on view. Other Lakota chase the retreating army soldiers across the picture plane. Like the other drawings in this sequence on the Battle of Little Big Horn, the page is a riot of action, movement, and color, all carefully observed.

Bad Heart Bull's original work is no longer available for study, having been buried with his sister Dollie Pretty Cloud in 1947. Although scholars may mourn the loss of this unique artwork, burial is an appropriately Lakota way of dealing with such a powerful and personal item. The Lakota believe that objects can be imbued with *nagi*—spiritlike potency. Because of this power, estab-

lished customs dictate proper ownership, distribution, and disposal of personal possessions. Customarily, valued possessions are either buried with the deceased or burned.

In the early years of the twentieth century, anthropologists and other scholars worked among the Lakota and other peoples of the Plains, documenting what they perceived to be the remnants of the great nineteenth-century traditions that still lingered in the memories of the older generation.[66] The drawings that survive from this period were, for the most part, made for sale to such scholars or the tourist trade. Artists such as No Two Horns (1852–1942), White Bull (1849–1947), Kills Two (1869–1927), and Standing Bear (1859–1933) produced work, often on commission, that illuminated late-nineteenth-century Lakota life.[67] In some cases, such works are almost indistinguishable stylistically from Lakota drawings done forty years before (with the possible exception of the amount and precision of iconographic detail, such as headgear, shield imagery, and the like). As art historian Evan Maurer has observed, such visual conservatism is not "a flaw of impoverishment but instead an affirmation of tradition that honors deep cultural and spiritual values."[68]

Standing Bear had traveled with Crazy Horse's band, fought as a youth in the Battle of Little Big Horn, and later traveled extensively in Europe with Buffalo Bill's Wild West Show. He is best known for the drawings he did in 1931 to illustrate *Black Elk Speaks*. But long before this he had painted ambitious narrative scenes on large expanses of muslin, mostly on commission. He also made many small drawings on paper depicting the ceremonies and regalia of traditional Lakota life.[69] In the drawing illustrated here (fig. 9), Standing Bear has made a portrait of two Lakota headmen; it is not a portrait of particular individuals, but of the kind of regalia worn by such leaders. Himself

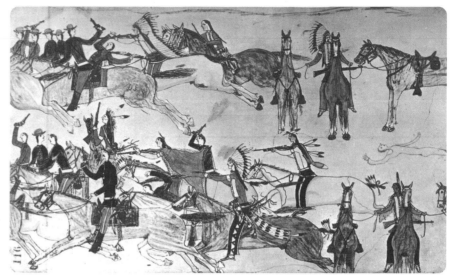

FIGURE 8 Amos Bad Heart Bull, Reno's retreat during the Battle of Little Big Horn, ca. 1900. Ink and pencil on paper, 7 x 12 in. (17.8 x 30.5 cm). Photograph courtesy of the University of Nebraska Press

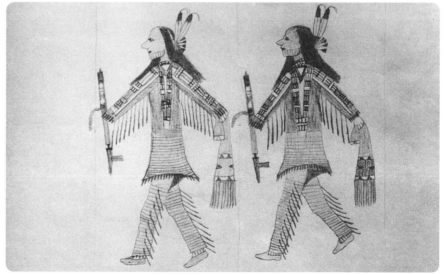

FIGURE 9 Standing Bear, two Lakota headmen, 1920s? Buechel Museum, St. Francis Mission, Rosebud, South Dakota

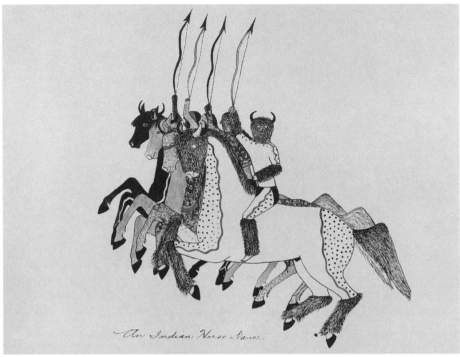

FIGURE 10 Kills Two, Horse Dance, 1920s? Location unknown. Reproduced from plate IX in Hartley Burr Alexander's *Sioux Indian Painting*

a headman of his group, Standing Bear renders the quilled shirt fringed with human hair, the quilled and painted leggings, pipes, and pipebags owned by such individuals (compare to fig. 2 and pls. 22, 23).

This drawing was part of a visual documentation project that Standing Bear completed, perhaps in the 1920s. He drew the regalia of his people for Father Eugene Buechel, a Catholic missionary to the Lakota from 1902 to 1954 and an amateur linguist and ethnologist. Though Standing Bear sometimes indicates a sense of locale through depictions of rivers, camp circles, and the like in his ambi-

tious narrative paintings on muslin, most of his small drawings adhere closely to the Lakota pictorial tradition of simple figures rendered without background or ground line. Like Black Hawk, he valued fine detail in his drawings.

Kills Two, like Standing Bear, continued to follow the stylistic precepts of classic Lakota warrior art, even in the 1920s.[70] His Horse Dance (fig. 10) depicts a ceremonial reenactment of a vision of Thunder Beings and Thunder Horses (compare with pls. 1, 2, discussion on pp. 26–30). The horses and riders are painted with hail emblems and streaks of lightning. The faces and limbs of the horse and rider in the foreground are covered with shaggy buffalo fur. Kills Two carefully renders four horses prancing in a row, front legs upraised.

Compared with works like Swift Dog's, the artistry of Standing Bear and Kills Two evinces a greater control and precision in their use of materials. Their work is more illustrative, but less immediate and bold in its execution. Yet they continue to use nineteenth-century conventions to depict events that had transpired in that century. They were making an artistic choice that linked them with their own youth and with generations of artists who had preceded them. At the same time, many of these works of art were made for sale to outsiders who were eager to have representations of the "old days." The rather simple, untutored look of some of them undoubtedly filled these buyers' criteria for authenticity in Indian art (however specious we might find those criteria today).

What modern viewers respond to in these captivating drawings is their immediacy. Many of the best works balance delicate, intricate detail with graphically bold simplification. Swift Dog's drawing may seem rudimentary compared to the more fully realized compositions of Black Hawk or Bad Heart Bull. Yet the aesthetic prin-

ciples of Plains graphic arts are fully formed within the earlier work: action generally moves from right to left, an oversized horse commands the space, a horizontal format is favored, and abstraction vies with narrative detail in a predominantly flat picture plane.

This brief survey of the history of Lakota graphic art demonstrates that in the last three decades of the nineteenth century and the first three decades of the twentieth, there was no unilinear development in that drawing tradition. Instead, the traditional pictographic shorthand, which had been the legacy of generations of hide painters, continued to be central to Lakota artists. The 1880s and 1890s did, however, witness experiments with more full-blown narrative styles among some artists, while others maintained the visual economy of the earlier style. Moreover, the graphic experiments in this period provided the foundation for Lakota visual arts of the twentieth century, a topic that will be discussed in chapter 3.

❈

THIS INTRODUCTION to Lakota life, thought, and art, and to the meager information known about Black Hawk himself, serves as a springboard to a better understanding of the seventy-six individual works of art by which this extraordinary artist communicated his vision of the Lakota world. These works are examined in detail in the next chapter.

BLACK HAWK'S DRAWINGS

This series of sketches by Black Hawk represents the incidents in a long dream which he had.

The winter of 1880–81 was a very severe one at the Cheyenne Agency in Dakota. My father, William Edward Caton, was Indian Trader at the agency, having been appointed to this position in 1878. He was held in high esteem by the Indians and was their great friend.

Black Hawk, Chief Medicine Man of the Sioux was in great straits that winter, having several squaws and numerous children dependent upon him. He had absolutely nothing, no food, and would not beg. Father knew his condition; he sent for him and asked him to make pictures of the dream, offering to furnish paper and pencils, and to give him 50 cents in trade at the store for each sheet he brought in. Father gave him what paper he had on hand, which was ordinary double foolscap, and ink and pencils.

—Edith M. Teall, 1932[1]

THE SEVENTY-SIX DRAWINGS made by Black Hawk, preserved for posterity in a handsome, leather-bound book compiled by William Edward Caton in 1881, are the most richly detailed compendium of Lakota drawings in existence. Because, as the above statement by Teall indicates, Black Hawk did not, himself, conceive this collection of images as a book, there is no need to replicate in this publication the sequential order of the drawings as they appear in the bound volume.[2] In fact, there appears to be no order, with the exception of the first two drawings, which Caton clearly chose as the dramatic introduction to his bound book, accompanying them with neatly penned captions. For that reason, and because these drawings depict a powerful vision of Spirit Beings well known in Lakota cosmology, they are discussed first. In the sections that follow, the other drawings are analyzed in detail by subject matter, starting with the most sacred images.

Visions of Spirit Beings

No Lakota should undertake anything of great importance without first seeking a vision relative to it. Hanble *(a vision) is a communication from* Wakan Tanka *or a spirit to one of mankind. It may come at any time or in any manner to anyone. It may be relative to the one who receives it, or to another. It may be communicated in Lakota or* hanbloglaka *(language of the spirits). Or it may be only by sight or sounds not of a language. It may come directly from the one giving it, or it may be sent by an* akicita *(messenger). It may come unsought for or it may come by seeking it.*

—George Sword[3]

IN ALL SOCIETIES on the Great Plains, the personal dream or vision is a primary means for gaining knowledge and power. Through a personal encounter with the sacred, one is strengthened and enriched or given war medicine, or artistic designs, or powers for healing. As George Sword indicated, a vision may come unbidden, or one might seek it. The Lakota term *hanblecheyapi,* "vision-seeking quest," refers to the act of separating oneself from quotidian activities and seeking an encounter with the sacred. While this experience is open to either gender, it was traditionally expected that young men in particular would seek a vision, in a solitary fast in the wilderness, lasting several days.[4]

FIGURE 11 Caton's handwritten caption to plate 1

Though a vision is intensely personal, there are social mechanisms for the sharing of the fruits of such visions. Song, performance, and the making of art are among the most common. A man might paint his vision on a shield or drum; material aspects of it might be incorporated into his personal medicine bundle or clothing. A woman might fashion innovative designs in her quill- or beadwork as the result of a vision. Some artists painted their visions on tipis, while others, like Black Hawk, drew them on paper to share with an audience.

When Caton had Black Hawk's drawings glued to linen and bound into a book, he chose to begin the pictorial narrative with two very arresting images of Spirit Beings (pls. 1, 2). On the facing pages, Caton wrote captions only for the first three images in the book. The captions of the first two read: "Dream or Vision of himself changed to a destroyer and riding a Buffalo Eagle" (fig. 11) and "Same as first."

Black Hawk's two compositions are based on the image of a horse and rider—a ubiquitous theme in the iconography of the Great Plains—yet the steeds and their riders are anything but ordinary. Their arms and legs have been transformed into eagles' talons, and buffalo horns curve from their heads. The intensity of the riders' clenched teeth in the round, buffalolike heads is enhanced by their mesmerizing yellow eyes. In plate 2, both figures are covered with small dots, representing hail. In plate 1, the steed has orange hail on its torso. In both images, the rider and his mount are connected by lines of energy between the riders' talons and the animals' mouths. These lines resemble electrical charges or lightning flashes as well as reins. The emotive energy of these figures is emphasized by small jagged or hatched lines, in black and red, that radiate from each figure. In plate 2, the unusual

staff with cloth-tipped ends held by the rider also quivers with power; horse and rider fly through the sky, passing through a rainbow formed from the beast's multicolored tail.

Each of these drawings is rendered in a sure hand that varies according to what it chooses to emphasize: the bold lines of the "Buffalo Eagle" itself (as the caption describes it); the nervous, shimmering lines that surround each being; and the hot yellow eyes and orange or blue accents on each figure. While Black Hawk called these destroyers, they clearly represent Thunder Beings—powerful supernatural creatures who sometimes appear to supplicants in Vision Quests. Depictions and descriptions of Thunder Beings often combine the attributes of eagle, horse, and buffalo—all sacred animals. The rainbow, too, is not only an entrance to the spirit world, but a symbol of Thunder Beings themselves.[5] Various descriptions of Thunder Beings emphasize their powerful eyes. Black Elk commented that every time the great beast snorted, "there was a flash of lightning and his eyes were as bright as stars"[6] (see his further description, below). George Bush Otter said that Thunder Beings "do not open their eyes except when they make lightning."[7] Both of these quotations suggest that the round, yellow eyes of the riders are meant to be as vivid as lightning. When men performed public dances impersonating such figures, their black, horned head coverings had mirrors where the eyes should be, in order to flash and glitter in the same manner as these lightning-eyed Spirit Beings.[8]

Horses are the messengers of Thunder Beings.[9] So images of sacred horses, or transformed horses, relate to these celestial powers. Thunder Beings (and their messengers) bring summer's powerful electrical storms, which are so dramatic on the Great Plains. They *are* the thunder, the lightning, the wind, and the hail.

As mentioned previously, most nineteenth-century Plains drawings chronicle warfare and horse capture; a smaller number depict scenes of daily life and courtship. But only a handful endeavor to convey the transformative power of religious experience. The caption—"Dream or Vision of himself changed to a destroyer . . ."—makes it clear that Black Hawk is depicting his own transformation: this was not simply something he saw, but something he became. While these images are unusual in the corpus of Plains Indian drawings, their imagery is not unfamiliar to Lakota people who have seen (or have themselves become) Thunder Beings while on a Vision Quest. Nor are these images unfamiliar to those who have merely read about visions experienced, performed, or narrated by others within Lakota communities.

While every vision is a unique and personal experience, visions of Thunder Beings that conform to certain visual patterns have been reported by a number of Lakota. The most well known is Black Elk's experience, made popular by John Neihardt in *Black Elk Speaks;* at its core it was a vision of spirit horses. While Black Hawk's drawings lack an accompanying narrative, his compatriot's words provide insight into the larger themes Black Hawk seeks to convey visually. Black Elk recalled:

> I looked over there and I saw twelve black horses toward the west, where the sun goes down. All the horses had on their necks necklaces of buffalo hoofs. I was very scared of those twelve head of horses because I could see the lightning and thunder around them.
>
> Then they showed me twelve white horses with necklaces of elks' teeth [in the north]. . . .

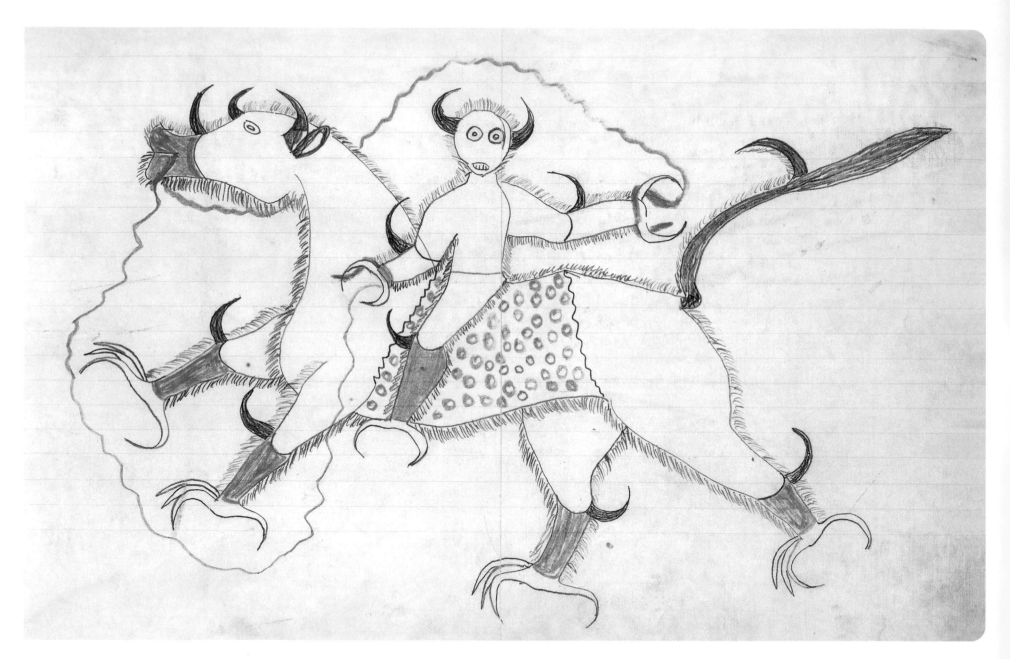

PLATE I

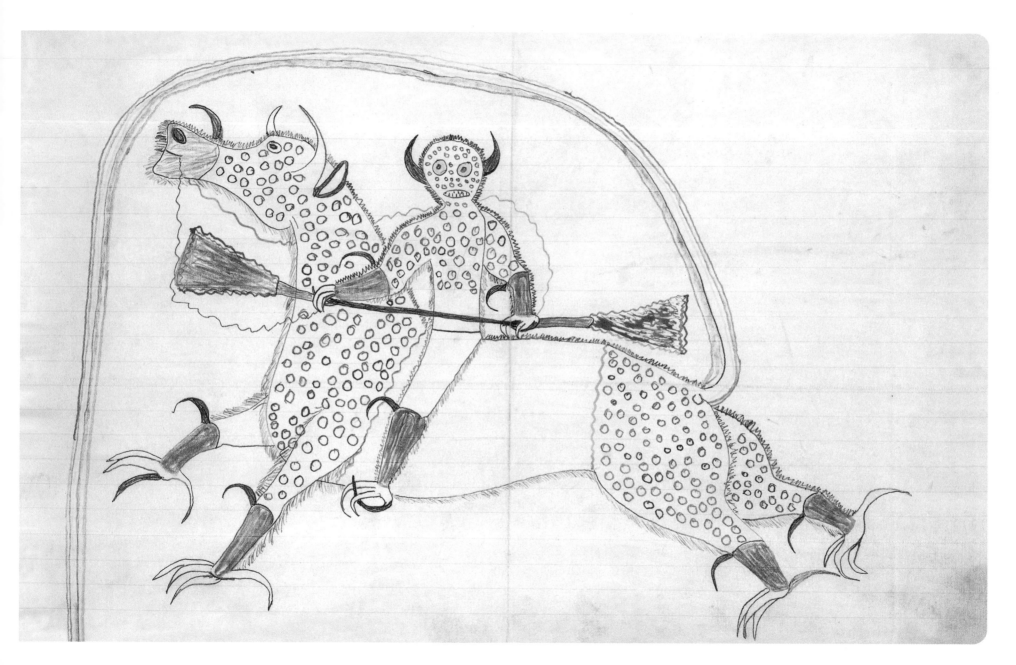

PLATE 2

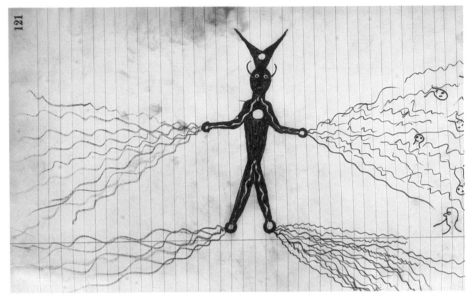

FIGURE 12 Artist unknown, Thunder Being, date unknown. Microfilm roll 0220, page 121, Mrs. Edward M. Johnson Collection, State Historical Society of North Dakota, Bismarck

Then I turned around toward the east. . . . I saw twelve head of horses, all sorrels.

Then I turned to the place where you always face, the south, and saw twelve head of buckskin horses. These horses had horns. . . .

Then these horses went into formations of twelve abreast in four lines—blacks, whites, sorrels, buckskins. As they stood, the bay horse looked to the west and neighed. I looked over there and saw great clouds of horses in all colors and they all neighed back to this horse and it sounded like thunder. . . .

The bay horse said to me, "Behold them, your horses come dancing." I looked around and saw millions of horses circling around me—a sky full of horses. . . . I looked around and all the horses that were running changed into buffalo, elk, and all kinds of animals and fowl and they all went back to the four quarters.[10]

We don't know when Black Hawk saw the Thunder Beings he depicts in plates 1 and 2. But just a few months after Black Hawk made these drawings, in the spring of 1881, several hundred miles away, the sixteen-year-old Black Elk conducted the Horse Dance as a public enactment of the most spectacular portion of the vision of celestial horses he had experienced some years earlier, as a nine-year-old boy.[11]

Drawings of Horse Dancers and Thunder Beings by other Lakota artists show remarkable unity in the iconographic features of these images. Bad Heart Bull and Kills Two depicted masked, horned equestrian figures, painted with lightning bolts, performing the Horse Dance (see fig. 10). Lakota shields and drums depicting Thunder Horses and Thunder Beings all emphasize the horns and lightning and hail imagery. In one drawing of a Thunder Being, a figure radiating crackling electrical charges from its extremities has a face remarkably similar to those in Black Hawk's representations (fig. 12).[12] Such images persist in Lakota visions and art: in 1995, a Lakota artist showed me paintings he had done after a Vision Quest. His images of the Thunder Beings resembled those as well.

Sacred Pipes and Sacred Altars

The pipe is their heart; all hold firmly to it.

—Thomas Tyon[13]

THE MOST ENIGMATIC works in Black Hawk's corpus are the four drawings in which people make offerings of flowering herbs to an unusual constellation of images composed of pipes, buffaloes, sacred hoops, and arrows (pls. 3, 4, 5, 6). Along with his drawings of Spirit Beings

(see pls. 1, 2), these four images seem to represent the core of Black Hawk's spiritual vision. Before describing them more fully, or considering their possible meanings, it is necessary to discuss further the role of the Sacred Pipe in Lakota life and philosophy.

As seen in the previous chapter, the appearance of White Buffalo Woman countless generations ago is the central religious mystery in Lakota thought, one that is reenacted even today, at the modern Sun Dance, when a young woman of good moral character is chosen to walk into the Sun Dance enclosure. Emerging from over a hill, singing the ancient song, "I walk in a sacred manner," she is a stand-in for White Buffalo Woman, reminding people of the time when this mysterious emissary said, "I am bringing something so the people will live."[14]

This profound exchange between the world of the spirits and the Lakota nation—the gift of the Sacred Pipe—accounts for much of what is fundamental in Lakota culture, including its various ceremonies and religious observances. White Buffalo Woman's gift of the pipe, along with instructions about methods of smoking as a means of prayer, has continued to be of central importance. Whenever a pipe is smoked in a ritual manner, the smoke itself is a prayer or a message taken from the world of humans to the spirit world.

The pipe that White Buffalo Woman gave the Lakota is said to have come down through nineteen generations of the same Sans Arc family, and always to have been kept on the Cheyenne River Sioux Reservation.[15] Originally the sacred bundle containing the pipe was housed in a painted tipi, but for the past few generations it has had its own small house, near the community of Green Grass, South Dakota.

The pipe has an undecorated stone bowl, though other pipes exist in which a buffalo calf is carved out of stone as the bowl of the pipe.[16] The pipe is kept wrapped in a sacred bundle[17] with other powerful items when not in use; it is taken out infrequently, and when it is, a ceremonial altar is laid out for it. A stack of four cloths, one each of red, black, yellow, and white, is arranged at each of the four corners of the altar, with a different color on top in each corner. Small offerings of tobacco are wrapped in red, black, yellow, and white cloth and strung together to surround the altar. These directional offerings and other items represent animal powers, human beings, and other forces of the natural world, all brought into harmony.[18]

This detour into the importance of the Sacred Pipe to the Lakota in general, and to the people living on the Cheyenne River Sioux Reservation in particular, should help elucidate Black Hawk's four drawings of buffaloes and pipes. Series of four are important in Lakota thought. Ritual items or actions often occur in sets of four, usually relating to the four directions. In each of these four drawings there is a person on one side and an unusual assemblage on the other.

These assemblages may simply represent visions made manifest in order to invoke the power of the vision. They seem to be diagrams of altars made as a result of a vision. Certainly buffalo skulls are often used as altars by the Lakota, but here Black Hawk seems to be delineating a three-dimensional portrayal of items placed to form an altar.

In each case, a Sacred Pipe extends vertically through the image, like an *axis mundi,* linking the earth with the sky. In two instances (pls. 4, 5), the tip of the pipe is actually stuck into the ground; in the latter instance, an arrow is laid in front of it. Each pipe has a red catlinite bowl attached to the wooden stem.[19] Each stem is slightly

different, some painted with diamonds or circles. Many Lakota pipes have painted or carved wooden stems, and many are ornamented with finely plaited quillwork, as all of these are.

In each image, four arrows and four hoops are overlaid diagonally across the pipe, and a uniquely ornamented buffalo is placed across this group of objects. Each buffalo, with his colored horns and round, staring eyes, is painted or clothed in black, blue, red, or yellow hail, like the Spirit Beings (see pls. 1, 2) and the Sun Dance practitioners (see pl. 8). On three of the buffaloes (pls. 3, 4, 6), the bands of hail look almost like dotted cloth wrapped around the animal effigy, much like the spotted cloth wrapped around the Sun Dancers (see pl. 8). The fourth buffalo (pl. 5) itself appears spotted, like the steed in plate 2. This buffalo has weblike or mirrorlike designs on its back and its flank, indicating that it is a power object—a portal to the sacred realm (for further discussion of the web or mirror as a portal to the sacred in Lakota thought, see pp. 50, 54).

The four hoops in each drawing are important iconographic elements as well.[20] In Lakota thought, hoops, like spider webs, provide a point of entry from the profane world to the sacred. (These hoops will be seen again in the scenes of animal transformation—see pls. 10–15, 18.) In the four buffalo altar drawings, one hoop is drawn at each corner, each encircling one arrow tip and one arrow feather. The colors vary: four blue hoops (pl. 4), two blue and two red (pl. 5), and one each of red, blue, yellow, and black (pl. 6). The red, blue, yellow, and black hoops recur in plate 3, although here the colors are associated with different directions. The black hoop is drawn with red, blue, and yellow portions to it. The meaning of this directional color imagery is unclear.

These drawings of sacred altars are stylistically unlike any other imagery in Lakota art. The careful, studied presentation of diverse symbolic elements in a composition that is both layered and symmetrically balanced is unique. Like the drawings of Spirit Beings (see pls. 1, 2), these are almost certainly central to Black Hawk's personal visionary experience.

In these four images, each pipe, each buffalo, and each human who carries a bunch of sacred herbs to the altar is different. These powerful images may represent actual altars constructed for four specific types of medicine. Each calls upon the power of the buffalo and the pipe in a particular way.

In every case, a person offers a flowering herb to the altar. In Lakota ceremonial practice, sage is a medicinal herb used to purify and sanctify many ritual actions. When Lakota elder Darlene Young Bear examined these drawings, she called the herb "male mint." The generic term for sage in Lakota is *peji hota*, literally "gray herb." But *sage* is a term that, in Lakota taxonomy, seems to encompass both *Salvia reflexa* (*maka ceyaka*, or "earth mint") and *Artemesia ludoviciana* (*peji hota*, or "white sage").[21]

The man wearing the black buffalo robe (pl. 5) holds a saber. The handle of it, just visible below the flowering herb, is tied with a black sash. Perhaps he petitions for medicine to ensure success in war. The man in the painted buffalo robe (pl. 3) is dressed formally; his face is painted, and four quilled sticks and a golden feather ornament his hair, like some of the Sun Dancers in other drawings (see pls. 7, 8, 9). He is dressed for ceremony or for courtship. Could he be seeking love medicine or medicine for success in his spiritual or marital undertakings?

The man who stands frontally (pl. 6) wears a buffalo robe with a beaded blanket strip on it. An arrow quiver made out of mountain

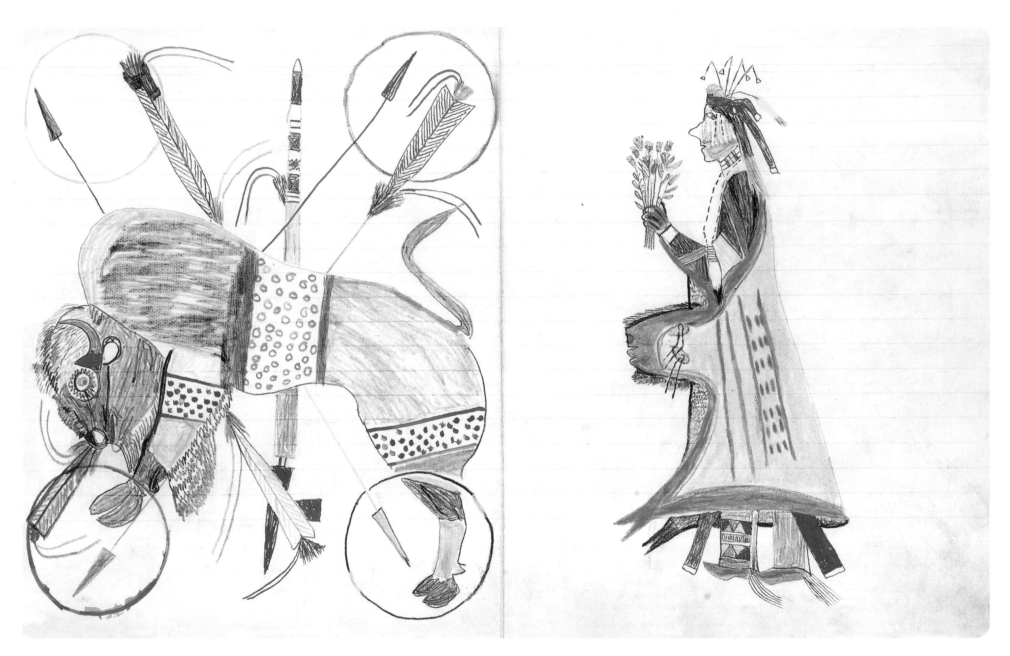

PLATE 3

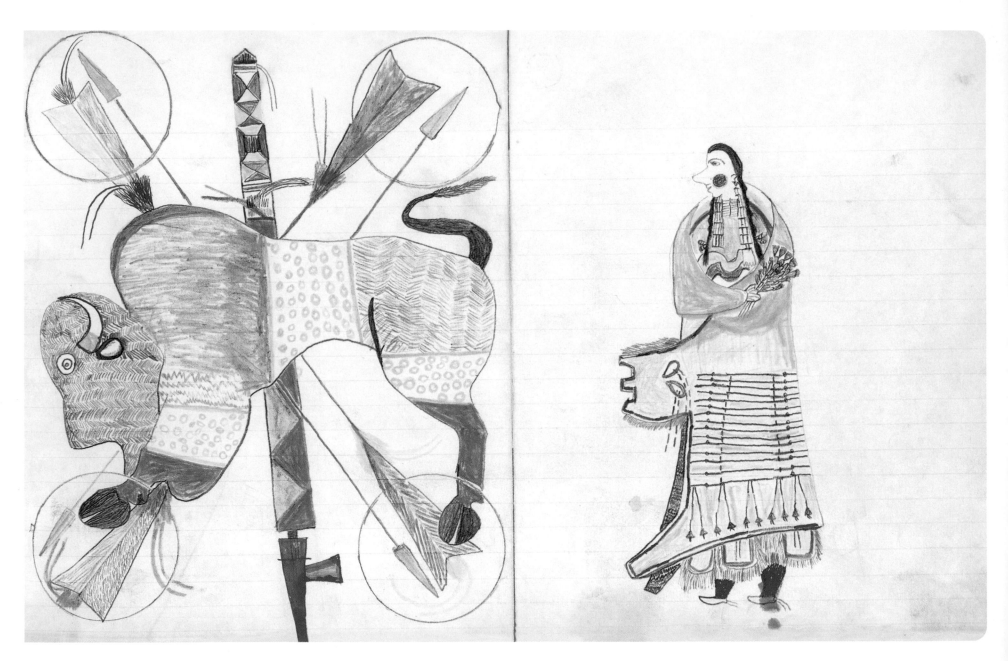

PLATE 4

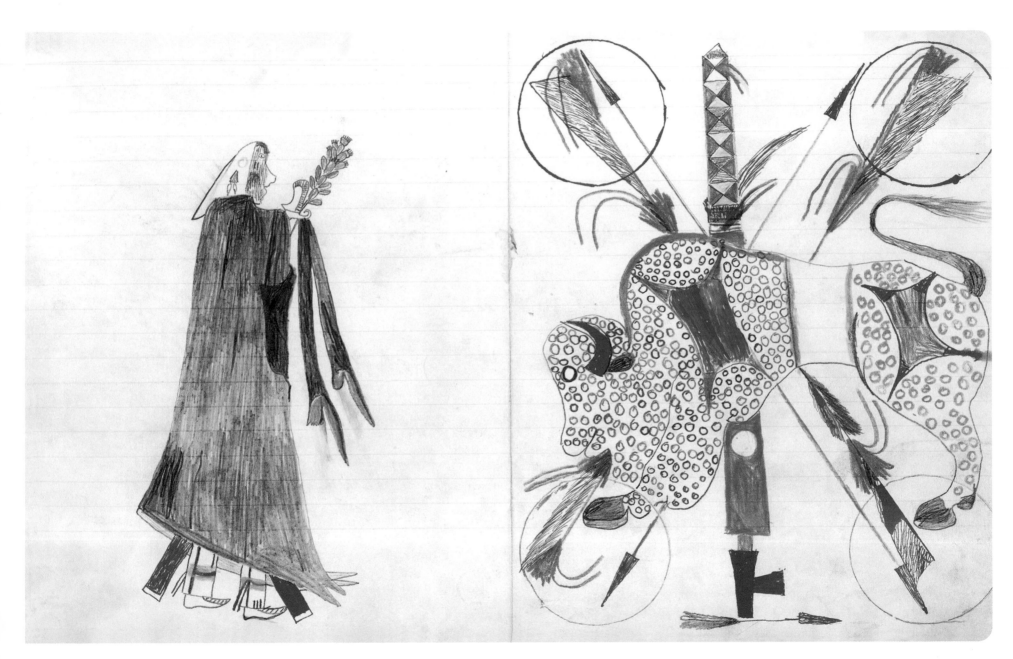

PLATE 5

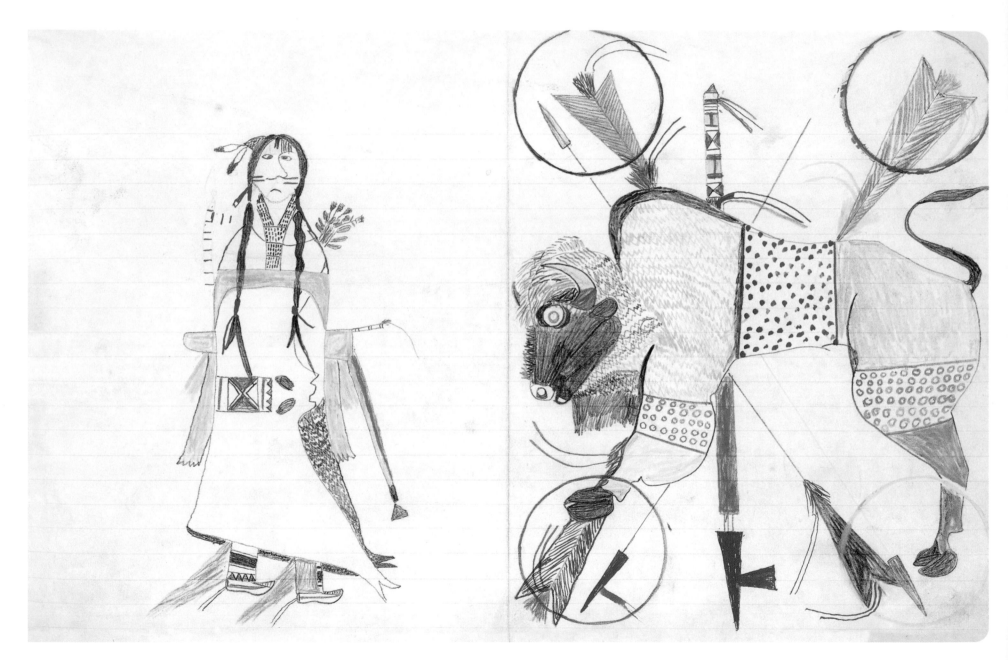

PLATE 6

lion skin is slung over his shoulders and rests upon his back. Is he, perhaps, looking for success in hunting?[22] The fourth figure is the sole woman among the group (pl. 4); she wears an old-style tabbed dress with a blue beaded bodice, and over this a spectacular quilled buffalo robe.[23] Her cheeks are painted with red circles, and she wears long earrings made of dentalium shells. Perhaps she is looking for spiritual aid in matters that concern women, such as artistry or procreation.

Altars and sacred bundles are always idiosyncratic, based on the highly personal visions of their owners. Because the details of their meanings are essentially unknowable to the uninitiated, we can only deduce from these images that Black Hawk had encounters with sacred Thunder Beings from whom he received the power to call upon the buffalo and the Sacred Pipe in his medicine. Perhaps these altars represent the sacred tools Black Hawk used in ceremonies.

The story of White Buffalo Woman and the gift of the pipe demonstrates that, to the Lakota, the pipe and the buffalo are the foundations for human life on earth. *Wakan Tanka,* the great mystery, or the great unknowable, makes itself partly known through these conduits. Black Hawk's drawings, too, show that both the buffalo and the pipe are the fundamental building blocks of religious practice.

The most fully realized visual manifestation of the mystery of the pipe and the buffalo occurs on an early-nineteenth-century hide tipi painted on the interior, which exists now only in a replica in the Museum für Völkerkunde, Berlin. In this sacred cosmogram (fig. 13), all life seems to emanate from the pipe, the sun, and the buffalo.[24] Entering the tipi, the viewer would have confronted a

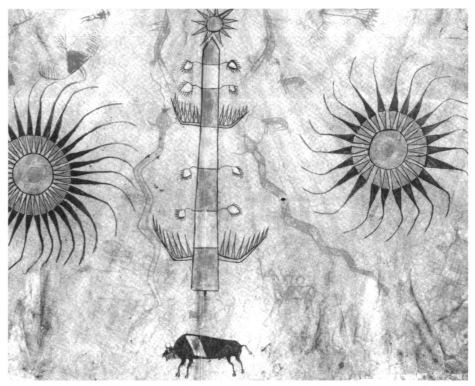

FIGURE 13 Artist unknown, central portion of a design painted on a Lakota tipi, early nineteenth century. The original tipi no longer exists; this detail is reproduced from a color plate in Friederich Weygold's "Das indianische Lederzelt im Koniglichen Museum für Völkerkunde zu Berlin." A replica of the tipi, based on the Weygold plate, is in Museum für Völkerkunde, Berlin.

large, vertical winged or feathered pipe. Like Black Hawk's pipes, its bowl faces the earth, its tip points to the sky, and it is striped with seven green and yellow bands. Four attachments of down and two sets of wings are fastened to it. Beneath the pipe stands a delicately painted buffalo. On either side, horned snakes face the sky; above

them are cranes. A small solar disk is painted directly above the pipe, while large solar disks flank it. Painted around the rest of the tipi's interior are manifestations of the bounty of life on earth—more than one hundred images of snakes, hares, horses, thunderbirds, rodents, humans, grizzly bears, spiders, magpies, dragonflies, turtles, and elk. In the discussion of the altar prepared for the Sacred Pipe, it was noted that various colored cloths and other items placed on the altar stood for people, animals, and other forces of the universe; here they are represented in their fullness.

Although this tipi left Lakota hands before 1830, cultural memory of it persisted. A Lakota named Buffalo Hump told artist Friederich Weygold about it; he, in turn, recognized it when he saw it in Berlin. Moreover, Buffalo Hump told Weygold that a "winged" pipe existed on the Cheyenne River Sioux Reservation. Was this his memory of the Sacred Buffalo Calf Pipe?[25]

Certainly as a medicine man of the Sans Arc, Black Hawk would have been well aware of the powers of the Sacred Pipe. He may well have been among those powerful enough to use it. Black Hawk was married to Hollow Horn Woman (see chapter 1); one of the Keepers of the Sacred Pipe in the nineteenth century was an individual named Hollow Horn, perhaps a relative of Hollow Horn Woman.[26] Black Hawk's visionary altars may well have pertained to the most sacred pipe of his people. Surely in the 1870s and 1880s—desperate times of genocide, starvation, and dislocation—the Keeper of the Sacred Pipe would have turned to it for aid, just as Martha Bad Warrior, the pipe's keeper, did in 1934, when she sat in the blazing sun with the pipe in her hands to bring rain to the parched Cheyenne River region.[27]

The Sun Dance

The Sun Dance is probably the most formal of all learning and teaching experiences. Inherent in the Sun Dance itself is the total epistemology of the people.

—Arthur Amiotte[28]

THE SUN DANCE is a summer ceremony practiced by numerous tribes on the Great Plains. Usually occurring sometime after the summer solstice, it is a rite of renewal in which human beings place themselves in spiritual alignment with all the mysterious forces of the natural and supernatural world. Numerous activities, ritual enactments, and ceremonies lead up to the central event of the Sun Dance: a large gathering place is chosen; a cottonwood tree is selected, cut, and "captured" like an enemy, and then raised in the center of the clearing; and several public performances take place. But the core of the mystery, at least on the Northern Plains, involves the shedding of one's own blood and the removal of small pieces of one's own flesh, in an act of sacrifice undertaken by the bravest individuals.[29]

In part because of the bloody spectacle involved in one portion of the Sun Dance, it has been a source of continuing fascination to outsiders. Many non-Native artists, military officers, ethnographers, and journalists have written about the Sun Dance with varying degrees of insight and understanding. Native literature on the Lakota Sun Dance is also notable.[30]

It is surprising that among his varied and complex drawings of Northern Plains life, Black Hawk made so few drawings of the Sun Dance. Only three focus on the event (pls. 7, 8, 9). In these three

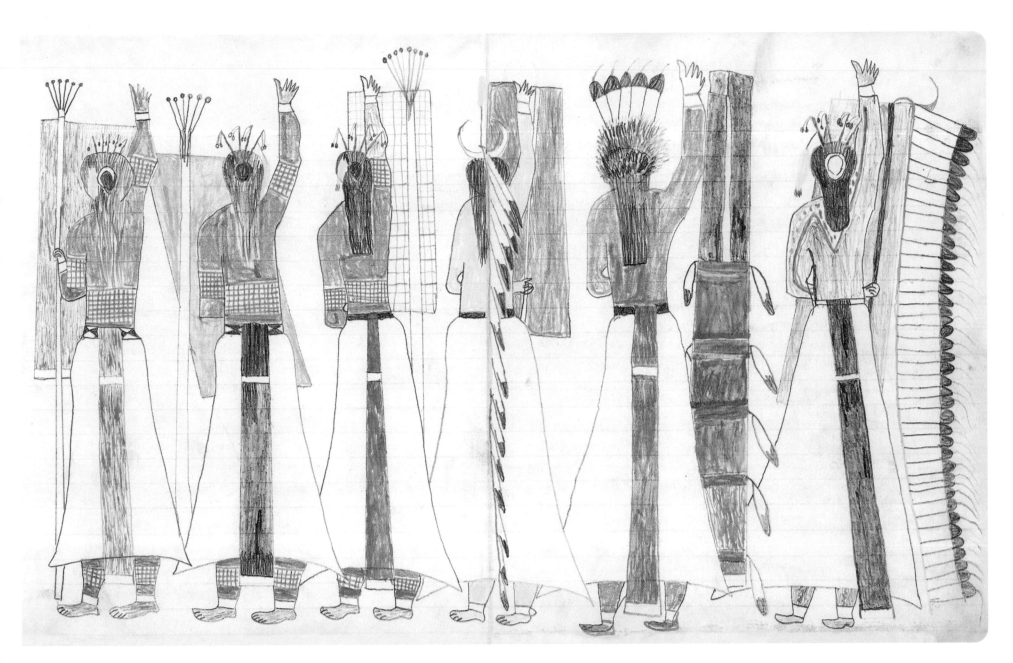

PLATE 7

images, a total of twenty men participate in the preliminary dances of the Sun Dance. In two of these (pls. 7, 8), the figures stand with their backs to the viewer, with the exception of the figure on the extreme right in plate 8, who peers out over the top of his shield. They raise their right hands skyward, all feet in profile formation, moving toward the left. In plate 9, seven figures dance in profile, all heads slightly raised skyward. They blow the eagle wing-bone whistles, which are an essential component of Sun Dance regalia.

Most of the men hold long stakes, to which cloth banners are tied, and which are stuck in the ground, defining the sacred space of the Sun Dance arena. All of the dancers wear unadorned wristlets and anklets, though these ornaments are traditionally described as being made from buffalo hair and rabbit skin or from garlands of sage.[31] Most of the men wear four hair-sticks—small wooden sticks wrapped with quill- or beadwork, with delicate tassels or feathers, "four being the usual number," according to Frances Densmore.[32] Not only are these hair ornaments decorative, they also serve as scratching sticks, for touching one's own body is prohibited during the Sun Dance.

The dancers also sport their war paraphernalia, another characteristic of the preliminary performances at the Sun Dance. Some of the individuals depicted are high-ranking enough to wear or carry the buffalo horn and eagle feather headdress, an item of ceremonial regalia earned only after many years as a brave warrior (pl. 7, figure on the right; pl. 9, fourth figure from the left). One has the *Miwatani* sash of a high-ranking warrior society (pl. 7, second figure from the right), an emblem of those who would sacrifice their own lives in war to defend the lives of their cohorts. (See the use of the *Miwatani* sash in battle in pls. 41, 42 and discussion of this society on p. 104.)

Black Hawk has shown some slight variety in body painting. Most men are painted yellow or orange, with only a couple of darker figures. Some of the dancers have similar attire: blue polka-dotted or checked cloth ankle bands, armbands, and waistbands, perhaps indicative of a specific rank or membership in a warrior society. One man has a rawhide horse effigy tied to his wrist (pl. 8, second from left), reminiscent of the buffalo and man effigies, which, as discussed below, are tied to the Sun Dance pole itself. In plate 9, we can see how five dancers' faces are painted in various ways: circles marked into four quadrants, or with dots, or with a buffalo face painted over chin and mouth. All the dancers seem to wear plain deerskin skirts, with trade cloth sashes of red, blue, or black hanging front and back.

To my knowledge, Black Hawk's are the earliest Lakota drawings on paper depicting the Sun Dance. But other images painted during the reservation era give a fuller picture of this complex public ritual. Several versions of Sun Dance themes, in what seem to be one artist's hand, occur in drawing books in different collections.[33] Most illustrate the moment of flesh piercing—the dramatic crescendo to a multiday religious event that includes fasting, dancing, and other sorts of offerings. In one drawing, for example, two dancers are attached to the sacred Sun Dance pole by thongs fastened to small, pointed sticks that pierce the skin of their chests (see fig. 5). Each man strains away from the pole, endeavoring to rip himself free of his attachment, shedding his own blood. The dancer's act of sacrifice (ritually akin to an act of warfare) is perceived not as torture, as some early observers misinterpreted it, but as an embodiment of a profound cosmological truth: for a short time he has been conjoined to the sacred power inherent in the

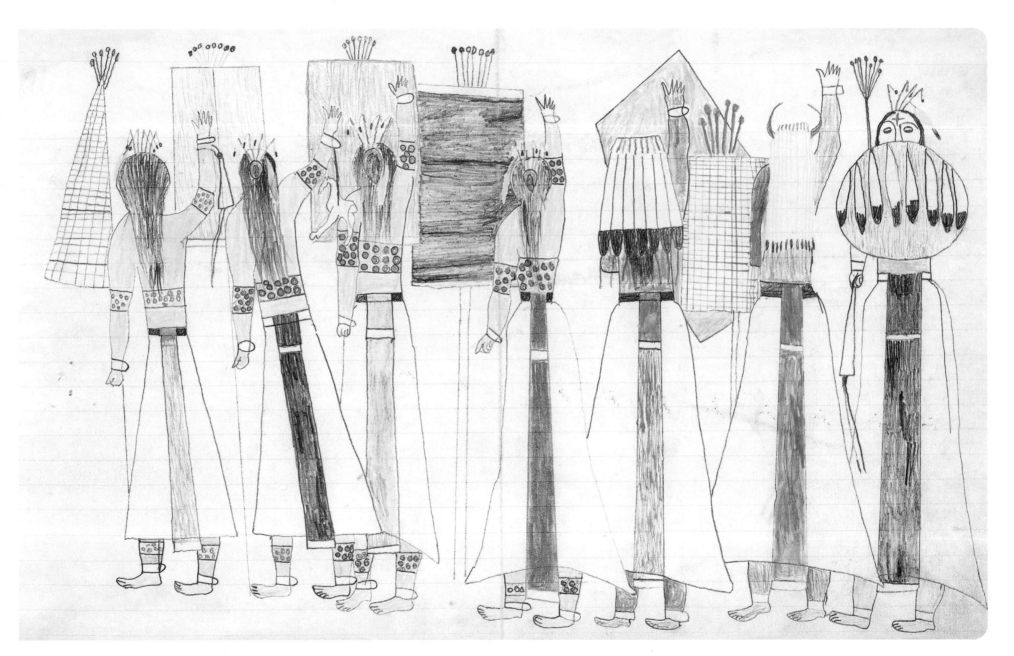

PLATE 8

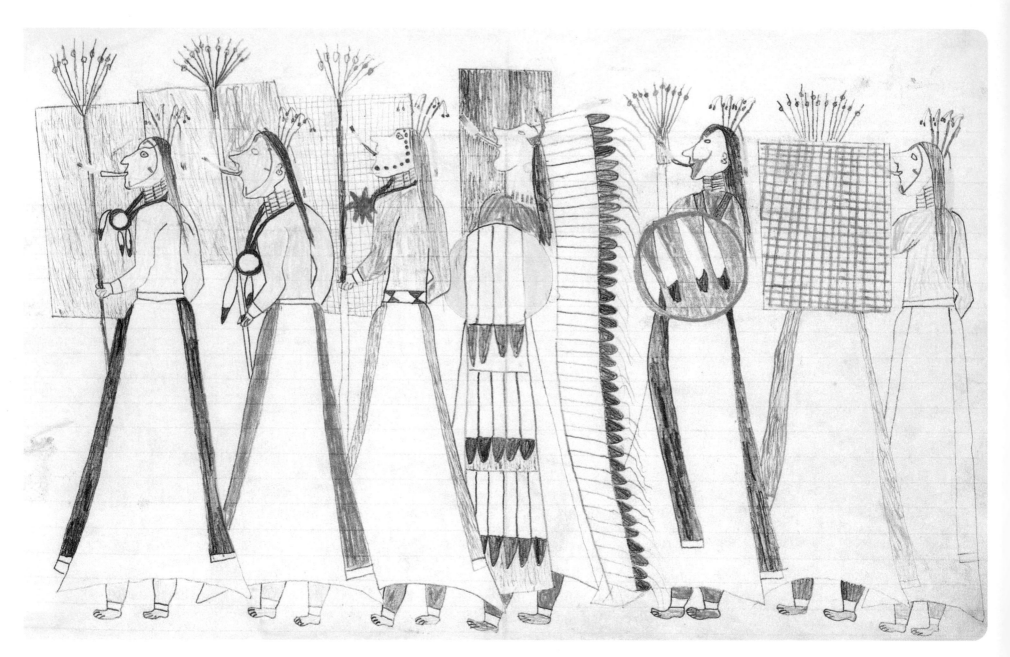

PLATE 9

sun; the tree; the zenith of the sky, where the pole reaches; and the nadir of the earth, in which it is planted. Through sacrifice, he is transformed into something sacred.[34] Moreover, by shedding his blood, the celebrant ritually aligns himself with *Inyan,* the primal rocklike stuff of the universe, who, in order to set primordial creation in motion, summoned up blood from inside his obdurate self to create the earth. The dancer is, therefore, recapitulating the origin of the Lakota universe.[35]

Each dancer, as he strains away from the pole to rend his flesh, blows his sacred bird-bone whistle and gestures at the small black figures tied to the pole. These effigies represent the buffalo and the enemy. But the male effigy, though referred to as "the enemy" and shot at with arrows just like the buffalo, is understood in Lakota metaphysics as not simply the literal enemy of traditional warfare, but also the flaws within man himself that sometimes make him his own worst enemy.[36]

Bad Heart Bull also drew several moments in the Sun Dance; like Black Hawk, he portrays the opening ceremony in which participants dance with right arm raised and blow their bird-bone whistles.[37] Among the most fully realized renderings of the Sun Dance are several similar paintings on muslin made by Standing Bear around 1900.[38] Standing Bear depicted the 1876 Sun Dance directly before the Battle of Little Big Horn—a time when Lakota people had numerous trade goods, for they had been receiving annuities from the U.S. government for many years. Yet both Standing Bear and Bad Heart Bull depict the dancers wearing mainly traditional dress, made of hide, feathers, and other indigenous materials. The artist of the Sun Dance scene in figure 5 and Black Hawk, in contrast, both depict the reality of reservation life, and the impact of trade goods, even in ceremonial practice, where checked, dotted, and plaid cotton cloth as well as white-selvaged trade woolens are lavishly used.

Black Hawk's drawings of the Sun Dance, as well as his images of other social dances (see pls. 27, 28, 29), corroborate what military man and budding ethnologist John Gregory Bourke described so vividly in his journal. A mere six months after Black Hawk drew these images at the Cheyenne River Agency, Bourke witnessed a Sun Dance farther west, at Pine Ridge:

June 20, 1881 Pine Ridge Agency

As the crier began to proclaim the orders of the day, the Indians once more closed in spontaneously around him, forming a great ring 50 or 60 yards in diameter, and 8 or 9 persons deep, and aggregating several thousand men, women, and children. The display was no less brilliant than fantastic. Some were on foot, many on ponies, and quite a number in American country vehicles. Nothing could be added in the way of dazzling colors. Calico shirts in all the bright hues of the rainbow, leggings of cloth, canvas, and buckskin, moccasins of buckskin, crusted with fine beadwork were worn by all, but when it came to other garments no rule of uniformity seemed to apply. Many of the men and women had wrapped themselves in dark blue blankets with a central band of beadwork after the manner of medallions; others gratified a more gorgeous trade by wearing the same covering of scarlet or of scarlet and blue combined. A large fraction of the crowd moved serenely conscious of the envy excited by their wonderfully fine blankets of Navajo manufacture, while a much smaller number marched as proud as peacocks in garments of pure American cut. Chief among these was "Sword," the captain of the Indian police, attired in a blue uniform with gilt buttons and a silk plug hat worn in a style which he must have imitated from some New York ward politician.

Nearly all the Indians were painted, and wore their hair in two long tresses down the sides. These tresses were wrapped in red flannel, or in otter fur and reached to the waist. The median line of the head was painted with vermilion. Eagle feathers ornamented the crown and wonderful achievements in nacreous shell-work dangled from the lobes in their ears.

. . . The scene was animated to a wonderful degree and appealed to the eye much more powerfully than pen can reproduce.

June 21

Those dancers who were naked were marked with red paint in those places where they had been wounded. The greatest diversity prevailed in their dress or lack of dress. Bare legs strode side by side with limbs encased in black, blue, or scarlet cloth and bright calico leggings; bare feet with fancy moccasins. Red, blue, yellow, white, and check shirts with the costume that prevailed before the Fall. The only approach to uniformity lay in the fact that eagle feathers floated from the heads of each dancer and that each was armed with rifle or revolver or both.

Of the male dancers with eagle-bone whistles, Bourke says:

Their breechclouts were elegantly made of only the finest scarlet or blue cloth, tidily embroidered and made so broad that from the waist down they seemed to be concealed by narrow petticoats.[39]

The annual Sun Dance brought together people from diverse bands and tribes. As Standing Bear indicated on his large muslins, which depict numerous scenes of various activities, the Sun Dance was also a time for courtship and the performance of dream visions. Men who had had visions of antelope, elk, or buffalo might don masks and enact what they had witnessed in the spirit world.

Ceremonial Practice and the Arts of Transformation

No man can succeed in life alone, and he cannot get the help he wants from men; therefore he seeks help through some bird or animal which Wakan Tanka *sends for his assistance.*

—Siyaka[40]

MOST INDIGENOUS North American societies have long recognized that certain individuals have exceptional receptivity to visionary experience. Among the Lakota, as we have seen, individual visionary experience is the core of religious practice. Some individuals harness the nonhuman powers of the world through the mystery of transformation. By transforming themselves into animals, they gain some of the power of nonhuman creatures. Masquerade is the first step in effecting such transformation. To don the head and hide of a buffalo, for example, begins—and makes visible to others—the process of changing into a buffalo spirit and tapping its power. Or public masquerade may be the remembrance, the cultural reenactment of a private dream or vision.

The assemblage of objects worn, used, and danced in ritual performance often mixes different realms of power—human, land animal, and avian, for example. Such ritual attire can be ephemeral, contingent, and improvisational, based on an individual's visionary experiences. In another context, half a world away, Africanist scholars have discussed masking as the "wearing of thresholds" that keep secret the distinction between the spirit world and the world of the living. They define masking as "sacred

facelessness," pointing out that altars as well as masked costumes are "sacred boundary-making, boundary-hiding devices," and that, in liturgical language, an altar is called "the face of the gods."[41] These observations are applicable here, as well, in situations in which Plains Indian men cover their faces in order to present the faces of the spirit world.

The Buffalo Dreamers, Elk Dreamers, Deer Dreamers, Wolf Dreamers, and Antelope Dreamers were medicine societies—if one had a dream of these powerful animals, one would join such a society and take part in public ritual that made manifest one's dream experience. Graphic artists rendered such profound visions in another, less ephemeral medium. A number of Lakota artists (including Black Hawk, Bad Heart Bull, and Standing Bear) depicted scenes of shamanic transformation. At first glance, most of the figures they drew look like humans wearing masks, but when humans don ceremonial masks and garments, they become transformed, as Black Hawk's drawings clearly show: no longer simply human, they have animal feet and leave animal tracks rather than human footprints behind them (pls. 12, 13).

Buffalo Dreamers. The Buffalo Nation, *pte oyate,* as it is called in Lakota, was long the sustenance of those who lived in the vast middle of the North American continent. Provider of food from its meat, warm clothing from its skin and fur, thread for sewing from its sinew, ladles and other tools from its horns and bones, the buffalo was at the center of traditional Lakota life. Ancient history as depicted on pictorial winter counts refers to a time in the distant past when emissaries from the Buffalo Nation were cultural heroes to the Lakota; foremost among them was White Buffalo Woman, who brought the Sacred Buffalo Calf Pipe.

Four of Black Hawk's drawings depict buffalo transformation ceremonies (pls. 10, 11, 12, 13). Two drawings depict four buffalo masqueraders (pls. 10, 11). Each wears a large head-covering made of a buffalo hide reshaped into a head form, the hair cascading down the dancer's back, and a loincloth made of red trade cloth. The bodies and limbs are painted variously with yellow, blue, red, or black paint. Some of the dancers have bunches of buffalo hair attached to wrists or ankles. In one image (pl. 10), the Buffalo Dreamers just carry hoops; in the other (pl. 11), they carry hoops and lances. The former drawing reveals that the process of transformation has begun, for most of the human feet have become the split hoofs of buffalo. In the figure on the far left of plate 10, one hand has transformed into a hoof as well. From this dreamer's hands and feet emanate wavy lines of power that terminate in a large centipede and another insect.

In two other images (pls. 12, 13) this transformation continues in an even more potent manifestation. Individual dancers are covered by full buffalo pelts; wavy lines of power extend from their feet and hands, with insects and arrows emanating from these power lines, and their human feet leave buffalo hoof prints. Each dancer carries a thick black hoop of transformation, each with a bell tied inside. A hoop represents a window into the spirit world—a gateway into a different realm. Each buffalo/man has been wounded by an arrow with an eagle feather on it, and blood spurts from the wound. Anthropologist Clark Wissler, writing in 1912, reports that during the Buffalo Dreamer performance a hunter would shoot an arrow at the buffalo/man: "The shaman would then stagger, vomit blood, and spit up an arrow point. . . . Later another shaman would use medicine, pull the arrow out, and at once the wound was healed."[42]

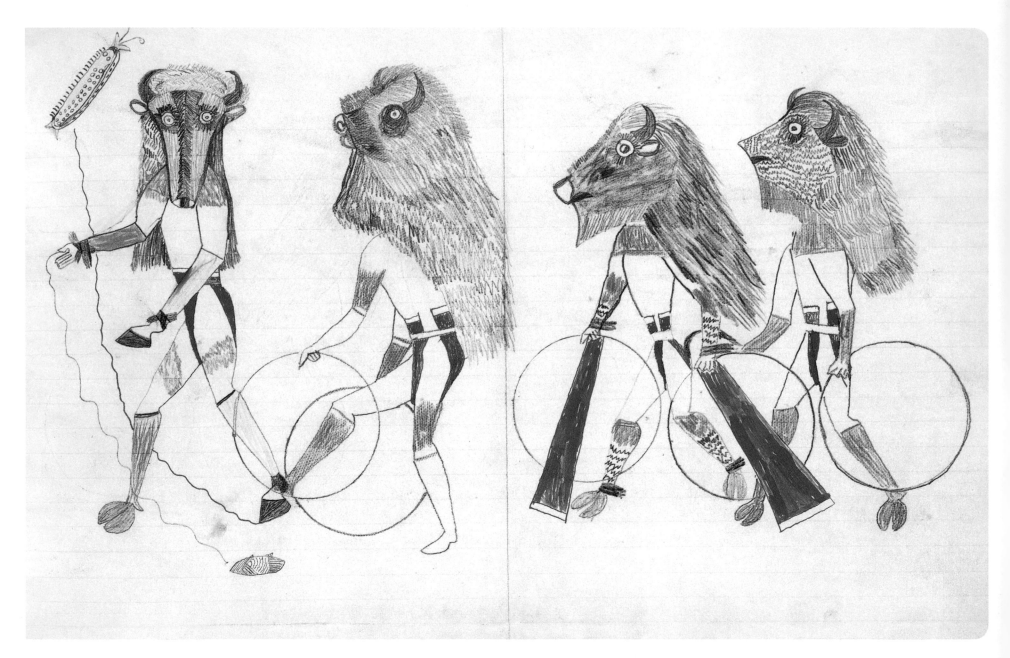

PLATE 10

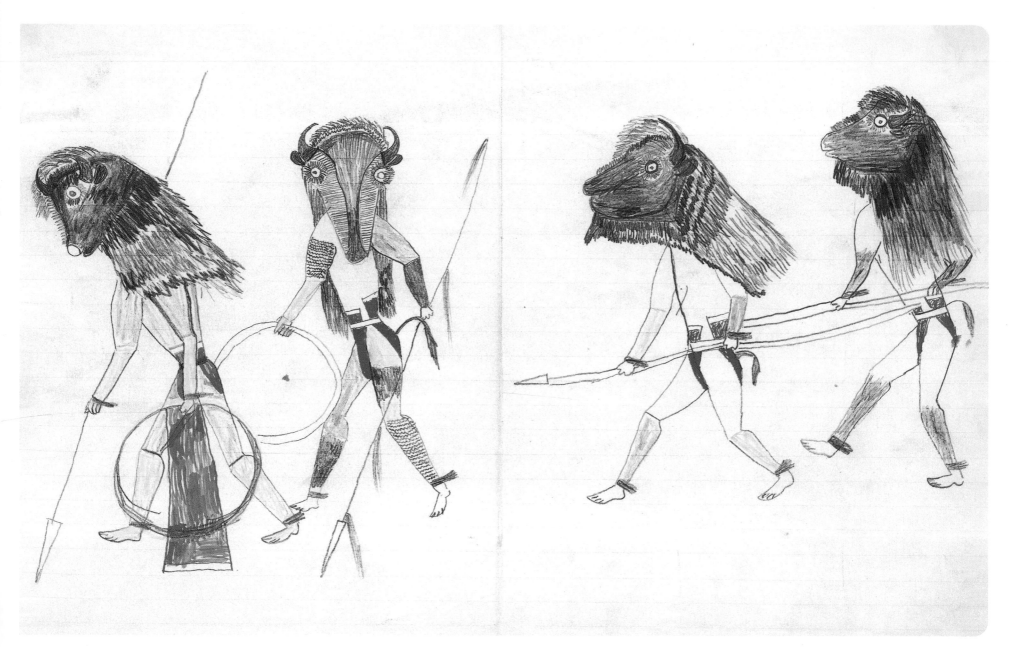

PLATE II

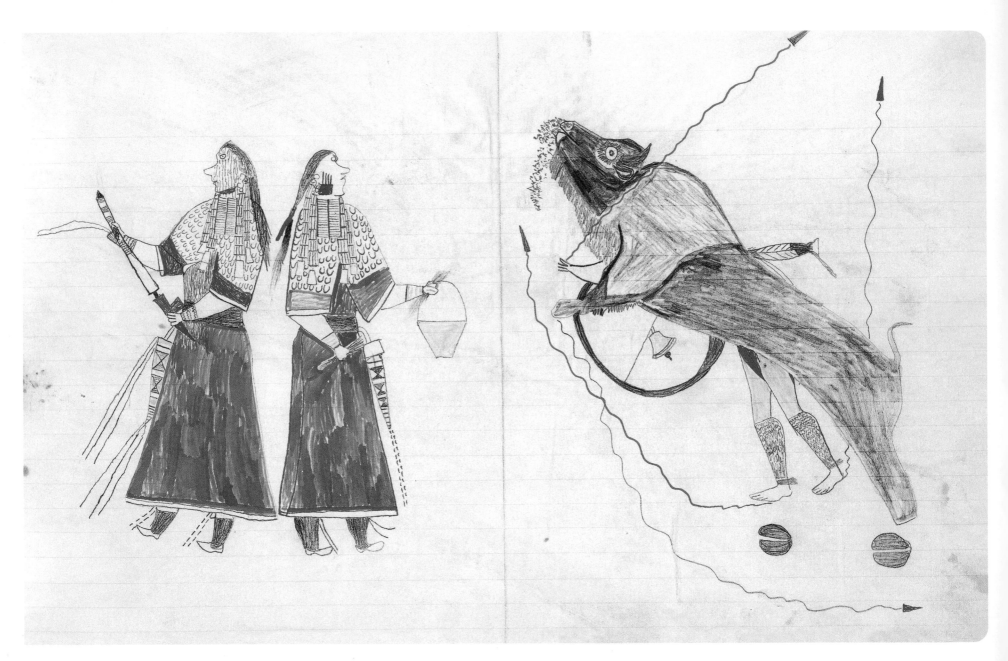

PLATE 12

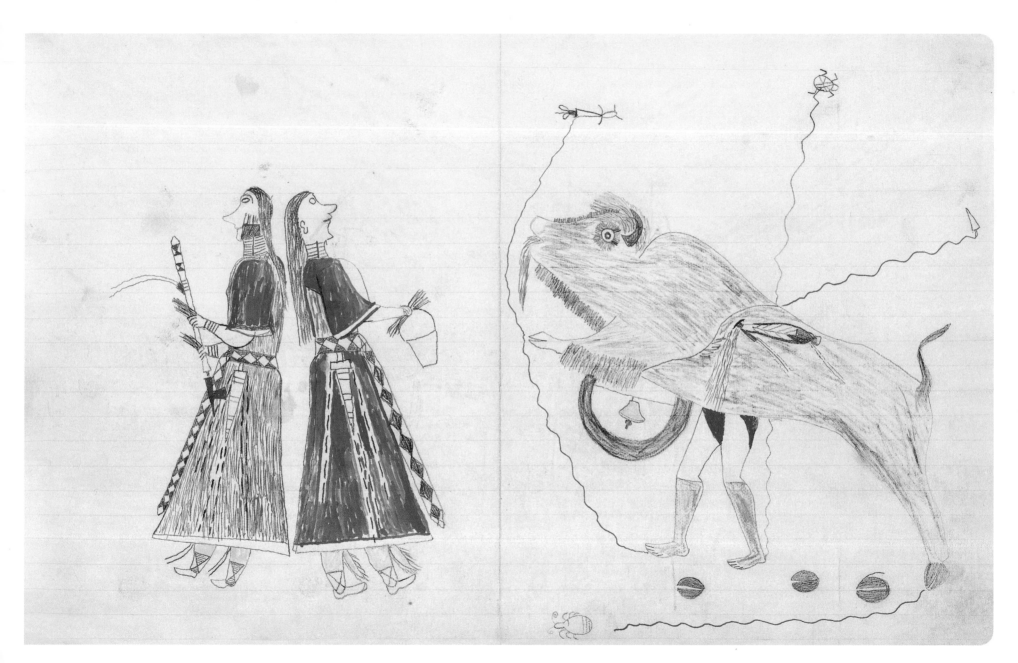

PLATE 13

In each drawing, two women wearing fine red trade-cloth dresses attend the buffalo shaman. One carries a pipe, while the other holds a water pail. In plate 12, the bodices of their dresses are covered with rows of elk teeth, signifying wealth and prosperity. Their red painted cheeks indicate that they have gone through the Buffalo Ceremony, marking them as particularly distinguished and virtuous young women. Only such women have the strength of character and purity to take an active role in ceremony.

Frank Fools Crow (ca. 1890–1989), a Lakota holy man who lived at Pine Ridge, recalled the way they did the Buffalo Dance in the first half of the twentieth century:

> The performers wore a buffalo skin headdress made from the buffalo's head, and a piece of the hide with the tail attached hung down their backs. Porcupine quills had to be part of the costume, and for this purpose, arm, wrist, or knee bands, or quilled moccasins, were worn. Each dancer carried a gourd rattle in one hand and a pipe in the other. The rattle did not have a buffalo tail attached to it.
>
> The last Buffalo Dance I saw was held about forty-four years ago at a place near Whiteclay, Nebraska, which is just south of the town of Pine Ridge. The gathering was a four day affair, during which time we had the Buffalo Dance, the Horse Dance, and the Eagle Dance.
>
> Some of the performers did an excellent job of preparing their buffalo headdresses. The finished ones looked like real buffalo heads. They used the skin of the full head, shaping and drying it in such a way as to keep its original form. They did not use wooden blocks to make the eye and nose holes as the Mandans did. The performers kept the actual eye and nose holes open until the skin dried, and then looked and breathed through these when they danced.
>
> In doing the dance, the performers entered the dancing arena and formed a circle. Then when the music began they imitated the actions of real buffalo. They would make noises and frighten each other. They would chase each other and fight, pawing the dirt in a fierce way and then bumping heads like fighting bulls.
>
> There were a fixed number of songs for the dance, and the dancers kept track of them as they were sung. About two thirds of the way through the ritual, some of the performers used sticks that were imitation bows and arrows and lances to kill one of the buffalo. He fell to the ground and lay there while the other performers danced around him four times. At the end of their fourth circle he struggled slowly to his feet and joined them. He was alive again, and this meant that the buffalo would continue to be available to the Sioux. Finally, there was joyful shouting and singing from the audience, who were happy because Grandfather would continue to provide for them by sending buffalo.[43]

Other Lakota graphic artists have depicted Buffalo Dreamer ceremonies, but none with such a wealth of detail as Black Hawk.[44]

Deer and Antelope Dreamers. Black Hawk portrays other animal medicine societies, such as impersonators of the black-tailed deer (*Odocoileus hemionus columbianus*, pl. 14). The distinctive black-tipped tail of this animal is evident behind the breechcloths of all the dancers. Those who wear the mask of the white-tailed deer (*Odocoileus virginianus*) appear in plate 15, its large, fluffy white tail drawn only on the horned figure on the right side of the page. Like the Buffalo Dreamers, the Deer Dreamers carry hoops, and their feet (some human, some in deerlike split-toe formation) show the transformation of these men into animal spirits. In plate 16, the masks represent the distinctive faces and hooked horns of the pronghorn antelope (*Antilocapra americana*).[45] All but one of the Antelope Dancers carry live prairie rattlers (*Crotalus viridis*). These dangerous snakes, which impart power to this ceremony, are also used by the Wolf Dreamers (pl. 17). Two of the Antelope Dancers carry rectangular objects emanating waves of energy. These are probably mirrors, used to deflect powerful forces.

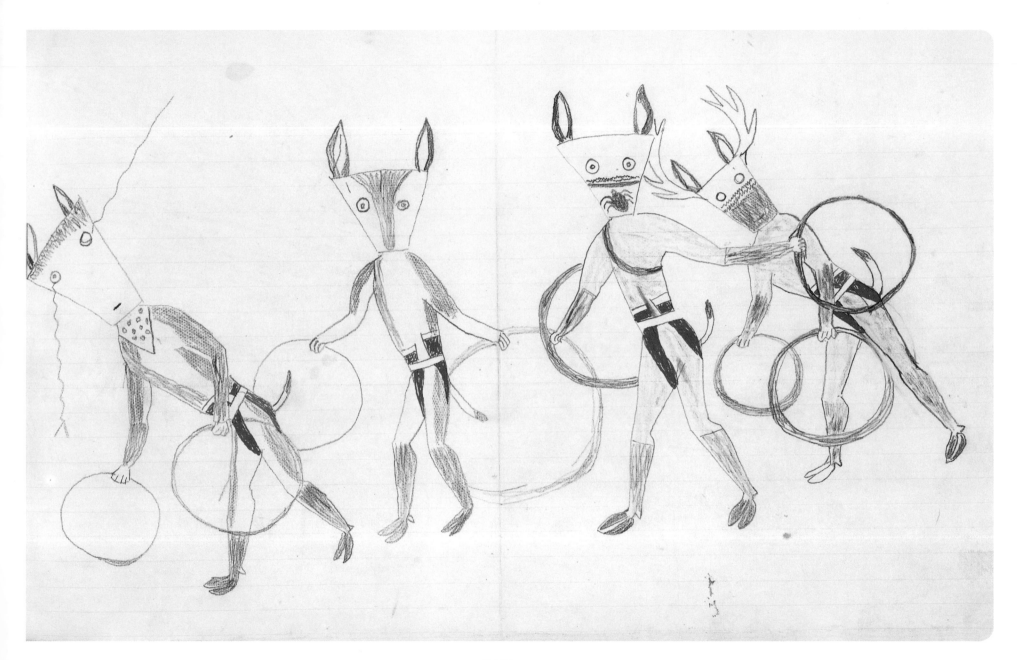

PLATE 14

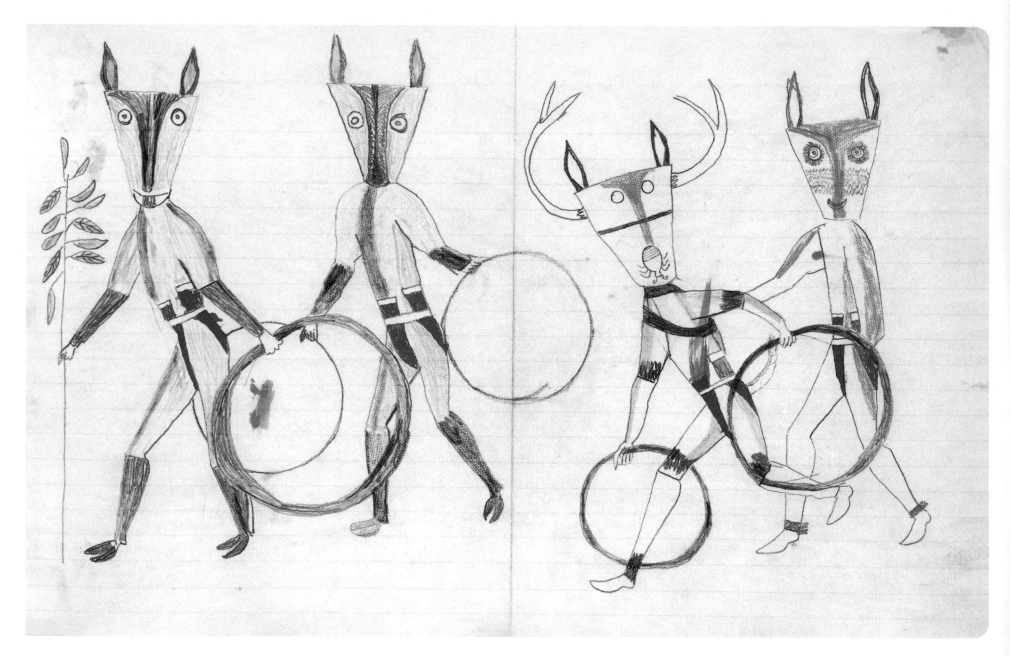

PLATE 15

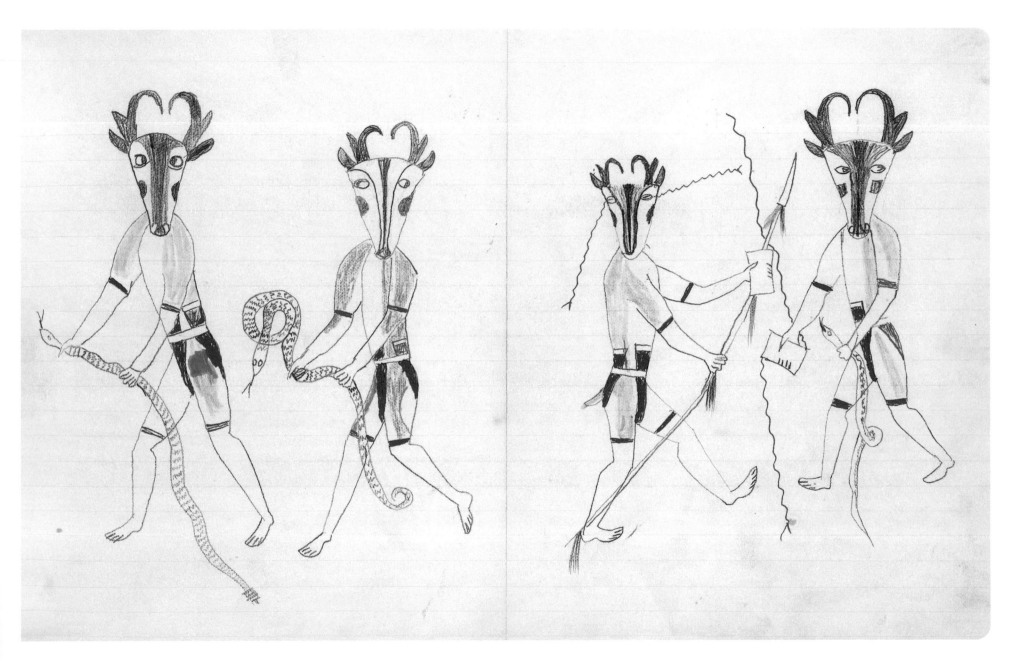

PLATE 16

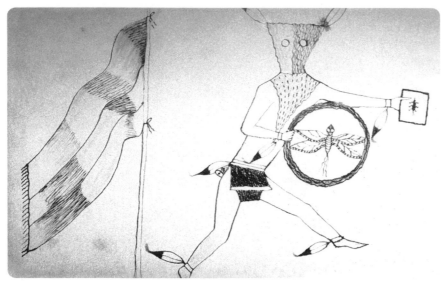

FIGURE 14 Charles Little Bear, Black-Tailed Deer Dreamer, ca. 1890. Ink and colored pencil on paper, 3¾ x 5½ in. (9.5 x 14 cm). Gilcrease Museum, Tulsa, Oklahoma (4526.13.10)

Less has been written about these animal societies than about Buffalo or Elk Dreamers, but often they performed at the same time. The Black-Tailed Deer Medicine Society was said to be the most powerful, for if these dancers cast their gaze on someone, that individual would fall down dead.[46] A famous and well-remembered occasion when many Lakota saw performances of the animal dreamers was Sitting Bull's Sun Dance that took place on the Rosebud River in the summer of 1876, just before the Battle of Little Big Horn. Standing Bear commemorated that Sun Dance circle, the animal dreamers, and the battle itself in several muslins painted around 1900.[47]

Bad Heart Bull and others also depicted Deer Dreamers.[48] The Gilcrease Museum in Tulsa owns a particularly fine unpublished drawing book that contains images of Black-Tailed Deer Dreamers

(fig. 14). This dancer wears a black-tipped feather at his lower back, simulating the black-tipped tail of the deer. The deer's ears are similarly represented by feathers.[49] The mask of this figure is clearly made of two pieces of cloth of different colors. In contrast, Black Hawk's deer masks are far more realistic, fashioned from the actual heads of animals. In his left hand, the dancer in figure 14 carries a mirror with an insect on it. Within the large hoop in his right hand is a dragonfly, symbol of speed and agility. These emblems have been called the "ammunition" of the dreamer— those objects, animals, or insects with particular potency for an individual.[50]

Wolf Dreamers. In plate 17, four men clad in wolf skins dance across the page; the head of the one on the left is in profile, his face partly visible behind his mask, while the other three look out at the viewer, their human faces hidden behind square, boxlike masks. Like the Antelope Dreamers (pl. 16), three carry a prairie rattler. In a dream that a Lakota man named Brave Buffalo recounted to Frances Densmore, wolves instructed him in the use of an herb to capture a rattlesnake, which he then was supposed to carry when giving the public performance of his wolf dream. Bad Heart Bull, too, depicts Wolf Dreamers carrying snakes.[51]

Black Hawk's drawing conforms to the description of Wolf Dreamers given to early anthropologists:

They have wolf skins on their backs, on the arms and legs. On the heads they wear a rawhide mask with holes for eyes and one for the mouth through which the whistle is sounded. . . . Some carry an imitation snake from which they shoot *wakan* influence. When members are shot, they spit out bird claws, sage, and bugs, supposed to have been shot into the victims.[52]

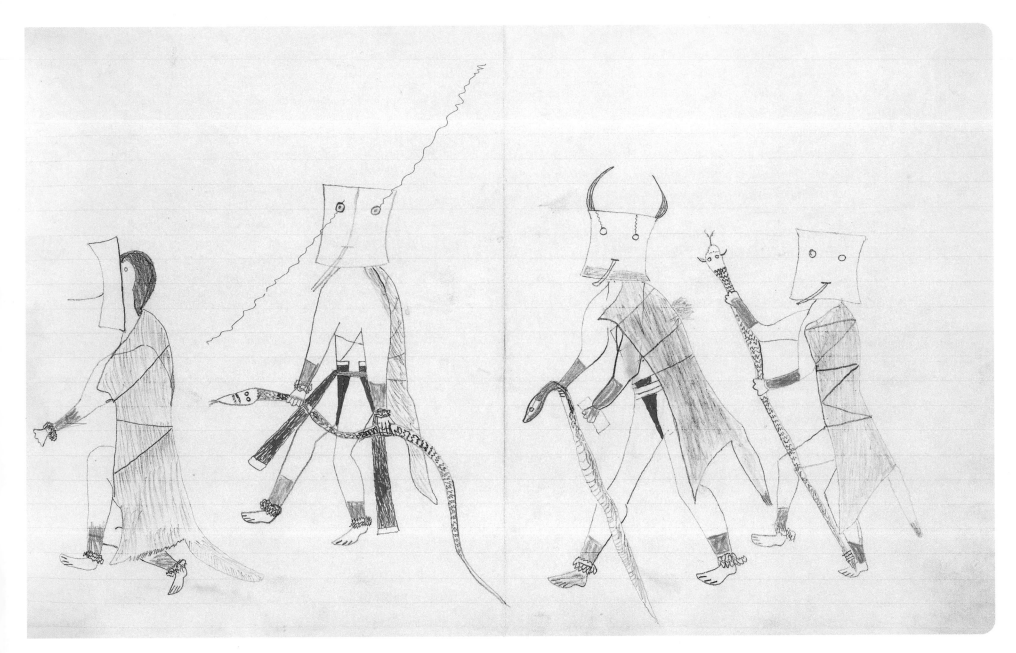

PLATE 17

This is reminiscent of the Buffalo shamans discussed above, who, after being shot, would vomit an arrow point. Wolf Dreamers are also said to be adept at making war medicines. Standing Bear called the Wolf Dreamer ceremony *Sunkmanitu Kage* ("Wolf Making") and said that the dreamer carries a rattlesnake or bull snake "with which he can find out things."[53]

Like the Antelope Dreamers, Black Hawk's Wolf Dreamers must be mere performers rather than shamanic transformers—all seem to remain resolutely human, with human feet and no animal tracks in sight.

Elk Dreamers. Writing about courtship and sexual attraction in traditional Lakota life, the anthropologist Clark Wissler made the following observation in 1905:

> In the days of their prosperity the young men of the Dakota prayed for power over the sexual passions of women as much as for power over the arms of the enemy when on the war-path. Their ideals and ambitions as revealed in myth and ritual lead to the impression that they gave far more than half their energy to the former. Love and sexual desire were interpreted, after their mode, as manifestations of the working of some magic or supernatural power. When one young person was drawn toward one of the opposite sex by a power too strong to be resisted, it was considered certain that the object of this passion had the use of some charm or the aid of some unseen power that produced the desired result. . . . A number of mythical creatures were supposed to manifest similar powers over the sexes. The chief of these was the bull elk.[54]

The male elk, who in nature often seems solitary, is well known for his distinctive mating cry, by which he attracts females (see section on natural history drawings, pp. 119, 124). Young men who dreamed of the elk, or who sought to obtain his charismatic power,

would perform the Elk Dreamers' Dance. Alice Fletcher, witnessing this dance in 1882, said that the performers wore only breechcloths, and each was painted according to the colors of his particular vision:

> They wore masks resembling the heads of elk. These masks were made by bending willow branches so as to form a framework, with a straight bar across the top of the head, two side pieces passing down by the ears and fastened to withes which circled both forehead and neck. Antlers, resembling those of the elk, were ingeniously shaped from boughs and covered with rolled bands of cloth; these were fastened to the side pieces. Over the frame a thin cloth was stretched, having holes to let the antlers through and enclosing the head of the man like a bag. The cloth masks were variously painted and decorated. One had a small circular looking-glass like a single eye fastened on the forehead, others had two glasses in place of eyes; nearly all had something fastened on them which would catch and reflect the light.

Fletcher described the awesome scene of masked Elk Dreamers pursuing two young virtuous women carrying pipes:

> Sometimes the elk would leap, crouch, trample the dirt, or glide noiselessly along. Two or three of the men carried a hoop in their hands, one hoop containing a square from which depended a fringe of rattling deer hoofs. The neophyte held one having a circular mirror, fastened by four cords, from which he cast a reflection of the sun from time to time upon the ground, or held up the hoop and flashed the mirror.[55]

This tracking of the young women by the Elk Dreamers went on for hours and covered several miles. Adults and children alike flocked after the performers, Fletcher reported, but always maintained a distance of fifty feet from them. In 1995, Lakota elder Darlene Young Bear recalled that when she was young, in the 1930s,

they still performed the Elk Dance in the community of Red Scaffold before the Fourth of July celebration, but the children were not allowed to witness it. "Only the young women who had gone through ceremonies could resist the elks' power," she said, referring to the puberty ceremonies (to be discussed presently).[56]

Unlike his drawings of Buffalo, Antelope, Deer, and Wolf Dreamers, Black Hawk's sole drawing of elk power does not focus on ceremonial mimesis. Instead, he shows the individual who has effected a full transformation into the Elk Spirit (pl. 18). Drawn on the left side of the page, the elk's head is slightly lowered, its full rack of antlers displayed. A hoop encircles the chest of the animal, and his front left leg steps through it, suggesting that some moments before he was a man holding such a hoop, as in the previous dreamers pictured (pls. 10, 15). Hoops carried by Elk Dreamers Society performers were made of bent willow rods covered by wild bergamot (*Monarda mollis*), a fragrant herb said to be much liked by elk.[57]

An insect is drawn on the elk's shoulder, a black bird hovers over his head, and two feathers float through the picture. On the right-hand side of the page stands a curly-haired horse, who has similar feathers attached to his mane. The riderless horse awaits the return of his two-legged owner, who has been transformed into the powerful elk. Black Hawk's series of natural history studies contains four images of elk (see pls. 60, 61, 62, 63), but no visual reference is made in any of these studies to spiritual power or transformation.[58]

Other Lakota graphic artists occasionally depicted Elk Dreamers or sacred elk. One unpublished drawing by an artist at Standing Rock Reservation depicts a naturalistic-looking elk standing within a sacred hoop, much like in Black Hawk's drawing. The animal grazes outside a painted tipi, as if suggesting that the object of the transformed man's attention is a woman residing inside.[59] Often when these spirit elk are drawn, they are depicted with their heads back, bugling the distinctive cry that attracts their female counterparts. In one small drawing, the Lakota artist Sinte depicted the intended effect of the Elk Dreamer's actions and of his mating call: the female elk follows closely on the heels of her bugling mate (see fig. 6). The small pictographic figure of a man at the top left of Sinte's drawing suggests that this man, through the power of the hoop of transformation attached to him by a wavy line, will himself become like this powerful bull elk, able to attract the devotion of the female he desires.[60] Bad Heart Bull, too, depicts the activities of elks and Elk Dreamers in his chronicle of Lakota life. In two drawings of spirit elk, he emphasizes the noise emerging from the mouth and the waves of power that entice the females.[61]

Social Transformations: "They Sing over the One Dwelling Alone." Indigenous ideas about transformation include more than just human-animal transformation. Equally important are the profound changes that take place as one moves from childhood to adulthood or from one social status to another. Of course, the power of sacred animals is tapped for these ritual passages, too.

Among the ceremonies that White Buffalo Woman brought as gifts to the Lakota are two that are closely related, for both concern the passage from one state of human relationship into another. These are *Isnati Awicalowanpi* (the female puberty ceremony) and *Hunka Lowanpi* (the making of relatives). The *Hunka* ceremony is a ritual adoption, a rare event marking the transformation of friends into kin or the recognition of a particularly strong bond of kinship that already exists.[62] Black Hawk does not illustrate this ceremony, but three of his drawings (pls. 19, 20, 21) seem to depict the other, the

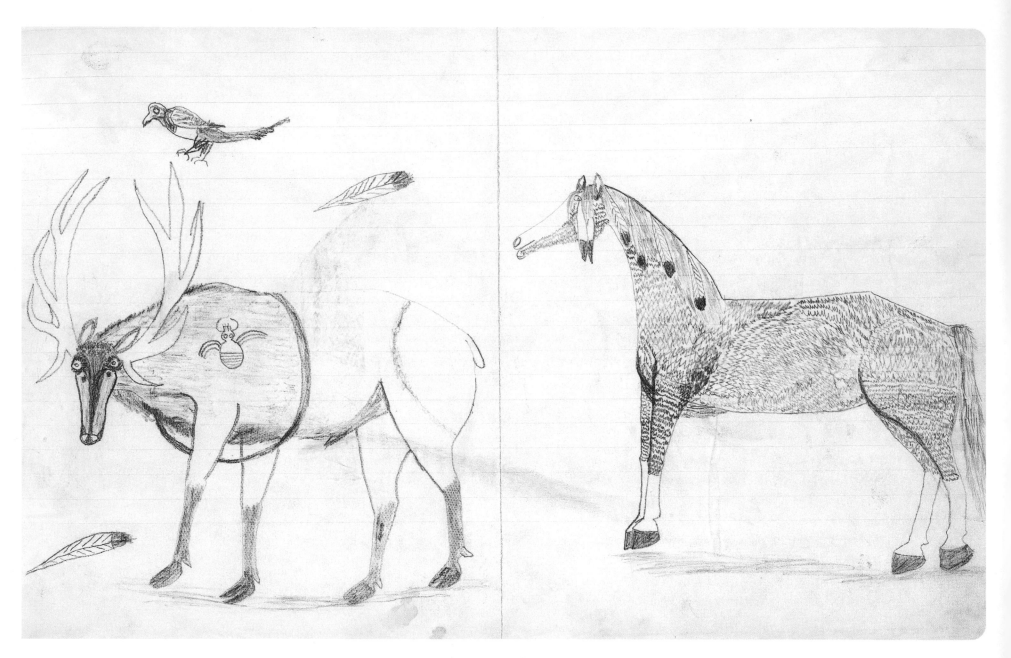

PLATE 18

Lakota name of which translates as "they sing over the one dwelling alone," referring to the practice of female menstrual seclusion.[63] Sometimes called the Buffalo Ceremony (*Tatanka Lowanpi*), it takes place directly after a young woman has experienced her first menstrual period. It marks her passage from the realm of childhood to the realm of adulthood.

In Black Elk's recounting of the first performance of this ceremony, a man came and presented a Sacred Pipe to a medicine man named Slow Buffalo, asking him to purify his daughter upon the occasion of her first menstrual period.[64] Slow Buffalo took the pipe and used it in the ceremony. In plate 19, on the left, stands a richly dressed man who holds the wooden stem of a pipe in his left arm while he grasps the stone bowl of the pipe in his right hand. He resembles Lakota headmen or pipe bearers (see pp. 64–67), but he may, in fact, be the father of the young woman undergoing the rite.

The ceremony takes place within a tipi, just as Black Hawk shows it (pl. 19). The young woman's father chooses a male to officiate, preferably a medicine man, who in one source is described as wearing a buffalo headdress like those in plates 10 and 11. Elsewhere it is said that the person conducting the ceremony wears only a breechcloth, leggings, and moccasins, as in plate 19.[65] His face and body are painted for the occasion. Black Hawk shows a combination of red and blue face paint and blue patches on his bare upper body in two of the three images; in the third he wears a cloth shirt (pl. 21, left). Lakota experts describe the celebrant's face painting as either red with black stripes, or red with blue on the forehead. Black Hawk depicts the latter.[66]

In each picture, the young woman is dressed in extremely fine clothing, resplendent with beadwork and quillwork. Fine hair-pipe jewelry (see p. 67) hangs from her neck and ears. The young girl begins the ceremony by sitting with her legs crossed, as children and men do. But as she is transformed into a woman, she is instructed to sit "as a woman sits," with her feet and legs together, tucked to the side.[67] All of the drawings show participants who have progressed to that point in the ceremony, sitting like modest adult women.

Both the man conducting the ceremony and the young women receiving it wear their hair in prescribed fashion: one side hangs down long, while the other is tied up into a tuft wrapped with red stroud.[68] This may have been idiosyncratic to the Sans Arc or to Black Hawk's own ritual practice. All that is mentioned about hairdo in the textual sources is that during the ceremony the young woman's mother braids her daughter's hair and places it "in front, as women wear their hair, instead of behind, as a girl's hair is worn."[69]

Of the numerous actions and objects necessary to the female puberty ceremony (which include a buffalo skull, a supply of dried cherries, eagle plumes wrapped with green mallard feathers, and other items), Black Hawk depicts only three: a drum, a bowl, and a bundle of hair. In each picture, a round hand drum either is held by the officiating male or rests prominently in the foreground. Also in each picture, the seated female holds bunches of black hairlike material in her hands. In plates 20 (right) and 21 (left), the medicine man holds a similar item near her head. Slow Buffalo made a small bundle of sweet grass, cherry-tree bark, and hair from a live buffalo, which he held over the young girl's head. As he prayed, he rubbed the bundle down her side and asked various powers of the universe to purify her.[70]

In plate 21 (right), a large hemispherical bowl is depicted in front of the celebrants. Dried cherries are placed in this bowl of water, and

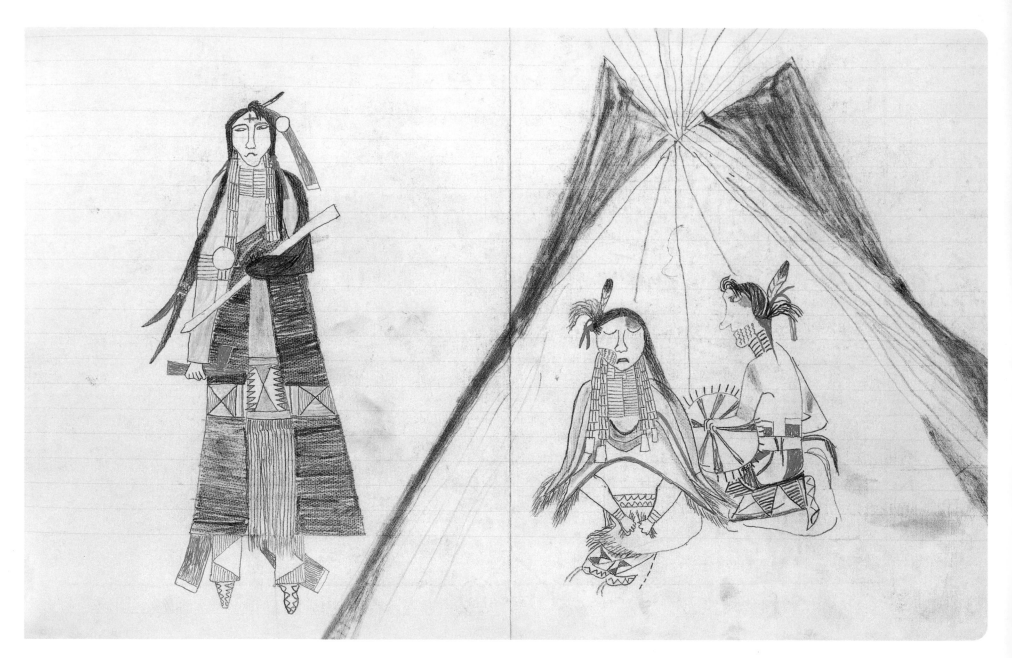

PLATE 19

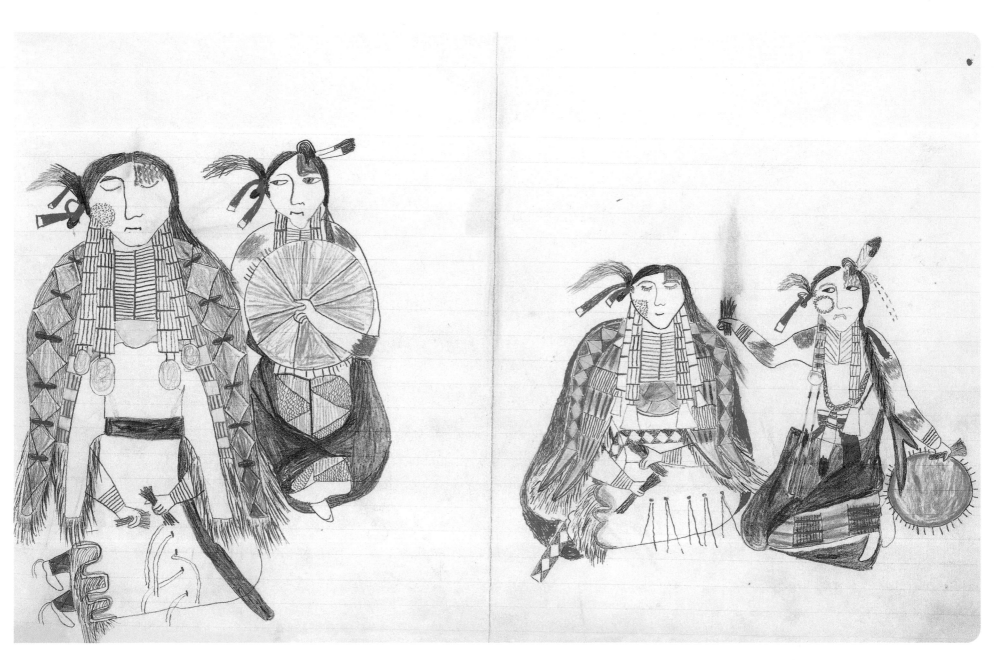

PLATE 20

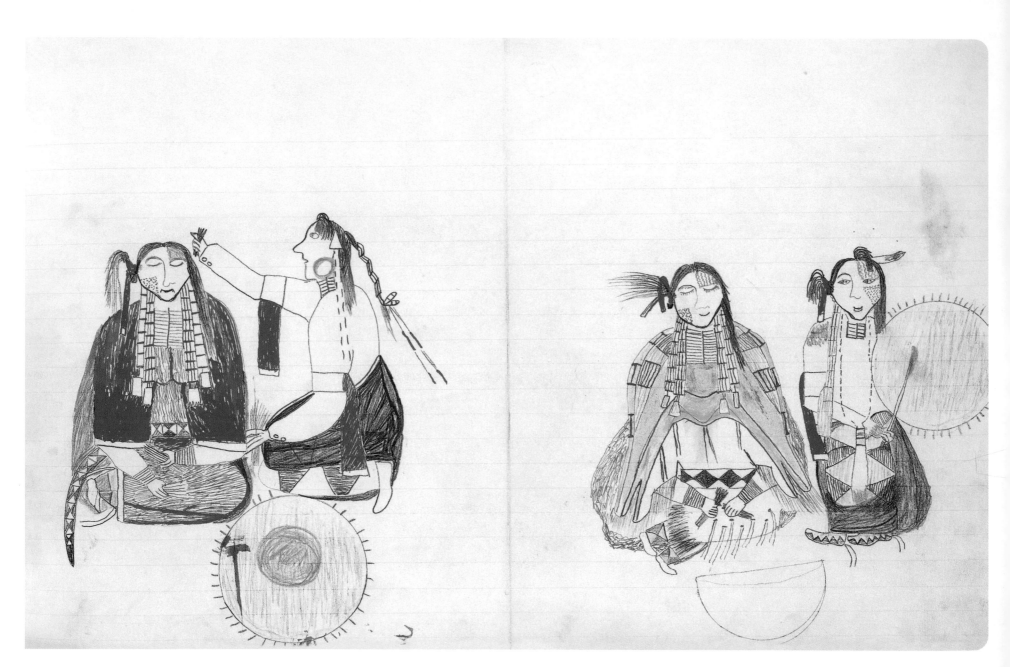

PLATE 21

the participants drink the reddened water. In the drawings, the young women's faces have already been painted red along one side of the jaw; red pigment highlights the parts in their hair. Of this, the medicine man says:

> Red is a sacred color. Your first menstrual flow was red. Then you were sacred. You have taken of the red water this day. This is to show that you are akin to the Buffalo God and are His Woman. The Buffalo God is pleased with an industrious woman. He is pleased with those who give food to the hungry. He will cause a brave man to desire her, so that he will pay the price for her. She may choose the man she desires. If he has other wives, she will sit next to the *catku* [that is, the place of honor within the tipi]. They will carry wood while she mends moccasins. You are now a buffalo woman. You are entitled to paint your face in this manner.[71]

The *Isnati Awicalowanpi* ceremony is accompanied by a feast and gift giving. To demonstrate that a buffalo woman is generous rather than stingy, the young woman removes her beautiful new dress and gives it away to someone who needs it more than she does.

Those who have been transformed by the rites of *Hunka Lowanpi* or *Isnati Awicalowanpi* bear a special burden, a sort of Lakota noblesse oblige: they, in turn, must be extraordinarily generous and kind to all. Slow Buffalo said this to the first young woman, named White Buffalo Cow Appears, over whom he conducted this rite:

> You will now go forth among your people in a holy manner, and you will be an example to them. You will cherish those things which are most sacred in the universe; you will be as Mother Earth—humble and fruitful. May your steps, and those of your children be firm and sacred. As *Wakan-Tanka* has been merciful to you, so you, too, must be merciful to others, especially to those children who are without parents. If such a child should ever come to your lodge, and if you should have but one piece of meat which you have already

placed in your mouth, you should take it out and give it to her. You should be as generous as this![72]

Those generous individuals form a sort of moral aristocracy among the Lakota. Slow Buffalo's observation that the young woman who has undergone the ceremony will sit in the honored place in the tipi and will "mend moccasins" indicates that the buffalo women (who ever after are recognized by their face paint, their demeanor, and their actions) may have the leisure to work on fine quillwork and beadwork designs rather than prosaic chores like carrying firewood.

Writing in 1917, James Walker noted that the Buffalo Ceremony was almost obsolete among the Lakota; looking at Black Hawk's depictions of it almost eighty years later, Darlene Young Bear confirmed this: "Almost nobody does this ceremony anymore. They don't know how. We could use these [pictures] to help remember."[73]

Public ritual in any culture reinforces the fundamental values of that culture. All of the ceremonies discussed in this section—the various animal dreamer dances and the Buffalo Ceremony held at menarche—serve to remind people in a formal, ceremonial way of an essential belief, deeply held by Lakota people. It was expressed by Slow Buffalo in this fashion:

> May they always remember their relatives at the four quarters, and may they know that they are related to all that moves upon the universe, and especially the buffalo, who is the chief of the four-leggeds, and who helps to raise the people.[74]

This truth is also expressed by the succinct Lakota phrase uttered on many occasions: *mitakuye oyasin,* "all my relations," which evokes the fundamental truth that humans, animals, and the forces of nature are all profoundly related and that humans must maintain

a humble position within these bonds of kinship. As William Powers has observed, the Lakota epistemological system is, in this respect, at odds with the Judeo-Christian one; in the Old Testament, human beings are formed last—the crowning glory of God's creation. For the Lakota, in contrast:

> Humans were last, and that makes them newest, youngest, and most ignorant. When Lakota seek knowledge about their present state of affairs, they seek it through the instructions imparted to the medicine men from animals, birds, and other animate and inanimate forms that serve as his helpers.[75]

Lakota Social Organization and Daily Life

Any family could maintain itself adequately as long as the father was a good hunter and the mother an industrious woman. But socially that was not enough; ideally it must be part of a larger family, constituted of related households, called a tiyospaye *("group of tipis"). In the camp circle such groups placed their tipis side by side where they would be within easy reach for cooperative living. In their closeness lay such strength and social importance as no single family, however able, could or wished to achieve entirely by its own efforts.*

In the atmosphere of that larger group, all adults were responsible for the safety and happiness of their collective children. The effect on the growing child was a feeling of security and self-assurance, and that was all to the good. Almost from the beginning everyone could declare, "I am not afraid; I have relatives." To be cast out from one's relatives was literally to be lost. To return to them was to recover one's rightful haven.

—Ella Deloria, *Waterlily*[76]

UNLIKE BAD HEART BULL, who set out to fashion a pictorial encyclopedia of the Lakota world, Black Hawk drew only a few pictures that concern themes of daily life within the camp. Depictions of quotidian activities (butchering animals, scraping hides, eating, scenes of childhood) were of little interest to this artist. Indeed, such scenes form a relatively small part of the visual archive of Plains Indian graphic arts—only a handful of Kiowa, Cheyenne, and Lakota drawings depict such subjects.[77] In his small number of drawings of group leadership, courtship, and social dancing, Black Hawk provides a window onto mid- to late-nineteenth-century social organization that complements the narratives recorded by James Walker and other early ethnologists.

Headmen of the Lakota. Two drawings depict with portraitlike accuracy the grave-looking, well-dressed men who form the council that helped regulate social life among the Lakota (pls. 22, 23). The early ethnographic sources are not in agreement about the number of councilors, chiefs, *wakikonza*, or shirt wearers that existed under the head chief. Sometimes these terms are used interchangeably. Red Feather told James Walker that there were four or six head chiefs, called *wakikonza*, while Walker's own summaries describe one *wakikonza* and a council made up of an indefinite number. Black Elk says there were six councilors who made the laws and a group of men (*wicasa yatapika*—usually glossed as "shirt wearers") who elected the chiefs. It is likely that these offices and the numbers of men who held them were flexible and perhaps differed among the bands or varied at different points in time. The size of these leadership offices might have depended upon the size of the band or whether there were multiple bands.[78]

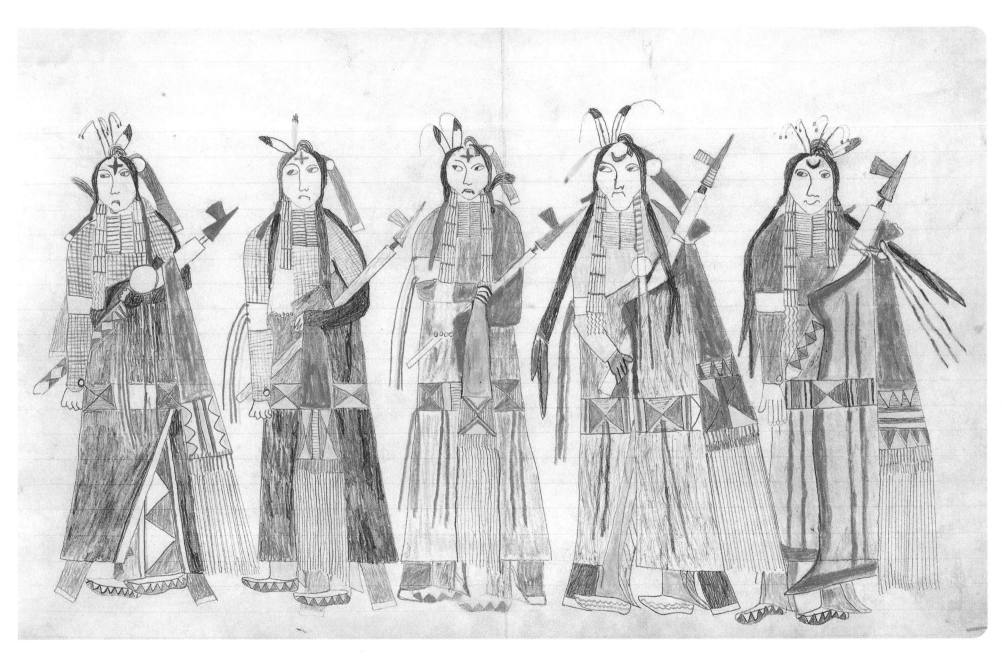

PLATE 22

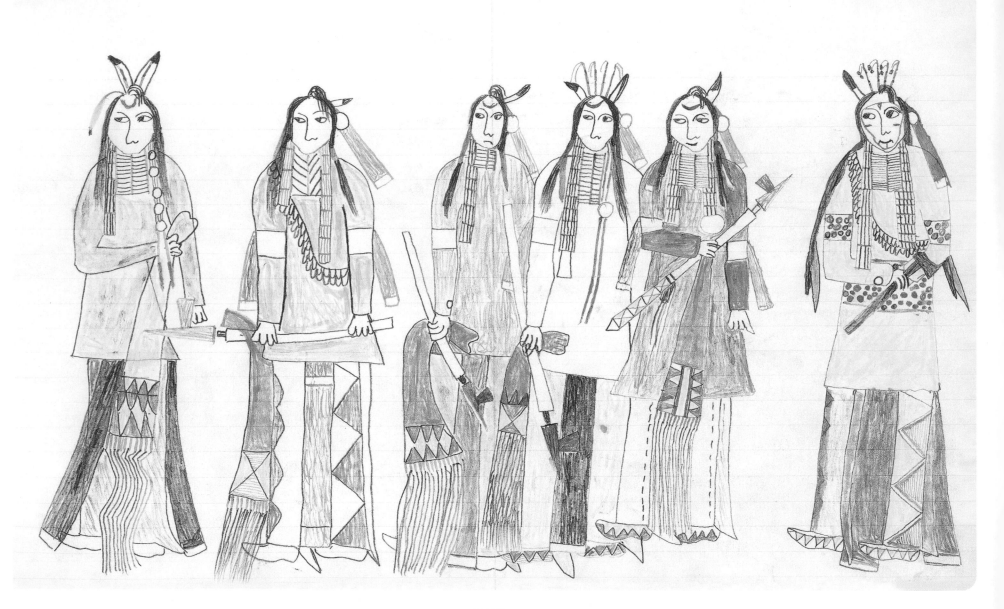

PLATE 23

When Darlene Young Bear, an elder at the Cheyenne River Sioux Reservation examined these drawings in 1995, she immediately said:

> These six men with the pipe bags—they are the six *wakikonza.* There are always six. We still have them at Red Scaffold. They are beneath the chiefs. They take care of the people.[79]

In Black Hawk's drawings, all of the men have serious demeanors, befitting their roles as councilors. Most have some kind of face painting, U shapes and crosses being most common. Most hold pipes and elaborately beaded pipe bags.[80] In plate 23, the figure on the extreme right holds an axe instead, while the figure on the extreme left holds just a pipe bag. All the men in this drawing wear trade-cloth shirts and beaded leggings. Most of them wear cloth armbands over their shirts. The armbands and belt of the axe holder are spotted, like those worn by some Sun Dancers in plate 8. Also like the Sun Dancers, the pipe bearers wear various ensembles of feathers, quilled sticks, and cloth ornaments in their hair. In plate 22, in addition to the leggings and trade-cloth shirts, each man wears a cloth or buffalo-skin robe, ornamented with a blanket strip beaded with triangular blocks of color.

All the men wear abundant amounts of hair-pipe jewelry. These long cylindrical hollow ornaments made of shell were fashioned into chokers, necklaces, and ear ornaments and worn by men and women alike. In ancient times, such beads were manufactured all across the Eastern Woodlands, but by the late eighteenth century, they were commercially manufactured in New Jersey for the Indian trade. Before 1880, they were principally made of *Strombus* shells; after 1880, cheaper and more durable cattle bones were used. In formal portrait photography during the reservation period, it is common to see copious amounts of hair-pipe jewelry worn over equally extravagantly beaded garments.[81]

In several other drawings, Black Hawk shows similarly dressed men, singly or in groups of two, holding pipes (see pls. 19, 24, 37, 38). In these instances, Lakota men seem to be taking part in a variety of social events, including courtship, diplomatic relations with the Crow, and (as overseers) female puberty ceremonies.

Early in the twentieth century, Standing Bear also drew pipe bearers for Father Eugene Buechel (see fig. 9). His drawing, entitled *Wicasayatapika,* "Chiefs," is captioned, in part, "they must help all who need help: food, clothing, horses, etc. The pipe is for all to smoke."[82] Like the men Black Hawk depicted, they carry pipes and fringed pipe bags and wear the double eagle feather hair ornaments. They also wear the quilled and fringed shirts and leggings of high-ranking warriors (compare with fig. 2).

Courtship. The flirtation of young, unmarried people and their attraction to each other is evoked in pictorial form through one conventional image familiar all across the Plains: a man and a woman enveloped within the same buffalo robe or blanket. Black Hawk depicts scenes of courtship in just three images (pls. 24, left; 25, 26). The Lakota call this *wioyuspa,* "catching a woman," and it is the essential prelude to marriage. Because virtue in women was highly valued in Lakota society, no young woman would engage in these flirtations lightly. She would strive to appear uninterested in the young man's attentions. One of Ella Deloria's informants characterized male suitors in this fashion: "If they notice they are greatly desired, they make themselves unattainable. And if they are ignored, they are wistful in their longing."[83]

In one of the drawings (pl. 24, left) the young woman seems to be showing precisely this lack of interest, normally ascribed to young men. Her suitor's identity is concealed, for his red trade-cloth blanket

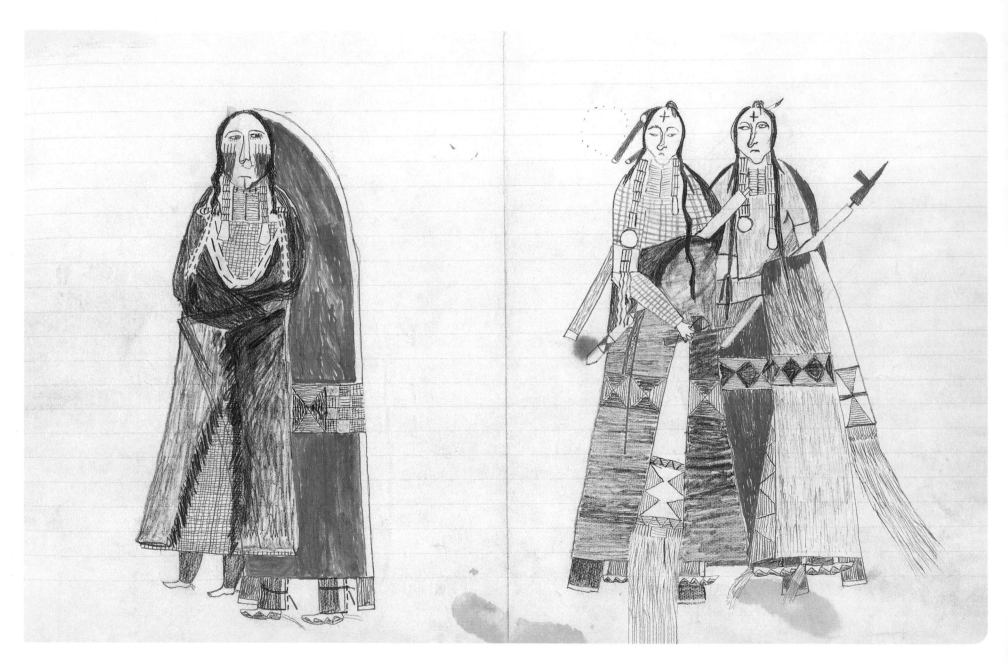

PLATE 24

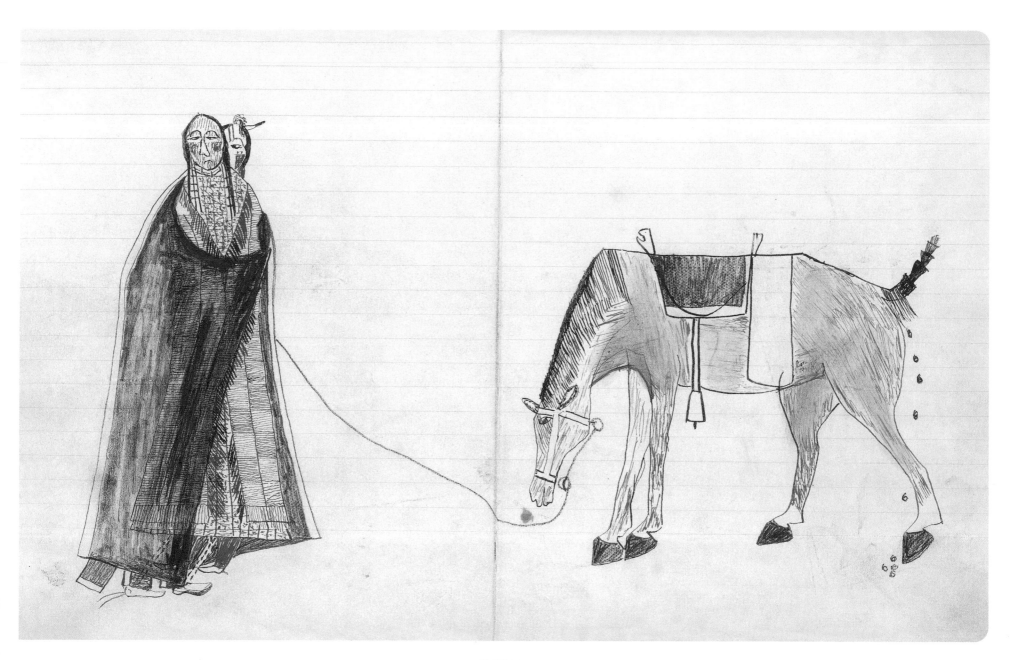

PLATE 25

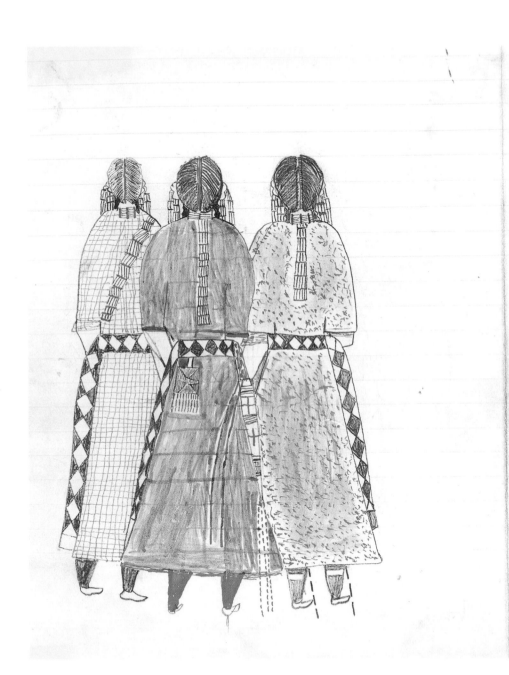
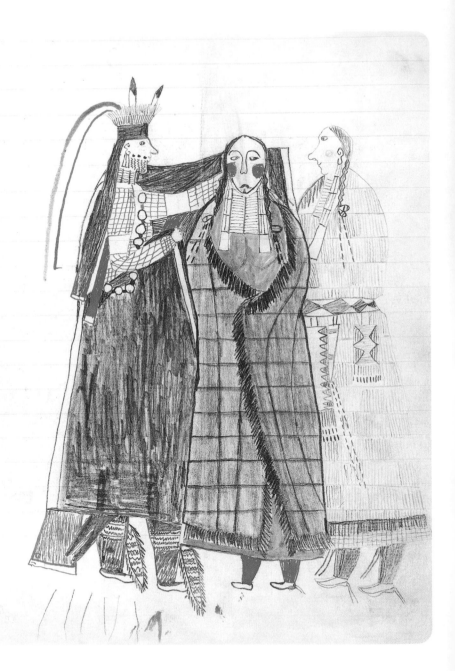

PLATE 26

covers his head. She stands in front of him, resolutely wrapped in her own buffalo skin robe. The suitor in plate 25 is somewhat more successful. He has ridden up to see his sweetheart and holds his horse's bridle while he flirts. He has wrapped her within his black cloak, but she faces away from him. Nearby, the horse waits patiently, grazing and defecating.

Black Hawk drew the woman in her checked and fringed shawl first, then overlaid this image with the black ink of the cloak. On many occasions, he has shown people posed frontally or from the rear, but with their feet in profile (pls. 27, 28). Here, however, this technique is visually confusing. The woman's small foot, with red legging, is turned left; the man's larger feet (with the bottom of his white-edged red stroud leggings peeking out) are turned right, yet he stands behind her and envelopes her in his robe. Perhaps the artist has done this deliberately to stress the awkwardness of the woman's grudging acceptance of her suitor's tender act.

In the final image (pl. 26), the courtship seems to be taking place at a more public event. On the left, three women dressed like social dancers (pls. 27, 28, 29) stand discreetly by. The young woman being courted stands in a frontal pose, wrapped within her own black-checked and fringed robe. A very well dressed man gestures, as if to wrap his own black robe around her, too. To the right, another woman serves as chaperone. Bad Heart Bull drew similar scenes of courtship; in some cases he shows men lining up for a chance to plead their interest with an especially eligible young woman.[84]

Social Dancing. Anyone who has ever attended a powwow has been impressed by the color, movement, sound, and spectacle of Native American dance: the whirling of bodies, the shimmer of fringe on a shawl, the bright, saturated colors of fabrics, the sound of bells or deer-hoof rattles attached to a garment. In three images (pls. 27, 28, 29), Black Hawk evokes the colorful scene of a social dance. Plate 27 is one of only three in the book that were captioned by Caton (the others were the scenes of Spirit Beings, see pls. 1, 2). This caption reads "Wah-chee-pe. Festival dance of males and females." *Wacipi* (as it would be spelled according to modern Lakota orthographic conventions, maintaining the soft *c,* as in *chill*) is simply the Lakota word for "dance."

Black Hawk has filled each page with a colorful group of nine or ten dancing figures, seen from the back. Males alternate with females in the lineup. Because it is unusual to see Lakota men and women dancing together, their arms intertwined, this can only be the social dance called "Shuffling the Feet Dance" or "Dragging the Feet Dance" (*nas'loha wacipi*).[85]

As in his Sun Dance pictures (see pls. 7, 8, 9), here the artist has meticulously rendered every detail of clothing and adornment. Most of the garments are made of trade cloth. Some women wear plaid or checked cotton dresses, while others wear garments of solid color. In plates 27 and 28, one woman in each group wears a black stroud dress ornamented with hundreds of elk teeth. (In 1851, the artist Rudolph Kurz commented that a hundred elk teeth cost as much as a horse.)[86] A woman who could afford a dress with the bodice covered with such costly adornments, front and back, was wealthy indeed. In some instances, hundreds of less costly dentalium shells were sewn in rows across the bodices of stroud dresses in place of elk teeth. Dentalium shells originate on the Pacific Coast, so these were traded over long distances; even so, they were less expensive than the rare elk incisors.[87]

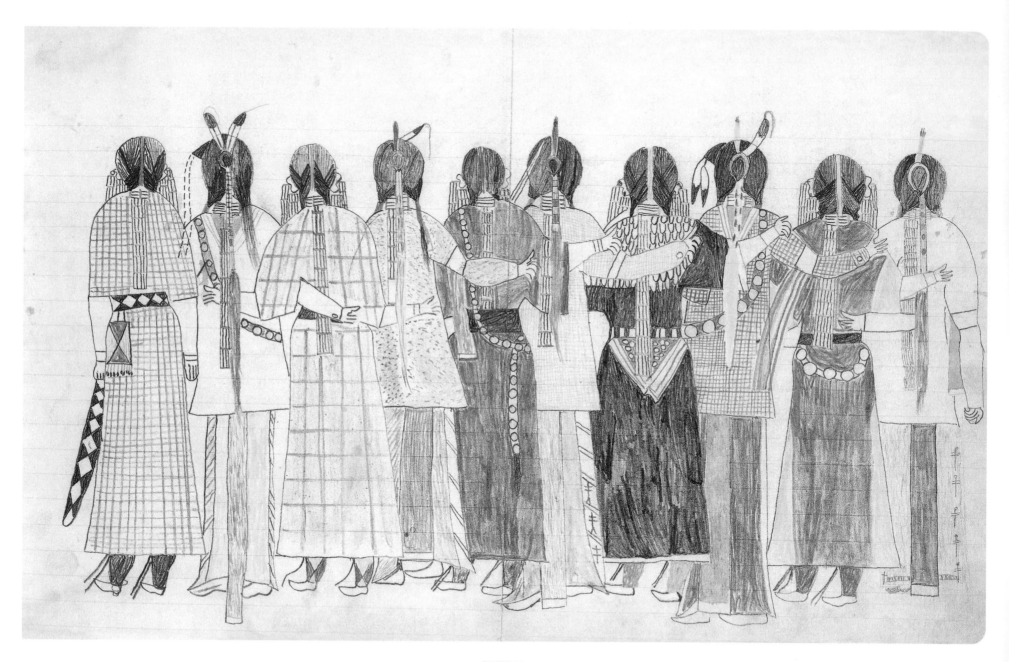

PLATE 27

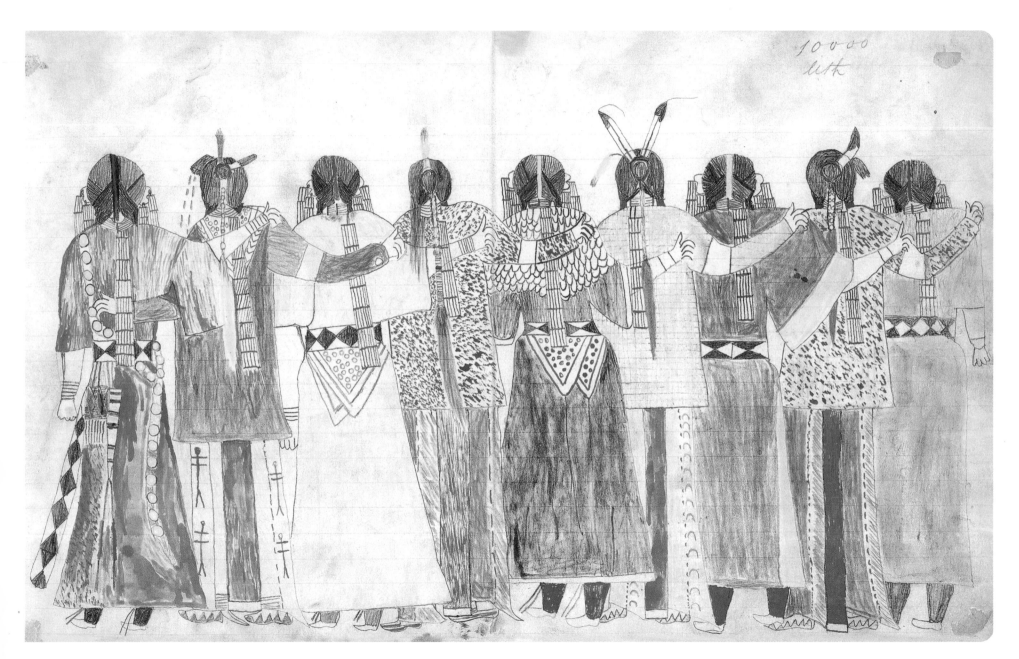

PLATE 28

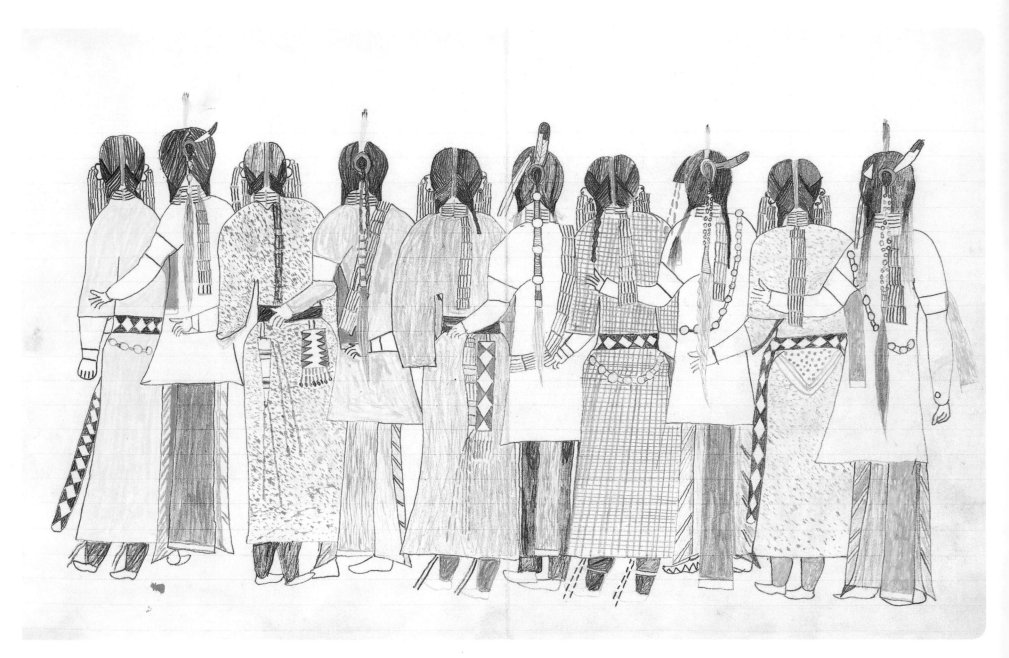

PLATE 29

Some women have folded cloth handkerchiefs or head scarves diagonally under their belts, for an extra color accent. In each drawing, one woman wears a small beaded bag appended to her belt (in pls. 27, 28, she is farthest to the left; in pl. 29, she is third from the left). Plains Indian women often wore beaded awl cases, knife sheaths, and "strike-a-light" bags (containing flints) on their belts.[88] Some women wear leather belts adorned with metal disks, while other belts seem to be beaded in black and white diamond patterns. Both men and women wear strings of brass buttons as belts or shoulder strap ornaments.

The men wear trade-cloth shirts, sometimes with upper armbands atop the fabric. Their leggings and breechcloths seem to be made variously of cloth or fringed, tanned hides. In plate 28, the second figure from the left wears yellow leggings painted with red dragonflies; tiny blue dragonflies can be seen in the leggings of the central figure in plate 27. Warriors customarily painted both their horses and themselves with dragonflies in order to be swift and nimble in battle, emulating this aerodynamically designed insect whose movements make it almost impossible to catch.[89] Perhaps in these circumstances, the dragonfly emblems aided in nimble and deft dancing, but more likely the men were wearing the same leggings they had worn a little while before in a warrior dance.

Both men and women wear lavish shell necklaces, earrings, and hair ornaments of the type described in the section on Lakota headmen. The parts in the women's hair are painted red or yellow. Men wear quilled hair ornaments and feathers.

John Gregory Bourke, whose eyewitness accounts of a Lakota Sun Dance have already been quoted, had this to say of women's garb on festive occasions:

June 20, 1881

Walking over by the line of squaws (who kept pretty much to themselves), I noticed that they were dressed in all sorts of styles, while there was a decided preponderance of gaudy calico dresses and cheap rainbow-hued shawls. The more conservative adhered to the old-time gown of white antelope skins embroidered heavily with pale blue and salmon colored beads at bust, neck, shoulders, tip of skirt, waist and seams. . . .

. . . Mention has already been made of the many beautiful costumes among the squaws; these seemed to increase both in number and in beauty as the cloudless sky of evening assured safety from the damaging effects of rain, which doubtless had kept many a Dakota belle under the shelter of her lodge during the day. Blue and salmon colored beadwork, fine blue cloth studded with elk teeth, Navajo blankets of the first quality, calico dresses in all the colors of the rainbow, blankets of the deepest blue and most vivid scarlet, and moccasins of fine buckskin composed the toilet in which much scope was afforded for the display of savage style.[90]

In these three drawings, Black Hawk reveals himself to be a master of color and pattern. In terms of their graphic and decorative quality, they rank with some of the best works of the Cheyenne artist Howling Wolf (1849–1927), the acknowledged master of linear and coloristic patterning.[91] Black Hawk's interest in repetitive color and pattern and his keen eye for cultural life was not limited to his own tribe, however. He also drew some remarkable pictures of Crow Indian men dressed and painted for ceremonial display.

Crow Indian Ceremonialism

I put on my war shirt and leggings of softly tanned mountain-sheep skin trimmed with weasel skins and scalp locks. Around my neck I wore a good wampum necklace and attached long pieces of false hair to my head. In my own hair I wore a red plume tied to a brass ring. Then I rode my beautiful bay horse to their meeting ground.

—Two Leggings, a Crow warrior[92]

AMONG THE MOST unusual drawings in Black Hawk's book are a series in which he carefully depicts Crow men painted for ceremony (pls. 30–34), and finely dressed Crow horsemen on parade (pls. 35, 36, 37, 38). An expert visual ethnographer, the artist provides rich cultural information in these drawings—details of headgear, clothing, and beadwork that identify these men as Crow, traditional enemies of the Lakota.

Today the Crow Reservation is southeast of Billings, Montana. In the nineteenth century, the several divisions of the Crow roamed from the Upper Missouri River, in what is today North Dakota, across Montana into Wyoming, clustering mainly in the middle Yellowstone valley. They traded with whites at the major trading depots, like Fort Union, and they fought with Lakota, Cheyenne, Blackfeet, and Shoshoni over control of territory and resources. They were greatly outnumbered by the Lakota, who moved relentlessly west in search of game, pushing the Crow away from lands they had hunted for several generations.[93] Crow and Lakota histories (oral, written, and pictorial) are full of references to the enmity between these two groups. Indeed, the very first pictograph recorded on the famous Lone Dog's winter count is a set of thirty marks, recording the killing of thirty men by Crow Indians in the winter of 1800–1801.[94] Lakota pictographic histories record battles with the Crow in many subsequent years, as do many drawings (see, for example, fig. 4). Nonetheless, despite this troubled history between the two groups, Black Hawk evinces great interest in the religion, fancy dress, military prowess, and horsemanship of the Crow.

In the nineteenth century, numerous outsiders commented upon the fine appearance of Crow horsemen and warriors. Edwin Denig, a fur trader on the Upper Missouri in the second quarter of the nineteenth century, wrote:

The warrior class is perhaps the handsomest body of Indians in North America. They are all tall, straight, well-formed, with bold, fierce eyes, and as usual good teeth. These also dress elegantly and expensively. A single dress often brings the value of two, three, or four horses. The men of this age are neat and clean in their persons, fond of dress and decoration, wear a profusion of ornaments and have different dresses suitable for different occasions. They wear their hair long, that is, it is separated into plaits to which other hair is attached with gum, and hangs down their backs to several feet in length in a broad flat mass which is tied at the end and spotted over with clay. A small portion in front is cut short and made to stand upright. On each side of the head hang frontlets made of beads or shells, and alongside each ear is suspended several inches of wampum. Their faces on ordinary occasions are painted red, varied with a tinge of yellow on the eyelids. In large slits through the ears are tied sea shells cut into angular shapes, which are of a changeable blue and green color. These shells find their way from the coast of California through the different nations until handed to the Crows in exchange for other property.[95]

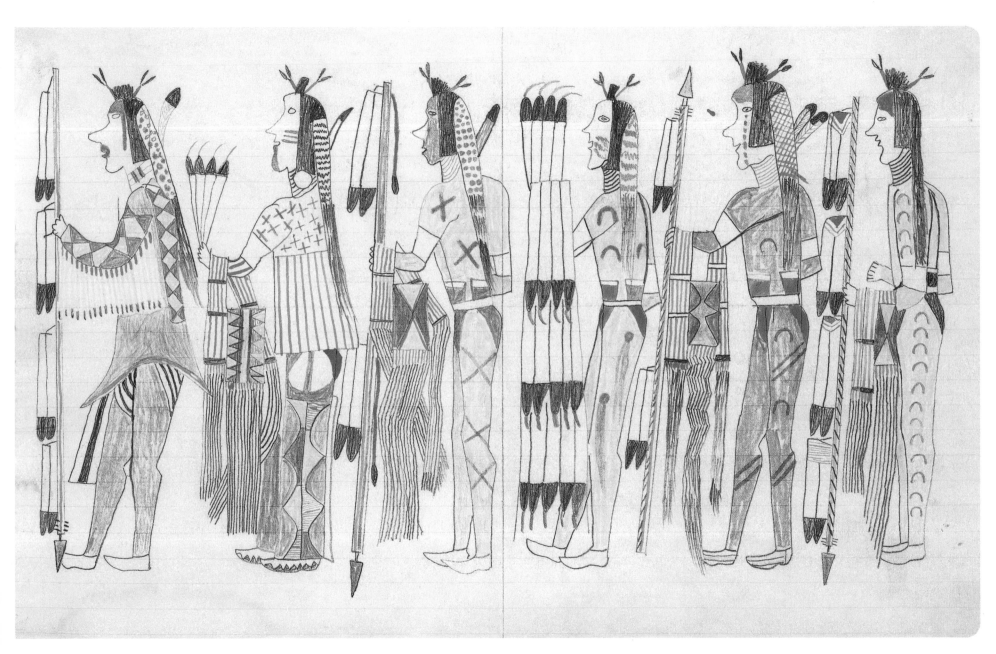

PLATE 30

Black Hawk's five drawings of Crow men in profile (pls. 30–34), wearing ceremonial garb, show the distinctive hairdo—pompadour on top, long hair extensions, and the ornaments that Denig describes. The Lakota called this "enemy hairdo," and it is a convention found in drawings by Lakota, Cheyenne, Crow, and other artists to indicate Crow, Hidatsa, Assiniboine and other warriors of the Northern Plains.[96] Each of the twenty-five men meticulously drawn by Black Hawk is distinctive. No two are identical, although some are dressed or painted similarly. For example, certain figures wear war shirts ornamented with bead- or quillwork, with long ermine skin appendages hanging from the arms (pls. 30a, 31a, 33a, 34b, and 34e, counting *a* as the figure farthest to the left, *b* the one to his right, and so forth). These are classic Crow war shirts, worn by men of rank and distinction.[97] Most of these war-shirt men (pls. 30a, 31a, 33a, 34b) also wear a black-and-white striped breechcloth, while their companions, more skimpily dressed, wear short breechcloths of red or blue stroud cloth. A few wear beaded leggings (pls. 30b; 32e; 33a, b, d). Over their left arms, most of the men carry beaded mirror bags of characteristic Crow design. These have long fringes, some of which are braided, or tied with ribbon (see, for example, pl. 31b–f).[98] The Swiss artist Rudolph Kurz, who had occasion to see many Crow who came into Fort Union in 1851–52, describes one young man bedecked with many such bags, who came to visit him in his room:

> He swung his rifle over his shoulder in a sheath, bow and quiver in two broad bandoliers, the straps of both entirely covered with coral beads in various designs. The sheath was decorated with fringe and scarlet cloth. He carried with him three pouches, all richly ornamented, absolutely covered with beads arranged in different patterns. The largest of these pouches opened at the side; the shot bag,

with cover, was attached to his belt in front; a third pouch, closed with long tapering cover, was fastened to his belt in back. His knife sheath was just as elaborately embroidered. It was also trimmed with fringe and, like his knee bands, with falcon bells (from Leipzig). The tinkling of those rows of bells behind and before gave him an especial pleasure. In face and form he was quite attractive looking and manifestly the darling of many sisters or else of other girls who hoped to be his future wives.[99]

In depicting Crow shirts, leggings, and mirror bags, Black Hawk has done a creditable job of rendering the nineteenth-century blocky, bold Crow beadwork style, in which the primary aesthetic feature is the color contrast of large, geometric shapes.[100]

Among all Plains Indians, body painting was a way of ornamenting oneself for war or ceremony. Here, the faces of all the processional figures are painted in some way: diagonal, vertical, or horizontal stripes on the cheeks, red foreheads, spots cascading from the eyes, or painted lips. Many of the figures' bodies are painted yellow or red.[101] Crosses, horse tracks, and diagonal marks indicative of prowess in warfare are inscribed atop the base color.

In his memoirs, the Crow warrior Two Leggings recalls having made permanent scarifications of horse tracks on his arms:

> I asked Young Mountain to help me sacrifice my flesh and he lifted the skin on my left arm, cutting a piece that looked like a horse track. I hoped to steal horses and had asked for that cut. Then I faced east, held the piece up to the sky, and told the Great Above Person that I wished for some animal to eat this and help me receive a powerful medicine.[102]

He also records being painted with crosses before participating in the Sun Dance:

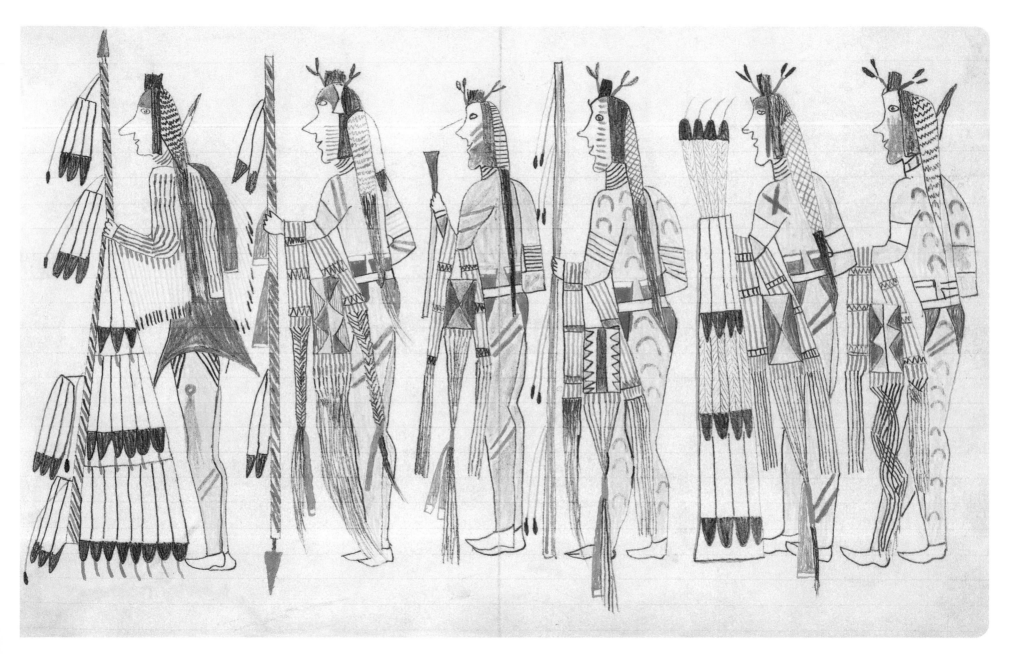

PLATE 31

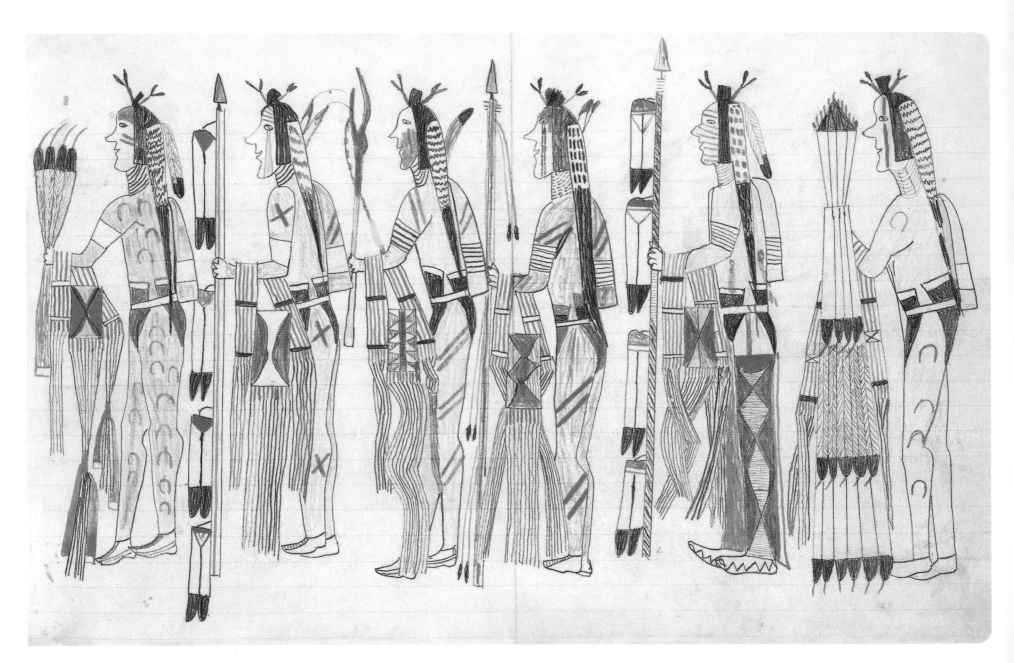

PLATE 32

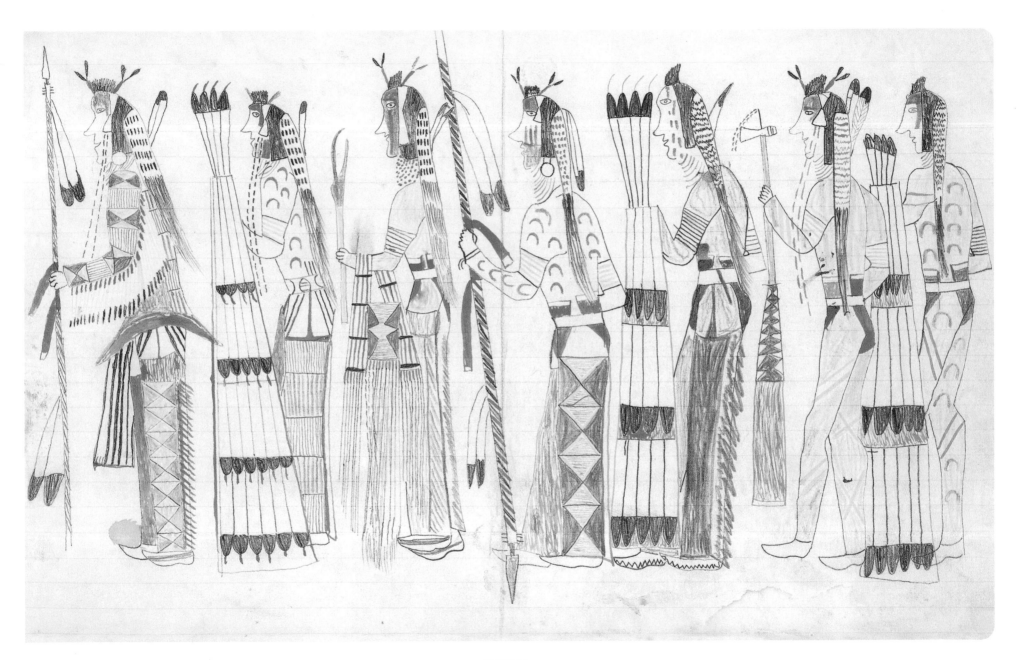

PLATE 33

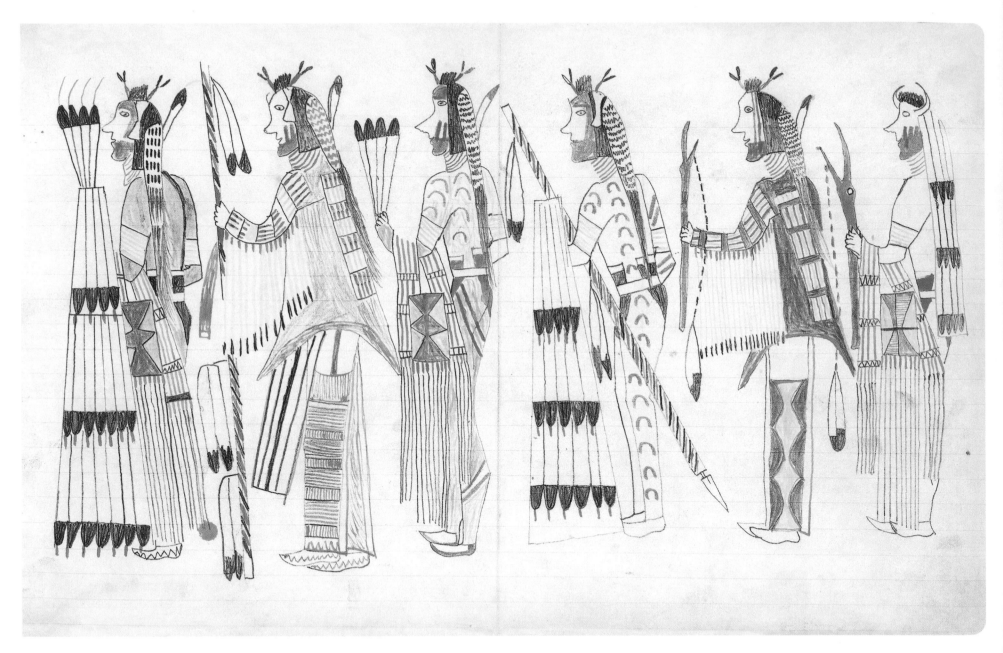

PLATE 34

He took a dish made of mountain sheep horn in which he had mixed white clay, sweet grass, and water. Stirring this several times, he ordered me to kneel and sing this song: "they want to have a lot of things."

When he finished singing he painted one stripe of the mixture up and down on my chest, one on my back, and one stripe down each arm. After singing another medicine song, he rubbed the mixture all over my body and scratched five crosses into the clay with his finger tips, one on my chest, and one at each elbow and each shoulder. Finally he scratched a half-circle from one side of my forehead to another.[103]

Sometimes such war honor marks were painted on garments instead of human flesh. The diagonal marks seen on the legs of many of Black Hawk's figures also occur on Mandan/Hidatsa leggings, and are said to indicate "strikes an enemy."[104]

Some of the men ornament their hair, along their temples, with dentalium shell hourglass-shaped "bows" (for example, pl. 34a, b, d). Generally worn as a pair, these often are made of hide, constricted in the center within a brass tube, forming a bowtie shape. Decorative shells and beads ornament either end.[105] Atop their heads are delicately quilled feather-tipped sticks, ornamenting their upswept hairdos. These are much like the hair sticks worn by Lakota Sun Dancers (see pls. 7, 8, 9). Many of the Crow wear incised brass bracelets on their upper arms (for example, pl. 32c, d, e) and multiple-strand wampum necklaces, for which Crow men were famous.[106]

Almost every man carries a war lance or coup stick. Some are wrapped diagonally with red and black cloth (pl. 31a, b). Other lances sport four pairs of eagle feathers. Black Hawk carefully shows the manner in which the feathers are attached by means of a little red cloth sleeve (pl. 32e). In other instances, the men carry eagle-feather fans, with long cascades of eagle feathers (pls. 30d; 31e; 32f; 33b, e). Of all the items pictured in the processional scenes of Crow men, the last were probably the most valuable. Rudolph Kurz commented that, in 1851 at Fort Union, a tail of twelve eagle feathers "costs here as much as a horse or six buffalo robes."[107]

Crow men dressed and painted themselves this way not only for war but also for the Sun Dance. Nevertheless, few details here suggest that the Sun Dance, in specific, is being shown; no eagle-bone whistles, for example, are evident. One item, however, the crane-headed staff carried by four figures (pls. 32c; 33c; 34e, f), is used in the Hot Dance (the Crow equivalent of the Omaha or Grass Dance that became popular across the Plains in the last quarter of the nineteenth century). Robert Lowie reports that the bearers of wooden crane-sticks were supposed to strike their enemies with these implements.[108] Yet other aspects of Black Hawk's ceremonial procession do not correspond to Lowie's descriptions of the Hot Dance—there are no feather bustles, no flags, no fox-skin necklace, no forked sticks—so it is unclear exactly what is transpiring in these drawings.

On four other pages, Black Hawk has drawn more of these Crow men (pls. 35, 36, 37, 38). Ornamented with the same regalia, they sit astride horses. Each horse wears a stroud saddle blanket, or sometimes two: red cloth is layered over black, or vice versa.[109] All men but one carry fringed strap-bags over their left arms, and eagle-feather fans with long cascades of feathers. The one who is different (pl. 36, right) carries a saber and wears a black robe and a long set of round German silver hair plates. Black Hawk may be depicting a Lakota here, like the man in plate 5, who wears a black

robe and carries a saber. These silver hair disks are a common feature on the Southern Plains, where Kiowa and Cheyenne men often wear them, but they were popular among the Lakota, too. In the first half of the nineteenth century, both the German traveler and naturalist Maximilian, prince of Wied, and the American historian Francis Parkman noted the use of brass or trade-silver hair plates among Sioux peoples; Bad Heart Bull shows them as part of Lakota dress, too.[110]

In two of these drawings, the mounted Crow are paired with Lakota pipe bearers (pls. 37, 38) who resemble the headmen discussed previously (see pls. 19, 22, 23, 24). Of these Lakota-Crow pairs, plate 37 is particularly intriguing, for the mounted Crow in ceremonial dress seems to lead an unusual horse to the Lakota pipe bearer. The horse wears a buffalo mask, suggesting a relationship to Thunder Beings.

The coats of both this horse and the one in plate 36, left, are different from the smooth-coated horses Black Hawk usually draws. Repeating hatch marks in black or red ink suggest that a wiry- or curly-haired horse is being represented. Several winter counts record that at the beginning of the nineteenth century, the Sioux either captured curly-haired horses from their Crow enemies or caught wild ones on the prairie.[111] A warrior named Young Eagle recalled, "these horses were raised by the Indians as far back as anyone can remember. Most of them were dark in color with hair 'singed.' Hence their name, which is *Sung-gu-gu-la,* literally 'horses with burnt hair.'"

Is Black Hawk recording an instance of a *Sung-gu-gu-la* being presented to a Lakota by a Crow? In traditional Lakota life, pictures like these would be shown when men recounted the events of the past.

Each picture, with its richly evocative details, would give weight and credence to men's recollections.

While I have identified all of the sartorial details of these images as characteristic of Crow Indians, many of them are actually part of a wider complex of cultural traits shared by the Crow, Hidatsa, Arikara, and other Northern Plains groups. There are good historical reasons for this: in the seventeenth and eighteenth centuries, the Hidatsa and Crow were so closely related that even in the nineteenth century, some Hidatsa were considered to be a band of the Crow. During the late eighteenth and early nineteenth centuries, once autonomous Mandan, Hidatsa, and Arikara villages along the Upper Missouri River consolidated forces. This was due, in part, to the devastation wrought by smallpox epidemics, which literally decimated these peoples. Living in close quarters, many of their cultural traits overlapped and melded.[112] It could be that Black Hawk is depicting traits observed not specifically among the Crow but among the people living far upriver from the Sans Arc.

In any event, Black Hawk describes the customs and attributes of non-Lakota people in a way that causes us to wonder why he did so. It goes beyond the simple stenographic identification of foreign warriors—pompadour, long, netted hair—that was widespread in Plains graphic arts. The meaning of these images is hard to decipher. Could they have been part of his dream or vision? In his vision, did a finely dressed Crow enemy bring Black Hawk a masked horse for his horse ceremony? Did this relate in some fashion to his vision of Thunder Beings (in whose honor horse dances are held)?[113]

Or do these drawings chronicle an event or ceremony that Black Hawk witnessed? Could this event have occurred during one of the infrequent pacts of peace between the Crow and the Lakota, or is

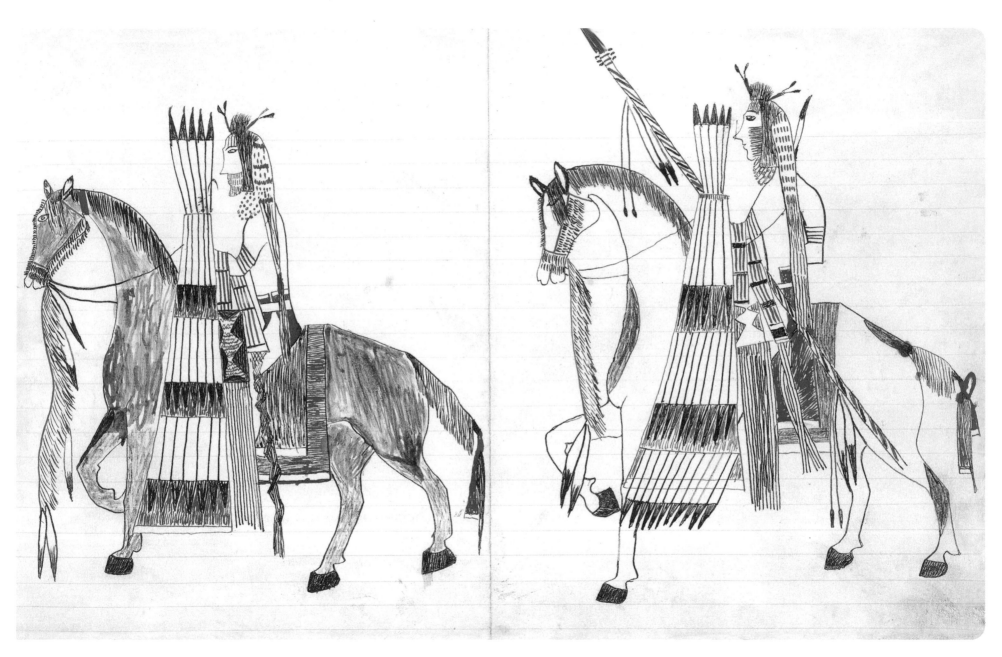

PLATE 35

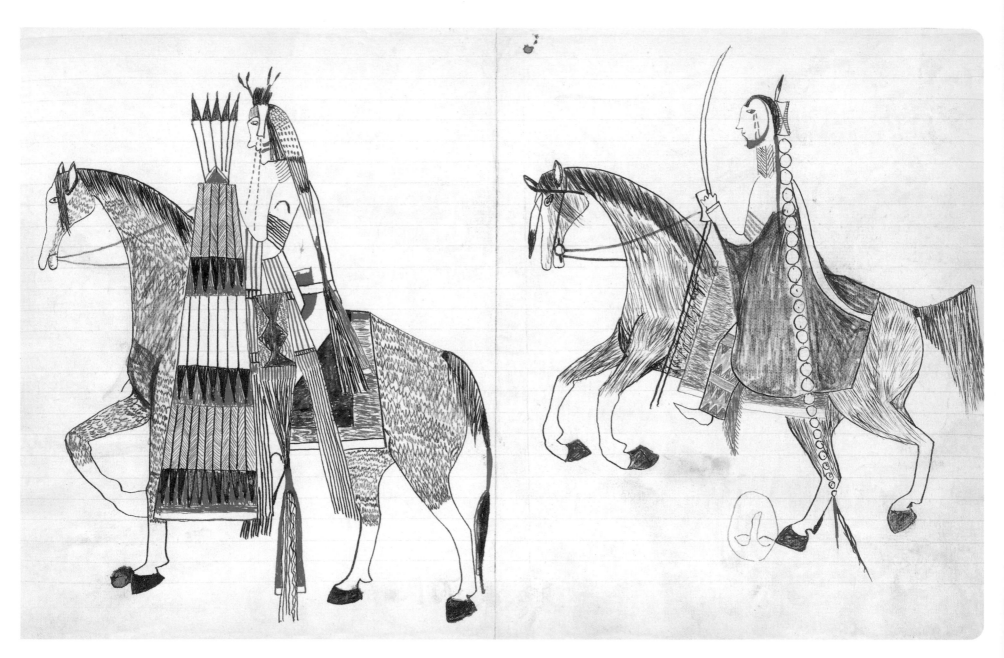

PLATE 36

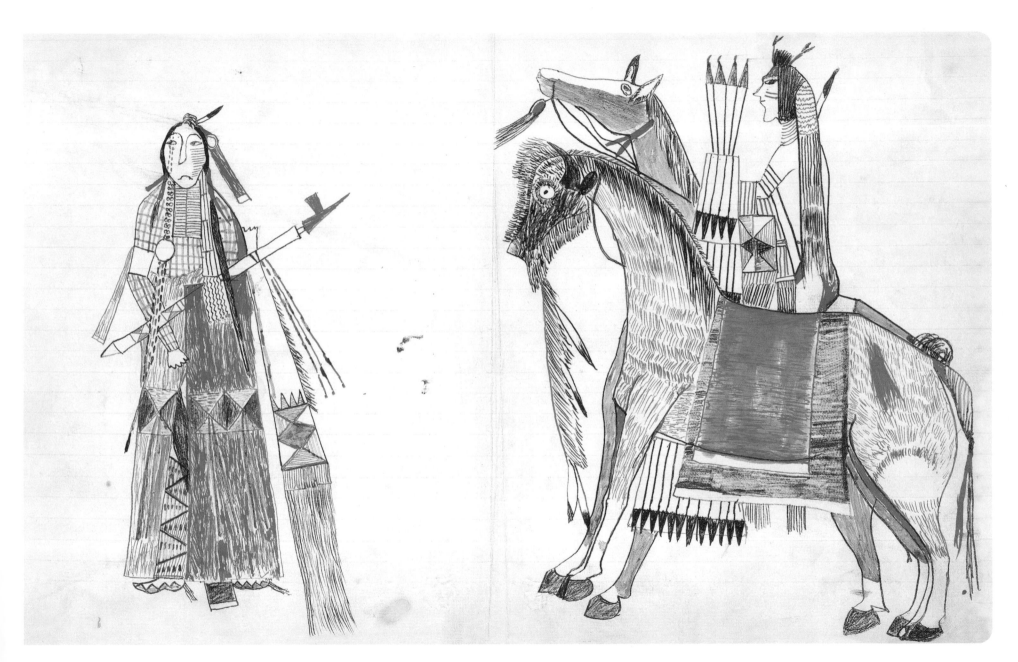

PLATE 37

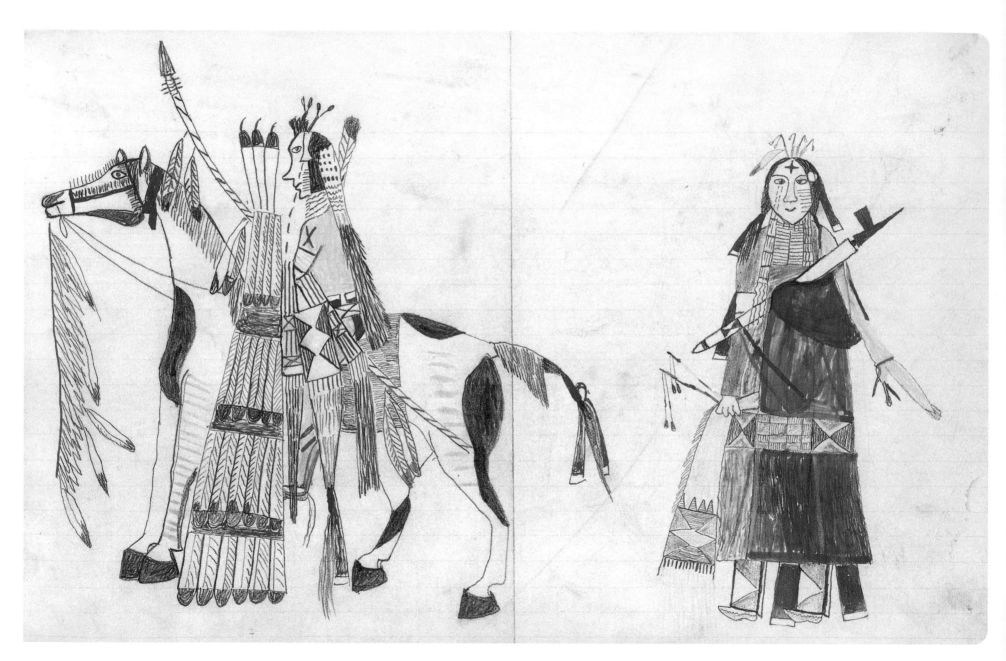

PLATE 38

SPIRIT BEINGS AND SUN DANCERS 89

the artist fascinated with the customs of the enemy for other reasons? Despite the fact that the Crow and the Lakota were traditional enemies, there were some peaceful relations between them, as there were among all Plains tribes. A Lakota drawing book by Red Hawk and others in the Milwaukee Public Museum records two instances of peacemaking between the Lakota and the Crow (see fig. 7), as well as numerous skirmishes between them.[114] War captives, especially women and children, were adopted into tribes; individual travelers and traders were occasionally welcomed. Edward Curtis mentions one Crow woman living among the Sans Arc band, as well as a Lakota woman whose husband went to visit among the Crow.[115] So, although we don't know the precise origin of Black Hawk's specialized knowledge of these foreign customs, or exactly what is being conveyed in this remarkable sequence of drawings, he certainly provides a vivid picture of nineteenth-century Crow ceremonialism.

These depictions are unique in the corpus of Lakota art. Much more common is the recording of ongoing warfare with the Crow. Their animosity was mutual, as evident in this oration by Old Crow, a nineteenth-century Crow chief:

> These are our lands by inheritance. The Great Spirit gave them to our fathers but the Sioux stole them from us. They hunt upon our mountains. They fish in our streams. They have stolen our horses. They have murdered our squaws, our children. What white man has done these things to us? The face of the Sioux is red, but his heart is black. But the heart of the pale face has ever been red to the Crows. The scalp of no white man hangs in our lodges. They are as thick as grass in the wigwams of the Sioux. The great white chief will lead us against no other tribe of red men. Our war is with the Sioux and only them. We

want back our lands. We want their women for slaves to work for us, as our women have had to work for them. We want their horses for our young men, and their mules for our squaws. The Sioux have trampled upon our hearts. The great white chief sees that my young men have come to fight. No Sioux shall see their backs.[116]

The locution "No Sioux shall see their backs" indicates that Crow warriors will defeat the Sioux or fight to their death doing so—but none will flee. Of course, the Lakota pictorial record is full of depictions of the backs of Crow warriors in retreat, as seen in the next section.

Warfare, Horsemanship, and the Hunt

I knocked the enemy down and scalped him. I was 18 years old at that time. It was down south on the South Platte [River]. Many men went on this war party and I became well known for my brave deed, friend. Many of the enemy shot at me but I was not wounded.

—White Bull[117]

THE IMAGE of the mounted Plains warrior, dressed in breechcloth and feathered headdress and running down his enemy, is one of the quintessential images of Indianness in the Western world's imagination. Endlessly propagated in films, books, and photographs for well over a century, this pictorial archetype had its genesis in the drawings done by Plains Indian men who recorded their own deeds of bravery in warfare, horse capture, and the hunt. This is by far the most often repeated subject drawn by Plains men. In Black Hawk's

oeuvre, twenty-one of his seventy-six drawings depict themes of warfare and hunting (pls. 39–59); among other Lakota artists an even higher proportion concerns such themes. Black Hawk depicts no scenes of horse capture, though this was a favored theme among other Lakota artists, for example, Swift Dog's horse-capture scene in figure 3.[118]

As mentioned in chapter 1, the incorporation of the gun and the horse into the world of the Lakota transformed them into a powerful, mobile warrior culture. Horses, brought to the New World by the Spaniards in the sixteenth century, gradually diffused from the Southwest, north and across the Plains in the seventeenth and eighteenth centuries, principally from traders in Santa Fe. The further exchange of horses, firearms, and all manner of other products of both Native and white manufacture took place at great Sioux trading fairs in the Dakotas in the early nineteenth century.[119] Most of the horses ridden, exchanged, and then bred by Plains Indians were descendants of the rugged breed called the Spanish Barb. More properly termed *ponies* because they were less than fourteen hands high at the withers, the horses used on the Plains were sturdy, surefooted, and fast.

Most Plains Indian graphic artists were consummate horsemen as well as artists. The many elegant drawings they made of warfare, hunting, and horse capture reveal the pleasure these artists took in depicting the lines of a beautiful horse. In some cases, characteristic features of an individual artist's hand are revealed in the idiosyncratic way that he draws hoofs, fetlocks, nostrils, or the long, linear sweep from the horse's neck to its rump.

Silver Horn, the master artist of the Kiowa nation, for example, drew horses that are robust and attenuated, with long, exaggerated necks and legs that curve in balletic poses. One of the Lakota artists in Red Hawk's drawing book specialized in slender, delicate horses, some of whom turn their heads to look out at the viewer. No Two Horns devised templates or stencils of horses, allowing him to efficiently repeat the image of a horse at a flying gallop, despite the fact that he was hampered by a crippled hand.[120]

Some of Black Hawk's drawings of intertribal warfare are among his most beautiful and stylistically most adventuresome. In addition to depicting horses in various states of movement as they seemingly gallop across the page, he also skillfully renders them from the back, in foreshortened three-quarter view (pls. 39, 40, 41), or in full rear view (pl. 42), a difficult task for an artist whose pictorial tradition does not emphasize one-point perspective. Through subtle details of pose, he depicts fine equestrian comportment, an aspect of the drawings evident to any expert on horsemanship— Lakota or non-Native—who views these works. For example, all the riders are shown sitting in proper riding posture, with toes up and heels down for good balance and control.

Black Hawk demonstrated his aesthetic appreciation of the diverse physical characteristics of the horses he remembered having seen in battle, both those of his own tribe as well as those owned by the enemy. The Crow were known to have been among the wealthiest in horses of any Plains tribe (which was probably why Lakota boys loved to steal into Crow camps on horse-capture expeditions). Edwin Denig, who worked for twenty-three years as a fur trader (1833–55) on the Upper Missouri, remarked:

> The Crows are perhaps the richest nation in horses of any residing east of the Rocky Mountains. It is not uncommon for a single family to be the owner of 100 of these animals. Most middle-aged

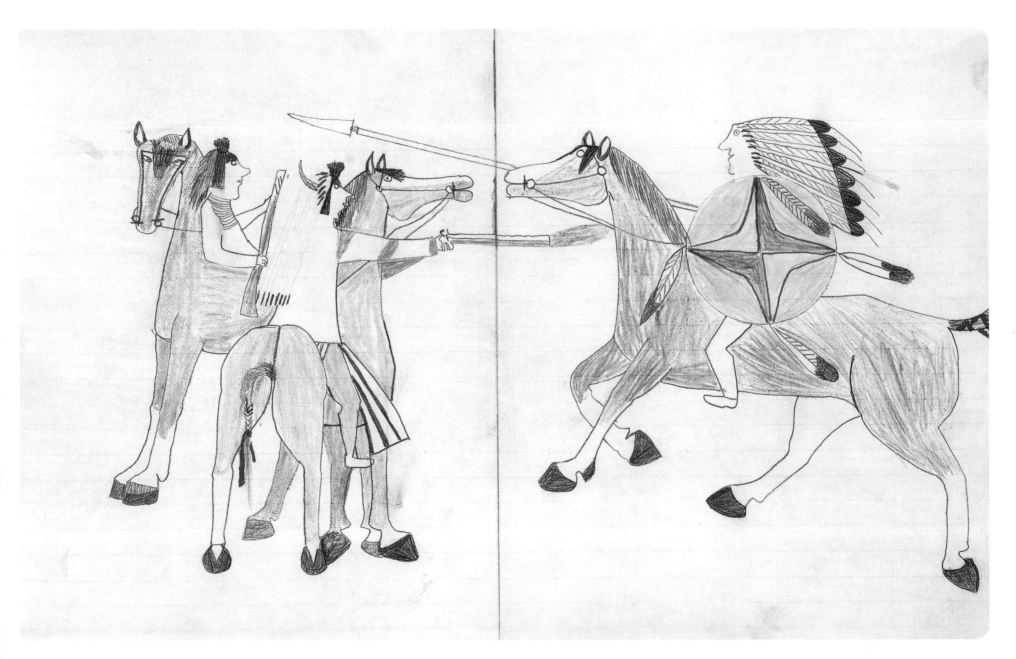

PLATE 39

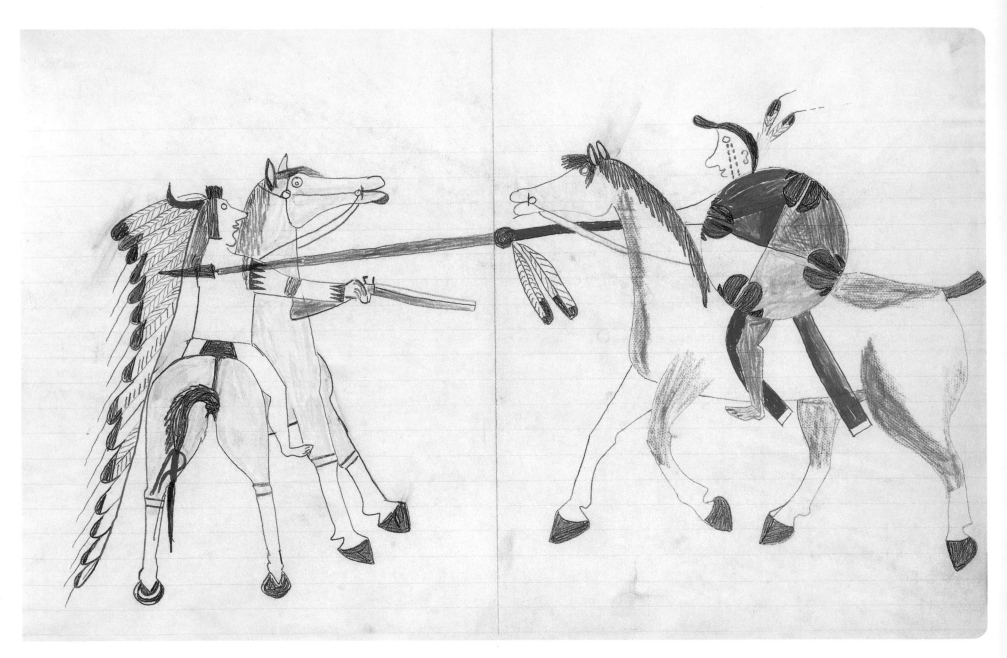

PLATE 40

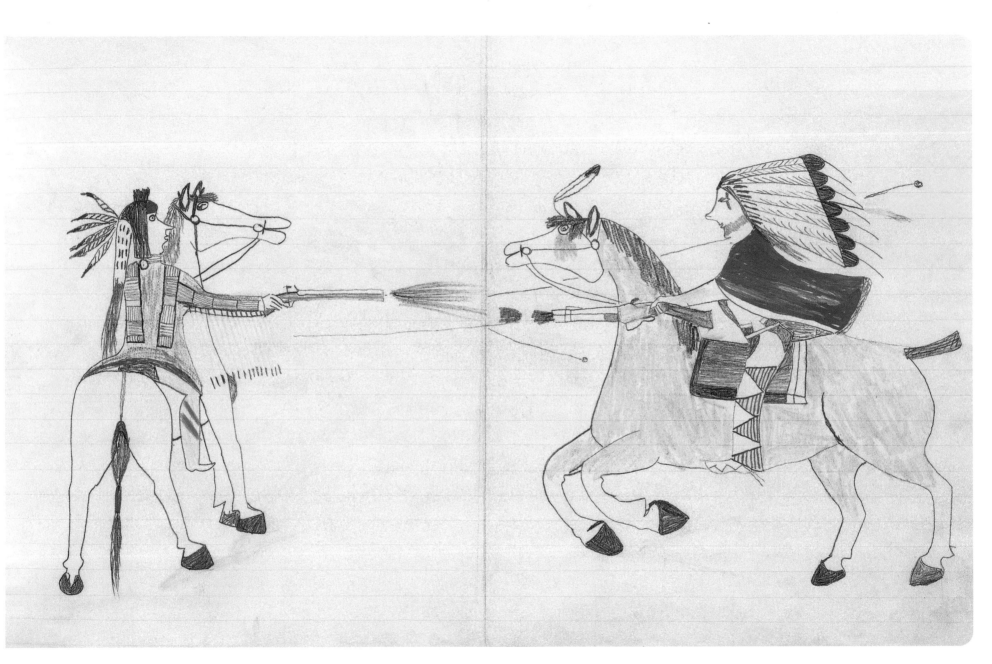

PLATE 41

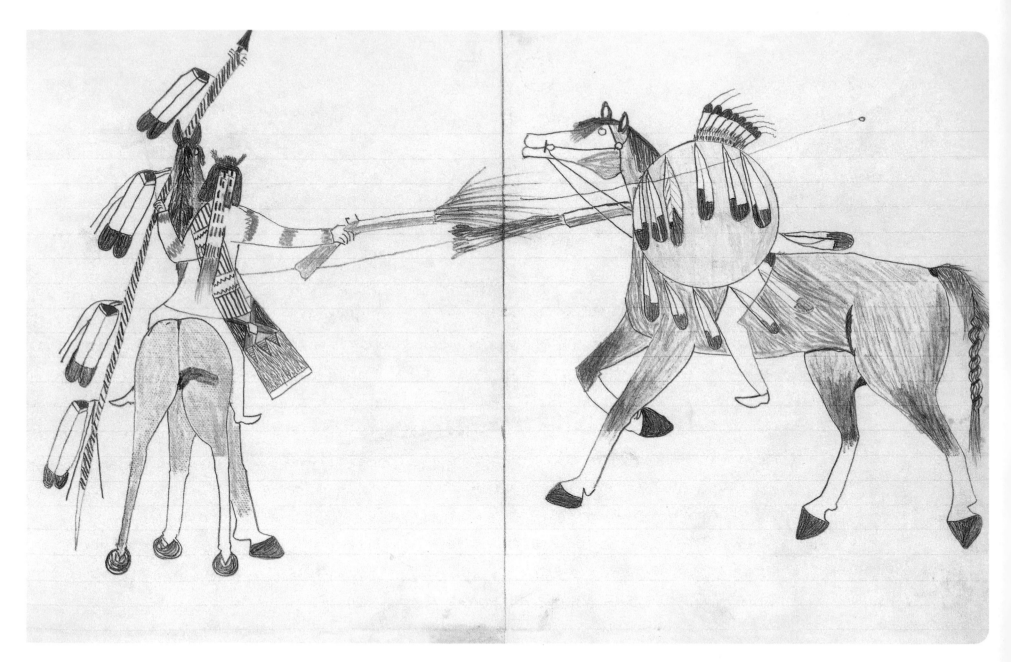

PLATE 42

men have from 30–60. An individual is said to be poor when he does not possess at least 20.[121]

Black Hawk depicts some fine Crow horses in his drawings, from the handsome dun-colored horse with black upper legs, white stockings, and a white blaze on its face (pl. 43, left) to the fine pintos (pls. 44, 45) who aid in successful feats of military prowess.

The Crow horse in plate 44 (left) is deftly captured by the artist in an abruptly halted position, his head tucked in. It is easy to imagine that if Black Hawk used such drawings to recount his youthful exploits, this portrait would have helped him recall the skillful horsemanship of his foe. Although the Crow's bullet only struck the Lakota's shield, the Crow kept his horse collected as he approached, using the pressure of his legs to engage the horse's hindquarters. By lowering his back haunches and placing his left rear hoof under the rider's center of gravity, horse works together with rider to maximum effect.[122] In plate 46, the Crow and his horse make a quick getaway from the Lakota dog soldier (perhaps because the wearers of these red cloth garments were known to be the fearless elite of the warrior societies). A connoisseur of horsemanship can see in this image that the Crow is really driving his horse forward, for both front feet are raised up off the ground. The animal's right hind leg is stretched far forward, revealing him to be an athletic horse, probably known for his speed and maneuverability.[123]

Black Hawk depicts many fine Lakota horses. He has taken exceptional care in drawing the portrait of one particular horse (pls. 43, 47). This may be a horse with long, curly hair (see discussion on p. 84); or the artist may be trying to depict the intermixed dark and light hairs of a roan (a chestnut red coat with white hairs in it).

This horse may have been considered particularly handsome, with four white stockings evenly matched, a rare occurrence.[124] The horse has a white blaze on her face; she also appears in a simple portrait study, where her tail hangs loose, and her mane is decorated with feathers to honor her prowess in war (see pl. 18). Even when a Lakota warhorse is acting up, Black Hawk shows that a skillful rider can prevail. The white horse in plate 48 has her nose in the air, a position that allows her to evade the action of the bit. Yet the Lakota rider successfully shoots the Crow in the torso, despite the antics of the Lakota's mount.

Two drawings depict horses that have been painted for war. One is a white horse painted front and rear with lightning bolts and with red spots meant to indicate hail (pl. 49). The other has yellow lightning bolts running down its legs (pl. 50). Men of all Plains tribes painted their horses with apotropaic designs for battle. Dragonflies, hail, and lightning bolts were thought to be especially effective visual metaphors for the speed, elusive grace, and devastating power of a fine warhorse.[125]

Just as Black Hawk summons up a convincing portrait of each horse, so, too, is every Lakota and his Crow adversary depicted with great care and immediacy. Some Lakota are identified by their distinctive painted shields, others by their garb. To protect themselves in combat from arrows, men carried rounds of tough buffalo hide with its durable construction as well as spiritual potency. Often painted with sacred dream imagery, these shields would have been immediately recognizable to a man's peers as his identifiable property. A few Lakota shields are well known, like No Two Horn's image of a raptor with outstretched wings and talons.[126] Black Hawk is clearly identifying individual warriors by means of their

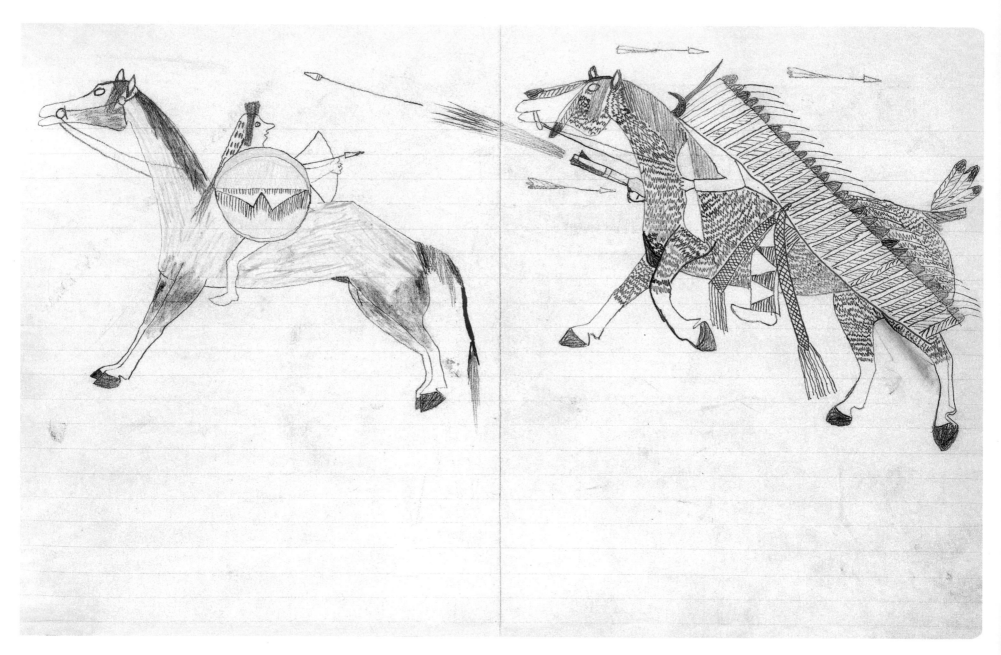

PLATE 43

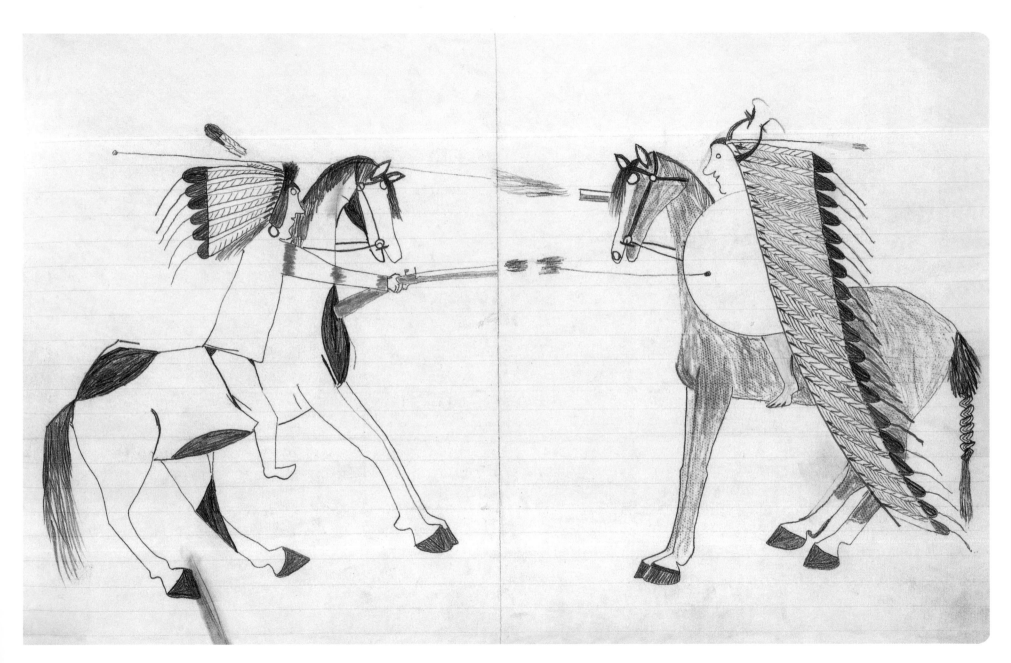

PLATE 44

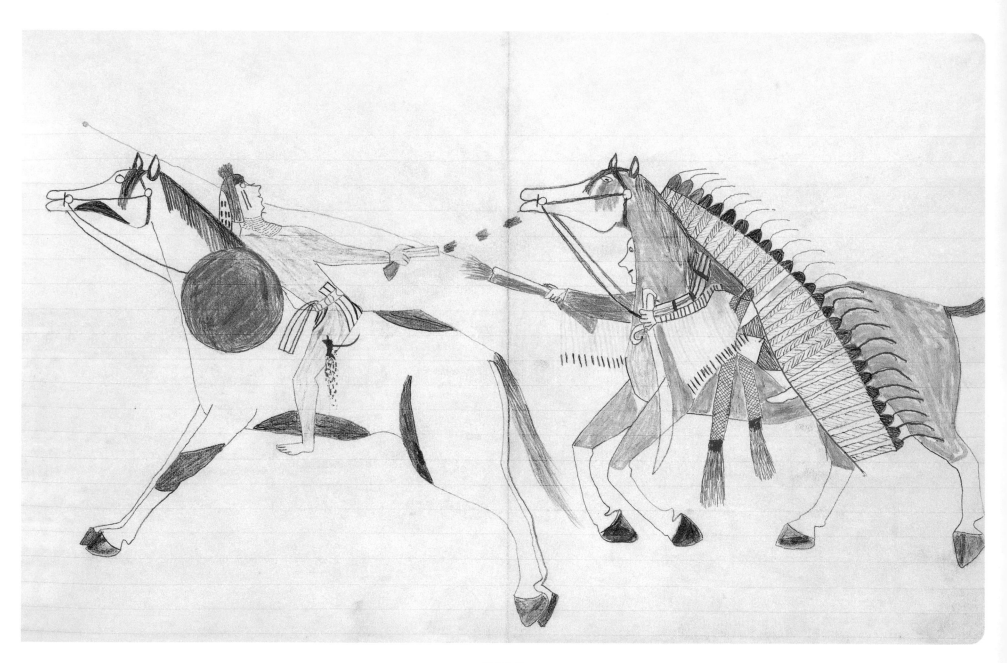

PLATE 45

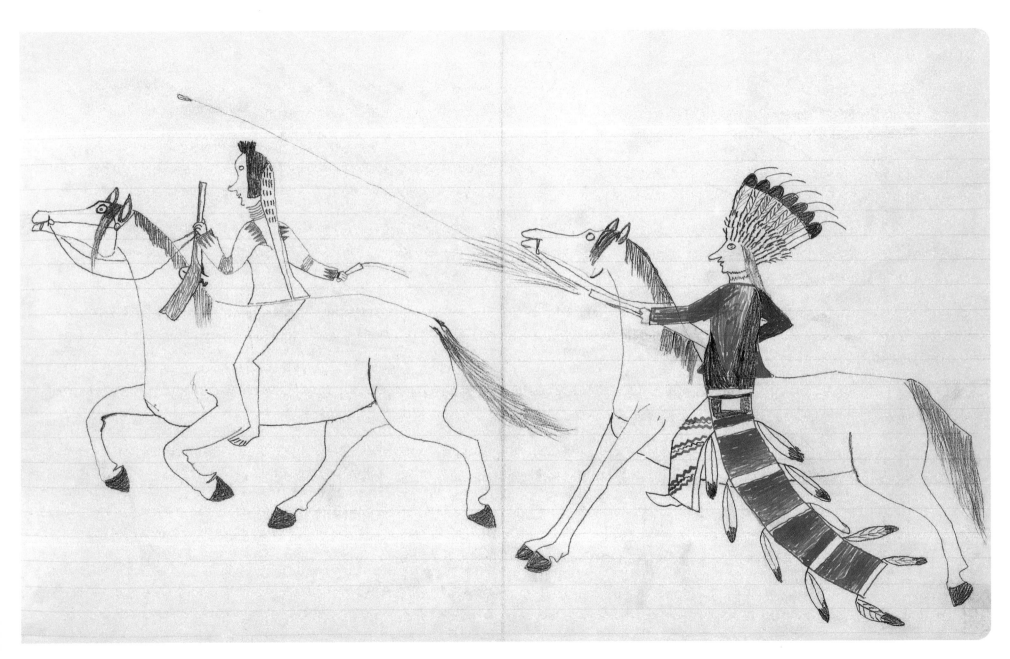

PLATE 46

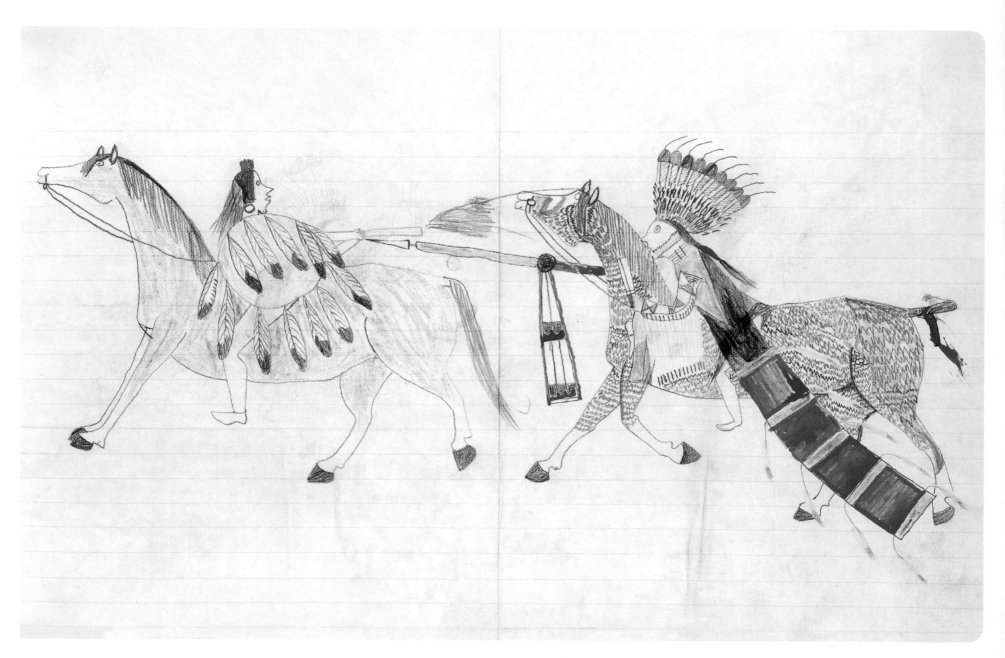

PLATE 47

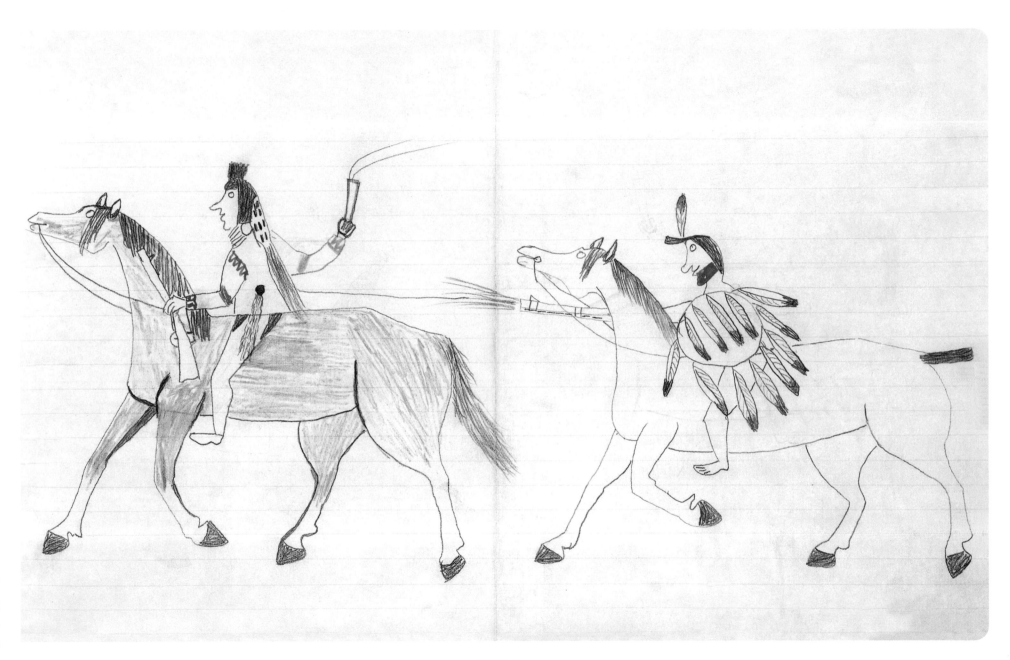

PLATE 48

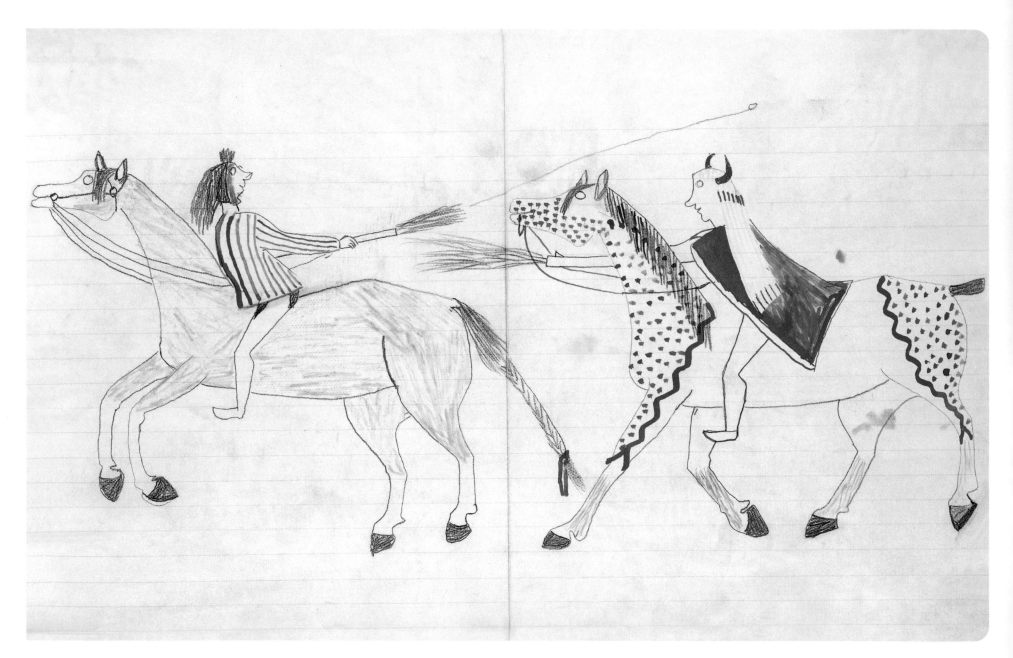

PLATE 49

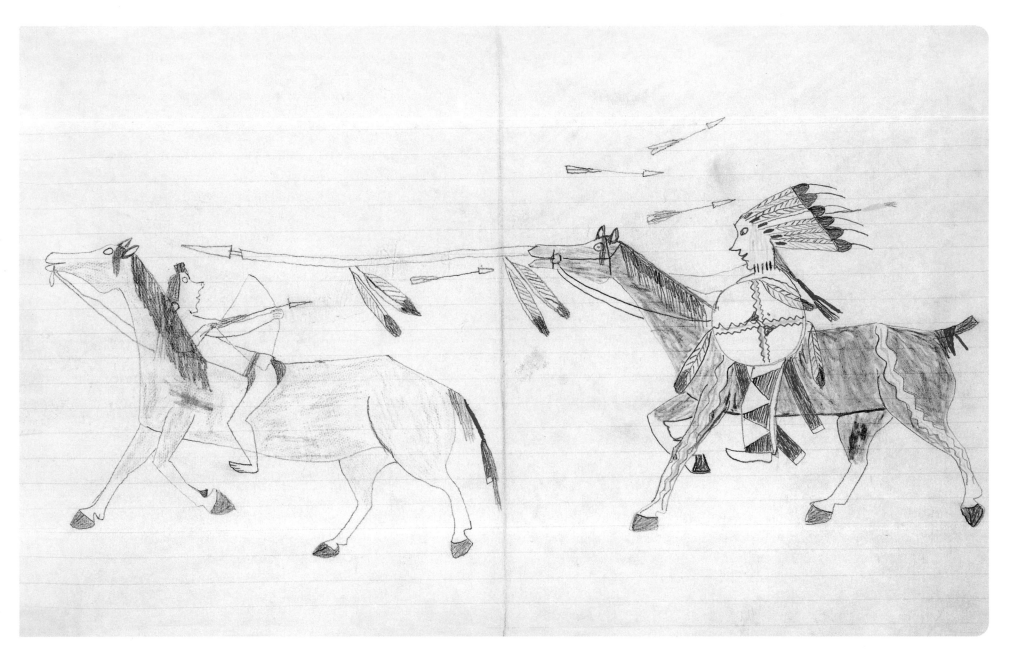

PLATE 50

shields, but, to my knowledge, no one has as yet conducted the thorough archival work that would allow us to recognize the artist's identifications.[127]

The charging bear on one shield (pl. 51) combined with the bear-claw ankle ornaments worn by this Lakota warrior shows that he draws his fierce powers of attack from the grizzly bear.[128] Others carry the morning star (pl. 39) or a bighorn sheep (pl. 52). Buffalo imagery ornaments two other shields (pls. 40, 53). The first one is painted in the colors of the four directions, with buffalo hoofprints approaching from each quadrant. A Lakota shield in the National Museum of the American Indian depicts buffalo hoofs emerging from four directions, but painted on a yellow ground.[129]

Lakota men's headgear in the warfare drawings ranges from a simple feather ornamenting a topknot (pls. 48, 52) to a full eagle-feather headdress (pl. 45), sometimes shown with the split horns of a buffalo at the crown (pls. 43, 44). Such finery was the prerogative of the most high-ranking warriors, those with many military honors. About one Lakota chief's feather bonnet, Stanley Vestal wrote, "White Bull wore it for its beauty. If he were to be killed, he wished to die in these fine war clothes." Moreover, such garments "made a man more courageous."[130] One man wears a split buffalo-horn head-dress adorned with long tassels of ermine fur (pl. 49). Another man in an eagle-feather headdress (pl. 45) wears an elegant war shirt adorned with ermine fringe down both arms, like those worn by Crow men on the left in plates 30 and 31. Among the Lakota, such war shirts more commonly had human-hair fringe (either from enemy scalps or from the hair of relatives, willingly given to orna-ment the shirt of a beloved warrior; see fig. 2).[131] Not to be outdone by all of this indigenous finery, one man wears a jaunty Euro-

American-style felt top hat, with two feathers attached (pl. 54). His sartorial modernity is further emphasized by the bold red-and-white striped tailored shirt he sports atop his beaded leggings.

Among the specialized war attire that Black Hawk illustrates is the distinctive red sash and the owl- and eagle-feather headdress of the Lakota *Miwatani* society (pls. 46, 47). In the headdress, the owl feathers are the shorter, red-tipped ones that surround the erect eagle feathers.[132] Members of this warrior society pledged that they would sacrifice their own lives in war to defend their comrades. The *Miwatani* society was equivalent to the Dog Soldier society found among other groups on the Plains; they, too, wore the long red cloth or hide sash that could be staked to the ground, so that the wearer would fight to his death rather than retreat.[133]

Four Lakota warriors wear red capes made of trade cloth, the undyed white selvage of the cloth clearly delineated in each instance (pls. 41, 49, 52, 55). It is not clear if this is an item of clothing associated with any particular military society; we find it in other Lakota drawings of the era. Arthur Amiotte has suggested that this may be the powerful cloth wrapping of a man's medicine bundle (*wotawe*), which individuals sometimes wore into battle for its pro-tective effect.[134] Two of these portraits of cape wearers depict the same man: in plates 41 and 55 he wears the same beaded moccasins and leggings, and an eagle-feather headdress with one yellow feather trailing behind his head. He rides different horses and shoots different weapons, however.

As all good soldiers do, Black Hawk pays careful attention to the details of weapons and their capabilities. In some cases, he depicts the long war-society lances with feathers with which a brave man could count coup on his enemy. The *Miwatani* society member in

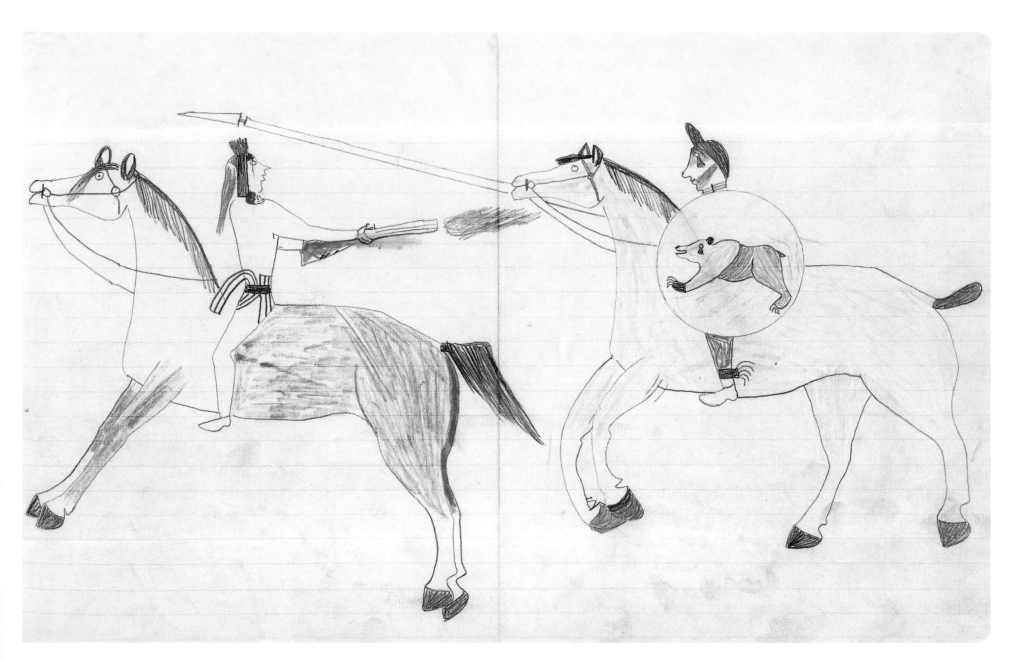

PLATE 51

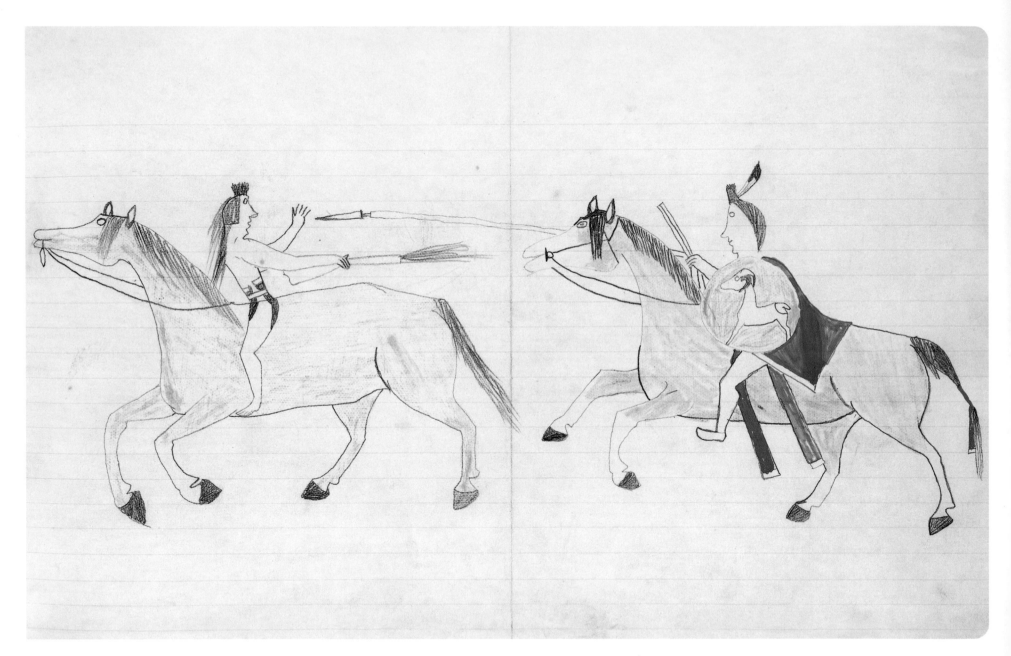

PLATE 52

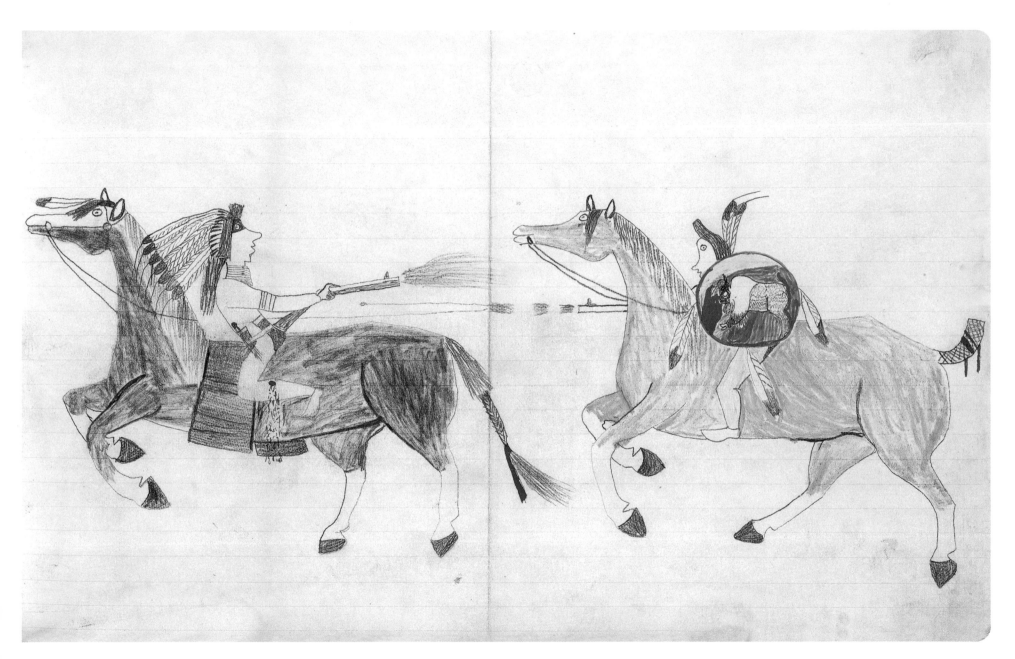

PLATE 53

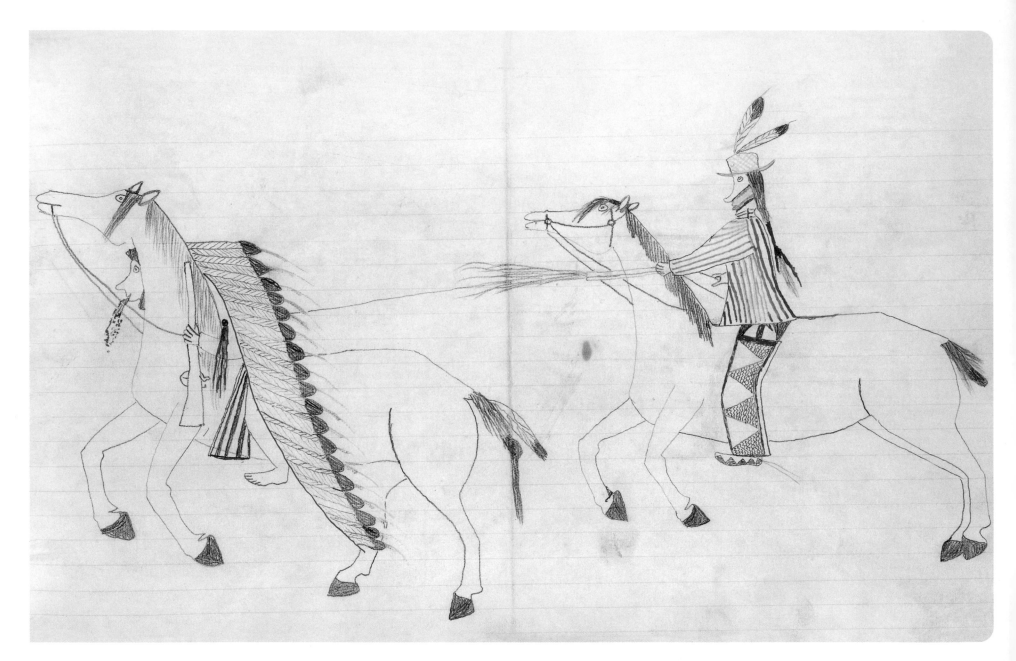

PLATE 54

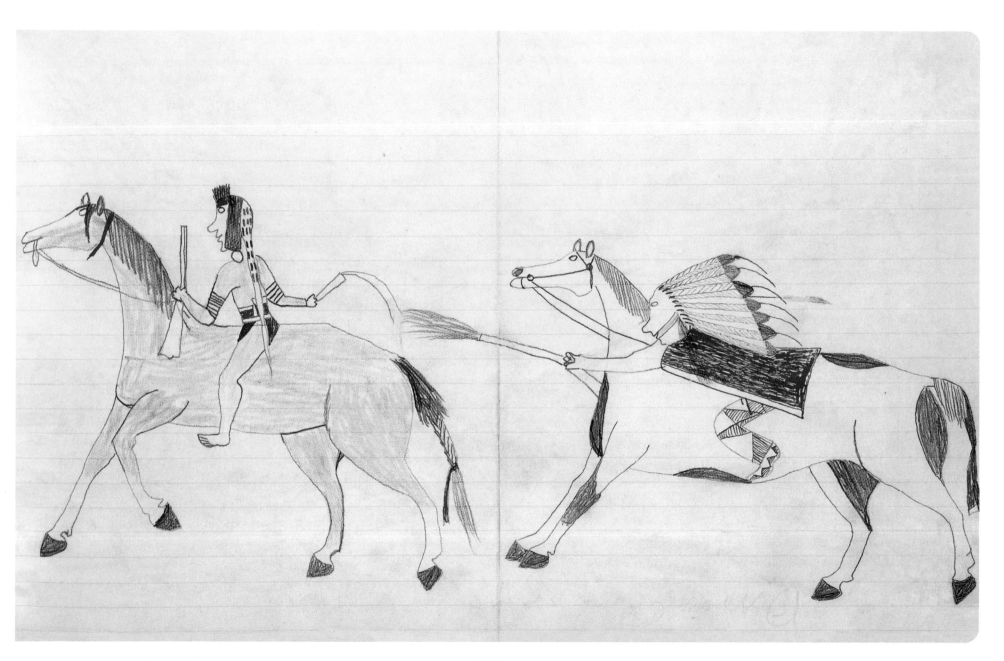

PLATE 55

plate 47 bears down upon his foe, intent on striking him with the lance, for touching an enemy and emerging unscathed was considered an act of military valor—certainly requiring more courage than simply firing a gun from a distance. Similarly, the owner of the buffalo-track shield extends his lance and strikes the shoulder of the Crow who is about to discharge his musket (pl. 40).

Black Hawk chronicles in these drawings the types of firearms available to the Lakota and the Crow in the 1860s and 1870s. Sometimes he is clearly indicating that the Lakota had better firepower. In plate 41, the Lakota on the right shoots an 1866 Winchester carbine, which uses bullets in a cartridge and can fire repeated shots before reloading, as the artist indicates by the two black discharges emitted from the barrel. His opponent, in contrast, shoots a sawed-off flintlock musket, which needs to be reloaded from the muzzle after each shot.[135] More of these muskets appear in other images (pls. 39, 40, 44, 46, 51, 53), although the artist does not take the care he usually does in showing whether a firearm could fire a single or a repeating round in plate 44, where he has mistakenly drawn two discharges emanating from the musket. Only two other Lakota have the prized Winchester seen in plate 41. In plate 43, its polished brass receiver and barrel peek out from behind the horse's chest; in plate 53, only the barrel is visible. In some instances the Lakota use the same kinds of muskets as their Crow adversaries (pls. 42, 44, 49).

The ermine-clad warrior in plate 45 successfully wounds a Crow with his musket, while the Crow ineffectually fires his Colt or Remington revolver back at him. This Lakota is not only well dressed but well armed; in addition to his musket, he clutches a U.S. cavalry saber in his left hand, along with the horse's reins. Perhaps his next act would be to count coup on the Crow, using the saber as a coup

stick. In contrast, the occasional Crow has only a bow and arrow with which to fight the more heavily armed Lakota (pls. 43, 50).

Several of the Crow hold quirts, short whips with which they encourage their horses to retreat more rapidly (pls. 46, 48, 55). Quirt handles were often made from bone or elk antler, with short, braided rawhide inserted as a whip.[136]

Black Hawk provides numerous visual clues that these are Crow enemies; foremost among them are the pompadour hairdo and hair extensions (see section above on Crow Indian ceremonialism for more details on Crow hairdos and dress). He draws one large Crow bandolier bag (pl. 42, left). He repeatedly draws the enemy wearing a white muslin shirt with red markings on it (pls. 39, 40, 42, 44, 46, 48). Of this garment, Bill Holm says, "muslin shirts with narrow, torn fringes and shoulders painted red were so characteristic of Crow war dress that their appearance in Plains warrior iconography is an almost sure indication of Crow identity."[137] Several of the Crow horsemen wear a black-and-white striped breechcloth (pls. 39, 45, 51, 54), which is also characteristic dress of Crow warriors.[138] Red Hawk's drawing of Holy Standing Buffalo making peace with a Crow (see fig. 7) shows the Crow wearing such a shirt and breechcloth.

To a knowledgeable circle of cohorts, examining these drawings even decades after the events they depict, such youthful escapades would be instantly recognizable as particular historical moments. These are not generic scenes of warfare, but specific vignettes, vividly remembered and artfully transcribed.[139] Of course, what is being commemorated here is heroism and victory. Not so much as one Lakota—nor one Lakota's horse—is wounded in these encounters. All bullets go wide of their marks. In plate 44, one bullet from a Crow's weapon hits a shield. The foes of the Lakota, in contrast, do

sustain some injuries (pls. 45, 48, 53, 54), perhaps because of the better weapons of some Lakota (the repeating Winchester rather than the muzzle-loading muskets or the bows and arrows). In this respect, the drawings do depict an idealized—if detailed—view of the past, in which all Lakota ponies are swift, all young men are brave, and none die in battle.

This stands in contrast to the more complex narratives of inter-tribal warfare depicted by some other artists, in which mortal injury is a regular consequence of the warrior's life. Bad Heart Bull, for example, devotes fully one-quarter of his book of more than four hundred drawings to Lakota-Crow warfare. As Helen Blish commented, he portrays Crow victories "with no less vigor than their defeat." In fact, in many instances, the Crow are "seeing the backs" of the retreating Lakota.[140] Unlike the relatively simple compositions favored by Black Hawk, in which combat is a one-on-one encounter, Bad Heart Bull's militaristic compositions are often astonishingly complex, including profile, frontal, and rear views of subjects, and grand panoramas with dozens of figures.[141]

Riding in war parties against human enemies and embarking upon a hunting expedition against powerful animals were analogous activities in the minds of Plains Indian men. In Cheyenne drawings, for example, certain pictorial conventions applied to both hunting and warfare. Eighty-four percent of the time, the Cheyenne hunter or warrior is depicted on the right side of the picture, riding in from the right, toward the center of the space.[142] This holds true for the great majority of Lakota drawings as well. In fact, in his drawings of warfare, 100 percent of the time Black Hawk depicts the Lakota protagonist on the right side of the page, facing the center, his adversary or adversaries on the left. Similarly, in his hunting scenes, the mounted hunters all ride in from the right, and all action proceeds toward the left. In Black Hawk's oeuvre, the sole object of the hunt is the buffalo. He shows no other animals as prey, despite the fact that the genre of Plains drawings is replete with hunting scenes involving antelope, bear, wild turkeys, and other animals.[143]

The largest land mammal in North America, weighing up to eighteen hundred pounds, the buffalo (or bison, as it is more properly called) was a challenge to even an experienced hunter trained in the nerve-racking art of riding alongside a stampeding herd of enormous, strong-smelling animals. In the nineteenth century, the buffalo hunt was central to life on the Great Plains. At least until the 1850s, bison were too numerous to count, and Lakota people could rely upon this multipurpose animal for much of their subsistence needs. Moreover, buffalo hide was a valuable currency in the trading partnerships undertaken to obtain guns, cloth, metal tools, beads, and other necessary items of foreign manufacture.

Numerous eyewitness accounts try to describe the vastness of mid-nineteenth-century buffalo herds:

> Soon we saw a cloud of dust rising in the east, and the rumbling grew louder and I think it was about half an hour when the front of the herd came fairly into view. The edge of the herd nearest us was one-half to three-quarters of a mile away. From an observation with our field glasses, we judged the herd to be 5 or 6 (some said 8 or 10) miles wide, and the herd was more than an hour passing us at a gallop.[144]

All four of Black Hawk's hunting scenes depict a communal buffalo hunt, as it was organized in pre-reservation days, when game was plentiful and entire communities could move freely across the prairie (pls. 56, 57, 58, 59). While a man could generally hunt on his own, at certain times of the year, especially in the autumn, a

collective buffalo-hunting expedition might be mounted by an entire band of people. The camp circle would be packed up, with everyone on the move in search of a large herd grazing in an optimum place for hunting and processing the kill.

The high-ranking men of the tribe would choose four skilled young men as marshals (*akicita,* in Lakota) to manage the logistics of the hunt.[145] Each would be presented with a feathered banner and a scalp shirt (see fig. 2), as insignia of his office. But during the hunt itself, the marshals, along with the other hunters, would wear only a loincloth for ease in maneuvering, just as Black Hawk represents. The visible badge of the office of *akicita* of the buffalo hunt, worn into the hunt itself by each marshal, was a streak of black paint smeared from eye to jaw. Black Hawk clearly shows this on two hunters (pls. 56, 57), indicating to the viewer that he is depicting the organized, communal hunt. In his drawings, all of the hunters ride bareback, corroborating what Frances Densmore was told at Standing Rock Reservation during her fieldwork there from 1911 to 1914: "[T]hose who were to chase the buffalo took the saddles from their horses,"[146] presumably for greater mobility and speed.

While it might seem that the powerful repeating rifle would be the weapon of choice for hunting stampeding animals, the former warriors interviewed by both James Walker and Frances Densmore at the turn of the twentieth century were unanimous on one point: the bow and arrow (of specialized size and type) was, in fact, the most effective weapon for buffalo hunting. It was silent and so would not spook the herd; when shot from the proper angle (from slightly behind, entering the body above the flank, in the area of the chest), it provided for a clean and quick kill.[147] Some old men recalled their fathers or grandfathers using flint or bone arrowheads, but by the mid-nineteenth

century the preferred arrowhead was made of metal cut from frying pans obtained from traders or soldiers, according to the recollections of one Lakota from the Cheyenne River Sioux Reservation.[148]

In two drawings (pls. 58, 59), Black Hawk shows hunters pursuing individual buffalo, some of whom have blood issuing from their mouths, indicating that they have been hit. One has fallen to the ground, its head raised as it bellows in pain. A hunter would leave such an animal behind while he pursued other prey. Upon retracing his tracks, he could tell which bison he had hit by the idiosyncratic design and choice of feathers on his arrows. In two other scenes (pls. 56, 57), men ride beside a cluster of buffalo. Not all the animal heads are visible, but the movement of legs and bodies provides a strong, rhythmic pattern across the page. The artist has delineated the distinctive pelage of the bison: the shaggy brown "cape" that covers the hump and forequarters, and the shorter, darker hair on the slimmer rear quarters.

In the aftermath of a communal hunt, women would move in, their knives sharpened for skinning and butchering. They would load the hides, meat, and other parts onto packhorses and travois to return to camp where processing, feasting, and celebrations would commence. Almost every bit of the buffalo had a use in the indigenous household. James Walker expressed it most succinctly:

> They used every part of these animals for some purpose: their hair for making ropes and pads and for ornamental and ceremonial purpose; the horns and hoofs for making implements and utensils; the bones for making soup and articles to be used in their various occupations and games; the sinews for making their sewing thread and their stronger cords such as bowstrings; the skins for making robes, tipis, clothing, regalia, thongs, and such other purposes as

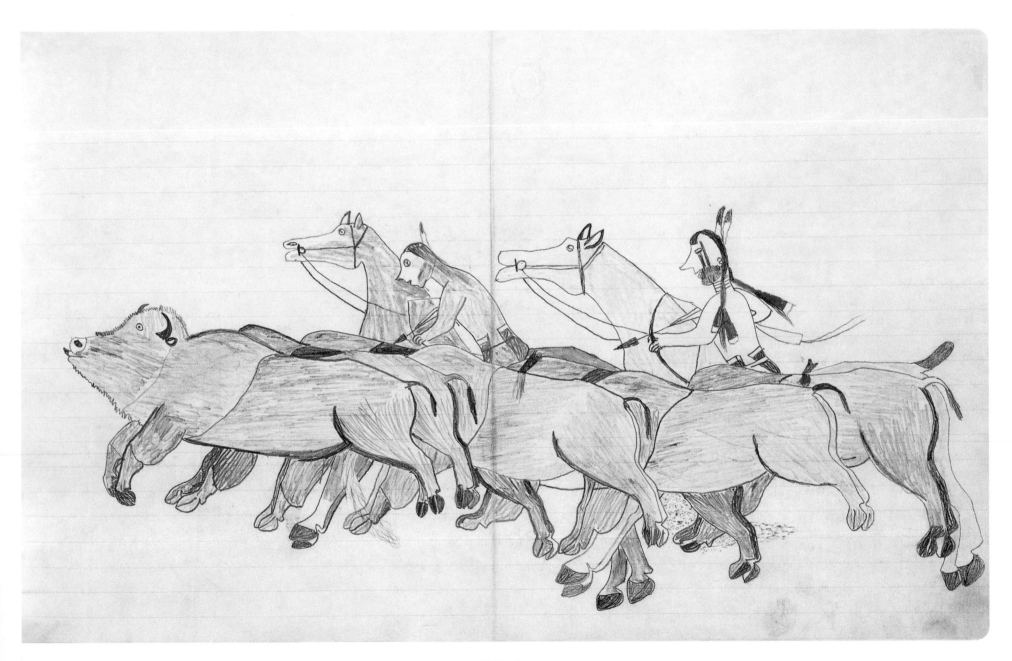

PLATE 56

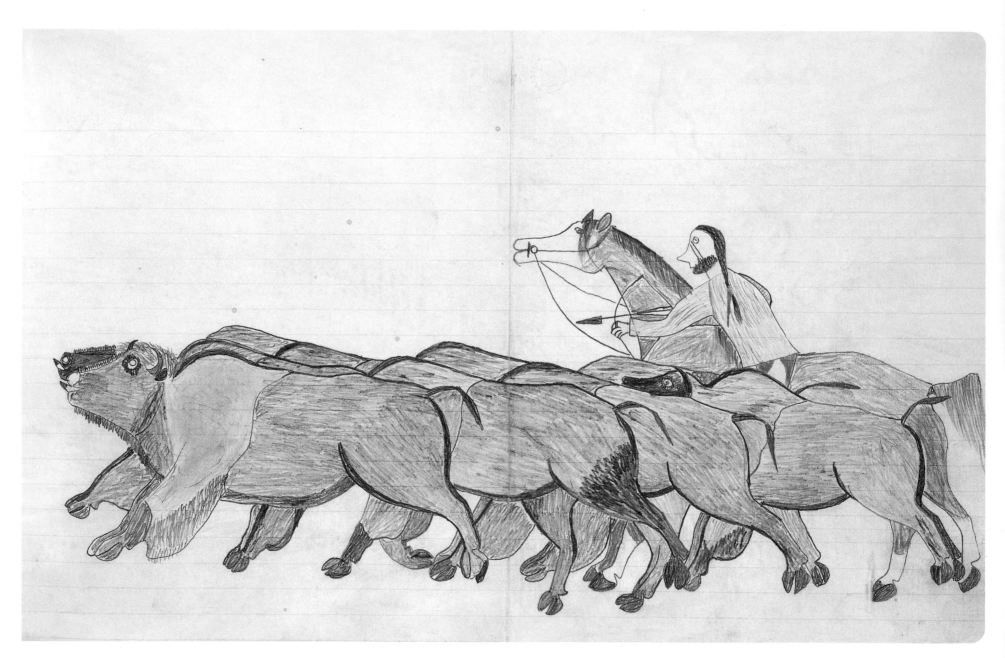

PLATE 57

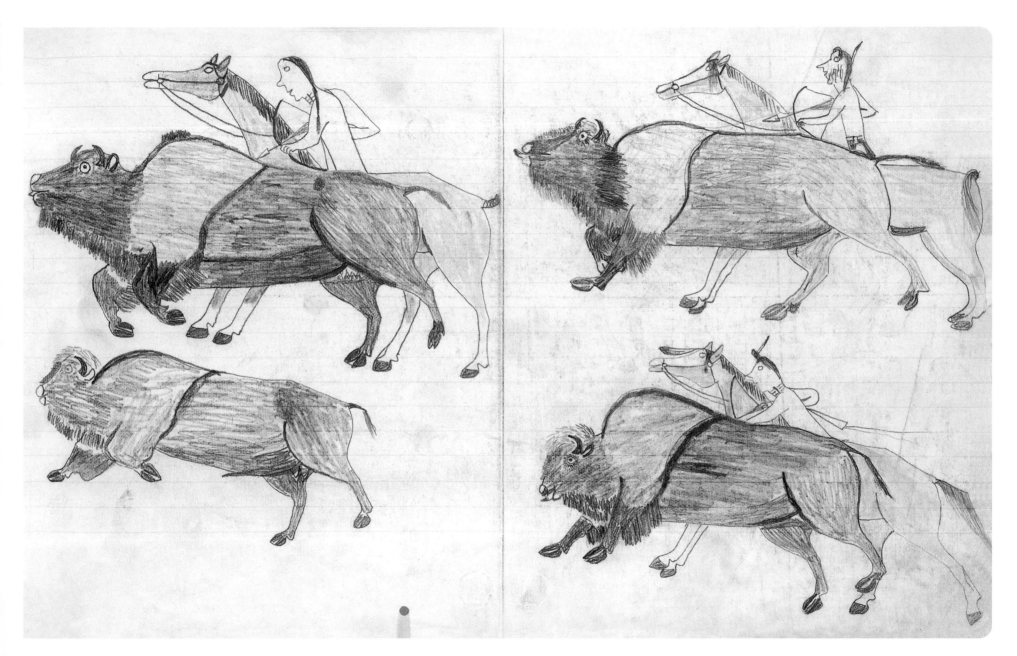

PLATE 58

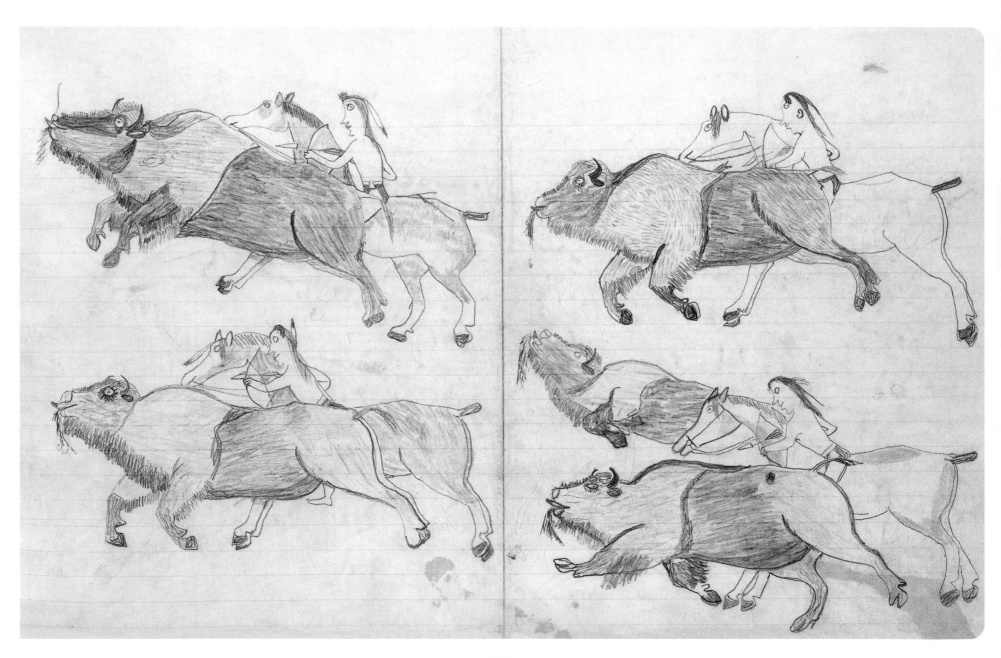

PLATE 59

required a strong, flexible, and tough material such as leather or like material is used for among the civilized peoples; the flesh and viscera for food; and the skull, as it was believed to be the place of abode of the spirit of the animal (which was intimately related to the supernatural being who presided over the chase and domestic affairs and which remained about the skull until it was swallowed by the earth) was regarded as *wakan* and was used to retain the spirit near at hand that it might act as an intermediary in invoking the aid of the supernatural being it was related to.[149]

Just as Walker indicates, the buffalo skull was an important item used in ceremony—both in the Sun Dance and on personal altars. In other drawings previously discussed (see pls. 10, 11, 12, 13), Black Hawk depicted the ceremonial act of propitiating the buffalo spirit by donning its head and skin and transforming oneself into a buffalo.

Natural History Drawings

Taku Wakan is all that is mysterious. It means all things mysterious taken together. To invoke Taku Wakan is to invoke all the spirits, but especially the mightier spirits. All beasts are wakan. These beasts are especially wakan: buffalo, horses, elks, wolves, weasels, bears, mountain lions, prairie dogs, ferrets, foxes, beavers, otters.

—George Sword and others[150]

My father always told me, "All wild animals have power, because Wakan Tanka dwells in all of them, even in a tiny ant. The white man has built a wall between himself and that power. To understand what the animals are telling us needs time and patience, and the white man never has time. Yes,

there is power in every wild animal, but none in those that are human-bred. There is great power in a Buffalo, but there is none in a Holstein or a Hereford. There is power in a Wolf or a Grouse, but not in a chicken or a poodle.

—Archie Fire Lame Deer[151]

ONE OF THE DEFINING MYTHS of European and Euro-American culture has long been that the spirit of scientific inquiry distinguishes the European mind and European intellectual history from other races. Yet various indigenous peoples of the Americas excelled in naked-eye astronomy, in mathematics and engineering, in ethnozoology, and in selective cultivation of plants to enhance particular properties.[152] Non-Natives also tend to think of indigenous peoples as having a purely instrumental view of the natural world. The many Plains Indian drawings of hunting scenes, for example, might suggest that Indian peoples focused only on the practical uses of game animals. Yet as some of the drawings of ceremonial life discussed earlier reveal, animals may also be conduits to the world of spiritual power (see, for example, pls. 12, 16).

A small number of drawings clearly demonstrate a third type of interest in animals, one that seems to approximate the spirit of scientific inquiry found in European and American natural history illustration of the eighteenth and nineteenth centuries. On the Great Plains, such drawings seem overwhelmingly to have been made by Lakota artists; I know of few other natural history studies of animals, in their habitat, that are not being hunted or utilized in any way.[153]

It is impossible to know if an interest in producing natural history drawings was engendered among Native artists by having seen European or Euro-American naturalists at work, but a few tantalizing hints suggest at least a confluence of interest, if not an

influence. In 1843, John James Audubon set out upon what was to be his last trip, a voyage up the Missouri River to Fort Union. In one letter home, Audubon wrote that some Indians had been invited on board the steamer to look at his drawings of quadrupeds:

> They came and saw, and the effect was beyond belief surprising.—One of the women actually ran off at the sight of the Wood Chuck exclaiming that they were alive. The chiefs knew all of the animals except the Little Squirrels from the Oregon. Their signs were most significant, and the interpreter told us of their delight and amasement [*sic*].[154]

While Audubon does not mention the tribal affiliations of the Indians, the journal of his companion, Edward Harris, notes that four of them were Sioux.[155]

The Swiss artist Rudolph Kurz, who lived at Fort Union in 1851–52 and kept a journal of his experiences, often mentions the Natives' regard for his drawings, and his own interest in drawing accurate life studies of animals as well as Indians. Perhaps some of the Indians who studied Kurz's efforts subsequently attempted their own life studies of animals.[156]

Of Black Hawk's oeuvre of seventy-six drawings, more than 20 percent are natural history studies. In seventeen drawings, he depicts forty-nine individual animals of at least fifteen different types. All are mammalian and avian species that were, in Black Hawk's day, a familiar site on the Northern Plains: elk, mountain sheep, sandhill cranes, owls, bats, bears, pronghorn antelope, mountain lions, porcupines, and others. While insects and snakes appear in some of his ceremonial scenes—see, for example, plates 10, 13, and 16—none of these creatures are found in the natural history studies. In some of Black Hawk's drawings, the poses (frontal and side views,

as in his studies of wild cats, pls. 72, 73) or the inclusion of both male and female of the species (as in his studies of elk, bighorn sheep, and deer, pls. 62, 63, 67) suggests that Black Hawk might have seen encyclopedias or natural history illustrations of some kind, perhaps at the trading post, missionary's office, or schoolhouse.

As anthropologist William Powers has demonstrated, the Lakota have a system for classifying the natural world according to certain well-ordered principles, in which animals are related hierarchically in a manner analogous to Linnaean taxonomy.[157] Behavior as much as morphology serves as the diagnostic feature of the Lakota classificatory system (unlike the Linnaean system, in which morphological characteristics are paramount). Powers points out that by linking behaviors, the Lakota create larger categories of interrelated species. This then provides a bridge between the realms of science and religion, which the Western world has demarcated as separate. Interspecies relationships are important for ceremonial practice, as we have seen in the discussion of Elk, Deer, and Buffalo Dancers (see pp. 45–57). Moreover, animals that have distinctive biological traits (like the bugling and rutting of the male elk) or that traverse separate spatial domains (like the owl, which moves between earth and sky) have powers that humans can endeavor to tap into. What French anthropologist Claude Lévi-Strauss termed "the science of the concrete" is at work here. Mythic thought, he tells us, is capable of generalizing in a scientific way; it, too, works by analogies and comparisons.[158]

Aaron McGaffey Beede, an Episcopal missionary to the Lakota in the first two decades of the twentieth century, as well as an avid student of ethnology, remarked several times upon the pronounced scientific attitude of the Lakota. His understanding of this

was unusual for a Euro-American of his era. In his unpublished field notes he remarked:

> Indians I have met, including especially the Western Sioux, have the scientific attitude pronouncedly. They assume, without supposing that anyone disagreed with them, that:
>
> a) certain nature processes give rise to all phenomena, including human beings, animals and birds, plants and trees, brooks, clouds, etc. with the customs and habits of all beings, as individuals or in groups.
>
> b) that such nature processes may become, and actually do become more and more known with the increasing intelligence of men and other beings (especially some species of animals).
>
> c) that such nature processes may be, and with increasing intelligence actually are more and more controlled by the intelligent beings who come into contact with them.
>
> d) that by such control of nature processes, they may, more and more, be made a means or mainspring of what is progressive, in the individual and the group and the nation and the race.[159]

I shall examine each subject of Black Hawk's natural history drawings briefly, before concluding with further remarks on Lakota ethnoscience.

Elk (pls. 60, 61, 62; 63, left). The North American elk (*Cervus elaphus*) is sometimes called the *wapiti,* a Shawnee Indian word, to distinguish it from the European red deer or elk. Centuries ago, it roamed throughout North America; today, herds of wapiti live mainly in the Rocky Mountain states and provinces. Black Hawk drew four studies of elk. Two of these (pls. 62; 63, left) depict male and female pairs. The larger male is distinguished by his rack of antlers and his shaggier, darker throat-mane. Both male and female have the characteristic tricolor pelage: a dark brown to black head, neck, and lower legs, grayish-red body, and cream to buff-colored rump,[160] all of which Black Hawk has drawn with great accuracy.

In early autumn, the dominant bull elk rounds up his harem of cows and mates with them repeatedly. Males vying for dominance conduct rutting battles with each other in which they clash antlers, sometimes even leading to fractured skulls and broken necks.[161] Black Hawk does not picture this conflict, but he does show two bull elk with their heads raised, engaging in the distinctive bugling that takes place during autumn rutting season (pl. 60). This bugling or yodeling has been described as "a low, throat-clearing tremolo stretched into a taut alto, wavering up to a soprano vibrato and sustaining, then trailing off rapidly in pitch and volume like a cry carried away on the wind; the finale is a staccato triad of sharp coughs."[162] The Lakota artist Sinte also drew a fine, naturalistic study of elk and the power of the bugling male elk over his cow (see fig. 6).

In plate 61, Black Hawk depicts another characteristic behavior of the wapiti bull: de-velveting the antlers. Elk shed their bonelike antlers each spring, growing an even larger set by autumn. The developing antlers are covered with a fuzzy, living tissue called velvet that, as it finishes its job of nourishing the growing rack, begins to itch, die, and peel away. The bull helps this de-velveting process by rubbing his antlers against trees. This not only rids him of the tattered velvet, but it polishes the antlers and helps the animal learn the size and shape of his unwieldy appendages before the upcoming sparring contests.[163]

As discussed in the section on Elk Dreamers (pp. 56–57), the Lakota believe that male elk hold great power over females, so elk

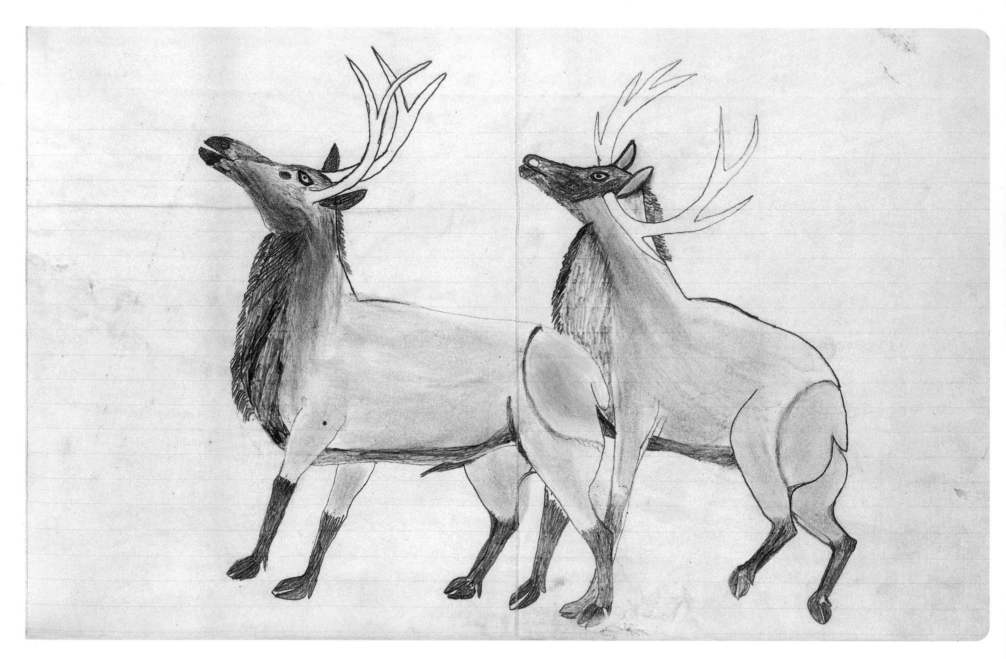

PLATE 60

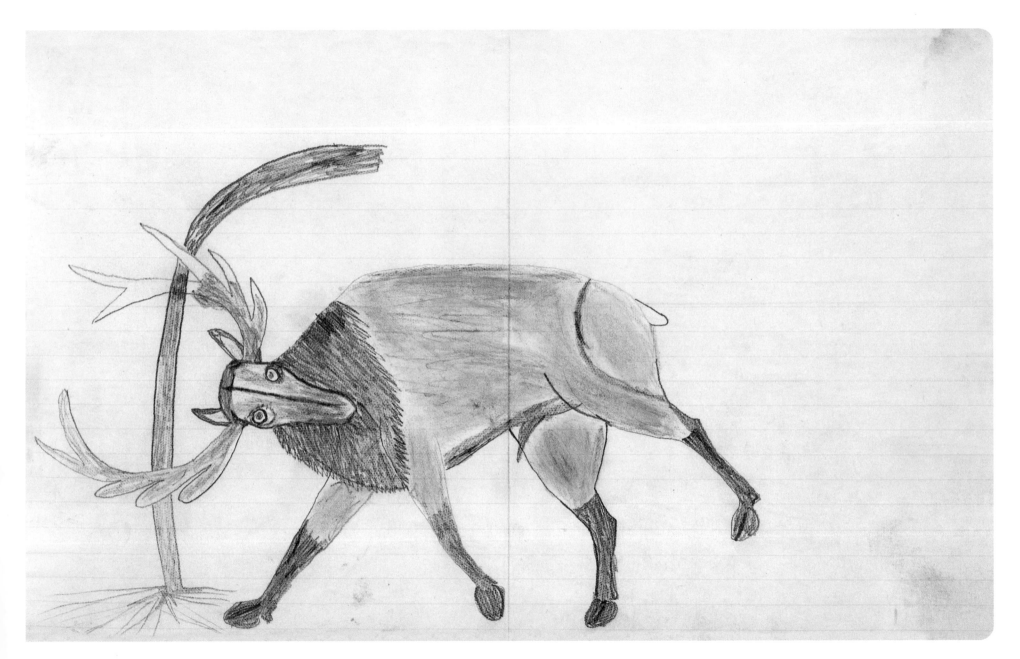

PLATE 61

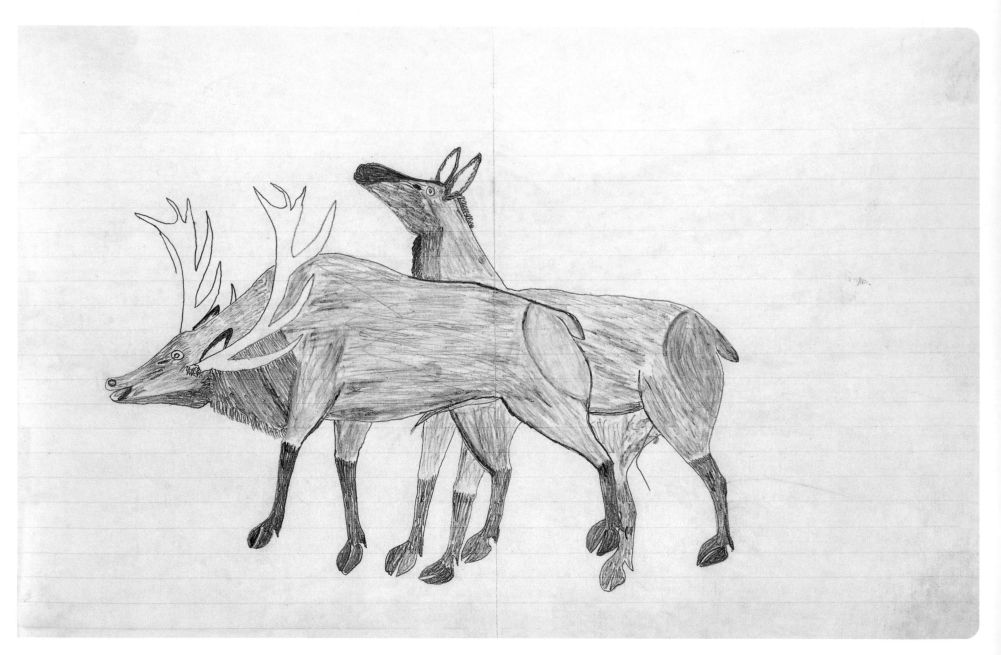

PLATE 62

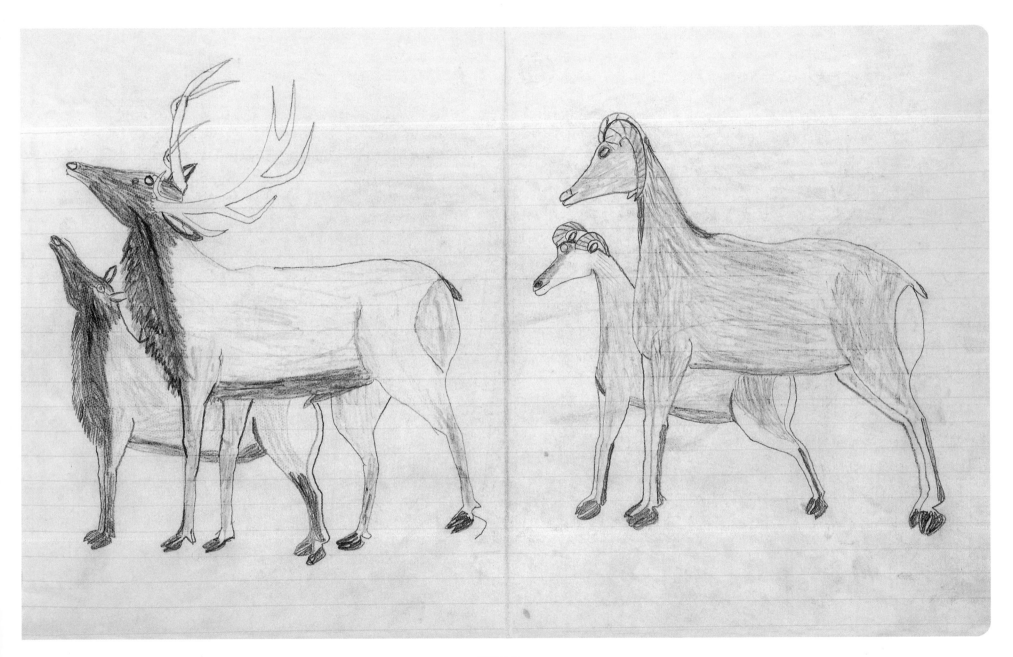

PLATE 63

medicine is prized as the love charm par excellence. Archie Fire Lame Deer wrote:

> Grandfather taught me, Hehaka, the Elk, is powerful. He rules the relationship between men and women. Hehaka is strong but gentle. He is a protector, always placing himself between his females and any danger that might threaten them. He loves beauty and speaks softly. Even though he is big and his antlers are wide, he moves through the woods without any effort. His steps are as light as a feather.[164]

One of the songs sung during the Elk Society masquerade proclaims in the voice of the bull elk, "whoever considers themselves beautiful after seeing me, has no heart."[165]

Bighorn sheep (pls. 63, right; 64, 65, 66). The bighorn sheep, sometimes called mountain sheep (*Ovis canadensis*), is a large, powerful animal, limited today to a range in the American and Canadian Rockies. But one subspecies, the Audubon Bighorn, extinct since the beginning of the twentieth century, was once widespread in the rugged badlands of eastern Montana, Wyoming, Nebraska, and the Dakotas.[166] Black Hawk places two scenes of bighorns in rocky escarpments characteristic of the Badlands and the Black Hills of South Dakota (pls. 65, 66), where he probably observed these animals.

Both male and female of the species have the characteristic curved horns. Unlike antlers, which are shed and renewed annually, these are true horns, growing larger each year and exhibiting annual growth rings. The ewe's horns are smaller and less impressive than the ram's, just as Black Hawk depicts in plate 63 (right), where he has drawn a male and female pair of bighorns next to a similar pair of elk. Like elk, bighorn sheep go through an autumn rutting ritual in which males vie for dominance through horn-butting contests.

Black Hawk indicates the subtle golden brown color sometimes observed in the horns, the characteristic white rump, and the distinctive two-part hoof of the bighorn. The artist models his figures into three-dimensional form by manipulating his graphite pencil: he intensifies the pressure of the pencil to make it darker, and rubs it with his finger to produce different shades of gray. This is especially evident in plates 64 and 66.

Like most Lakota artists of his era, Black Hawk evinces little interest in landscape or in placing figures within a landscape.[167] The studies of bighorns in plates 65 and 66 are notable exceptions. Perhaps because these animals were limited to a particular habitat (unlike the wider-ranging animals in most of his natural history studies), the artist felt the need to illustrate their unusual terrain. A bighorn sheep also appears in plate 52, where Black Hawk emblazoned one on the shield of a Lakota warrior riding into battle. These depictions of bighorn sheep are among the few found in nineteenth-century Plains Indian art.[168]

Deer (pl. 67). Black Hawk depicted two varieties of deer on one page. On the left are a white-tailed deer buck and doe (*Odocoileus virginianus*) with their young spotted fawn. White-tailed deer raise their characteristic long, bushy tails to flash the white underside when they are fleeing from danger.[169] On the right, Black Hawk depicts male and female of the variety of mule deer known as the black-tailed deer (*O. hemionus columbianus*). In addition to the small, black-tipped tail shown in this image, these deer have characteristically large ears (hence the name *mule deer*), but the artist has not accentuated the ears in this drawing.

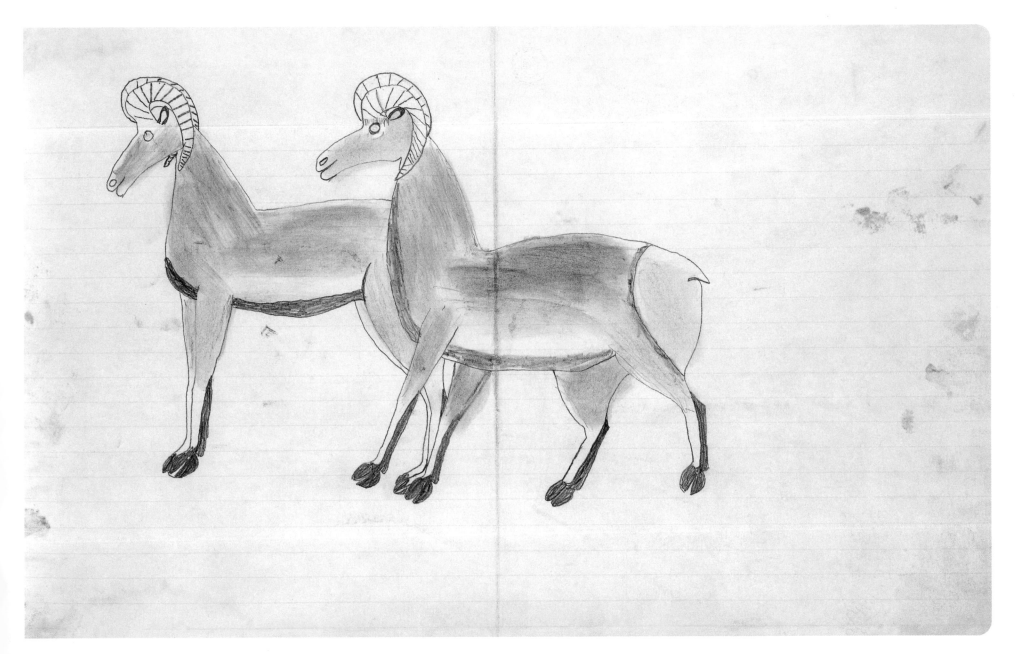

PLATE 64

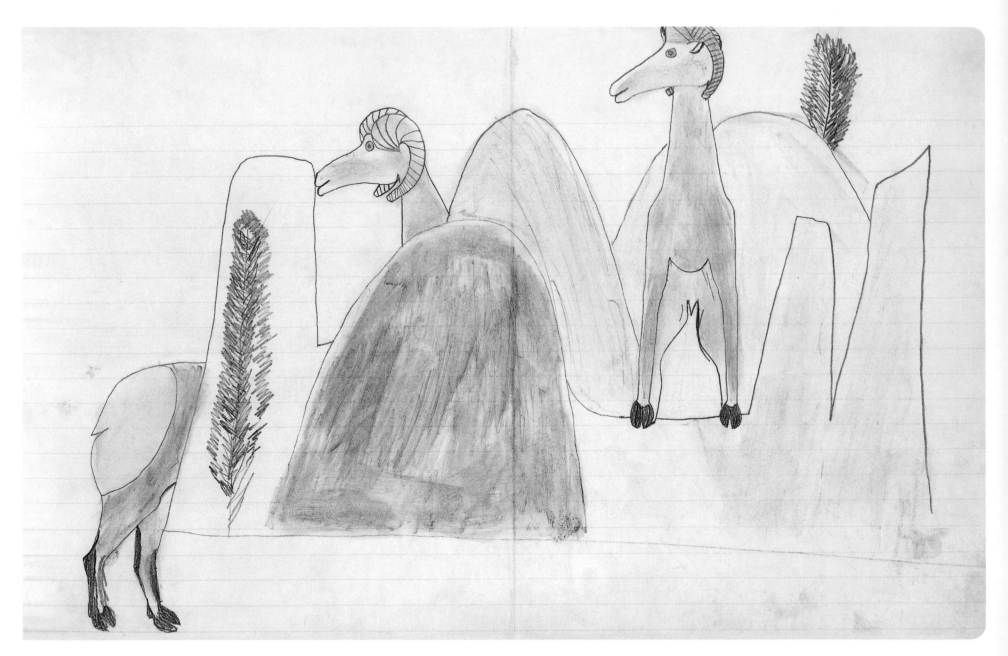

PLATE 65

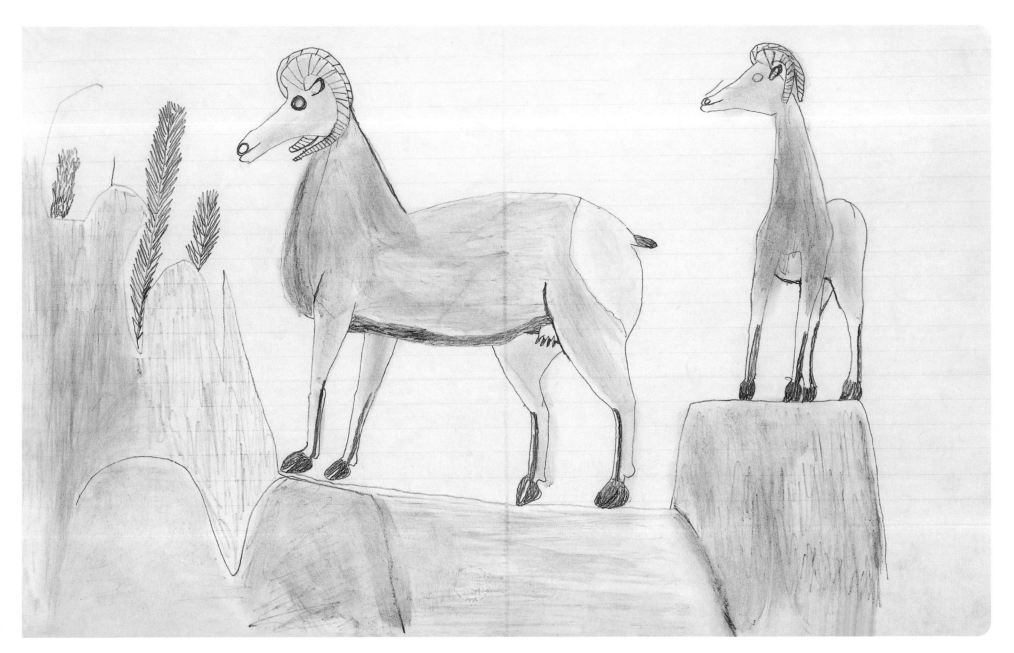

PLATE 66

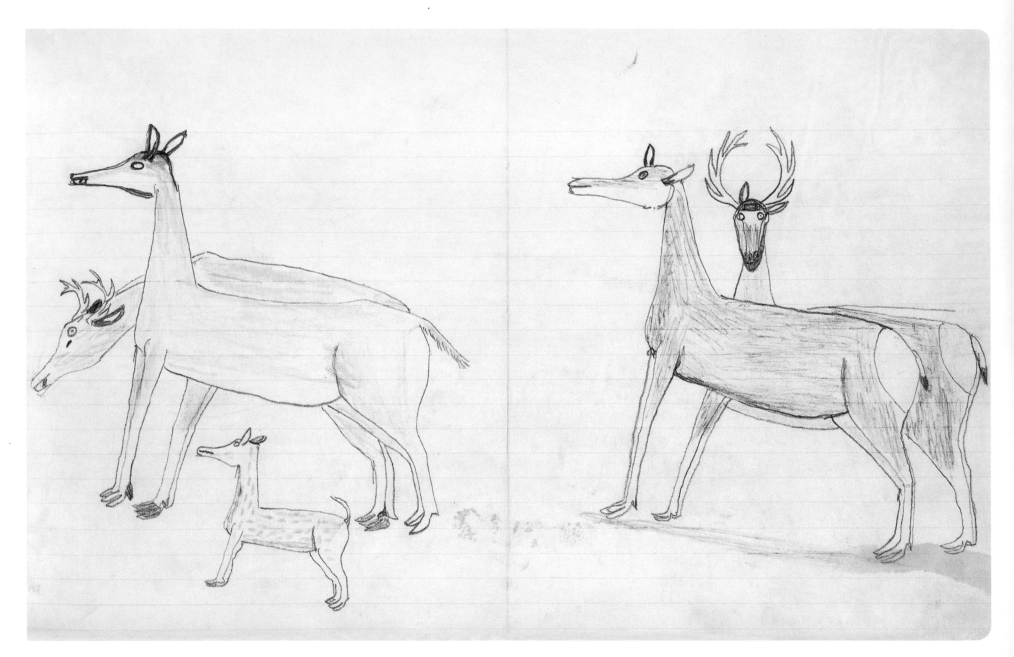

PLATE 67

Lakota consider both white-tailed and black-tailed deer *wakan* (sacred). Accounts differ as to whether the Lakota supernatural figure, Double Woman, transforms herself into a white-tailed or a black-tailed deer, but both animals are said to have the power to derange males of the human species.[170]

Pronghorn antelope (pl. 68, left). Black Hawk depicts just one example of the elegant pronghorn (*Antilocapra americana*), which is not a true antelope, but a distinctive genus that has persisted in North America for more than a million years.[171] Like the bighorn sheep, pronghorns—both male and female—have true horns. In this species, the outer sheath of the horn is shed annually, but the core remains. Male animals feature larger, more elaborate horns than females.

Black Hawk dispenses with his usual naturalism in coloration here, using a pink pencil to describe the coat pattern of the animal. He does, however, accurately depict its markings: white underparts and rump, white and dark banding on the neck, and the black patches on jaw and eye that are the distinguishing sex characteristics of the buck.[172] At the beginning of the twentieth century, George Bird Grinnell wrote, "Few people today realize that in old times the antelope in their range were probably more abundant than the buffalo. They were found in vast numbers over all the plains, but because of their small size and inconspicuous coloring, they did not impress those who saw them as did the black herds of the larger animals."[173] Many Plains Indian drawings depict these elegant creatures, usually in herds that were being hunted.[174]

Black bear (pls. 68, right; 69). Black Hawk's oeuvre contains three studies of the black bear (*Ursus americanus*), each capturing accurately the bear's shaggy, lumbering form. In plate 68, it is not clear if he intends the bear to be stalking the antelope or if these are simply two animal studies occupying the same page. The artist has taken exceptional care in depicting the coloration of the two bears in plate 69, carefully shading and highlighting around the edges of the limbs to provide a rudimentary chiaroscuro. The heads, upper backs, and shoulders of both bears are a medium brown, while the hindquarters and lower legs are black. In the seated, splayed-leg bear, the artist shows the pinkish skin visible around the genital area. As the images so accurately indicate, the so-called black bear is not always entirely black. Its coloration can range to shades of chocolate, cinnamon, and beige.[175]

The black bear has five curved claws on each foot, allowing the animal to climb trees easily. Black Hawk took considerable care in drawing each claw. Such claws, used in necklaces and amulets, were thought to contain the power of *Mato,* as the Lakota called the bear. In one of his battle scenes (see pl. 51), Black Hawk depicts a Lakota warrior wearing bear-claw anklets and carrying a shield painted with a charging bear. Although almost unknown on the Plains today, in the nineteenth century bears were common in this region and were much feared and respected by the Lakota. A man named Short Feather told James Walker:

> The Bear is the friend of the Great Spirit. He is very wise. He taught the shaman the secrets of the ceremonies. He teaches the medicine men about the medicines and the songs that they should sing.
>
> He is a spirit that comes to the shaman when the shaman seeks a vision. When a man sees the Bear in a vision, that man must become a medicine man.[176]

The reason bears are so profoundly connected with medicine and healing is further elucidated by Siyaka, who told Frances Densmore:

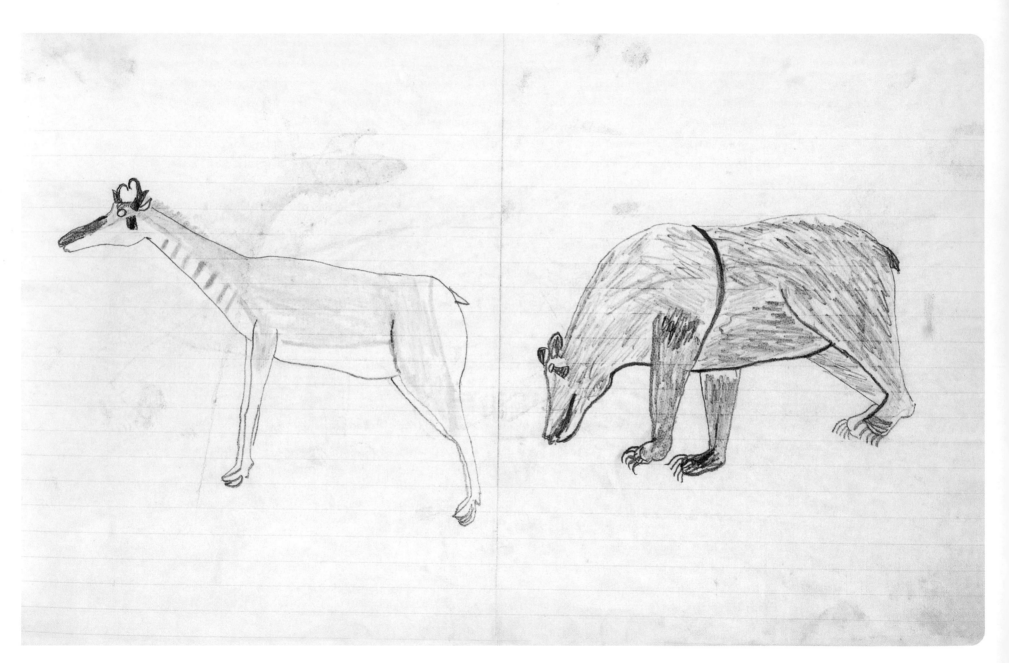

PLATE 68

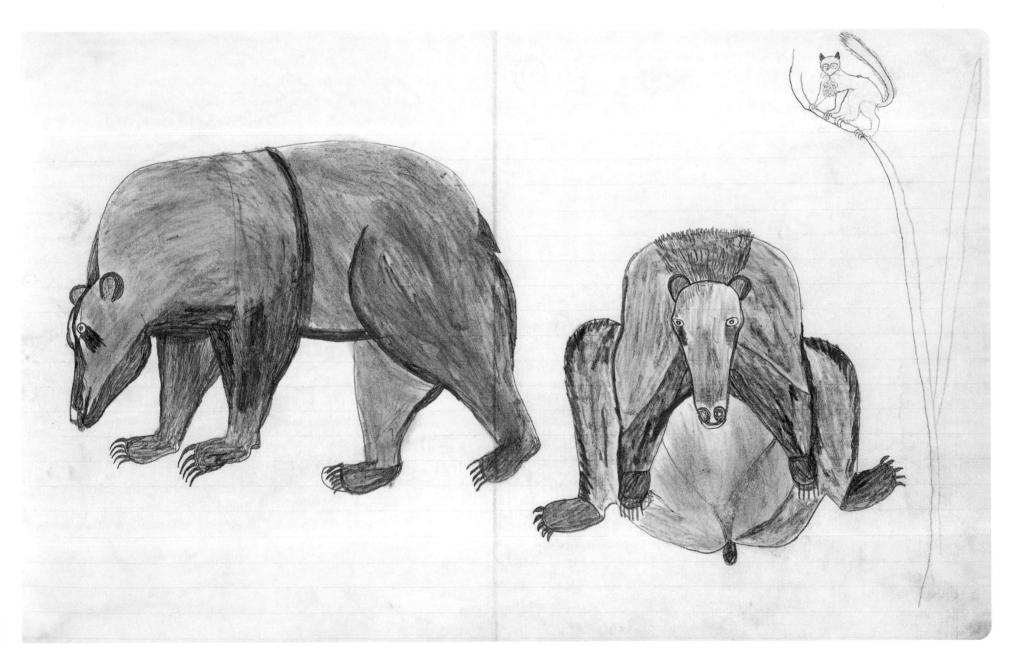

PLATE 69

The Bear is quick-tempered and is fierce in many ways, and yet he pays attention to herbs which no other animal notices at all. The bear digs these for his own use. The bear is the only animal which eats roots from the earth and is also especially fond of acorns, june berries, and cherries. These three are frequently compounded with other herbs in making medicine, and if a person is fond of cherries we say he is like a bear. We consider the bear as chief of all animals in regard to herb medicine, and therefore it is understood that if a man dreams of a bear he will be expert in the use of herbs for curing illness. The bear is regarded as an animal well acquainted with herbs because no other animal has such good claws for digging roots.[177]

Depictions of bears are uncommon in nineteenth-century Plains Indian drawings, though they are sometimes pictured on painted war shields.[178]

Bats (pls. 70, 71). The simply named little brown bat (*Myotis lucifugus*) is the most widespread and most abundant bat in the United States. Black Hawk drew two images of the little brown bat, one male and one female. In each image, the bats are shown with wings outspread, their lighter, redder bodies contrasting with the darker wings. The artist has misinterpreted one anatomical feature of the bat: all of its individual "fingers" should extend from the arm itself, at the top of the wing, rather than radiating from the body, as he draws it. He does accurately render the hooklike thumb at the top of the wing, however.[179]

In plate 71, a bat nurses two young, who cling to her nipples. While bats generally produce just a single offspring at a time, twins are not unknown.[180] Bats migrate, often wintering together in caves in huge numbers. In the west, large colonies have been reported in Wyoming, Montana, and Utah.[181] Although bats do not figure prominently in Lakota thought or myth, it is said that bats are *wakan* (sacred), for they are the helpers of the west wind.[182]

Porcupine (pl. 72, left). Black Hawk has drawn two porcupines (*Erethizon dorsatum*) perched in tree branches, as such animals often do, where they strip the trees of buds, leaves, and bark. Hunters and their dogs quickly learn how readily a porcupine will release its quills in self-defense: such quills, when they are embedded in a hunter's hand or a dog's muzzle, require painful removal. Like other peoples on the Great Plains, the Lakota hunted porcupines (and continue to do so today) principally for the quills, which are dyed and worked into intricate and colorful ornamentation for clothing (see fig. 2).

Fox (pl. 72). On the ground, below the porcupines and wildcats in the trees, Black Hawk has drawn two red foxes (*Vulpes vulpes*), instantly recognizable because of the black boots on the left fox. A red fox may have either a white or black tail tip; the artist shows one of each.[183]

Wild cats (pls. 72, right; 73, right). Black Hawk has drawn two types of wildcats, the bobcat and the larger mountain lion. In plate 72 (right) the artist depicts two views, frontal and profile, of the bobcat. Black Hawk's habit of showing the most characteristic views of the animal, as he does here, or the male and female pair, as he does elsewhere, suggests that he had seen some Euro-American scientific drawings. Named for its naturally "bobbed" tail, the bobcat (*Lynx rufus*) is distinguished by its tawny coloration, mottled coat, facial stripes, and white belly. The incomparable naturalist John James Audubon painted a memorable portrait of the bobcat, commenting upon the hunting skills of this mammal who "pursues his prey with both activity and cunning, sometimes bounding suddenly upon the object of his rapacity, sometimes with stealthy pace, approaching it in the darkness of night."[184]

The mountain lion (*Felis concolor*), also known as the cougar, is shown in two views as well (pl. 73, right). The artist deftly cap-

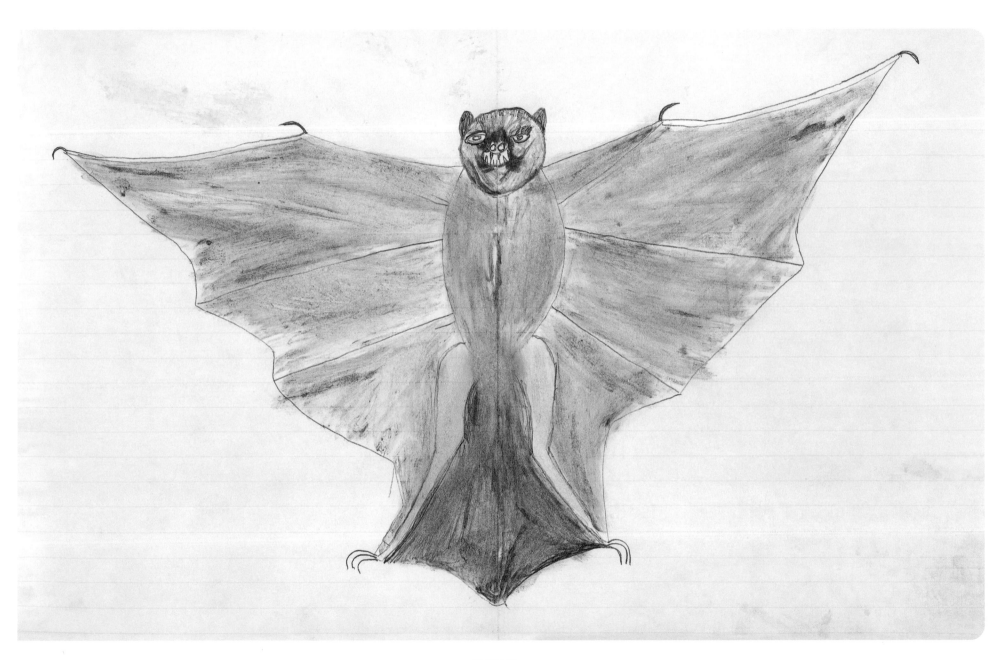

PLATE 70

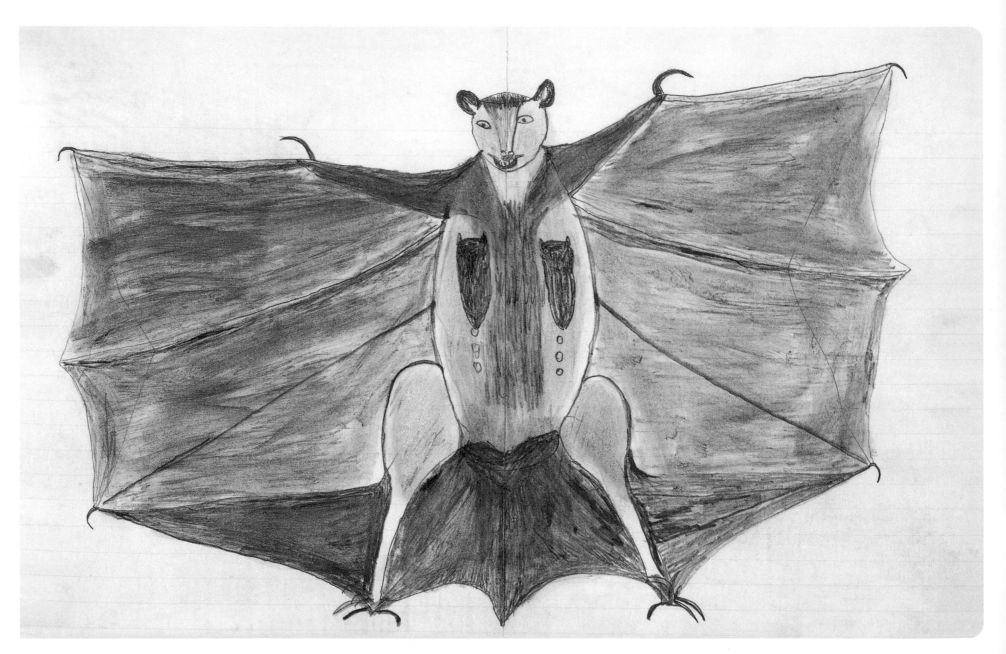

PLATE 71

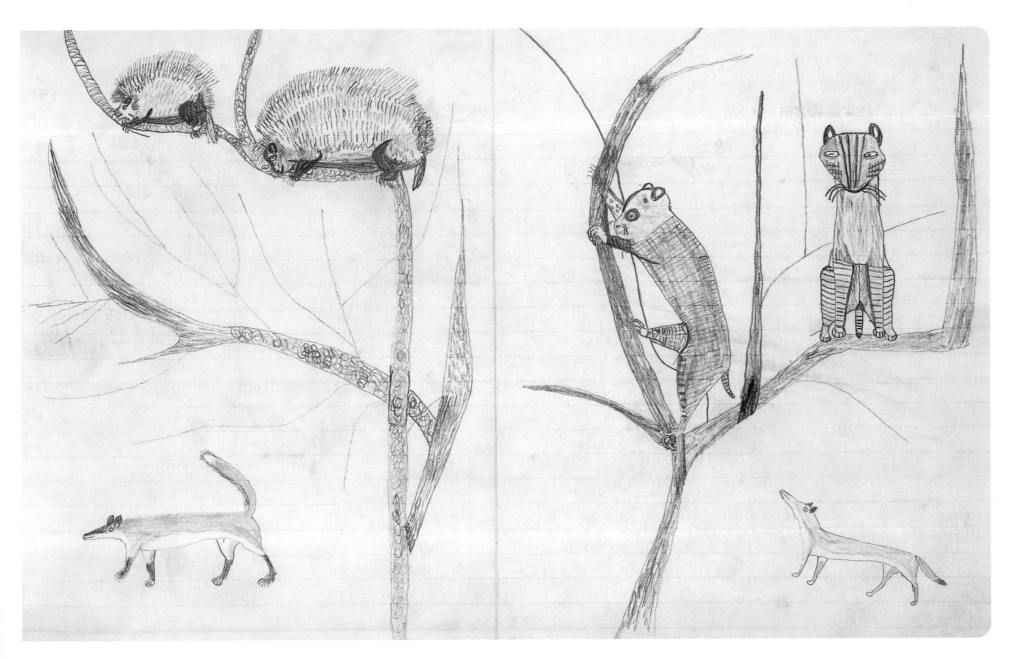

PLATE 72

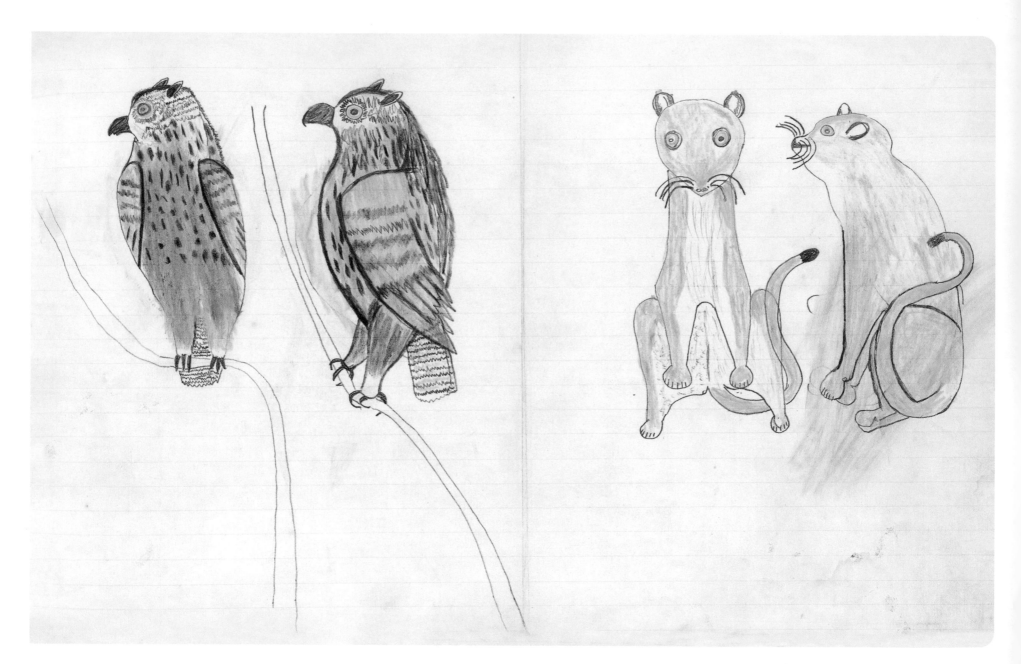

PLATE 73

tures its small, round head and eyes, its orange coloration, and its diagnostic black tail tip. Mountain lions are solitary, stealthy hunters. Perhaps the Plains Indian habit of making arrow quivers from mountain lion pelts (see pl. 6) is an act of sympathetic magic by which the hunter hopes that his arrow will catch its prey with as much stealth and accuracy as the mountain lion catches its own.

Great horned owl (pls. 73, left; 74, left). In two drawings, Black Hawk has rendered five studies of the most aggressive North American owl, the great horned owl (*Bubo virginianus virginianus*). Diagnostic of this bird are the ear tufts, which are generally raised up two inches when the bird perches erect. Even when perched, an angry owl will sometimes tilt its ear tufts backward at an angle, as Black Hawk has indicated in plate 73.[185]

Great horned owls have sharp talons and conspicuous round yellow eyes, just as depicted here. Their coloration varies but is predominantly grayish brown, with darker spots and bars on wings and body. Black Hawk used graphite pencil combined with a yellow pencil to demarcate this coloration. A white patch on the upper breast is characteristic of this species, but the artist shows this on only the middle owl (pl. 74). Formidable predators, and silent in flight, great horned owls prey on mammals, other birds, reptiles, amphibians, fish, and insects.

In the entire literature on the Lakota, there is just one mention of the Society of Owls, a warrior society characterized by "willingness to undertake or having done warlike things at night, or having surprised or defeated an enemy."[186] Obviously, Lakota warriors are drawing upon the owl's expertise at silent, aggressive night hunting. The fierce *Miwatani* warrior society members (see p. 104) wore owl-feather headgear. In Lakota thought, the cry of the great horned owl (*Hinhan sha* in Lakota) signals death.[187]

Other birds (pls. 74; 75, left; 76). In just three pages, Black Hawk has drawn studies of six different birds, in addition to the great horned owl. While none of these is proportionally accurate in relation to the others, most are carefully observed studies of identifiable species. The sandhill crane (*Grus canadensis*; pl. 74, middle) was formerly quite common in the Dakotas; today it remains most prominent in the wet marshes along the Platte River in Nebraska, where great flocks gather in the spring, building strength for migrations north. Black Hawk has accurately rendered the thick body, drooping tertial feathers, long neck, heavy bill, and red head-patch of the sandhill crane. He shows the bird on the ground where, indeed, cranes make their nests. In the tree to the right in the same image is a meticulously rendered American crow (*Corvus brachyrhynchos*). The artist has taken particular care in drawing the feathers with a light touch. The red pencil shading in the beak, wings, and tail is not accurate, but perhaps is meant to indicate the sheen of the feathers.

A similarly shaped bird is the largest image in plate 75 (left). It seems to blend aspects of the male scarlet tanager (*Piranga olivacea*), with its yellow beak and red coloration, and the male pine grosbeak (*Pinicola enucleator*), which has black, white, and pink wings.

Next to it is the vividly colored male mountain bluebird (*Sialia currucoides*), which is common in the Black Hills of South Dakota.[188] On the right side of the same page is an unfinished study of three human males in profile. Feathers in their upright headgear are carefully drawn, but it is unclear whether there is any relation between these human figures and the oversized bird studies on the left.

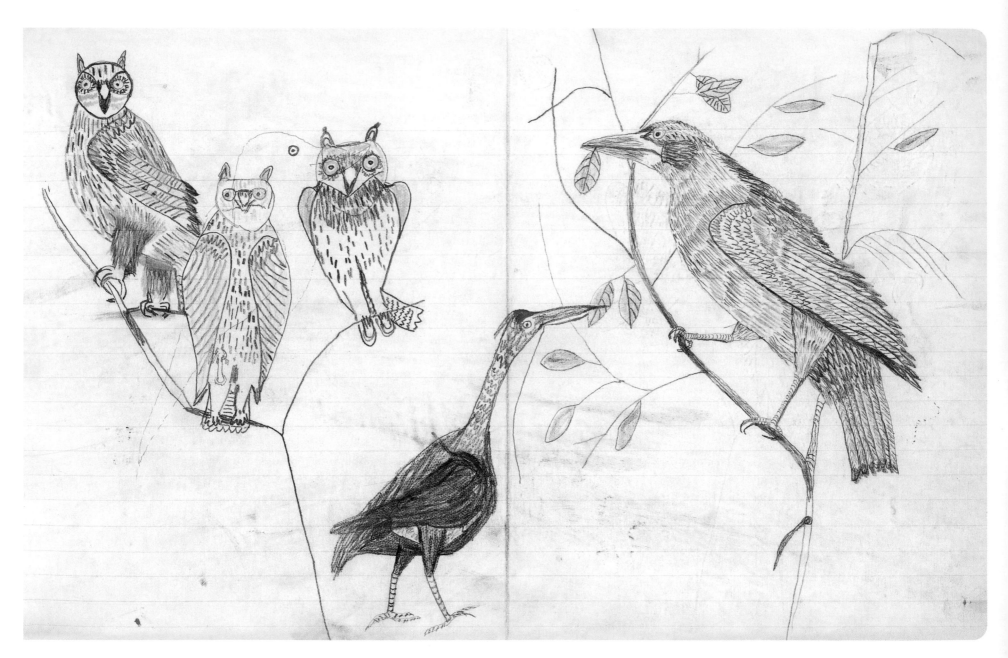

PLATE 74

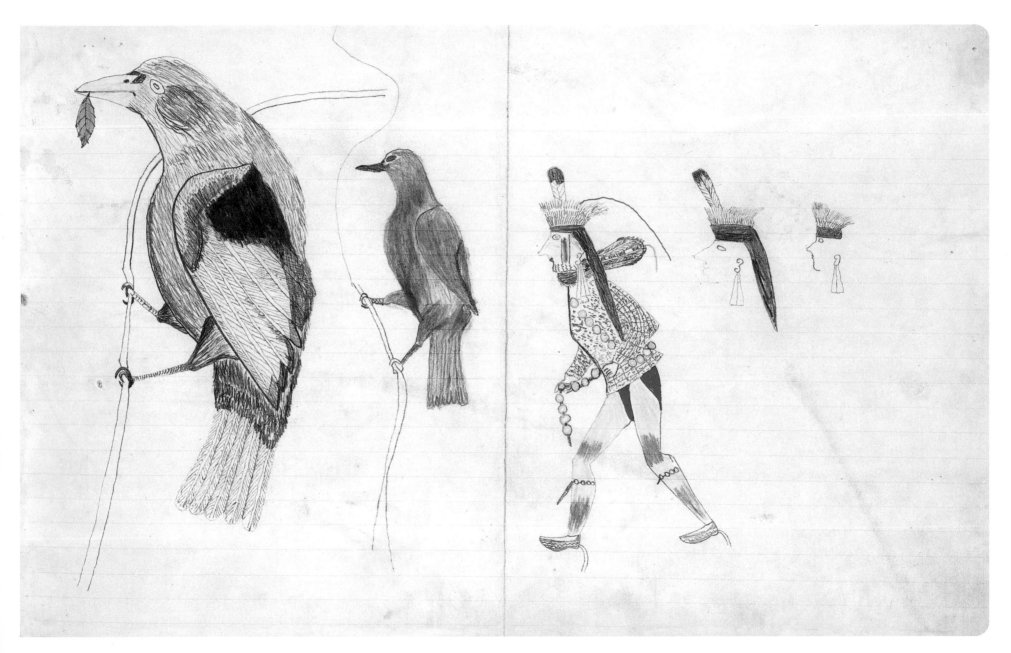

PLATE 75

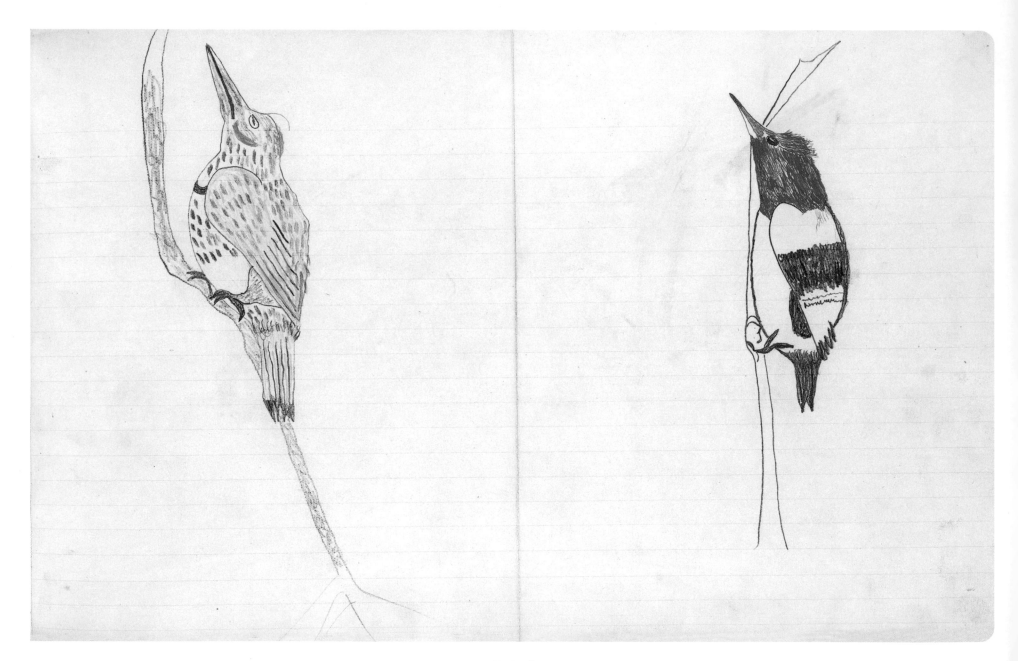

PLATE 76

In plate 76, Black Hawk has drawn two members of the wood-pecker family, each perched on a vertical branch. On the left is the male northern flicker (*Colaptes auratus*), which is common on the Great Plains. The artist shows the spotted coloration, including the diagnostic mustachial stripe of the male.[189] On the right is the redheaded woodpecker (*Melanerpes erythrocephalus*), whose red head, neck, and throat contrast with its white underparts and black-and-white wings.

Black Hawk's scrutiny of the natural world and its workings certainly informed his ritual knowledge and ceremonial practice. Yet these drawings of lactating bats, bighorn sheep in their natural habitats, and elk de-velveting their antlers also demonstrate a rigorous scientific mind at work. At the beginning of the twentieth century, Melvin Gilmore, a museum scientist, gave an elderly Sioux man called His Horse Appears an oral examination on the subject of natural history. Aaron McGaffey Beede, missionary and amateur ethnologist, recounted the results:

> The field covered was the large field of Natural History including Biology. They were agreed that he passed a 95% examination, and was proficient above most men teaching these subjects in schools in the Northwest. Mr. Gilmore, who knows well Omahas and Poncas and Pawnees, and realizes the scientific attitude of Indians, and knows the Sioux language somewhat, was surprised at the trenchantly scientific exact knowledge of this Indian, though I could produce a score of other Sioux here by Fort Yates equal to him, even surpassing him along some lines. They marked him off 2% however, for claiming that the bean mouse, the Missouri River Vole, has but one or at most two families a year, basing their own knowledge on books, not on original observation. I know that the old Indian is correct.[190]

The ethnozoological knowledge exhibited in Black Hawk's drawings accrued from a lifetime's worth of keen observation of nature and from hunting for food and materials used in daily life and ceremony. It was passed on predominantly through oral teaching. Natural history drawings like Black Hawk's are rare in the nineteenth-century Plains pictorial tradition. In Cheyenne, Arapaho, and Kiowa drawings, for example, almost all animals occur in hunting scenes. Some purely scientific studies of animals are found in other Lakota drawings, though they are relatively uncommon. We find no animal studies in Bad Heart Bull's ambitious pictorial corpus of more than four hundred drawings, for example. A Lakota sketchbook in the Smithsonian Institution contains about a dozen drawings of bear, geese, eagles, snakes, bighorn sheep, wapiti, and other animals, though none are rendered as skillfully as Black Hawk's fine studies.[191] Some animal drawings were made over the pages of a bible printed in the Sioux language in 1866, with the drawings done sometime during the next two decades. These include bighorn sheep, buffalo, elk, and deer.[192] All of these amount to no more than a few dozen drawings—a very small number out of the total corpus of nineteenth-century Lakota drawings that I estimate at somewhere over a thousand images.

※

BLACK HAWK'S VISION of the Lakota world embraced numerous diverse and overlapping realms. He sold to William Caton his small but eloquent images of social dances, the Sun Dance, and animal

dreamer masquerades. He re-created his awesome vision of Spirit Beings, and he demonstrated his encyclopedic knowledge of Crow warfare, horsemanship, and ceremonialism. His familiarity with hunting practices and his careful observation of mammalian and avian species are also documented in these fine works of art.

Yet Black Hawk's vision, as set down on seventy-six sheets of foolscap, was not an all-encompassing one. He seems to have steadfastly ignored the precipitous changes occurring around him in 1880. Or did he deem these events not worthy of his artistic consideration? This subject is considered in the next chapter.

WOWAPI WAKAN

Art and the Persistence of Cultural Memory

The picture is the rope that ties memory to the stake of truth.
—Lakota saying[1]

THE LAKOTA LANGUAGE is flexible and inventive; it allows words to be combined to create new concepts and metaphors or to name new objects and convey new experiences. For example, when the Lakota language was formed, the domesticated dog (*sunka*) was the only pack animal. When the horse became part of the cultural inventory in the late eighteenth century, its size, power, and beauty led it to be given the name sacred or mysterious dog (*sunka wakan*).

The Lakota were introduced to Christianity by the Catholic, Episcopal, and other denominations whose missionaries took up residence on the various reservations. These missionaries designated the term *wowapi wakan* for the Bible. The word *wowapi* is an elastic one, encompassing pictures, images, symbols, writing, and books.[2] *Wakan,* as noted before, connotes sacred, mysterious, and sometimes even unknowable.

However, long before the influx of white people and their religion to the Great Plains, Lakota people and their ancestors were

inscribing mysterious and sacred images on rock walls and painting them on hide robes. Eventually, they came to draw their own powerful images and symbols on paper and in books. It is appropriate, therefore, to reclaim the indigenous term *wowapi wakan* for the products of indigenous minds and hands. It applies to Black Hawk's book of mysterious drawings, and to others like it. Such powerful objects (symbols, pictures, books) are among the important ways that Lakota cosmological and epistemological systems have survived in the face of seemingly insurmountable odds.

Far too often the only story told about Native Americans is the story of loss and extermination. A single-minded focus on that narrative diminishes the very real fact of their own cultural authority, creativity, autonomy, and endurance. The other linked story tells of resistance and survival. The role of visual arts—that of Black Hawk, his cohorts, and their artistic descendants—in this survival story is crucial. The importance of indigenous *wowapi wakan* in this narrative of resistance and survival cannot be overestimated.

For Black Hawk, drawing in the winter of 1880–81, and for Bad Heart Bull, whose visual encyclopedia occupied so much of his time in the 1890s and early 1900s, their pictures did, indeed, tie memory to the stake of truth: the truth of an enduring Lakota universe that could neither be extirpated nor denied.

The Reservation Era
LOSS, ENDURANCE, AND SURVIVAL

A warrior I have been.
Now it is all over.
A hard time I have.

—Sitting Bull's song, after his 1881 surrender to U.S. authorities[3]

WHEN BLACK HAWK was recording his visions of the Lakota world in the winter of 1880–81, that world was under siege on all fronts. After George Custer and more than two hundred of his men were killed at the Battle of Little Big Horn in June 1876, the full force of the U.S. military machine came down upon the Lakota. On the eve of the United States's centennial celebration, in historian Robert Utley's words, "a stunned American nation demanded retribution."[4] A few facts will suffice to give a sense of the horrors of that era.

In the autumn of 1876, Generals Alfred H. Terry and George Crook carried out a ruthless policy of confiscating guns and horses at the Standing Rock, Cheyenne River, and Red Cloud Agencies. In the winter, army troops were stationed in prime buffalo-hunting territory, effectively blocking access to the herds, in hopes that the recalcitrant bands that had not yet come in to the agencies would either starve or surrender. One army colonel commented that Sitting Bull's Hunkpapa band, who had refused to come in to the agency, had no lodges or provisions, only horses "thin as shadows."[5] The army did its best to destroy or confiscate the lodges, food, and buffalo robes of any bands that had not sub-

mitted to agency rule. By spring of 1877, Sitting Bull and his fol-
lowers took refuge in Canada, out of reach of the U.S. Army.

In May of that year, Crazy Horse and nearly nine hundred of his
group (including many Minneconjou and Sans Arc) surrendered
themselves and twelve thousand horses at Camp Robinson,
Nebraska. The grave and ceremonial manner in which they con-
ducted themselves shows that they understood that this marked
the end of an era: Crazy Horse gave all his war regalia to his brother-
in-law, Red Cloud (the chief of the nearby, peaceful Red Cloud
Agency). He Dog, another ranking member of Crazy Horse's group,
removed his eagle-feather headdress and scalp shirt and put them
on Lieutenant William Clark, to whom they were surrendering. As
the single-file procession of Lakotas and ponies, two miles long,
entered the Agency, "from front to rear echoed a solemn peace
chant," one newspaper correspondent reported.[6] By autumn, the
legendary warrior Crazy Horse was dead, killed when U.S. military
officers and other Lakota chiefs tried to arrest him. Of the great
chiefs and warriors, one of few remaining holdouts was Sitting Bull.

By early summer of 1881, over twenty-eight hundred of Sitting Bull's
followers had surrendered and were brought back to American reser-
vations by steamboat, down the Missouri River. Sitting Bull himself,
and his remaining forty families of followers—starving and wearing
rags— surrendered in July 1881. This meant that the U.S. Army had
successfully confined to reservation life literally every Lakota.

In the 1880s, the railroads were depositing loads of white settlers in
the Dakotas. Towns and cities were being built, farms and ranches
established. Their numbers grew exponentially. As Utley described it:

In 1870, all Dakota Territory counted less than 5,000 white citizens.
By 1880, the year before Sitting Bull limped into Fort Buford, 17,000

whites dug Black Hills gold and another 117,000 peopled the balance
of the territory outside the Great Sioux Reservation. In only five
years, the number would double.[7]

Red Cloud, speaking to government officials in Washington, D.C.,
in 1870, said:

Whose voice was first sounded on this land? The red people who
had but bows and arrows. The Great Father says he is good and kind
to us ... what he has done in my country I did not want; I did not ask
for it; white people going through my country. Father, have you or
any of your friends here got children? Do you want to raise them?
Look at me, I come here with all these young men. All of them have
children and want to raise them.

The white children have surrounded me and left me with
nothing but an island. When we first had this land we were strong,
now we are melting like snow on a hillside while you are growing
like spring grass.[8]

But matters only grew worse. On the reservations, the traditional
male way of life, which had focused on warfare and the buffalo hunt
(see pls. 39–59), had been fractured, and the buffalo had been hunted
to the brink of extinction. The war societies and ceremonies associ-
ated with these pursuits no longer had any useful purpose. The only
social institution to replace them was the Indian police force, which
worked with reservation agents and the U.S. Army to keep peace.

In 1883, the U.S. secretary of the interior decreed that all tradi-
tional feasts and dances be outlawed, and all practices of traditional
medicine men, like Black Hawk, were forbidden. The particular
focus of the law was the Sun Dance, but it also included all the
other ceremonies that Black Hawk described, like the female
puberty ceremony and the animal dreamer dances (see pls. 7–21).
At the Cheyenne River Agency, agent William Swan advised men

that anyone planning or participating in the Sun Dance would be put in jail. When plans proceeded despite his injunction, he ripped apart the ceremonial enclosure and confiscated the drums.[9] The principal institution that was to replace the annual cycle of festivals was the Fourth of July festivities at which formerly free men and warriors could celebrate, if they wished, their patriotism for the U.S. government and its policies.

More and more children were sent to boarding schools, many of them in distant locales like Carlisle, Pennsylvania, and Hampton, Virginia. By withholding food rations, agents on the reservations persuaded parents to surrender their children. At school, boys' long braids were cut off and blankets and beads discarded. Both boys and girls were dressed in restrictive Victorian garb, and only English was allowed to be spoken. At the Cheyenne River Agency, there were both day schools and boarding schools, some of which were run by the Christian missions.[10] All of these various actions, from outlawing traditional religion, to the use of starvation tactics to ensure submission to government policies, were nothing short of cultural genocide.

During the 1880s, various bills and acts of Congress continued to shrink the size of the Great Sioux Reservation, which had been established "in perpetuity." Five separate, smaller reservations at the different agency locations were established, and eleven million acres were taken back by the U.S. government.[11] The Minneconjou and Sans Arc who had surrendered with Sitting Bull in 1881 had settled in the Cherry Creek district of the Cheyenne River Agency, where Black Hawk lived. By all accounts, this area was a locus of traditionalism. The agent characterized the residents as the "least progressive" at the agency,[12] which, in practice, probably meant that they were the least interested in doing the bidding of the govern-

ment's representatives. They adamantly opposed the government initiatives of 1888 and 1889 that opened some agency land to settlement by whites. In the summer of 1890, drought caused extensive crop losses. Various epidemics spread throughout the populations. Beef rations were cut, because of a reduction by Congress in the funds for Indian appropriations.

It was in this atmosphere of increased deprivation, hardship, and despair that word spread of a new religious movement, the Ghost Dance. Kicking Bear, a Lakota from the Cheyenne River Agency, had traveled with others to the Paiute Reservation in Nevada to hear the new religion being preached by an Indian named Wovoka. Kicking Bear and his cohorts returned and shared this hopeful message among the Lakota. Wovoka had had a vision in which he spoke to God, visited the ancestors in the world of the spirits, and determined that if Indian people lived peacefully with each other and with whites, they would be reunited with their ancestors, and the buffalo would return. As Kicking Bear told the Lakota:

> My brethren, I bring you the promise of a day in which there will be no white man to lay his hand on the bridle of the Indian's horse; when the red men of the prairie will rule the world and not be turned from the hunting grounds by any man. I bring you word from your fathers the ghosts, that they are now marching to join you, led by the Messiah who came once to live on earth with the white men, but was cast out and killed by them. I have seen the wonders of the spirit-land, and have talked with the ghosts. I traveled far and am sent back with a message to tell you to make ready for the coming of the Messiah and return of the ghosts in the spring.[13]

Among the Lakota, the Ghost Dance was a simple round dance, held around a sacred tree (like that formerly used in the Sun

Dance). People were sometimes overcome with visions, swooned and fainted, and saw the world of the ancestors. Ghost dancing commenced at Pine Ridge in August 1890 and at Rosebud and Cheyenne River in September, where it was taken up enthusiastically by Hump's and Big Foot's bands; adherents at Standing Rock Agency followed suit in October.[14] The Indian agents and other government emissaries were disturbed by these events, seeing in them a groundswell of feeling for traditionalist religion and Nativist moral autonomy. Those Lakota who had taken up this movement would not be quelled.[15] By November, substantial U.S. Army troops were marshaled at the reservations for the first time in more than a decade; military officers began to demand that Indians stop dancing and that, once again, they turn in all their weapons.

When on December 15, 1890, Sitting Bull was killed while being arrested by a delegation of whites and Indian scouts, many of his people fled to the Cheyenne River Sioux Reservation, hoping to find solace at Cherry Creek with Big Foot's people. Meanwhile, Big Foot and his followers had been ordered by army officers to report to the agency offices, but, instead, several hundred fled south to Pine Ridge, hoping to find safety with Red Cloud's people. They entered Wounded Knee, starving and freezing, with a white flag of surrender affixed to the wagon in which Big Foot lay seriously ill with pneumonia.

A few danced the Ghost Dance. But it was during the process of disarming the Indians that gun shots rang out on the morning of December 29, 1890. Within a few hours approximately two hundred Lakota were dead. Others died of their wounds within the next few days.[16] They had been shot by U.S. Army carbines and revolvers, and by the deadly Hotchkiss guns—small, rapid-fire cannons that released up to fifty explosive shells per minute, ensuring that almost nothing in their line of fire survived.

Thirty years later, Black Elk recalled what he and other Lakota from Pine Ridge saw that day, as army soldiers massacred so many of the refugees from the Cheyenne River Sioux Reservation:

> A little way ahead of us, just below the head of the dry gulch, there were some women and children who were huddled under a clay bank, and some cavalrymen were there pointing guns at them.
>
> We stopped back behind the ridge, and I said to the others: "Take courage. These are our relatives. We will try to get them back." Then we all sang a song which went like this:
> "A Thunder Being nation I am, I have said.
> A Thunder Being nation I am, I have said.
> You shall live.
> You shall live.
> You shall live.
> You shall live." . . .
>
> . . . [Later] we followed down along the dry gulch, and what we saw was terrible. Dead and wounded women and children and little babies were scattered all along there where they had been trying to run away. The soldiers had followed along the gulch, as they ran, and murdered them in there. Sometimes they were in heaps because they had huddled together, and some were scattered all along. Sometimes bunches of them had been killed and torn to pieces where the wagon guns hit them. I saw a little baby trying to suck its mother, but she was bloody and dead. . . .
>
> . . . When I look back now from this high hill of my old age, I can still see the butchered women and children lying heaped and scattered all along the crooked gulch as plain as when I saw them with eyes still young. And I can see that something else died there, in the bloody mud, and was buried in the blizzard. A people's dream died there. It was a beautiful dream.[17]

The few meager references to Black Hawk in the official records and census rolls of the Cheyenne River Agency end after 1889. Perhaps he died of old age, or hunger, or one of the epidemics that were circulating in 1890. Or perhaps he, his wife, and their adult son fled with their Minneconjou neighbors from Cherry Creek to Wounded Knee in December 1890. Perhaps, as a medicine man, he was receptive to the message of mysterious visions and prophecies offered by the Ghost Dance religion. Perhaps he, too, was a ghost dancer, one of those who desperately hoped that the white men would disappear, the ancestors return, and the buffalo be plentiful once more. Perhaps he was, after all, the Black Hawk listed in several records as one of Big Foot's followers slaughtered at Wounded Knee.[18]

Unfortunately for the Lakota, Wovoka's promises did not come to pass. And what of the many promises made by the U.S. government in so many treaties and negotiations? As one Lakota astutely observed in 1890:

> They made us many promises, more than I can remember, but they never kept but one: they promised to take our land, and they took it.[19]

On the Cheyenne River Sioux Reservation, this particular promise continued to be kept. When that reservation was established as a separate entity in 1889, it encompassed more than 2.8 million acres. Today it has been reduced to 1.5 million acres. In 1948, the federal government began construction of the Oahe Dam, which flooded more than one hundred thousand acres on the Cheyenne River Reservation and another fifty-six thousand at nearby Standing Rock. Now under water is the former town that housed Cheyenne River Sioux tribal headquarters, a hospital, a school, the most fertile agricultural land, and more than 90 percent of the forested land on the reservation, which many people relied upon for wood for fuel, and for wild fruits and game.[20]

It is important to keep alive in the American mind this history of lies, broken promises, and cultural genocide perpetrated by the government, for far too many Americans remain unaware of it. Even so, a history that focuses solely on warfare, defeat, and subjugation of a once-autonomous people is far too limited a history, as numerous contributions to a more balanced view of world history over the past three decades have demonstrated.[21] In recent years, scholars of Native American history have argued for an Indian-centered history, in which Native concerns and Native points of view are paramount.[22] This history, like much of the new social history, focuses on daily lives and pursuits as much as on the policies of governments and actions of leaders. It is in this more personal, local history that we find a narrative of endurance and survival.

Black Hawk, Bad Heart Bull, and their cohorts provide an Indian-centered view of history, of course, one in which the oral and the visual are dominant. Literacy came later. Publication of pictorial histories like Black Hawk's and Bad Heart Bull's serve to remind us that before the ethnographies of their culture were written by outsiders, Lakota people themselves were inscribing their own visual ethnographies. Indeed, before the literate Natives of the next generation, like George Bushotter and Ella Deloria began their scholarly projects, visual arts were keeping this material alive in a vivid, unforgettable way.[23]

Black Hawk and the Persistence of Cultural Memory

Now that he was old, Podh-lohk liked to look backwards in time, and although he could neither read nor write, the book [of ledger drawings] was his means. It was an instrument with which he could reckon his place in the world.

—N. Scott Momaday[24]

FUNDAMENTAL TO THE IDENTITY of the late-nineteenth-century Plains Indian artist was the act of inscribing historical drawings in books and on paper. These pictorial images clearly reveal how men in a culture under siege reckoned their place in a changing world through the act of drawing—an aesthetic mode that speaks eloquently across cultures and an act of resistance that can be read across the generations. When Pulitzer Prize–winning Kiowa author N. Scott Momaday visualizes his ancestor, Podh-lohk, a century ago, he imagines him with his book of powerful images—his own drawing book.

Three roles went hand in hand for Plains Indian men who drew works of art on paper at the end of the nineteenth century and the beginning of the twentieth: they were artists concerned with an aesthetic ordering of the world; they were visual ethnographers, at a time when most people think that only Euro-American social scientists were interested in the ethnographic details of other cultures; and they were historians who chronicled not only indigenous history but the astonishing changes that were irrevocably altering their world. To these, Black Hawk added a fourth: he was a scientist of the Lakota natural world, recording the habits and physical characteristics of the important animals in his ecosystem.

Although rich ethnographic and historical data are transmitted in all Plains drawings, in the best ones a concern with content is balanced by a love of the poetics of form, too. The spectacle of dance and ceremony provided a superb opportunity for the Plains graphic artist to exercise his love of patterning. Depicting the alternation of male and female dancers seen from the back (see pls. 27, 28, 29), Black Hawk delights in the play of patterned repetition: the slightly varied placement of the dancers' right arms; the variation in gingham, checked, plaid, and spotted cloth; the alternation of black, blue, yellow, and red outfits; the repeating yet different dark heads with paint applied to the part in women's hair; and the individual feathered and quilled hair ornaments of the men.[25]

While it has long been part of the communicative function of Plains graphic arts to render the enemy with an expressive economy of means—a scalp lock and flared moccasins to denote a Pawnee, a pompadour hairdo for a Crow—some drawings in the last quarter of the nineteenth century, Black Hawk's foremost among them, reveal a deep interest in the myriad details of the life, dress, and culture of other ethnic groups.[26]

Black Hawk was clearly fascinated with the ethnographic details of Crow culture: fully one-third of his drawings depict these traditional enemies of the Lakota (see pls. 30–55).[27] Most of Black Hawk's drawings of the Crow are historical records of encounters between warriors. But on five pages he drew Crow men in ceremonial procession (see pls. 30–34). We do not know how he came to see enemy ceremonials, but he provided a superb visual ethnography of an alien tribe.

The last quarter of the nineteenth century was a time devoted to negotiating the vast distances between Indian and Anglo cultures and making sense of them through pictorial means. This prefig-

ures the widespread ethnographic impulse in Native American painting at the beginning of the twentieth century, when artists in other regions were using modern materials to paint narrative scenes, principally of an auto-ethnographic nature.[28]

Indian artists in the final quarter of the nineteenth century were documenting not only their own worlds but also the worlds of neighboring peoples, both Native and non-Native. This ethnographic impulse is particularly interesting, because it happened at the same time that whites, too, were focusing on ethnographic depictions of vastly different worlds. Artists, photographers, anthropologists, and travelers were relentlessly documenting what they characterized as the "vanishing Indian," especially in the west. Silver Horn, who, among the Kiowa, played an equivalent role to that played by Black Hawk and Bad Heart Bull among the Lakota, provided visual records of war practices, courtship, ceremony, and oral literature. Candace Greene has noted that "Silver Horn's illustrations of ceremonies offer visual documentation that far exceeds the written records of these events and richly enhances the verbal knowledge still held within the Kiowa community."[29] Similarly, Black Hawk's oeuvre provides a parallel, visual commentary to that found in ethnographic accounts.

Modern viewers sometimes look at ledger drawings and facilely dismiss them as generic scenes of horse capture or warfare. In fact, most have specific historical referents. Unwarranted assumptions about the lack of historical traditions in aboriginal cultures reflect, in part, Euro-American culture's need for a timeless, ahistorical, "primitive" world as a foil for its own, as so many cultural critics have discussed over the last two decades. Scholars of Plains drawings are increasingly appreciative of the depth of historical data inscribed pictorially. Yet it would be a mistake to call them mere illustrations of history. For they are palpable representations of a vast, protean oral and performative tradition, rather than simple reifications of a fixed text. They serve to keep the specifics alive in memory, and the artist's rendering, in turn, influences how memory next apprehends the incident.

Plains graphic artists captured contemporary history with great accuracy, at a time when most outsiders were eager, principally, to capture the past. While many ethnographers, artists, and photographers pursued a paradigm of fleeting "authenticity," searching to record the pristine, the untouched (or even to re-create it, if it was not there to be recorded), their Plains counterparts drew the historical realities of reservation-era life. Some focused on battles with whites.[30] Others chronicled the visual and economic impact of trade goods. Some drawings document the influx of guns and military paraphernalia with such keen accuracy that modern military historians can identify the precise armaments depicted in these small drawings, including flintlocks, Smith carbines, Spencer repeaters, and Springfield rifles.[31]

But Plains artists were not merely literal historians; they were deeply spiritual men and artists in cultures where visual images and visual metaphors are powerfully meaningful. So indigenous history is a concept elastic enough to include records of spiritual encounters as well as intercultural ones, as seen in Black Hawk's drawings of Spirit Beings (see pls. 1, 2).

By looking at Plains drawings not simply as generic examples of late-nineteenth-century Indian art, but as expressive works by creative individuals participating in a well-established tradition, we further our understanding of a Native North American art history and of an era fraught with cultural conflict and contradiction, some of which was captured on paper by the indigenous graphic artists of the west.

Black Hawk and his artist-colleagues were, in both senses of the word, remembering a Lakota world: they were recalling the past, as well as putting back together and reconstituting that which had been fractured or dismembered. But it is noteworthy that, except for depicting the incorporation of trade goods into daily life, Black Hawk paid scant attention to the events of the encroaching white society. In contrast to many other artists of his era, he drew no pictures of log cabins and no scenes of fighting or submitting to white soldiers, for example. It is impossible to determine precisely why this is so. It may be that he was asserting the primacy of the Lakota world and was intent upon displaying his indifference or disdain for alien subject matter. He depicted the Lakota world as an unbroken hoop, to use Black Elk's metaphor.[32] Perhaps he was confident that it would not be broken.

On the Other Side of the Ledger

LAKOTA AESTHETIC PRACTICE ACROSS GENERATIONS

Mine is a family of Indian intellectuals. We examine the nature of life through ceremony, vision quest, mythology, and our history. . . .

In traditional ceremonies, we go back in time and start at the creation of the world, and then proceed through mythological and sacred time to arrive, once again, where we started. It's a cyclical kind of journey. . . . Ceremonies remind us of that process—not as individuals, but collectively as a whole people—of moving from the very origins of the universe and this planet to where we are now. That's a continual mode or way of looking at the world. We're constantly involved in that process.

—Arthur Amiotte[33]

AS I HAVE STUDIED the Black Hawk drawings over the last few years, learning more about Lakota art and religion, it has been astonishing to me to realize that a relatively small cultural group (never numbering more than about fifteen thousand people at any one time) produced such a profound body of thought encompassing art, ceremony, cosmology, oral literature, and music. Much of it has been carried quietly, sometimes surreptitiously, by small numbers of people. It has been passed on orally, through song, custom, and ceremony. It was passed on when Standing Bear allowed his granddaughter Olive (Arthur Amiotte's mother) to stand at the kitchen table in 1925 when he was working on one of his epic muslin paintings, narrating to her what happened in the Sun Dance circle of 1876 or the Battle of Little Big Horn that followed it. Perhaps when Black Hawk drew his images, some young nephew sat with him and heard told the stories of the battles with Crow Indians in the 1850s and 1860s, or the behavioral properties of elk or white-tailed deer, or the stories of the awesome Spirit Beings residing in the sky.

Like most Native American symbolic systems, Lakota art and language are multilayered, interlocking practices. In art, complex visual metaphors can be constructed, some of which are dependent upon a profound knowledge of artistic antecedents, the cosmological and epistemological underpinnings of the culture, and the syntax and structure of the language. So some richness is necessarily lost on those of us who do not speak Lakota or do not share the cultural background. But glimpses of the eloquence of the metaphorical system are possible, even across barriers of culture and language.[34] Some cultural critics today are impatient with the idea that art can transcend these boundaries. Yet perhaps Euro-American art connoisseurs, tribal elders, and contemporary aboriginal artists can agree

that a great work of art has the potency to affect people despite barriers of time, space, and ethnicity.

Black Hawk's blue-spotted Thunder Being is an arresting sight (see pl. 2). The artist's bold sense of color and graphic design, his authoritative use of line, and the potency of his subject matter, all work in concert to make an unforgettable image. One needs no understanding of Lakota culture to make this assessment and to admire this work of art. A Lakota who looks at this would see all that, of course, but might also recall the way metaphorical language is used to describe the meteorological forces that sweep across the Great Plains every summer.

Just as certain powerful animals are described collectively in Lakota as a "nation" (for example, *pte oyate,* or Buffalo Nation), so, too, in the spirit world there is the *wakinyan oyate,* the Thunder Being Nation. In ceremonial performance, men wearing dark masks with flashing, mirrored eyes ride hail-painted horses to evoke the mystery of nature, and the powerful celestial members of the Thunder Being Nation (see fig. 10).

In Lakota sacred language, which is rich in metaphor, one might personify the weather, using the term *wakinyan* (Thunder Being) and at the same time evoke images like Black Hawk's:

> *wakinyan agli*
> a storm is coming
> literally, "Thunder Beings are coming home."
>
> *wakinyan etunwanpi*
> lightning
> literally, "Thunder Beings are glaring."
>
> *wakinyan hotunpi*
> thunder
> literally, "Thunder Beings are sounding."[35]

So one looks at the image in plate 2 and hears thunder, sees lightning, feels the stinging fury of the hail, and experiences the prickly static in the air that is the signal of an incipient electrical storm. But this is not merely about the weather. Through various forms of knowledge, including dreaming, art making, and performance, one is able to convey that these powers of the universe (hail, lightning, thunder, the horse-buffalo-eagle creature) are the ancestors (*tunkasila,* literally, "grandfathers"). So that one might just as easily say, in Lakota sacred language, "the grandfathers are coming" (*tunkasila ukiye*) to indicate that a storm is imminent.[36] And knowledge of the ways of the ancestors gives potency to one's life and legitimacy to one's art. Even today, in the finest Lakota art, one identifies oneself in relation to history and cosmology.

Traditionally, the discipline of art history has concerned itself with palpable objects that outlast the moment of their historical making. Monuments, manuscripts, and masks all have a life that extends far beyond that of their creators. We study and classify such objects, enshrine them in museums, construct historical matrices within which to understand them. Indeed, there is much of merit in this approach, however imprecise and approximate it may be. But Native American scholars, poets, and artists continue to insist that objects are only part of the story and that historical objects will be used, understood, reabsorbed, and transformed through the minds and hands of every new generation. Only through the continuing actions of each generation will the past stay alive.

Native artists remind us that it is the vision, the idea, the germinal seed that is important. Only the individual who has had a vision can draw it on paper, paint it on a drum, or construct the ceremony within which it will be performed for the community. What is

owned, and inviolable, is the *right* to make an object that conveys one's family's biographical data or one's own visionary experiences. The ceremony can be reenacted. The material object can be renewed, remade, or reinterpreted by the next generation.

In keeping with this viewpoint, Lakota artists are very conscious of their artistic genealogy. When Bad Heart Bull endeavored to draw a pictorial encyclopedia of Lakota culture and history (see fig. 8), he was aware of the fact that he was incorporating the artistic styles as well as the historical events of previous generations within his work. His drawings, and those of Kills Two (see fig. 10), were shown at the influential Exposition of Indian Tribal Arts in New York City in 1931.[37] There it was rightfully presented as Indian art that had relevance to the future as well as to the past.

In the next artistic generation, Oscar Howe (1915–1983), the premier modernist of the Northern Plains, based his groundbreaking work on the narrative traditions of earlier Lakota artists. His well-known and influential experiments with a Cubist style of narrative painting in casein on paper, begun in the 1950s, influenced, in turn, a number of younger artists.[38]

In the decades since Howe, the work of nineteenth-century ledger artists came to have a new resonance for a new generation of artists. Rather than looking simply to the European and Euro-American traditions in which most of them had been trained, they turned to their artistic predecessors on the Great Plains for both stylistic and iconographic inspiration. Howe taught them that a Lakota artist could be taken seriously in any venue. Bad Heart Bull and other nineteenth-century artists taught them that they already were part of a distinguished history of art. But the finest artists realized that at the end of the twentieth century it would not do simply to reiterate the late-nineteenth-century drawing style—as if they had been untouched by the events of their own era. Arthur Amiotte explained it best:

> I realized that contemporary art was ignoring the whole reservation period. This had been a dynamic time. Some people were going to school in the east, to Carlisle and Hampton. It was the beginning of a transition to fine art styles. People were moving onto land allotments. They were familiar with printed media, exposed to lots of magazines, pictures, photographs. Some of them even had art lessons in school!
>
> Daily life was infused with this mixture of non-literate/literate. There were new technologies, and children going to school and bringing that new information back into their home. It seemed to me that it was more honest to deal with all this in my art, rather than to create a fake hide painting, which many artists were doing in the 1980s and continue to do today.[39]

In his collage series of the past dozen years, Amiotte has carried on a conversation with the works of his artistic forebears. He adapts images of and by Standing Bear, his own literal great-grandfather, and he quotes visual passages from Bad Heart Bull. In *Wounded Knee* (1988), he collaged a photo of the mass grave at the massacre site, quotations from his own earlier paintings, including one of Standing Bear, and nineteenth-century Lakota pictographic names, inscribing a narrative of loss and perseverance.

Just as Howe denied that his work was in response to European experiments in Cubism, Amiotte denies that his work is a response to text-image issues raised in the 1980s and 1990s by mainstream artists like Barbara Kruger and Jean-Michel Basquiat. He maintains that his work is primarily a conversation with his Lakota artistic ancestors, including Howe, Standing Bear, and Bad Heart Bull. These strategies

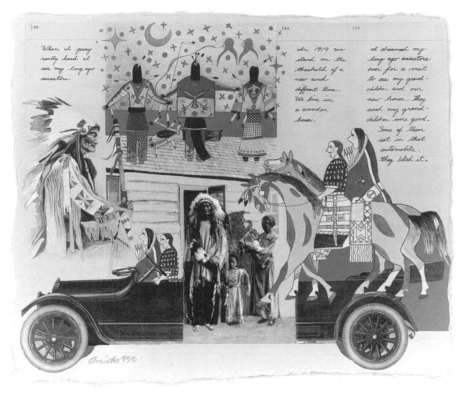

FIGURE 15　Arthur Amiotte, *The Visit,* 1995. Acrylic and collage on paper, 19⅜ x 23⅜ in. (49.2 x 59.4 cm). Buffalo Bill Historical Center, Cody, Wyoming (17.95), Gift of Mrs. Cornelius Vanderbilt Whitney

of denial, in both cases, are deliberate choices, made in order to affirm the primacy of the Lakota worldview.

His use and reuse of fragments of his history is very much in the Lakota tradition of graphic arts, in which one shows visually and reiterates orally the various episodes in one's history, recapitulating them in various ways. Black Hawk, Sitting Bull, and other nineteenth-century graphic artists restated important scenes from their personal and tribal histories. Amiotte reuses and restates his family history and tribal history, to make sense of it and to valorize all Lakota experience—that garnered on the reservation as well as in the world at large.

In Amiotte's 1995 collage *The Visit* (fig. 15), an Indian couple on horseback, at right, arrives to inspect the fine touring car parked in front of the home of the family in the central photo. The log cabin is that of the artist's great-grandfather, Standing Bear, who is pictured both in the photo and in the profile painting on the left. Above the central scene, standing on the roof of the house, are figures wearing Ghost Dance clothing and studying the sky for sacred portents. Part of the handwritten text reads, "In 1919 we stand on the threshold of a new and different time. We live in a wooden house" and "When I pray really hard I see my long ago ancestors."

❋

IN 1913, when a Lakota man named Moses Old Bull taught anthropologist Frances Densmore about the historical traditions of his people, he told her:

> We come to you as from the dead. The things about which you ask us have been dead to us for many years. In bringing them to our minds we are calling them from the dead, and when we have told you about them they will go back to the dead, to remain forever.[40]

These are the melancholy words of an old man who had seen too much death, too many changes, and far too much of white man's business. Fortunately, Old Bull was mistaken about the death of the

traditions of his people. By means of the visual images of Lakota history drawn by Old Bull himself, by Black Hawk, by Bad Heart Bull, and by others, the history—and art history—of the Lakota people were not consigned to the realm of the dead. The artistic and cultural legacy of nineteenth-century Lakota drawings still lives vividly. And these images will continue to nourish successive generations of Lakota historians, poets, religious practicioners, and artists well into the twenty-first century, just as they will move and inspire all of us who seek the energizing power of great works of art.

For the Lakota, the past is not dead, nor is it even "a foreign country" as one distinguished Euro-American scholar would have us believe about all historical traditions.[41] It is alive in the contemporary Sun Dance circle, in the urban artist's studio, in photographs of grandparents and great-grandparents—whether these images are preserved in a museum archive or family album—and in winter counts passed down even today among some Lakota families. It is alive in the imaginations of contemporary Native people as they marvel at the seventy-six drawings Black Hawk made as his gift to the world in the harsh winter of 1880–81.

In the Lakota language, the word *iyeska* is an intriguing term. In ordinary parlance, it refers to an interpreter. It also means a "half blood," someone who is the offspring of an Indian and a non-Native. But in Lakota sacred language, it refers to a ritual specialist—a medicine man or woman.[42] No matter how it is used, whether in ordinary or sacred language, *iyeska* refers to someone who has the facility to move between worlds. Black Hawk was both a medicine man—an intermediary between this world and the spirit world—and a cultural interlocutor between Lakota and non-Lakota realms. He sold his drawings to an outsider, not only as a way of earning money, but as a way of explaining his world: the potency of its ceremonies, the complexity of its spiritual traditions, the valor of its warriors, the strength of its young women, the richness of its natural world. His drawings ensured that that eloquent world, with all of its mystery, poetry, and beauty, would be remembered.

In several drawings Black Hawk demonstrates that he had the power to move within the realm of Spirit Beings. But in all of his drawings he demonstrates his power to move the hearts of all those who see them.

BLACK HAWK'S DRAWING BOOK AS A PHYSICAL OBJECT

The Artist's Methods and Materials

THE PAPER BLACK HAWK used is called "ordinary double foolscap" in the documents accompanying the drawing book (see appendix 2). To papermakers, the term *foolscap* refers to a particular size of paper, measuring 13 x 16 in. (33 x 40.6 cm). In common parlance, however, the term *foolscap* referred to ordinary writing paper, regardless of size.[1] We do not know the original size of Black Hawk's sheets of paper, for they were cut down and the corners rounded when they were affixed to a linen backing for binding. Presumably the individual sheets were trimmed only slightly for binding. Their current size is 10¼ x 16½ in. (26 x 41.9 cm).

Not every sheet of paper is identical, though all are ruled. The space between lines varies. Most of the paper has lines spaced about ⅜ in. (1 cm) apart; occasionally a sheet of paper with narrower lines is used (see, for example, pl. 36 for about ⁵/₁₆ in. [.8-cm] lines). Several different watermarks appear on the sheets, suggesting that the artist was, indeed, given whatever supply of paper was on hand.[2]

Black Hawk's principal implement was the simple graphite pencil.[3] He may have had pencils of varying hardness, for he was able to achieve masterful and various effects with this tool. For example, the buffalo head in plate 4 is shaded by deliberate, angled hatchings about ⅛ in. (.28 cm) long. In his depictions of buffalo, he used the pencil in different ways to suggest the variable pelage of the animal (see pl. 58). Sometimes he employed the side of a pencil for broad expanses of shading, then rubbed the graphite with his finger to achieve a smooth area (see pl. 66). None of these are, in themselves, remarkable effects; what is worth remarking upon, however, is how seldom they are employed by graphic artists on the Great Plains.

Mechanical pencils were available in 1880, and perhaps Black Hawk had them; but more likely, this rural artist sharpened his pencils with a knife or made a finely honed point with sandpaper, in order to achieve the delicate hatchings on the buffalo head in plate 4, for example. In addition to the simple graphite pencil, the artist also used colored pencils in a range of hues, including two shades of yellow, blue, green, and red. Sometimes he layered colors, as in the yellow and black shading of the great horned owl (see pl. 73) or the elk (see pl. 60).

The artist also used ink in an expert fashion. Black ink was used sparingly, principally to demarcate tiny areas of beadwork or shell jewelry (see pl. 24, for example). He used blue ink with both a pen and a brush. In plate 35, the blue horse was painted with a brush, whereas a pen nib was used to delineate the blue of the saddle blanket. A moderate amount of purple ink appears in some drawings (see, for example, pls. 7, 9, 22, 56). Black Hawk seems to have had a generous supply of both pink and red ink at his disposal. He used these on numerous drawings, employing a brush occasionally (as in the shirt stripes, horse decoration, and cape in pl. 49) but more

often using a fine pen nib. He seldom made a false line with his pen, easily inscribing fine details of jewelry, beadwork, and hairdo with a deft hand.

The artist drew with a very confident line. There is little evidence of overdrawing or erasure. Occasionally an errant line appears. In plate 67, for example, he seems to have started the back of one animal on the right with a higher line, and then reconsidered its placement. In plate 36, a human face was begun near the rear hoof of the horse on the right. The artist evidently reconsidered, turned the paper upside down, and began an entirely different scene. In plate 74, it seems that he drew a bird profile in red ink over the finished image of three owls. Occasionally Black Hawk attempted an erasure. In plate 73, he redrew the paws of the mountain lion on the right, and his erasure left a messy graphite smudge.

The artist evidently began some drawings on the backs of several of the sheets of paper but never finished them. On the back of plate 8, two partial human faces are visible, as well as the outline of a male body in profile wearing a shirt and a leg garter, above which a bullet wound shows. On the back of plate 18 is an unfinished drawing of two tipis. This is the only instance in the book where the artist seems to have used a ground line formed by the fold in the paper. He oriented the base of the tipis to this fold. He used no straightedge for the lodgepoles, indicating them simply by a bunch of hastily drawn lines. Yet he carefully drew the smoke flaps of the tipis, with their strings hanging loose. On the back of plate 24, a large, black crowlike bird with red tail-feathers (rather like the bird in pl. 75, far left) fills the entire left side of the page. On the reverse of plate 73 a male in profile wears a red spotted cloth shirt and red leggings, his garb reminiscent of that of some of the figures in plates 27 and 28.

Close examination of the original works of art under a raking light reveals at least a little about Black Hawk's drawing methods. He drew on large, flat sheets of paper that he then evidently folded in half to bring in to the trader, as the unbroken lines of ink and graphite over fold lines reveal. Often, the artist must have rested his drawing paper on the cover of a book in order to work. Many of the large shaded areas show a pattern in the color like that achieved by drawing on top of a buckram book cover. This patterning may have been intentional, for it occurs in certain parts of a drawing, while lacking in other parts of the same drawing. For example, close examination of the original drawing in plate 53 reveals this patterning under the hoofs of both horses and under the large black areas of the horse on the left. Similarly, the buckram patterning is visible in the large expanse of the pink mare's body on the right of plate 41, but nowhere else in this drawing.

Everything is drawn freehand, with the sole exception of the hoops in the drawings of sacred altars (see pls. 3, 4, 5, 6). All of these are precise 2 ¼ in. (5.7 cm) circles, drawn around some template — perhaps an ink bottle. The hoops in the animal dreamer images, in contrast, were drawn freehand (see pls. 10–15).

The Binding of the Drawings

A TYPEWRITTEN STATEMENT by Edith Teall (see appendix 2), the daughter of William Edward Caton, the man who commissioned the drawings, says that her father took the drawings to Minneapolis. There he had them mounted and bound in a classic hand-bookbinding technique of the sort still practiced by specialists today. The book is covered in full calfskin of a deep, rich brown color. The leather was applied to beveled boards measuring 10 ⅛ x 15 ⁹/₁₆ in. (25.7 x 39.5 cm). Gold leaf decorative banding runs around the edge of the front cover (pl. 77), and the title is also stamped in gold leaf on the front, all in capital letters:

<div align="center">

INDIAN PICTURES

DRAWN BY

BLACK HAWK

CHIEF MEDICINE MAN

OF THE

SIOUX

</div>

The back cover was hand-tooled with an embossing wheel, but no gold leaf was applied to the tooling. The cover is today distressed, with numerous nicks and scratches. The spine has five raised bands with green leather between the first, second, and third bands. The abbreviated title

<div align="center">

INDIAN SKETCHES

BLACK HAWK

</div>

is applied in gold leaf to the green leather between the bands.

The headbands are hand sewn. The endpapers are of a French shell marble pattern.[4] Each sheet of Black Hawk's drawings was glued onto a linen backing, and the drawings were interleaved with rag paper before binding, as was customary in fine drawing books of the era. The rag paper has an 1878 watermark of a crane, the emblem of the Crane Paper Company of Westfield, Massachusetts, which

was as well known for its fine papers in the nineteenth century as it is today.

The colored inks in the drawings remain bright, having been protected from light. On some pages, where a great deal of graphite was used, there is some smudging on the rag paper interleaves. There is occasional rusty bleeding through of iron, as if from the interleaves (see pl. 25, in front of the horse's face, for example).

At some point in the twentieth century, the book's binding was repaired. The original marbled paper flyleaves were rebacked with plain paper. Japanese rice paper was added at several corners of the flyleaves to stabilize the cracking paper. New leather was added to stabilize the exterior cover hinge, and new leather interior hinges were added, front and back, as part of the rebacking process. There are no apparent repairs to the individual drawing pages themselves, which are in excellent condition.

The Sequence of the Drawings

CATON DID NOT BIND the drawings in any discernible order, although it seems clear that the vivid visionary images of Thunder Beings were intentionally placed first. Following is a concordance of the original sequence of plates in the bound drawing book (numbers on the left) and the plate numbers they have been given in this monograph (numbers on the right).

1—1	27—13	53—66
2—2	28—17	54—5
3—27	29—25	55—6
4—28	30—12	56—58
5—8	42—39	57—72
6—22	32—61	58—3
7—75	33—48	59—4
8—37	34—74	60—59
9—26	35—47	61—67
10—68	36—57	62—54
11—69	37—71	63—24
12—70	38—18	64—49
13—65	39—14	65—42
14—64	40—44	66—35
15—62	41—43	67—33
16—56	31—40	68—23
17—9	43—21	69—55
18—34	44—11	70—38
19—32	45—15	71—46
20—29	46—16	72—63
21—7	47—45	73—73
22—31	48—10	74—60
23—30	49—52	75—19
24—53	50—50	76—51
25—41	51—76	
26—20	52—36	

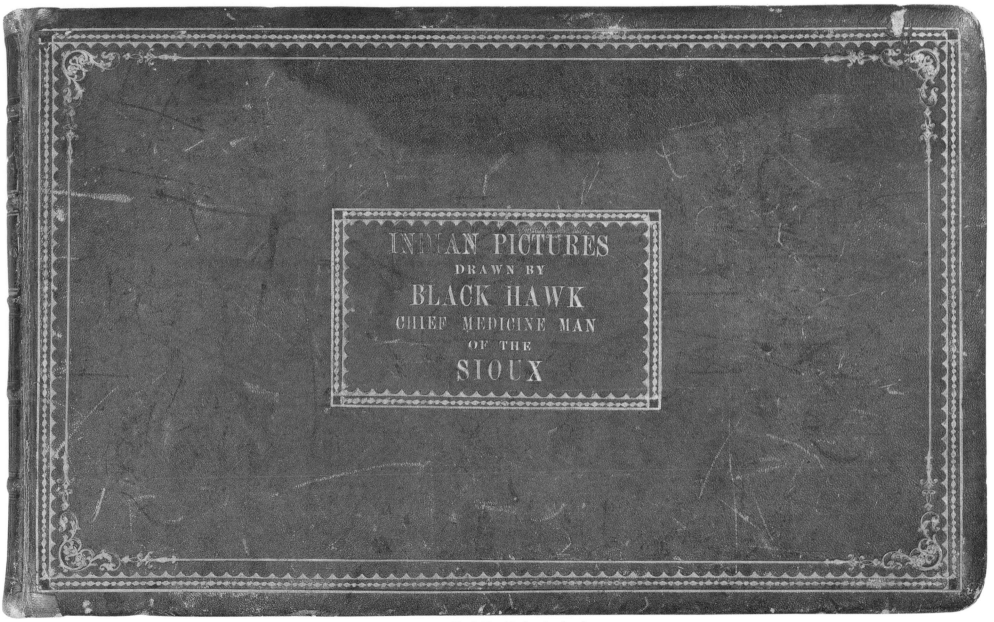

PLATE 77 Black Hawk's drawing book

HISTORICAL DOCUMENTATION FROM THE CATON FAMILY

THE TEXT BELOW was typed on a sheet of paper found taped to the inside cover of the Black Hawk drawing book. This sheet, providing valuable clues to the history of these works of art, accompanied the book as it made its way from the possession of the Caton family to the Los Angeles County Museum of History, Science, and Art, where it was displayed and copied in 1933; later to a file cabinet where it was abandoned in the breakup of a household estate; to Sotheby's in New York in 1994; then to a dealer's hands, a collector's home, and, finally, a public art museum.

Bound volume of INDIAN PICTURES DRAWN BY BLACK HAWK, CHIEF MEDICINE MAN OF THE SIOUX

Collected by William Edward Caton, Indian Trader at the Cheyenne Agency in Dakota, and bound in 1881.

76 pages.

"This series of sketches by Black Hawk represents the incidents in a long dream which he had.*

"The winter of 1880–81 was a very severe one at the Cheyenne Agency in Dakota. My father, William Edward Caton, was Indian Trader at the agency, having been appointed to this position in 1878. He was held in high esteem by the Indians and was their great friend.

"Black Hawk, Chief Medicine Man of the Sioux was in great straits that winter, having several squaws and numerous children dependent upon him. He had absolutely nothing, no food, and would not beg. Father knew his condition; he also knew that Black Hawk had had a wonderful dream. So he sent for him and asked him to make pictures of the dream, offering to furnish paper and pencils, and to give him 50 cents in trade at the store for each sheet he brought in. Father gave him what paper he had on hand, which was ordinary double foolscap, and ink and pencils.

"The Cheyenne Agency used to be 30 miles north of old Fort Pierre. Father took the sheets to Minneapolis, had them mounted and properly bound."

—Statement by Mrs. Edith M. Teall (daughter of compiler Wm. E. Caton), Redlands, California, August 21, 1932.

*The series started as a dream story, and Mr. Caton began to write the explanations. This idea was not carried out. The collection includes pictures of men and women in full costume, dances and various ceremonials of war, courtship and the hunt, many horses, buffalo, bear, Bighorn sheep, deer, bats, birds and prairie dogs. Arthur Woodward, Curator of History at the Los Angeles Museum in 1933, considered the record of costume, implements, designs and activities sufficiently valuable to have copies made for the Museum. Mrs. W. E. Caton, my grandmother, who gave me the book, asked that it go eventually to the Smithsonian Institution.

Dorothy M. Caton
P.O. Box 42
Carmel Valley, Calif.
7/23/63

NOTES

PREFACE

1. Sotheby's, *Fine American Indian Art,* lot 174.

2. See Berlo, ed., *Plains Indian Drawings,* pp. 71, 188–93; Berlo, "Nineteenth-Century Plains Indian Drawings," pl. 20; Berlo, "Plains Indian Drawings," pl. 3; Berlo, "Spirit Horses and Thunder Beings," p. 208; Berlo, "Artists, Ethnographers, and Historians," figs. 4, 8; Vincent and Berlo, "Black Hawk's Drawing of a Vision," p. 200; Berlo and Phillips, *Native North American Art,* pl. 16; Vincent, Brydon, and Coe, eds., *Art of the North American Indians,* pp. 145–47.

3. See Blish, *Pictographic History of the Oglala Sioux;* Ritzenthaler, "Sioux Indian Drawings."

CHAPTER ONE

1. In DeMallie, *The Sixth Grandfather,* p. 115.

2. See Rice, *Deer Women and Elk Men,* p. 106; G. Sword in Walker, *Lakota Belief and Ritual,* p. 79.

3. See Neihardt, *Black Elk Speaks,* chap. 3; DeMallie, *The Sixth Grandfather,* pp. 93–99, 109–42. Black Elk's narrative is quoted further in chap. 2, see p. 30.

4. For some of the finest examples of these, see Maurer, *Visions of the People,* pp. 144–48; Horse Capture et al., *Robes of Splendor,* pls. 4–6; Taylor, *Buckskin and Buffalo,* pp. 12, 28, 48, 63.

5. Walker, *Lakota Society,* p. 18. James Walker was a physician and amateur ethnologist who worked with Lakota people at the Pine Ridge Reservation in South Dakota from 1896 to 1914; he assembled an astonishing amount of data on traditional life and thought that has been published in three volumes: *Lakota Society, Lakota Myth,* and *Lakota Belief and Ritual.*

6. This terminological morass is admirably outlined in Powers, *Oglala Religion,* chap. 1. The Yankton and Santee Sioux are not part of the Lakota or Western Sioux designation and speak a dialectical variant of a Siouan language. Other tribes, like the Assiniboine, Crow, and Mandan, who are not ethnically Sioux, speak languages in the Siouan language family. For a short guide to Siouan speakers, see Parks, Liberty, and Ferenci, "Peoples of the Plains," especially pp. 290–94.

7. Some Lakota bands were given French names (Brulé, or "Burnt Thighs"; Sans Arc, or "Without Bows") in the eighteenth and nineteenth century by French traders, first from Canada and the Great Lakes region and later from St. Louis. The names the French gave them became fixed in the written literature.

8. See Hyde, *Red Cloud's Folk,* for a first-rate analysis of all of the diverse sources on the seventeenth through nineteenth century. My brief synopsis depends directly upon his work, as well as White's superb essay, "The Winning of the West," and Mekeel, "Short History of the Teton-Dakota."

9. Hyde, *Red Cloud's Folk,* p. viii.

10. For a thorough discussion of a century's worth of controversies surrounding the Black Hills, see Lazarus, *Black Hills/White Justice.* A Lakota interpretation of the Black Hills as the ancestral homeland from which the Lakota emerged and to which they returned was expressed in a public presentation by Victor Douville, Rosebud tribal historian, July 21, 1998, at the Colorado Historical Society, Denver.

11. Peters, *Seven Trails West,* p. 111.

12. To give some sense of the numbers involved, about 2,600 buffalo robes were shipped down the Missouri River to St. Louis annually between 1815 and 1830. In 1848, 110,000 robes were shipped. See White, "The Winning of the West," p. 330. For a quotation by an eyewitness concerning the size of mid-nineteenth-century buffalo herds, see my section on buffalo hunting in chap. 2, p. 111.

13. See White, "The Winning of the West," pp. 328–29.

14. Lakota social structure and customs are illuminated further in Walker, *Lakota Society.* A vivid portrait of Lakota life in a nineteenth-century camp is provided in the novel *Waterlily,* written by Yankton Sioux author Ella Deloria in the 1940s but not published until 1988.

15. For women's arts, see Torrence, *The American Indian Parfleche.* Lakota women's quillwork and beadwork are amply represented in all major

exhibition catalogues of Plains material. See especially Maurer, *Visions of the People*. Early, well-documented material is found in Hanson, *Little Chief's Gatherings*; Markoe, *Vestiges of a Proud Nation*.

16. Hassrick, *The Sioux*, pp. 42–44.

17. This is my paraphrase of the original myth (which appears in Wissler, *Societies and Ceremonial Associations*, p. 93). Double Woman's name refers to her appearance; she looks like a human woman, yet has two personas. She had been beautiful, yet was punished for infidelity by acquiring a second, horrific face. At once a benefactress to womankind and a temptress to men, Double Woman figures prominently in all discussions of Lakota women's arts, for she was the supernatural agent by which women first learned to make art. See Powers, *Oglala Religion*, pp. 58–59. For other instances in the Native American world of women being given artistic designs through dreaming, see Bunzel, *The Pueblo Potter*, pp. 49–55; Landes, *The Ojibwa Woman*, pp. 3–9, 19–20.

18. Walker, *Lakota Belief and Ritual*, pp. 165–66.

19. DeMallie, "Male and Female in Traditional Lakota Culture," p. 247. For further elucidation of the Double Woman myth, and other stories concerning women and art, see Berlo, "Dreaming of Double Woman."

20. Powers, *Oglala Women*, p. 70.

21. Hassrick, *The Sioux*, p. 42.

22. A Lakota supernatural figure, as quoted in T. Tyon, "The Pipe is *Wakan*," in Walker, *Lakota Belief and Ritual*, p. 149.

23. This story is not meant to show a distaste for sexuality, but rather to illustrate what happens to someone who does not recognize that he is

in the presence of something sacred. Arthur Amiotte, personal communication, 1995. The story of White Buffalo Woman and the gift of the Sacred Pipe varies in its details according to who has related the tale. See T. Tyon, "The Pipe is *Wakan*," in Walker, *Lakota Belief and Ritual*, pp. 148–50; P. Phillips, in Dorsey, "Legend of the Teton Sioux Medicine Pipe"; Finger, in Walker, *Lakota Belief and Ritual*, pp. 109–12; Black Elk in DeMallie, *The Sixth Grandfather*, pp. 283–88; Brown, *The Sacred Pipe*, chap. 1. Arval Looking Horse, the current Keeper of the Sacred Pipe, relates the story in "The Sacred Pipe in Modern Life," in DeMallie and Parks, *Sioux Indian Religion*.

24. See Berlo, ed., *Plains Indian Drawings*, pl. 128.

25. Howard, *The Warrior Who Killed Custer*, p. 15.

26. See Howard, *The Warrior Who Killed Custer*, p. 12; Vestal, *Warpath*, p. 263.

27. I have drawn upon diverse passages in Hyde's *Red Cloud's Folk* pertaining to the Sans Arc. See also Robinson, "Reports of the Commissioner of Indian Affairs"; Howard, "The Dakota or Sioux Indians"; Lawson, "Reservoir and Reservation"; Hoxie, "From Prison to Homeland."

28. Most of the details in this section come from Anderson, "History of the Cheyenne River Agency."

29. Mekeel, "Short History of the Teton-Dakota," p. 187.

30. See Hyde, *Red Cloud's Folk*, pp. 114, 153, 159, 261, 267, 291–92 for discussion of the movement of the Sans Arc in the 1860s and 1870s. The spring of 1877 was also when nearly one thousand members of Crazy Horse's band surrendered at nearby Camp Robinson, adjacent to the Red Cloud Agency. See Buecker and Paul, *The Crazy Horse Surrender Ledger*.

31. Robinson, "Reports of the Commissioner of Indian Affairs," p. 320. See also pp. 181, 183, 211.

32. Anderson, "History of the Cheyenne River Agency," p. 459.

33. Anderson, "History of the Cheyenne River Agency," p. 454.

34. The following year, an army officer stationed at the Cheyenne River Agency reported that of 1,046 horses and mules surrendered, 874 had brands identifying them as U.S. Army property. Presumably some of these had been taken at the Battle of Little Big Horn and other skirmishes. See Hyde, *Red Cloud's Folk*, p. 260.

35. Record group 75, document no. 518467, box 565. Bureau of Indian Affairs, Cheyenne River Sioux Agency, National Archives, Central Plains Region, Kansas City, Mo.

36. We don't know the prices paid for most commissioned drawing books, but for comparison, the Kiowa and Cheyenne prisoners at Fort Marion, Florida, in 1875–78 sold their sketchbooks of 12–24 drawings for $1–$2 per book. They were allowed to keep the proceeds and spend it on themselves. The Lakota artist White Bull, during the Great Depression, sold two versions of his pictorial and narrative autobiography, each with some three dozen drawings, for $50 and $70 in 1931 and 1932. See Howard, *The Warrior Who Killed Custer*, p. 2; Miles and Lovett, "Deeds that Put a Man among the Famous," p. 54.

On the Southern Plains, the situation was similar. In 1890–91, the Whirlwind ledger was traded for "several sides of bacon," while in 1897, Hugh Scott paid Silver Horn $50 for a book of drawings (Candace Greene, personal communication, 2000).

37. See Weeks, "Report on the Statistics and Wages," pt. 2, p. 29.

38. See Weeks, "Report on the Statistics and Wages," pt. 1, pp. 5, 58.

39. Many Indian names, including Black Hawk's, occur in different tribes and at different times. For example, the most famous Black Hawk (1767–1838) was a Sauk chief who fought on the side of the British in the War of 1812. Closer to home, Black Hawk was a name found among other Lakota bands at the end of the nineteenth century. See, for example, Buecker and Paul, *The Crazy Horse Surrender Ledger*, pp. 28, 79, 89, 123, 127, 139. Curiously, there is an African-American religious sect in New Orleans known as the Black Hawk religion, which is loosely based on the figure of the Sauk chief Black Hawk. See Berry, *The Spirit of Black Hawk*; Bettelheim, "Costume Types and Festival Elements."

40. Thus we find, for example, in the Crazy Horse Surrender Ledger of 1876–77 recorded at the Red Cloud Agency, Nebraska, names like Meat Prick, Steals Cunt, Tobacco Ass, Died in Shit, and Pretty Rump recorded alongside more classically poetic names such as Standing Bear, Good Heart, American Horse, and Whirlwind. See ledger pp. 63, 68, 75, and 128, respectively, in Buecker and Paul, *The Crazy Horse Surrender Ledger*.

41. An account of a white woman's life among the Lakota at the end of the nineteenth century mentions that a medicine man named Gray Hawk lived at the Cheyenne River Agency in the 1880s. See Duncan, *Blue Star*, p. 203. It is tempting to wonder if he and Black Hawk are the same person. In the Lakota language, *sapa* is black, while *saopapa* and *saokpukpe* (both with the first "a" nasalized) are the words for gray. See Buechel, *Lakota-English Dictionary*, p. 680.

42. Record group 75, document no. 518236–237. Bureau of Indian Affairs, Cheyenne River Sioux Agency, National Archives, Central Plains Region, Kansas City, Mo.

43. Document nos. 518345 (1882), 518395 (1885–87).

44. Arthur Amiotte and I are grateful to Mr. Russ McClure, superintendent of the Cheyenne River Sioux Agency, Sue Ella High Elk of the Realty Office, and Charlene Anderson, Research Specialist at the Realty Office, who aided us with our inquiries in their offices in the summer of 1995.

As an aside, it may be noteworthy that the son of Black Hawk and Hollow Horn Woman was born in 1862. Could this be the son listed as one of Black Hawk's four family members in this entry for 1886 in one of the registers of Indians? "Black Hawk, male, 55 years; Birds Are Afraid male, 24 years; female 54 years; girl 15 years, girl infant 1 yrs." (document no. 518365, entry no. 354, National Archives, Kansas City). If Birds Are Afraid (also born in 1862, if he was 24 in 1886) had been baptized sometime after 1886 by the Episcopal missionaries at the Cheyenne River Sioux Agency, he may well have been given a simple Christian name like John. All of this remains in the realm of conjecture, however, subject to further research.

45. Record group 75, document no. 518394, record of male Indians over the age of twenty-one, Bureau of Indian Affairs, Cheyenne River Sioux Agency, National Archives, Central Plains Region, Kansas City, Mo.

46. Yet even these records lack clarity. People known as Birds Afraid of Him and Hollow Horn Woman (age and sex of each unknown) are listed as survivors at Wounded Knee. Yet the name of the wife of the Black Hawk killed at Wounded Knee is variously listed as She Bear, Cheyenne Woman, or Comes Out. See Jensen, "Big Foot's Followers at Wounded Knee," pp. 202, 204. See also my prior note on Birds Are Afraid, n. 44.

47. Jensen, "Big Foot's Followers at Wounded Knee," p. 198.

48. Howard, *The Warrior Who Killed Custer*, p. 54.

49. See citations in n. 4, this chap. Possible early Lakota examples appear in Taylor, *Buckskin and Buffalo*, pp. 48, 63.

50. A more complete history of the genre can be found in Berlo, ed., *Plains Indian Drawings*. See also Szabo, *Howling Wolf*. Portions of this section on Lakota drawings appear in a slightly different and longer version as "A Brief History of Lakota Drawings," in Berlo, ed., *Plains Indian Drawings*, pp. 34–39.

51. See appendix 1 for further discussion of the kind of paper Black Hawk used.

52. Two of these drawings, including the one in figure 3, are in the collection of Mark Lansburgh; see also Maurer, *Visions of the People*, pp. 242–43. Two others are in the collection of Charles and Valerie Diker; see Berlo, ed., *Plains Indian Drawings*, pp. 220–21. Five or six others are said to be scattered in private collections. These drawings were all once in the collection of Paul Dyck, who was married to Swift Dog's niece. They are said to have been given to him by Swift Dog's family in the 1930s, following Dyck's wife's death in childbirth, as an act of honor (Mark Lansburgh, personal communication, 2000). They have been dated in some publications as "circa 1870" and "circa 1866" (Maurer, *Visions of the People*, p. 242; McCoy, "Swift Dog," p. 629). These dates were apparently assigned on the basis of their stylistic affinities with early hide paintings; the rest of Swift Dog's oeuvre

clusters between 1890 and 1922. The precision of detail in clothing and weaponry in these drawings makes the early date of about 1870 unlikely, yet they surely antedate the muslins he painted in his old age (see McCoy, "Swift Dog," figs. 3, 4, 6). Moreover, as Swift Dog was a member of Sitting Bull's band, which retreated to Canada in 1876 rather than submit to reservation life, it seems improbable that he could have held onto these fragile drawings for four or five decades.

53. For illustrations and further discussion of these drawings, see Berlo, ed., *Plains Indian Drawings*, pp. 198–99; Maurer, *Visions of the People*, pp. 212–13. Yet even Four Horns's drawings are almost certainly not the earliest ones executed. In the collection of the National Museum of the American Indian is a book of drawings said to be by a Sioux artist named Samuel. While the catalogue data are sketchy, they note that the book was "Collected by General William Nicholson Grier during Indian Campaigns in the West 1835–1861" (National Museum of the American Indian, catalogue no. 23/2855). The drawings are on the unlined pages of a small notebook and show scenes of mounted warriors as well as warriors in procession on foot. At this point, the collection history of this drawing book is not secure enough to include here.

54. See Stirling, "Three Pictographic Autobiographies of Sitting Bull," p. 37. Known as the Pettinger Record, after Pratt's descendants who brought them to the attention of scholars at the Smithsonian, the Pratt drawings eventually came into the collection of the Buffalo Bill Historical Center in Cody, Wyoming. Lieutenant Tear's drawings, called the Smith Record, are in the collection of the Smithsonian Institution.

55. Stirling, "Three Pictographic Autobiographies of Sitting Bull," p. 35.

56. Hewitt, ed., *Journal of Rudolph Friederich Kurz*, p. 301.

57. This same expansion of the pictorial repertory occurs elsewhere on the Plains. In the 1870s Kiowa and Cheyenne men incarcerated at Fort Marion, Florida, drew scenes of courtship, daily life, and ceremonial activity. See Petersen, *Plains Indian Art from Fort Marion*; Szabo, *Howling Wolf*; Viola, *Warrior Artists*.

58. Although I recognize that individual students at the Hampton Institute in the years after 1879 drew images of ceremonial activity, these drawings do not exhibit the complex narrative character seen in the Black Hawk oeuvre.

In November 1878, forty-nine young Lakota and individuals from other Northern Plains tribes arrived at the Hampton Institute in Virginia to join some young Southern Plains men who had gone there directly from their incarceration at Fort Marion, Florida (1875–78). Many of these students made drawings; presumably the Lakota artists were influenced by the Fort Marion artists to expand their subjective and stylistic repertoire. While some of the Sioux artists drew memories of traditional life on the Plains, we also see the first visual descriptions of ceremonial actors such as Black-Tailed Deer Dancers and Elk Dreamers (Ewers, Mangelsdorf, and Wierzbowski, eds., *Images of a Vanished Life*, figs. 7, 29, 37). Such images became among the most prevalent in Lakota drawings of the 1880s and 1890s (see chap. 2, pp. 50–57). Other Hampton Institute drawings reveal the dramatic changes that reservation life had brought to a recently mobile people, such as log cabins and plowed fields (Ewers, Mangelsdorf, and Wierzbowski, eds., *Images of a*

Vanished Life, figs. 10, 12, 15). These drawings are the first to chronicle, for Northern Plains people, the dramatic processes of acculturation rendered so vividly (and in greater numbers) by Southern Plains artists.

59. Many of Sinte's drawings, in the American Museum of Natural History, remain unpublished, but see Berlo, ed., *Plains Indian Drawings*, pp. 216–19.

60. For a discussion of the clothing of the figure on the left as diagnostic of the Crow, see chap. 2, p. 110. For further discussion of Red Hawk's drawing book, see Berlo, ed., *Plains Indian Drawings*, pp. 210–15.

61. Helen Blish's book, *A Pictographic History of the Oglala Sioux*, thoroughly documents the drawing book, based on her own study of it between 1927 and 1940 and interviews with the artist's relatives.

62. Blish, *Pictographic History of the Oglala Sioux*, p. 8.

63. It may be noteworthy that Bad Heart Bull's uncle, Short Bull, himself a noted artist and historian, moved to Pine Ridge in 1890, the same year that Bad Heart Bull commenced his magnum opus. See Wildhage, "Material on Short Bull"; McCoy, "Short Bull."

64. See Blish, *Pictographic History of the Oglala Sioux*, figs. 80, 81, 210, 362, 363.

65. For the other drawings, see Blish, *Pictographic History of the Oglala Sioux*, figs. 133–69. This episode of the battle occurred on the afternoon of June 25, 1876. Major Reno's battalion, moving separately from Custer's principal troops, sighted the enormous encampment of Lakota and Cheyenne. Realizing that his meager force of 135 men had no hope of successfully attacking the village, Reno ordered them to form a skirmish line. As they were overwhelmed by

Indian warriors, Reno ordered his men to retreat. The Indians pursued and routed them across the Little Big Horn River, killing some men and capturing some horses. See Map 20 and its descriptive caption in Robertson et al., *Atlas of the Sioux Wars.* For oral recollections, from the Native point of view, of the events Bad Heart Bull illustrates, see Greene, *Lakota and Cheyenne,* chap. 3.

66. See, for example, Densmore, *Teton Sioux Music;* Vestal, *Warpath;* Wissler, "Societies and Ceremonial Associations." For discussion of the circulation of Lakota art in the early-twentieth-century tourist trade, see Bol, "Defining Lakota Tourist Art."

67. For No Two Horns, see Wooley and Horse Capture, "Joseph No Two Horns"; Berlo, ed., *Plains Indian Drawings,* pp. 204–7. For White Bull, see Miles and Lovett, "Deeds That Put a Man among the Famous"; Howard, *The Warrior Who Killed Custer;* Berlo, ed., *Plains Indian Drawings,* pp. 222–23. For Kills Two, see chap. 1, n. 70; for Standing Bear, see chap. 1, n. 69.

68. Maurer, *Visions of the People,* p. 31.

69. Most of the details of Standing Bear's life were told to me by his great-grandson, Arthur Amiotte, in conversations in 1995. One of Standing Bear's muslins is thoroughly explicated and illustrated by Peter Powell in "Sacrifice Transformed into Victory." Thirty-one of Standing Bear's drawings on paper, one of which is illustrated here (see fig. 9), are held in the Buechel Museum, St. Francis Mission, Rosebud, South Dakota.

70. A selection of ten of Kills Two's works were reproduced in part 1 of H. B. Alexander's famous portfolio, *Sioux Indian Painting,* where it was written that they were in Alexander's own collection. The current whereabouts of these works is unknown. Another drawing on paper by Kills Two is in the collection of the Burke Museum, University of Washington, Seattle (accession no. 24E167). The work of both Kills Two and Bad Heart Bull was exhibited at the Exposition of Indian Tribal Arts in New York City in 1931, where both were celebrated for their pictorial boldness and expressiveness. See Alexander, "The Art of the American Indian"; Alexander, "The Bad Heart Buffalo Manuscript."

CHAPTER TWO

1. The full text appears in appendix 2.

2. Appendix 1 lists the drawings in the sequence in which they appear in the bound book.

3. In Walker, *Lakota Belief and Ritual,* p. 79.

4. For a first-person account of a contemporary Lakota Vision Quest, see Amiotte, "Eagles Fly Over." For a classic anthropological account, see Benedict, "The Vision in Plains Culture." A superb recent account, from the vantage point of the history of religion, is provided in Irwin, *The Dream Seekers.*

5. For the meaning of the rainbow, see DeMallie, *The Sixth Grandfather,* p. 115.

6. In DeMallie, *The Sixth Grandfather,* p. 132.

7. In Dorsey, *A Study of Siouan Cults,* p. 442.

8. Wissler, "Societies and Ceremonial Associations," p. 98.

9. See Rice, "*Akicita* of the Thunder"; DeMallie, *The Sixth Grandfather,* pp. 84–89.

10. My quotation is abbreviated from the stenographic transcription provided in Demallie, *The Sixth Grandfather,* pp. 114–15. Neihardt, *Black Elk Speaks,* provides a slightly different version in chap. 3.

11. Fifty years later, Standing Bear drew Black Elk's Horse Dance performance. Like Black Hawk, he drew the horned riders and the hail-spotted horses. See his unpublished drawings collected by Father Eugene Buechel, now in the collection of the Buechel Museum, St. Francis Mission, Rosebud, South Dakota, and unpublished drawings in the John Neihardt Collection, Library Archives, University of Missouri–Columbia, as well as one drawing published in color in the 1972 paperback edition of *Black Elk Speaks.*

12. For Bad Heart Bull's drawing, see Blish, *Pictographic History of the Oglala Sioux,* pl. 318. For Lakota shields of Thunder Horses, see Maurer, *Visions of the People,* pl. 87; Feder, *American Indian Art,* pl. 35. For a hand drum with Thunder Being imagery painted at Pine Ridge by Eddie Little Chief, see Penney, *Art of the American Indian Frontier,* p. 284. The whereabouts of the drawing in fig. 12 is unknown. It seems to exist today only in a microfilm copy in the Mrs. Edward M. Johnson Collection, microfilm roll no. 0220, p. 121, State Historical Society of North Dakota, Bismarck. Three Arapaho drawings that show similar luminous figures astride supernatural horses occur in the Henderson Ledger Book, drawn in 1882. See Petersen, *American Pictographic Images,* pls. 13, 15, 24, 25; in the last image, these figures are depicted in a scene in which they appear to a man in a vision.

13. T. Tyon, in Walker, *Lakota Belief and Ritual,* p. 149.

14. See Amiotte, "The Lakota Sun Dance," p. 85.

15. The present keeper, Orval Looking Horse, considers himself Minneconjou, through his father.

For the number of generations that his family has owned the pipe, see Looking Horse, "The Sacred Pipe in Modern Life," in DeMallie and Parks, *Sioux Indian Religion*. Other accounts suggest fewer generations. See Thomas, "A Sioux Medicine Bundle," p. 607; Smith, *Short History of the Sacred Calf Pipe*, pp. 6–9 (discusses the divergent genealogies given by previous writers on the subject). It is fruitless to try to reconstruct an exact genealogy that might extend prior to the early nineteenth century. The point is simply that "from time immemorial," this family has been the Keeper of the Sacred Pipe.

16. The Sacred Buffalo Calf Pipe is pictured in Thomas, "A Sioux Medicine Bundle," pl. II. A Sioux pipe bowl carved in the shape of a buffalo calf—as many observers insist the original Sacred Pipe was—is illustrated in Ewers, *Plains Indian Sculpture*, pl. 5.

17. The concept of a sacred bundle or a medicine bundle is both widespread and ancient among the aboriginal inhabitants of Meso- and North America. Sacred bundles may contain items pertaining to ancestors, or powerful objects from nature such as mysterious stones or body parts from efficacious animals. See, for example, Wildschut and Ewers, *Crow Indian Medicine Bundles;* Thomas, "A Sioux Indian Medicine Bundle."

18. See Smith, *Short History of the Sacred Calf Pipe*, p. 15, fig. after p. 20. See also Smith, "Ceremony for the Preparation of the Offering Cloths." When Arthur Amiotte witnessed the bringing out of the Sacred Pipe in 1973, a ceremony officiated by Frank Fools Crow, the pipe was displayed in an enclosure ringed with four cherry trees and offering cloths were tied to each of these trees (Amiotte, personal communication, February 2000).

19. Catlinite, named for the American painter and author George Catlin, is an easily carved red stone, the principal souce of which is a quarry near present-day Pipestone, Minnesota. It is prized by numerous Plains and Great Lakes tribes for the making of pipes. For superb examples of Lakota and other pipes, see Ewers, *Plains Indian Sculpture*, chap. 2; Vincent, Brydon, and Coe, eds., *Art of the North American Indian*, p. 153; Conn, *Native American Art*, figs. 144–48.

20. The sacred hoop (*cangleska wakan*) became an important metaphor in twentieth-century Lakota thought, referring to the collective identity of the Lakota people in particular, and the essential oneness of all of creation in general. See Neihardt, *Black Elk Speaks*. This metaphor grows out of the circle of tipis in the camp—the primal metaphor for social solidarity. See Powers, *Oglala Religion*, p. 41.

21. See Rogers, *Lakota Names and Traditional Uses for Native Plants*, pp. 36, 50. This book is based on information and plant samples that Eugene Buechel collected in 1920.

22. Mountain lion-skin quivers are very distinctive because the animals' legs and paws are left attached, as if the arrows are taken from inside one living animal to find their target within another. See Berlo, ed., *Plains Indian Drawings*, pls. 32, 69, 72, 131, for depictions of these quivers in other Plains drawings.

23. For Northern Plains dresses, see Penney, *Art of the American Indian Frontier*, pls. 60, 115. See also Penney and Longfish, *Native American Art*, p. 80, for a fine early beaded and quilled dress collected on the Upper Missouri River by Louis and Clark in 1804. For fine women's robes from the Plains with parallel lines of quillwork, see Hanson, *Little Chief's Gatherings*, figs. 49, 50;

Penney, *Art of the American Indian Frontier*, pl. 124. Lakota and other women ornamented many items with parallel rows of bead- or quillwork, sometimes punctuated with little red wool tufts, like Black Hawk's depiction of this robe. See, for example, Hanson, *Little Chief's Gatherings*, figs. 44, 45, 60.

24. For a good color plate of fig. 13, see Furst and Furst, *North American Indian Art*, pl. 4.

25. See Corum, "A Teton Tipi Cover Depiction," p. 235. See also Weygold, "Das indianische Lederzelt." For a photo of the Sacred Pipe as it looked when it was unwrapped in 1934, with its feathered attachments, see Thomas, "A Sioux Medicine Bundle," pl. II.

26. Smith, *Short History of the Sacred Calf Pipe*, chart after p. 8.

27. Smith, *Short History of the Sacred Calf Pipe*, p. 8, pl. 5.

28. Amiotte, "The Lakota Sun Dance," p. 84.

29. The Kiowa, on the Southern Plains, in contrast to most other groups, do not shed blood or cut flesh in the Sun Dance. See Scott, "Notes on the Kado," p. 345.

30. For censorious, early accounts of the Sun Dance, see Paige, "George W. Hill's Account of the Sioux Sun Dance." Among the standard sources on the Lakota Sun Dance are Walker, "The Sun Dance and Other Ceremonies"; Fletcher, "Lakota Ceremonies"; Densmore, *Teton Sioux Music*. The recent history of the Sun Dance is recounted in Mails, *Sundancing at Rosebud and Pine Ridge*. A fine, succinct account is provided in Powers, *Oglala Religion*, pp. 95–100. For noteworthy accounts by Sioux people themselves, see Deloria, "Sun Dance of the Oglala Sioux"; Amiotte, "The Lakota Sun Dance"; Amiotte, "The Road to the Center," as well as

numerous accounts by Lakota informants compiled in Walker, *Lakota Belief and Ritual*.

31. Walker, "The Sun Dance and Other Ceremonies," p. 112, describes buffalo and rabbit-skin ornaments. More recent dancers customarily wear sage; see Mails, *Sundancing at Rosebud and Pine Ridge*, unnumbered photos, pp. 382–85.

32. Densmore, *Teton Sioux Music*, p. 125.

33. These books are the following: a drawing book said to be by Walter Bone Shirt, in a private collection (see Berlo, ed., *Plains Indian Drawings*, pp. 194–97); an unpublished drawing book in the collection of the Gilcrease Museum in Tulsa (accession no. 4526.13) inscribed with the name "Charles Littlefeather" or "Little Bear" (see fig. 14 herein); a drawing book in The Detroit Institute of Arts, published in part in Penney, *Art of the American Indian Frontier*, pp. 290–93 (see fig. 5 herein); and an unpublished collection of drawings labeled "Picket Pin, 1890," whereabouts unknown, photos in the collection of Arthur Amiotte. For a discussion of the stylistic relationship among these books see Berlo, ed., *Plains Indian Drawings*, p. 194.

34. Amiotte, "The Lakota Sun Dance," p. 88.

35. This is described in Walker, *Lakota Myth*, pp. 206–7. It is elegantly rendered in visual form in modern Lakota painting by Colleen Cutschall; see Cutschall, *Voice in the Blood*, pls. 1, 2.

36. Arthur Amiotte, personal communication, 1995. In some such scenes, a horse effigy rather than a buffalo is affixed to the pole. See Berlo, ed., *Plains Indian Drawings*, pl. 121.

37. See Blish, *Pictographic History of the Oglala Sioux*, figs. 11, 12, 13, 15, for Bad Heart Bull's depictions of the sacred paraphernalia, the piercing of

flesh, the dragging of buffalo skulls, and the associated animal dances.

38. One of these ambitious pictorial narratives has been thoroughly discussed by Powell, "Sacrifice Transformed into Victory" (see his n. 1 for mention of two others). One more, in the South Dakota Historical Society, was not included in Powell's list; it was identified as Standing Bear's work by Arthur Amiotte and me in the summer of 1995.

39. Quotes from John Gregory Bourke's diaries were transcribed from photocopies at the Center for Southwestern Research, Zimmerman Library, University of New Mexico, Albuquerque, document no. 917.8 B66d, vols. 43–44, abridged from pp. 1460–1504; handwritten originals are at the Library of the U.S. Military Academy, West Point, New York.

40. Siyaka, a Lakota at Standing Rock, quoted in Densmore, *Teton Sioux Music*, p. 184.

41. See Nunley and Bettelheim, *Caribbean Festival Arts*, p. 26. See also Nunley and McCarty, *Masks: Faces of Culture*.

42. Wissler, "Societies and Ceremonial Associations," p. 91.

43. Mails, *Fools Crow*, p. 79.

44. Five drawings of Buffalo Dreamers with similar iconography occur in an autograph book drawn by Walter Bone Shirt, who may have been a Brulé Lakota from Rosebud. See Maurer, *Visions of the People*, fig. 46, for an illustration of one Buffalo Dreamer. See Berlo, ed., *Plains Indian Drawings*, pp. 65, 194–97, for other drawings from Bone Shirt's book and more information on this artist. Three drawings by Picket Pin, a Brulé from Rosebud, show

similar dreamers. The location of the originals of these unpublished drawings is unknown; Arthur Amiotte has color photos of them, which Joseph Epes Brown gave him in the 1970s. Two drawings by Standing Bear (a Lakota from Pine Ridge) in the collection of the Buechel Museum, St. Francis Mission, Rosebud, South Dakota, are labeled "*Tatank kage*, buffalo bull making" (nos. 11 and 12 of a numbered series of thirty-two drawings made for Buechel). A Lakota book done by an unknown artist before 1892, in the National Anthropological Archives of the Smithsonian Institution, depicts drawings of Buffalo Dreamers as well (nos. 54,064A–B, one published in Brown, *Animals of the Soul*, p. 26). Finally, Bad Heart Bull illustrated two Buffalo Dreamers in his epic pictorial history, see Blish, *Pictographic History of the Oglala Sioux*, figs. 188, 190. In the latter, the Buffalo Dreamer is accompanied by two women in trade-cloth dresses who carry pipes, as in Black Hawk's drawings (pls. 12, 13).

45. For Black Hawk's natural history studies of the animals themselves, and discussion of these species, see pp. 129–30.

46. Wissler, "Societies and Ceremonial Associations," p. 90.

47. See n. 38 above.

48. Deer Dreamers with similar iconography occur in two drawings by Picket Pin, a Brulé from Rosebud, see n. 44 above; Penney, *Art of the American Indian Frontier*, p. 292. Standing Bear's drawing, no. 13 in the collection of the Buechel Museum, St. Francis Mission, Rosebud, South Dakota, is titled "*Sintesapela kage*, Blacktailed deer making." For Bad Heart Bull, see Blish, *Pictographic History of the Oglala*

Sioux, figs. 115, 187. David Simmons, a Sioux student at the Hampton Institute in Virginia in 1879, drew hoop-carrying Black-Tailed Deer Dreamers as well. See Ewers, Mangelsdorf, and Wierzbowski, eds., *Images of a Vanished Life,* pl. 29.

49. This feature occurs in the unpublished Picket Pin drawings, too. For discussion of the possible authorship of the Gilcrease drawings, see Berlo, ed., *Plains Indian Drawings,* p. 194.

50. Blish, *Pictographic History of the Oglala Sioux,* p. 201.

51. For Bad Heart Bull, see Blish, *Pictographic History of the Oglala Sioux,* fig. 190. For Brave Buffalo's dream, see Densmore, *Teton Sioux Music,* p. 179.

Aaron McGaffey Beede discusses the use of rattlesnake venom as a powerful charm: "I have heard old western Sioux Indians say that their ancestors in the old times would catch rattlesnakes and irritate them into fanging meat, and then dry the meat completely (other objects than meat were sometimes used) and from this poisoned substance they made, as required, a mixture which was rubbed onto places on the arms and chest (sometimes nearly all over the body) of a young warrior. This was done on the face also. The places where this poison was applied were somewhat irritated before it was applied. The process of thus doing, on the arms, face, chest, and other parts of the body, was not done all in one day, but parts became healed before it was applied to other parts. As many parts as thought safe for the person to endure were poisoned at the first poisoning because sometimes it would not 'take' after the first (more often after the second or third treatment). Some warriors thus treated were blotched (*kdekde*) all over, they say. A warrior thus tatooed had great

honor, they say, and his adversaries startled at his approach as creatures startle at the sound of a rattler—and even more so, because the venom of the rattler was now directed by the intelligence of the tatooed man." Unpublished notes from Fort Yates, North Dakota, September 19, 1924, Beede Archives, North Dakota Historical Society, Bismarck. For more information on Beede, see chap. 2, n. 159, below.

52. Both the quotation and the data in the next paragraph on war medicines are from Wissler, "Societies and Ceremonial Associations," p. 90.

53. Caption of unpublished drawing no. 15 by Standing Bear, Buechel Museum, St. Francis Mission, Rosebud, South Dakota.

54. Wissler, "The Whirlwind and the Elk," p. 261. An Elk Dreamer has been worked in beadwork on a vest illustrated in Maurer, *Visions of the People,* no. 53.

55. Fletcher, "The Elk Mystery or Festival, Oglalla Sioux," in "Lakota Ceremonies," pp. 285–87. See also Densmore, *Teton Sioux Music,* pp. 176–79, 295–98.

56. Darlene Young Bear, interview with the author and Arthur Amiotte. South Dakota, July 1995.

57. Densmore, *Teton Sioux Music,* p. 178, pl. 26.

58. The elk of transformation remains a powerful symbol as well as a family icon. The figure of an elk surrounded by the sacred hoop of transformation is incised on the carved gravestone of Mikeyela Black Elk (1961–1993), descendant of the celebrated Lakota holy man. Her gravestone is located in the cemetery at Manderson, South Dakota, on the Pine Ridge Reservation.

59. Unnumbered drawing in the Mary Collins Collection, South Dakota Historical Society, Pierre. For information on other drawings in

that collection, see Berlo, ed., *Plains Indian Drawings,* pp. 182–84. Several other unpublished drawings in the Collins Collection depict elks and Elk Dreamers.

60. In addition to the Sinte drawing illustrated here, there are other Elk Dreamers Society drawings in the Cronau Collection at the American Museum of Natural History, New York. Several of these were redrawn for publication in Brown, *Animals of the Soul,* pp. 107–8. (Note that on p. 108, top, a black bird is attached by a wavy line to the foot of the elk. It is similar in form to the black bird that hovers over the head of the elk in Black Hawk's drawing.) See also the unpublished Sinte drawing, no. 50.2100 37f, of elks and hoops. For more information on Sinte and the Cronau Collection of drawings, see Berlo, ed., *Plains Indian Drawings,* pp. 216–19.

61. See Blish, *Pictographic History of the Oglala Sioux,* pls. 113, 114; an Elk Dreamers performance is depicted in pl. 187. The series of unpublished drawings by Picket Pin (see chap. 2, n. 44, above) also includes two fine drawings of Elk Dreamers carrying hoops. For drawings illustrating Elk Dreamers made by Sioux students at the Hampton Institute in Virginia in 1879, see Ewers, Mangelsdorf, and Wierzbowski, eds., *Images of a Vanished Life,* figs. 7, 37.

62. It is sometimes called the Beloved Ceremony. See Brown, *The Sacred Pipe,* chap. 6; Walker, *Lakota Belief and Ritual,* pp. 193–241; Curtis, *North American Indian,* vol. 3, pp. 71–87; and Densmore, *Teton Sioux Music,* pp. 68–77.

63. Walker, *Lakota Belief and Ritual,* pp. 241–53, 302, n. 41. For other discussions of the female puberty ceremony, see Brown, *The Sacred Pipe,* chap. 7; Powers, *Oglala Women,* pp. 66–73; Walker, "The Sun Dance and Other Ceremonies," pp. 141–51.

64. See Brown, *The Sacred Pipe*, p. 117. The need for purification at this occasion is not meant to suggest that the young woman is "dirty." Rather, it is that menstrual blood brings power that competes with other sorts of power within the human community, and this power must be properly harnessed and channeled so as not to adversely affect other events.

65. Walker, "The Sun Dance and Other Ceremonies," p. 144.

66. Walker, "The Sun Dance and Other Ceremonies," p. 144; Brown, *The Sacred Pipe*, p. 111.

67. Walker, "The Sun Dance and Other Ceremonies," p. 146.

68. Stroud or strouding—red or blue woolen cloth, originally made in Stroud, England—was popular as a trade item across the Plains. Men made breechcloths and leggings out of it. Women made dresses, and both genders wore blankets made of stroud. It is readily recognizable in drawings, for many artists meticulously depict the undyed white selvage of the cloth.

69. Walker, "The Sun Dance and Other Ceremonies," p. 149.

70. Brown, *The Sacred Pipe*, p. 124.

71. Walker, "The Sun Dance and Other Ceremonies," p. 149.

72. As quoted in Brown, *The Sacred Pipe*, p. 126. The name of the young woman who, in Lakota tradition, was the first to receive this blessing, serves to remind people of the supernatural figure from whom it came: White Buffalo Woman.

73. Interview with the author and Arthur Amiotte, South Dakota, July 1995.

74. As quoted in Brown, *The Sacred Pipe*, p. 126.

75. Powers, *Sacred Language*, p. 154.

76. *Waterlily* is a novel of nineteenth-century Lakota life.

77. See Harris, *Between Two Cultures*, pp. 45–46; Berlo, ed., *Plains Indian Drawings*, pl. 48; Viola, *Warrior Artists*, pp. 29–30. Notably, most of the Southern Plains examples were drawn by men incarcerated at Fort Marion, Florida, in 1875–78, and may represent nostalgic memories of life back home.

78. See Walker, *Lakota Society*, pp. 38, 58. For Black Elk, see DeMallie, *The Sixth Grandfather*, p. 320; see also Price, "Lakotas and Euroamericans."

79. Darlene Young Bear, now deceased, interview with the author and Arthur Amiotte, South Dakota, July 1995.

80. For examples of such bags, which protected the pipe when it was not in use, see Conn, *A Persistent Vision*, fig. 41; Maurer, *Visions of the People*, figs. 112, 114, 227, 269; Hail, *Hau, Kóla!*, figs. 237–44.

81. See, for example, the photo of Lakota people from Rosebud published in Hail, *Hau, Kóla!*, fig. 100. For an exhaustive study of hair-pipe jewelry, see Ewers, *Hair Pipes in Plains Indian Adornment*.

82. Transcriptions from Lakota by Raymond DeMallie, based Eugene Buechel's inscriptions. These are in the Standing Bear drawings files, Buechel Museum, St. Francis Mission, Rosebud, South Dakota.

83. As quoted in DeMallie, "Male and Female in Traditional Lakota Culture," p. 254. Sioux author Ella Deloria's novel, *Waterlily*, vividly captures in fictional form the reality of male/female interaction in the mid-nineteenth-century Lakota world. For other

scenes of men and women wrapped in a blanket, see Harris, *Between Two Cultures*, pp. 57, 59; Greene, *Silver Horn*, fig. 9.1.

84. Blish, *Pictographic History of the Oglala Sioux*, pls. 86, 87, 112, 210, 355, 356.

85. See Densmore, *Teton Sioux Music*, p. 477, pl. 78; Wissler, "Societies and Ceremonial Associations," p. 78.

86. Hewitt, ed., *Journal of Rudolph Friederich Kurz*, p. 252.

87. Edward Curtis published a photo of a woman he identifies only as "Slow Bull's Wife," wearing a dentalium-shell-covered trade-cloth dress, long dentalium shell earrings, a hair-pipe breastplate, and a rope of hair pipes and beads slung diagonally across her torso, like the brass-studded bands worn by several figures in Black Hawk's dance scenes. See Curtis, *The North American Indian*, vol. 3, plate after p. 86.

88. See Markoe, *Vestiges of a Proud Nation*, pls. 77, 106, 111, for Lakota examples of all of these.

89. For Lakota warriors and horses painted with dragonflies, see Berlo, ed., *Plains Indian Drawings*, pls. 122, 139, 140, 153.

90. Quotes from John Gregory Bourke's diaries were transcribed from photocopies at the Center for Southwestern Research, Zimmerman Library, the University of New Mexico, Albuquerque, doc. no. 917.8 B66d, vols. 43 and 44, pp. 1473–78; handwritten originals are at the Library of the U.S. Military Academy, West Point, New York. For other Plains drawings that depict the rich visual display of trade cloth garments, see McCoy, *Kiowa Memories*, pls. 24, 26, 28, 30.

91. See Szabo, *Howling Wolf*, pl. 13; Berlo, "Nineteenth-Century Plains Indian Drawings,"

pl. XXI. For other Plains Indian drawings of line dancers viewed from the back, see Warner, *Ledger Art of the Crow and Gros Ventre Indians,* unnumbered plate of drawing no. 1930.67.

92. Nabokov, *Two Leggings,* p. 169.

93. For a fuller explication of these events, see White, "The Winning of the West"; Hoxie, *Parading through History,* chaps. 2, 3.

94. Mallery, "Picture-Writing of the American Indians," p. 273.

95. Denig, *Five Indian Tribes of the Upper Missouri,* pp. 154–55. For similar descriptions by others, see Catlin, *Manners, Customs and Conditions of the North American Indians,* vol. 1, p. 49; Hewitt, ed., *Journal of Rudolph Friederich Kurz,* p. 251; Curtis, *The North American Indian,* vol. 4, p. 23. Lowie, "The Material Culture of the Crow Indians," p. 228.

96. See, for example, Cheyenne and Lakota examples in Berlo, ed., *Plains Indian Drawings,* pls. 30, 31, 32, 36, 37, 149, 150; for Crow depictions of themselves, see Warner, *Ledger Art of the Crow and Gros Ventre Indians,* passim.

97. An example of such a shirt is illustrated in Wardwell, *Native Paths,* pl. 18. For photos of men dressed in this fashion, see O'Connor, *Fred E. Miller,* pl. 36; Powell, *To Honor the Crow People,* pp. 12, 17, 32; Nabokov, *Two Leggings,* unnumbered photo after p. 98.

98. For photographs of such bags, see Wade, *Arts of the North American Indian,* pl. 45; Conn, *Native American Art,* pl. 182.

99. Hewitt, ed., *Journal of Rudolph Friederich Kurz,* p. 260.

100. For examples of this distinctive nineteenth-century Crow beadwork aesthetic, see Vincent, Brydon, and Coe, eds., *Art of the North American Indians,* p. 159; Wardwell, *Native Paths,* pls. 17, 18, 19, 53; Wildschut and Ewers, *Crow Indian Beadwork.*

101. For Crow use of yellow body paint with red designs on top, see Curtis, *The North American Indian,* vol. 4, p. 108.

102. Nabokov, *Two Leggings,* p. 62, unnumbered photo before p. 99. Rudolph Kurz illustrates a Mandan man similarly adorned with horse tracks. See Hewitt, ed., *Journal of Rudolph Friederich Kurz,* pl. 27, bottom.

103. Nabokov, *Two Leggings,* p. 46.

104. See Gilman and Schneider, *The Way to Independence,* pp. 105, 172 (color pl.).

105. See Bancroft-Hunt, *Indians of the Great Plains,* p. 111, unnumbered figure.

106. For a modern painting of a nineteenth-century Crow warrior in his finery, showing many of the items depicted in Black Hawk's drawings, see Bill Holm's *A Chief by Means of Deeds,* 1993, in Brown and Averill, *Sun Dogs and Eagle Down,* pl. 23. Examples of the brass armbands and necklaces are illustrated in Conn, *A Persistent Vision,* pls. 103, 145, 146.

107. Hewitt, ed., *Journal of Rudolph Friederich Kurz,* p. 182.

108. See Lowie, *The Crow Indians,* pp. 207–8. Lowie says that the Crow purchased the rights to the Hot Dance from the Hidatsa around 1875. If this date is accurate, it suggests that Black Hawk is depicting an event from recent history rather than from his youth. The Hot Dance stick is illustrated in Lowrie, *The Crow Indians,* fig. 13c. These crane sticks look very much like Lakota courting flutes, which also depict long-billed birds. Both the Hot Dance stick and the Lakota flute are illustrated in Maurer, *Visions of the People,* nos. 18, 19.

109. Kurz observed that Crow men always put blankets on their horses, but in 1850, these were made of buffalo hide rather than wool. See Hewitt, ed., *Journal of Rudolph Friederich Kurz,* p. 260.

110. For Bad Heart Bull, see Blish, *Pictographic History of the Oglala Sioux,* pls. 8, 207. For Southern Cheyenne examples, see Szabo, *Howling Wolf,* fig. 48. For Kiowa examples, see Berlo, ed., *Plains Indian Drawings,* pls. 71, 72, 78, 95. See also Hanson, *Metal Weapons, Tools and Ornaments,* pp. 93–96, for mention of Maximilian and Parkman, and for use of these objects among the Lakota.

111. See Howard, *The British Museum Winter Count,* p. 22; for a discussion of the varied recountings of this event within different winter counts, see pp. 21–22. Depending on the winter count, the year for this event ranges from 1801–4.

112. See Bowers, *Hidatsa Social and Ceremonial Organization,* pp. 13, 21, 37, as well as Douglas Parks's exemplary introduction to that volume; see also Hoxie, *Parading through History,* chap. 2.

113. The Crow had a Horse Dance that Lowie characterized as a "minor ceremony." Unlike the complex pageantry of the Lakota Horse Dance, which commemorated a vision of Thunder Beings, the Crow Horse Dance seemed to be principally a rite for restoring exhausted horses to full vigor, or for providing more horses to the tribe. See Lowie, *Minor Ceremonies of the Crow Indians,* pp. 329–34.

114. In Ritzenthaler, *Sioux Indian Drawings,* pls. 21, 32 (two instances of peace between these enemies), pls. 3, 9, 12, 13, 15, 17, 31 (skirmishes between Lakota and Crow). Other drawings are captioned "Crow," but the iconography suggests that perhaps Pawnee are the foes.

115. Curtis, *The North American Indian,* vol. 4, pp. 102–3.

116. Old Crow is quoted as having said these words in a military council with white soldiers on the Bozeman Trail. See Hebard and Brininstool, *The Bozeman Trail,* p. 156. For other Crow accounts of warfare with the Sioux, see Lowie, *The Material Culture of the Crow Indians,* pp. 252–63; Nabokov, *Two Leggings,* pp. 103–7, 162–72; Hoxie, *Parading through History,* chaps. 3–4.

117. White Bull was a Minneconjou Lakota, who wrote an autobiography in the Lakota language and in pictographic drawings as well. See Howard, *The Warrior Who Killed Custer,* p. 36.

118. See, for example, Howard, *The Warrior Who Killed Custer,* pls. 9–35 (White Bull); Blish, *Pictographic History of the Oglala Sioux,* figs. 60, 62, 82, 96, 97 (Bad Heart Bull); Berlo, ed., *Plains Indian Drawings,* p. 199 (Four Horns), p. 205 (No Two Horns), pp. 211, 214–15 (Red Hawk).

119. A still unsurpassed account of the impact of the horse and firearms is given in Ewers, *The Horse in Blackfoot Indian Culture,* chap. 1.

120. Silver Horn's work is well illustrated in Greene, *Silver Horn*; Donnelley, ed., *Transforming Images.* See Berlo, ed., *Plains Indian Drawings,* pp. 210–11 (Red Hawk), pp. 206–7 (No Two Horns).

121. Denig, *Five Indian Tribes of the Upper Missouri,* p. 145.

122. Personal communication from equestrienne India Frank, December 1999.

123. Frank, personal communication, December 1999.

124. Frank, personal communication, December 1999. Horse breeder India Frank suggests that the white stockings indicate a genetic basis for the identification of this as a roan horse, which is characterized by a coat of intermixed red and white hair. In two other drawings, Black Hawk shows similar horses. In pl. 36 (left), a Crow warrior seems to be riding the same horse. Did he capture it in a horse-stealing raid? In pl. 37, a Crow warrior leads a roan horse wearing a buffalo mask. Here, its coat is indicated by strokes of pink ink.

125. See, for example, Berlo, ed., *Plains Indian Drawings,* pls. 34, 35, 89, 92, 101, 122, 132, 133. For a drawing of a horse spectacularly painted for the Sun Dance, see Penney, *Art of the American Indian Frontier,* p. 293.

126. See Conn, *Native American Art,* fig. 171; Berlo, ed., *Plains Indian Drawings,* pls. 132, 149.

127. In contrast, Nagy, in "Cheyenne Shields" and "Lame Bull," has identified several Cheyenne warriors' individual shields.

128. Hyde (*Red Cloud's Folk,* pp. 291–92) says that the Sans Arc who surrendered at Spotted Tail Agency in April 1877 were under the leadership of chiefs named Red Bear and High Bear. There was a well-known Lakota warrior named Charging Bear (*Mato Watakpe*), who is depicted fighting Crows in a drawing by Bad Heart Bull, see Blish, *Pictographic History of the Oglala Sioux,* fig. 250. A Yanktonai Sioux named Medicine Bear attached grizzly-bear claws to his moccasins, see Markoe, ed., *Vestiges of a Proud Nation,* pp. 86, 93. For a similar grizzly-bear shield used by a Cheyenne warrior, see Cowdry, *Arrow's Elk Society Ledger,* pl. 21.

129. Slide no. 2476, National Museum of the American Indian, Smithsonian Institution, Washington, D.C.

130. Vestal, *Warpath,* p. 186.

131. For another Lakota fringed war shirt, see Markoe, ed., *Vestiges of a Proud Nation,* pp. 80–81.

132. See Densmore, *Teton Sioux Music,* pp. 326–29. For other depictions of *Miwatani* soldiers and their regalia, see Berlo, ed., *Plains Indian Drawings,* pp. 183, 205; Blish, *Pictographic History of the Oglala Sioux,* pp. 106, 211; Vincent, Brydon, and Coe, eds., *Art of the North American Indians,* no. 129 (*Miwatani* soldier painted on a Lakota drum by the Hunkpapa artist Jaw).

133. See Afton, Halaas, and Masich, *Cheyenne Dog Soldiers,* pp. 61–63, pl. 34.

134. Arthur Amiotte, personal communication, June 1995. See also Berlo, ed., *Plains Indian Drawings,* pp. 184, 213.

135. I am grateful to Bill Holm, whose patient explanations of armament technology helped elucidate the actions in these pictures.

136. For fine examples of Crow quirts, see Penney, *Art of the American Indian Frontier,* pls. 196, 197.

137. See Bill Holm's painting, *Brass Finery,* in Brown and Averill, *Sun Dogs and Eagle Down,* pl. 29; caption, p. 142.

138. Bill Holm, personal communication, July 1995. These items can also be seen in a war record drawn by the Crow artist Spotted Buffalo in 1884, see Warner, *Ledger Art of the Crow and Gros Ventre Indians,* unnumbered plate of object no. 1930.39.

139. Anthropologist George Bird Grinnell recounted an anecdote about an Cheyenne man named Old Bear, to whom he showed a book of drawings that had been removed from Cheyenne territory some twenty years before. Old Bear identified the artist of the book "and professed great indignation that many of the pictures had been taken out of it" (Grinnell, unpublished and undated manuscript on the Double Trophy Register, object file 10/8725, National Museum of the American Indian,

Smithsonian Institution, Washington, D.C.). For an illustration from that book see Berlo, ed., *Plains Indian Drawings*, pl. 47.

140. Blish, *Pictographic History of the Oglala Sioux*, p. 35; images of retreating Lakota warriors occur in figs. 63, 65–70, 72, 73, 75, 76, 78, 220, 221, 223, 224, 230, 233, 234.

141. See, for example, Blish, *Pictographic History of the Oglala Sioux*, figs. 49, 52, 71, 101, 102, 282, 283, 288, 301.

142. Greene, "Structure and Meaning in Cheyenne Ledger Art," p. 26.

143. See, for example, Cowdry, *Arrow's Elk Society Ledger*, pls. 74, 76, 92, 100, 105, 120, 126; Viola, *Warrior Artists*, pp. 23, 41.

144. McHugh, *The Time of the Buffalo*, p. 15; other early accounts, pp. 1–17.

145. This account relies principally upon Walker, *Lakota Society*, pp. 74–94.

146. Densmore, *Teton Sioux Music*, p. 442.

147. See Walker, *Lakota Society*, p. 80; Densmore, *Teton Sioux Music*, pp. 437–38.

148. Densmore, *Teton Sioux Music*, p. 442.

149. Walker, *Lakota Society*, p. 74.

150. In Walker, *Lakota Belief and Ritual*, p. 101.

151. In Lame Deer and Erdoes, *Gift of Power*, p. 133.

152. A small sampling of scholarly works that consider this knowledge includes Goodman, *Lakota Star Knowledge*; Rogers, *Lakota Names and Traditional Uses for Native Plants*; Schaeffer, "Bird Nomenclature and Principles of Avian Taxonomy"; Nabhan, *Gathering the Desert*, pp. 137–49; Henderson and Harrington, *Ethnozoology of the Tewa Indians*.

153. One of very few non-Lakota drawings that fits into this category is the Cheyenne artist Making Medicine's drawing *Fowls of Indian Territory*, done in 1876 or 1877, in which he depicts seventeen types of birds, including a red-tailed hawk, a long-billed curlew, a magpie, a barn swallow, a bald eagle, a crane, and a great horned owl; see Berlo, ed., *Plains Indian Drawings*, pl. 59. In the Henderson Ledger, done by Arapaho artists in 1882, there is one drawing of birds and mule deer, one of centipedes, and one of an owl, mountain lion, and jackrabbit; see Petersen, *American Pictographic Images*, pls. 2, 84, 90. A Crow artist named Medicine Crow drew zoo and circus animals he encountered on a trip to Washington, D.C., in 1880; see Warner, *Ledger Art of the Crow and Gros Ventre Indians*, unnumbered plates of drawing no. 1930.22; Heidenreich, "Crow Indian Ledger Art," fig. 13.

154. McDermott, *Audubon in the West*, p. 73.

155. See Streshinsky, *Audubon*, pp. 148–49.

156. See Hewitt, ed., *Journal of Rudolph Frederich Kurz*, pp. 76–77, 95, 98, 144, 198–99, 224, 301. For Indians' regard for Kurz's drawings, see pp. 81, 121, 137, 162, 210–12, 245–47, 253–55, 260, 268, 271, 274, 293, 299 (Kurz's life studies of dogs, antelope, elk, moose, bighorn sheep, fox, and other animals are mentioned). See pls. 3 (bottom), 28 (bottom), for images of his life studies of animals.

157. See "Naming the Sacred" in Powers, *Sacred Language*, pp. 145–63.

158. "The Science of the Concrete" in Lévi-Strauss, *The Savage Mind*, especially p. 20.

159. Beede, "The Scientific Attitude of Indians." Beede wrote more than seven thousand pages of field notes on Indians based on his missionary years and his period as county judge on the Sioux Reservation. I am grateful to Arthur Amiotte for calling this document to my attention.

160. Petersen, *Among the Elk*, p. 7.

161. Petersen, *Among the Elk*, pp. 25–26.

162. Petersen, *Among the Elk*, p. 23.

163. Petersen, *Among the Elk*, pp. 42–44.

164. Lame Deer and Erdoes, *Gift of Power*, p. 143; see also Densmore, *Teton Sioux Music*, p. 176.

165. Densmore, *Teton Sioux Music*, p. 294.

166. Bauer, *Big Game of North America*, p. 12.

167. In contrast, many Southern Plains artists, especially those Cheyenne and Kiowa incarcerated at Fort Marion, Florida, in the 1870s, became expert at landscape scenes. See, for example, all the drawings by the Kiowa artist Zotom in Viola, *Warrior Artists*; Szabo, *Howling Wolf*, pls. 18, 19, 20; Harris, *Between Two Cultures*, pp. 47, 95, 101, 105.

168. But see Powell, *People of the Sacred Mountain*, p. 1113 (an illustration of a Cheyenne horseman in pursuit of a bighorn sheep, from the Little Wolf Ledger).

169. Another fine pictorial study of white-tailed deer that emphasizes the bushy tail occurs in an anonymous Lakota drawing book once owned by Morning Star Gallery in Santa Fe; see Berlo and Anderson, *Animals of Power*, fig. 1.

170. See Walker, *Lakota Belief and Ritual*, pp. 166–67; Lame Deer and Erdoes, *Gift of Power*, p. 134. For an illustration of Double Woman with a human body ending in deer hoofs, see Maurer, *Visions of the People*, pl. 104.

171. Van Wormer, *The World of the Pronghorn*, p. 16.

172. Van Wormer, *The World of the Pronghorn*, p. 18.

173. Grinnell, *The Cheyenne Indians*, vol. 1, p. 277.

174. See, for example, Powell, *People of the Sacred Mountain*, p. 1109 (a mounted Cheyenne who shoots at a herd of pronghorn, wounding one,

from the Little Wolf Ledger). The Cheyenne artist Making Medicine illustrated scenes of hunters in pursuit of pronghorn in a drawing book he made at Fort Marion, Florida, in 1877, see Viola, *Warrior Artists*, pp. 23, 41.

175. Anderson, *Black Bear*, p. 1.

176. Walker, *Lakota Belief and Ritual*, p. 116. See also pp. 157–59.

177. Densmore, *Teton Sioux Music*, p. 195.

178. See Powell, *People of the Sacred Mountain*, p. 1107 (a Cheyenne who has wounded a bear with an arrow, from the Little Wolf Ledger). For famous shields painted with bear imagery, see Maurer, *Visions of the People*, pls. 23, 25.

179. Compare the anatomy of a little brown bat in Mohr, *The World of the Bat*, p. 18.

180. Barbour and Davis, *Bats of America*, p. 47.

181. Barbour and Davis, *Bats of America*, p. 51.

182. Walker, *Lakota Belief and Ritual*, p. 125.

183. Grzimek, *Grzimek's Animal Life Encyclopedia*, vol. 12, pp. 245–48.

184. Quote from *The Viviparous Quadrupeds of North America*, vol. 1, p. 14, as quoted in Foshay, *John James Audubon*, p. 128, where Audubon's bobcat painting is also illustrated.

185. Eckert, *The Owls of North America*, p. 228.

186. Walker, *Lakota Belief and Ritual*, p. 273. This may be a reference to the *Miwatani* Society, see Densmore, *Teton Sioux Music*, p. 326.

187. Lame Deer and Erdoes, *Gift of Power*, pp. 145–46. In the National Museum of the American Indian, there is a Ghost Dance shield painted with an image of a great horned owl. See Galante, "The Painter," p. 14.

188. Johnsgard, *Birds of the Great Plains*, p. 347.

189. Scott, ed., *Field Guide to the Birds of North America*, pp. 264–65.

190. Beede, "The Scientific Attitude of Indians."

191. Manuscript 154064, National Anthropological Archives, Smithsonian Institution, Washington, D.C. Most of these are illustrated in Barbeau, *Indian Days on the Western Prairies*, figs. 19–150. For examples by another Lakota artist, Sinte, see Berlo, ed., *Plains Indian Drawings*, pl. 143 (on one page, a bear, buffalo, elk, bighorn sheep, deer, and antelope).

192. Bolz, "Die Berliner Dakota-Bibel," figs. 1, 2, 30–37. Other drawings made within the pages of this New Testament include scenes of hunting, warfare, and horse capture.

CHAPTER THREE

1. As quoted in Blish, *Pictographic History of the Oglala Sioux*, p. xxi.

2. Buechel, *Lakota-English Dictionary*, p. 613.

3. Densmore, *Teton Sioux Music*, p. 459.

4. Utley, *The Lance and the Shield*, p. 165. Other accounts of this era, which amplify the events outlined in this section, include Utley, *Last Days of the Sioux Nation*; Jensen, Paul, and Carter, *Eyewitness at Wounded Knee*; Mooney, *The Ghost-Dance Religion*.

5. As quoted in Utley, *The Lance and the Shield*, p. 176.

6. As quoted in Buecker and Paul, *The Crazy Horse Surrender Ledger*, p. 2.

7. Utley, *The Lance and the Shield*, p. 235.

8. As quoted in Lazarus, *Black Hills/White Justice*, p. 60.

9. Utley, *Last Days of the Sioux Nation*, p. 33.

10. Anderson, "History of the Cheyenne River Indian Agency," pp. 532–44.

11. See Hoxie, "From Prison to Homeland," p. 57.

12. Anderson, "History of the Cheyenne River Indian Agency," pp. 494–506.

13. Vanderwerth, *Indian Oratory*, p. 244.

14. Utley, *Last Days of the Sioux Nation*, p. 244. This entire volume is a gripping story of the events of 1889–91, told principally from the perspective of U.S. Army and government officials. The next several paragraphs are based principally upon this source.

15. For an insightful view of the Ghost Dance religion that is somewhat different from most, see DeMallie, "The Lakota Ghost Dance."

16. The difficulties of making an exact count of the dead are discussed by Jensen, "Big Foot's Followers at Wounded Knee," p. 198.

17. Excerpted from Neihardt, *Black Elk Speaks*, pp. 219–30.

18. See chap. 1, n. 46, for records of a man named Black Hawk, who died at Wounded Knee.

19. Utley, *Last Days of the Sioux Nation*, p. 59.

20. See Lawson, "Reservoir and Reservation," especially pp. 125, 127, 142, 157; Hoxie, "From Prison to Homeland."

21. A small sample of such studies includes Wolf, *Europe and the People without History*; Braudel, *The Structures of Everyday Life*; Hoxie, *Parading through History*.

22. See, for example, Martin, ed., *The American Indian and the Problem of History*; Hegeman, "History, Ethnography, Myth"; Deloria, *God Is Red*; Hoxie, *Parading through History*; Hill and Hill, Sr., *Creation's Journey*.

23. See DeMallie, "George Bushotter"; Wong, "Pictographs as Autobiography."

24. Momaday, *The Names, A Memoir,* p. 48.

25. The circle of dancers viewed from the outside is an essential feature of Plains ritual performance. The Kiowa artist Silver Horn, too, took on the graphic challenge of this image. In *Ghost Circle Closed,* eighteen figures are shown in part or in whole, most of them in straight-on back view. Silver Horn delights in the long vertical rectangles of red and black trade blankets demarcated by a crisp white selvage. He plays these off against the plaids, prints, and stripes of the women's garments. See Donnelley, *Transforming Images,* pl. 34.

26. The first fully realized examples of this may be in some drawings made by Kiowa and Cheyenne prisoners at Fort Marion, Florida, 1875–78. These men were chronicling the Victorian-era Euro-American culture within which they lived. Not only did they inscribe the history of their own imprisonment and forced acculturation, but they were also careful ethnographers of the inscrutable cultural habits of their captors. See Donnelley, *Transforming Images,* pls. 13, 14; Viola, *Warrior Artists,* pp. 120–21.

27. Around 1885, Silver Horn chronicled in sketchbooks the scenes of warfare, courting, and hunting that are typical in Kiowa drawing books. He also depicted an unusual image of three masked dancers not typical of the Plains, but of the Apache. His drawing of three Mountain Spirit Dancers depicts with ethnographic precision these Apache ritual performers. See Berlo, "Artist, Ethnographers, and Historians," fig. 7.

28. For an exemplary history of this, see Brody, *Pueblo Indian Painting.*

29. Greene, *Silver Horn,* typescript p. 120. For Silver Horn's and other artists' collaborations with anthropologists, see Ewers, "Plains Indian Artists and Anthropologists."

30. See, for example, some of the drawings illustrated in Powell, *People of the Sacred Mountain,* and in Afton, Halaas, and Masich, *Cheyenne Dog Soldiers.*

31. The identification of military paraphernalia has been carried out with admirable precision in the case of the Summit Springs Ledger, which has been collaboratively studied by an anthropologist, a historian of the West, and a military historian. See Afton, Halaas, and Masich, *Cheyenne Dog Soldiers.*

32. See, for example, DeMallie, *The Sixth Grandfather,* pp. 125–30.

33. In Hill, ed., *This Path We Travel,* p. 27.

34. For fine elucidations of the interlocking meanings of oratory and the visual arts in another region of Native North America, see Dauenhauer, "Tlingit At.óow: Traditions and Concepts"; Meuli, *Shadow House,* especially chap. 1.

35. Powers, *Sacred Language,* p. 214.

36. Powers, *Sacred Language,* p. 212.

37. See chap. 1, n. 70.

38. See Dockstader, *Oscar Howe.*

39. Arthur Amiotte, personal communication, June 1995.

40. Densmore, *Teton Sioux Music,* p. 412. Densmore calls him Old Buffalo, but he is clearly the same individual as Moses Old Bull, who illustrated and narrated the same stories of his heroism to Densmore in 1913 and to Walter Stanley Campbell more than sixteen years later. See also Miles and Lovett, "Pictorial Autobiography of Moses Old Bull."

41. Lowenthal, *The Past Is a Foreign Country.*

42. Powers, *Sacred Language,* p. 205.

APPENDIX ONE

1. Guralnik, ed., *Webster's New World Dictionary,* p. 543. Stationer's promotional circulars of the 1880s advertise foolscap paper (sometimes called Fools Cap) as sold by the ream (five hundred sheets) for $2.25 or by the quire (twenty-four sheets) for fifteen cents. See Spelman Brothers, Catalogue of Fancy Goods and Notions, p. 95; Ridley, Catalogue and Price List, p. 117.

2. For example, pl. 26 has a watermark of four buildings, while pl. 64 bears a watermark inscribed "Crystal Lake" with a crown and a surrounding garland of wheat.

3. He almost surely drew with pencils made in the United States. Fine pencils imported from England, France, and Germany, were in widespread use in the United States in the first half of the nineteenth century (made by such companies as Conté, Faber, and Staedtler, still recognized for their excellent writing instruments). But during the Civil War, steep tariffs were imposed on foreign manufactured goods such as pencils. Concurrent American advances in mechanization and mass production made American pencils ubiquitous and inexpensive. See Petroski, *The Pencil,* especially chaps. 11–12. New York stationers of the era advertised pencils from eighty-eight cents per gross (twelve dozen) to five dollars per gross, depending on quality. See Spelman Brothers, Catalogue of Fancy Goods and Notions, p. 96.

4. See Roberts and Etherington, *Bookbinding and the Conservation of Books,* pl. XIa.

Afton, Jean, David F. Halaas, and Andrew E. Masich. *Cheyenne Dog Soldiers: A Ledgerbook History of Coups and Combat.* Denver: University Press of Colorado and the Colorado Historical Society, 1997.

Albright, Peggy. *Crow Indian Photographer: The Work of Richard Throssel.* Albuquerque: University of New Mexico Press, 1997.

Alexander, Hartley Burr. "The Art of the American Indian." *The Nation* 132, no. 3435 (May 1931): 501–3.

———. "The Bad Heart Buffalo Manuscript." *Theatre Arts Monthly* 16 (1932): 9–41.

———. *Sioux Indian Painting.* Nice, France: C. Szwedzicki, 1938.

Amiotte, Arthur. "The Road to the Center." *Parabola* 9, no. 3 (1984): 246–54.

———. "The Lakota Sun Dance: Historical and Contemporary Perspectives." In *Sioux Indian Religion,* edited by Raymond J. DeMallie and Douglas R. Parks, 75–89. Norman: University of Oklahoma Press, 1987.

———. "Eagles Fly Over." In *I Become a Part of It,* edited by D. M. Dooling and P. J. Smith. New York: Parabola Books, 1989.

Anderson, Harry H. "A History of the Cheyenne River Indian Agency and Its Military Post, Fort Bennett, 1868–1891." *South Dakota Historical Collections* (Pierre, South Dakota Historical Society) 28 (1956): 390–551.

Anderson, Tom. *Black Bear: Seasons in the Wild.* Stillwater, Minn.: Voyageur Press, 1992.

Bancroft-Hunt, Norman. *The Indians of the Great Plains.* Norman: University of Oklahoma Press, 1981.

Barbeau, Marius. "Indian Days on the Western Prairies." *National Museum of Canada Bulletin* (Ottawa) no. 163 (1960).

Barbour, Roger, and Wayne Davis. *Bats of America.* Lexington: University of Kentucky Press, 1969.

Bauer, Edwin. *Big Game of North America.* Stillwater, Minn.: Voyageur Press, 1997.

Beede, Aaron McGaffey. "The Scientific Attitude of Indians." Undated manuscript. Beede Archives, North Dakota Historical Society, Bismarck.

Benedict, Ruth. "The Vision in Plains Culture." *American Anthropologist* 24, no. 1 (1922): 1–23.

Berlo, Janet Catherine. "Dreaming of Double Woman: The Ambivalent Role of the Female Artist in North American Indian Myth." *American Indian Quarterly* 17, no. 1 (1993): 31–43.

———. "Nineteenth-Century Plains Indian Drawings." *The Magazine Antiques* 150, no. 5 (November 1996): 686–95.

———, ed. *Plains Indian Drawings 1865–1935: Pages from a Visual History.* New York: Harry N. Abrams, Inc., 1996.

———. "Plains Indian Drawings 1865–1935: A Traveling Exhibition." *American Indian Art* 22, no. 1 (1996): 56–65.

———. "Spirit Horses and Thunder Beings: Plains Indian Dream Drawings." *Grand Street* 56 (1996): 199–208.

———. "Artists, Ethnographers, and Historians: Plains Indian Graphic Arts in the Nineteenth Century and Beyond." In *Transforming Images: The Art of Silver Horn and His Successors,* edited by Robert G. Donnelley. Chicago: The Smart Museum, University of Chicago, 2000.

———. "Black Hawk." In *Art of the North American Indians: The Thaw Collection,* edited by Gilbert Vincent, Sherry Brydon, and William Coe, 145–47. Cooperstown, N.Y.: Fenimore Art Museum, 2000.

Berlo, Janet Catherine, and Ken Anderson. *Animals of Power: African, Native American and Oceanic Art from Private Collections.* St. Louis, Mo.: Craft Alliance Gallery, 1991.

Berlo, Janet Catherine, and Ruth Phillips. *Native North American Art.* Oxford: Oxford University Press, 1997.

Berry, Jason. *The Spirit of Black Hawk.* Jackson: University of Mississippi Press, 1995.

Bettelheim, Judith. "Costume Types and Festival Elements in Caribbean Celebrations, Part 2: The Afro-Amerindian." *African Caribbean Research Review* 4 (1999): 1–46.

Blish, Helen H. *A Pictographic History of the Oglala Sioux.* Lincoln: University of Nebraska Press, 1967.

Bol, Marsha. "Defining Lakota Tourist Art: 1880–1915." In *Unpacking Culture: Art and Commodity in Colonial and Post-Colonial Worlds,* edited by Ruth Phillips and Christopher Steiner, 214–28. Berkeley: University of California Press, 1999.

Bolz, Peter. "Die Berliner Dakota-Bibel, Ein Fruhes Zeugnis der Ledger-Kunst bei den Lakota." *Baessler-Archiv N.F.* 36, no. 1 (1988): 1–59.

Bourke, John G. Unpublished diaries, 1872–96. Library of the United States Military Academy, West Point, N.Y. Photocopies on file at the Center for Southwestern Research, Zimmerman Library, University of New Mexico, Albuquerque.

Bowers, Alfred W. *Hidatsa Social and Ceremonial Organization.* Lincoln: University of Nebraska Press, 1992. Originally published in 1965 as Bureau of American Ethnology Bulletin no. 194 (Smithsonian Institution, Washington, D.C.).

Braudel, Fernand. *The Structures of Everyday Life.* Vol. 1 of *Civilization and Capitalism 15th–18th Century.* New York: Harper and Row, 1981.

Brody, J. J. *Pueblo Indian Painting: Tradition and Modernism in New Mexico 1900–1930.* Albuquerque: University of New Mexico Press, 1997.

Brown, Joseph. *The Sacred Pipe: Black Elk's Account of the Seven Rites of the Oglala Sioux.* Baltimore: Penguin Books, 1972.

———. *Animals of the Soul: Sacred Animals of the Oglala Sioux.* Rockport, Mass.: Element, Inc., 1992.

Brown, Steven C., and Lloyd Averill. *Sun Dogs and Eagle Down: The Indian Paintings of Bill Holm.* Seattle: University of Washington Press, 2000.

Buechel, Eugene. *Lakota-English Dictionary.* Edited by Paul Manhart. Vermillion: Institute of Indian Studies, University of South Dakota, 1983.

Buecker, Thomas, and R. Eli Paul. *The Crazy Horse Surrender Ledger.* Lincoln: Nebraska State Historical Society, 1994.

Bunzel, Ruth. *The Pueblo Potter.* New York: Columbia University Press, 1929.

Catlin, George. *Letters and Notes on the Manners, Customs and Conditions of the North American Indians.* 2 vols. 1844. Reprint, New York: Dover Publications, 1973.

Conn, Richard. *Native American Art in the Denver Art Museum.* Denver: Denver Art Museum, 1979.

———. *A Persistent Vision: Art of the Reservation Days.* Denver: Denver Art Museum, 1986.

Corum, Charles Ronald. "A Teton Tipi Cover Depiction of the Sacred Pipe Myth." *South Dakota History* 5, no. 3 (1975): 229–44.

Cowdrey, Mike. *Arrow's Elk Society Ledger: A Southern Cheyenne Record of the 1870s.* Santa Fe: Morning Star Gallery, 1999.

Curtis, Edward S. *The North American Indian.* Vols. 3–4. 1909. Reprint, New York: Johnson Reprint Company, 1970.

Cutschall, Colleen. *Voice in the Blood: An Exhibition of Paintings by Colleen Cutschall.* Brandon, Manitoba: Art Gallery of Southwestern Manitoba, 1990.

Dauenhauer, Nora. "Tlingit At.oów: Traditions and Concepts." In *The Spirit Within: Northwest Coast Native Art from the John H. Hauberg Collection,* edited by Steven Brown, 21–29. New York: Rizzoli International; Seattle: Seattle Art Museum, 1995.

Deloria, Ella. "The Sun Dance of the Oglala Sioux." *Journal of American Folklore* 42 (1929): 354–413.

———. *Waterlily.* Lincoln: University of Nebraska Press, 1988.

Deloria, Vine. *God Is Red: A Native View of Religion.* 2d ed. Golden, Colo.: North American Press, 1992.

DeMallie, Raymond J. "George Bushotter: First Lakota Ethnographer." In *American Indian Intellectuals,* edited by Margot Liberty, 90–102. St. Paul, Minn.: West Publishing Co., 1978.

———. "The Lakota Ghost Dance: An Ethnohistorical Account." *Pacific Historical Review* 51, no. 4 (1982): 385–405.

———. "Male and Female in Traditional Lakota Culture." In *The Hidden Half: Studies of Plains Indian Women,* edited by Patricia Albers and Beatrice Medicine, 237–66. Washington, D.C.: University Press of America, 1983.

———. *The Sixth Grandfather: Black Elk's Teachings Given to John G. Neihardt.* Lincoln: University of Nebraska Press, 1984.

DeMallie, Raymond J., and Robert H. Lavenda. "*Wakan:* Plains Siouan Concepts of Power." In *The Anthropology of Power,* edited by Raymond Fogelson and Richard Adams, 153–65. New York: Academic Press, 1977.

DeMallie, Raymond J., and Douglas R. Parks, eds. *Sioux Indian Religion.* Norman: University of Oklahoma Press, 1987.

Denig, Edwin Thompson. *Five Indian Tribes of the Upper Missouri: Sioux, Arickaras, Assiniboines, Crees, Crows.* Norman: University of Oklahoma Press, 1961.

Densmore, Frances. *Teton Sioux Music.* Bureau of American Ethnology Bulletin no. 61. Washington, D.C.: Smithsonian Institution, 1918. Reprinted as *Teton Sioux Music and Culture.* Lincoln: University of Nebraska Press, 1992.

Dockstader, Frederick. *Oscar Howe: A Retrospective Exhibition.* Tulsa: The Thomas Gilcrease Museum, 1982.

Doll, Don. *Vision Quest: Men, Women, and Sacred Sites of the Sioux Nation.* New York: Crown Publishing, 1994.

Donnelley, Robert G., ed. *Transforming Images: The Art of Silver Horn and His Successors.* Chicago: The Smart Museum, University of Chicago, 2000.

Dorsey, George A. "The Cheyenne." *Field Columbian Museum Publication* (Chicago) 99, Anthropological Series 9, nos. 1–2 (1905).

———. "Legend of the Teton Sioux Medicine Pipe." *Journal of American Folklore* 19 (October 1906): 326–29.

Dorsey, James Owen. *A Study of Siouan Cults.* Washington, D.C.: Smithsonian Institution Bureau of Ethnology, 1894.

Duncan, Kunigordo. *Blue Star.* Caldwell, Idaho: Caxton Printers, 1938.

Eckert, Allen. *The Owls of North America.* New York: Weathervane Books, 1987.

Ewers, John C. *The Horse in Blackfoot Indian Culture.* Bureau of American Ethnology Bulletin no. 159. Washington, D.C.: Smithsonian Institution, 1955.

———. *Hair Pipes in Plains Indian Adornment: A Study in Indian and White Ingenuity.* Bureau of American Ethnology Bulletin no. 50. Washington, D.C.: Smithsonian Institution, 1957.

———. "Plains Indian Artists and Anthropologists." *American Indian Art* 9, no. 1 (1983): 36–49.

———. *Plains Indian Sculpture: A Traditional Art from America's Heartland.* Washington, D.C.: Smithsonian Institution Press, 1986.

Ewers, John, Helen Mangelsdorf, and William Wierzbowski, eds. *Images of a Vanished Life: Plains Indian Drawings from the Collection of the Pennsylvania Academy of Fine Arts.* Philadelphia: Pennsylvania Academy of the Fine Arts, 1985.

Feder, Norman. *American Indian Art.* New York: Harry Abrams Press, 1965.

Fletcher, Alice. "Lakota Ceremonies." *Papers of the Peabody Museum of American Archaeology and Ethnology* (Cambridge, Harvard University) 3, nos. 3–4 (1884): 260–307.

Foshay, Ella. *John James Audubon.* New York: Harry N. Abrams, Inc., 1997.

Furst, Jill, and Peter Furst. *North American Indian Art.* New York: Rizzoli Press, 1982.

Galante, Gary. "The Painter: The Sioux of the Great Plains." In *The Ancestors: Native Artisans of the Americas,* edited by Anna C. Roosevelt and James G. E. Smith, 1–21. New York: Museum of the American Indian, 1979.

Gilman, Carolyn, and Mary Jane Schneider. *The Way to Independence: Memories of a Hidatsa Indian Family, 1840–1920.* St. Paul: Minnesota Historical Society Press, 1987.

Goodman, Ronald. *Lakota Star Knowledge: Studies in Lakota Stellar Theology.* Rosebud, S.Dak.: Sinte Gleska University, 1992.

Greene, Candace. "Structure and Meaning in Cheyenne Ledger Art." In *Plains Indian Ledger Drawings 1865–1935: Pages from a Visual History,* edited by Janet Catherine Berlo, 26–33. New York: Harry N. Abrams, Inc., 1996.

———. *Silver Horn: Master Illustrator of the Kiowa.* Norman: University of Oklahoma Press, 2000.

Greene, Jerome A. *Lakota and Cheyenne: Indian Views of the Great Sioux War, 1876–1877.* Norman: University of Oklahoma Press, 1994.

Grinnell, George Bird. *The Cheyenne Indians.* 2 vols. 1923. Reprint, Lincoln: University of Nebraska Press, 1972.

———. Unpublished manuscript. The Double Trophy Register, object file 10/8725, National Museum of the American Indian, Smithsonian Institution, Washington, D.C., n.d.

Grzimek, Bernhard. *Grzimek's Animal Life Encyclopedia.* New York: Van Nostrand Reinhold, 1972.

Guralnik, David, ed. *Webster's New World Dictionary.* 2d college ed. New York: The World Publishing Company, 1970.

Hail, Barbara. *Hau, Kóla! The Plains Indian Collection of the Haffenreffer Museum of Anthropology.* Providence, R.I.: Haffenreffer Museum, Brown University, 1980.

Hanson, James Austin. *Metal Weapons, Tools and Ornaments of the Teton Dakota Indians.* Lincoln: University of Nebraska Press, 1975.

———. *Little Chief's Gatherings.* Crawford, Nebr.: The Fur Press, 1996.

Harris, Moira. *Between Two Cultures: Kiowa Art from Fort Marion.* St. Paul, Minn.: Pogo Press, 1989.

Harrison, J. B. *The Latest Studies on Indian Reservations.* Philadelphia: Indian Rights Association, 1887.

Hassrick, Royal. *The Sioux.* Norman: University of Oklahoma Press, 1964.

Hebard, Grace R., and E. A. Brininstool. *The Bozeman Trail.* Glendale, Calif.: The Arthur Clark Co., 1960.

Hegeman, Susan. "History, Ethnography, Myth: Some Notes on the 'Indian-Centered' Narrative." *Social Text* 23 (Fall/Winter 1989): 144–60.

Heidenreich, C. Adrian. "The Crow Indian Delegation to Washington, D.C., in 1880." *Montana: The Magazine of Western History* 31, no. 2 (1981): 54–67.

———. "The Content and Context of Crow Indian Ledger Art." In *Proceedings of the Fifth Annual Plains Indian Seminar,* edited by George Horse Capture and Gene Ball, 111–32. Cody, Wyo.: Buffalo Bill Historical Center, 1984.

Henderson, J., and J. P. Harrington. *Ethnozoology of the Tewa Indians.* Bureau of American Ethnology Bulletin no. 56. Washington, D.C.: Smithsonian Institution, 1914.

Hewitt, J. N. B., ed. *The Journal of Rudolph Friederich Kurz.* Bureau of American Ethnology Bulletin no. 115. Washington, D.C.: Smithsonian Institution, 1937.

Hill, Richard W., ed. *This Path We Travel.* Washington, D.C.: Smithsonian Institution and the National Museum of the American Indian, 1994.

Hill, Tom, and Richard W. Hill, Sr., eds. *Creation's Journey: Native American Identity and Belief.* Washington, D.C.: Smithsonian Institution Press, 1994.

Horse Capture, George, Anne Vitart, Michel Waldberg, and W. Richard West, Jr. *Robes of Splendor: Native American Painted Buffalo Hides.* New York: The New Press, 1993.

Howard, James H. "The Dakota or Sioux Indians: A Study in Human Ecology." *Anthropological Papers* (South Dakota Museum, Vermillion) no. 2 (1966).

———, ed. *The Warrior Who Killed Custer: The Personal Narrative of Chief Joseph White Bull.* Lincoln: University of Nebraska Press, 1968.

———. *The British Museum Winter Count.* Occasional Paper, 4. London: British Museum, 1979.

Hoxie, Frederick E. "From Prison to Homeland: The Cheyenne River Indian Reservation Before World War I." In *The Plains Indians of the Twentieth Century,* edited by Peter Iverson, 55–75. Norman: University of Oklahoma Press, 1985.

———. *Parading through History: The Making of the Crow Nation in America, 1805–1935.* Cambridge, England: Cambridge University Press, 1995.

Hyde, George E. *Red Cloud's Folk: A History of the Oglala Sioux Indians.* Norman: University of Oklahoma Press, 1937.

———. *A Sioux Chronicle.* Norman: University of Oklahoma Press, 1956.

Irwin, Lee. *The Dream Seekers: Native American Visionary Traditions of the Great Plains.* Norman: University of Oklahoma Press, 1994.

Jensen, Richard. "Big Foot's Followers at Wounded Knee." *Nebraska History* 71, no. 4 (1990): 194–212.

Jensen, Richard, R. E. Paul, and J. E. Carter. *Eyewitness at Wounded Knee.* Lincoln: University of Nebraska Press, 1991.

Johnsgard, Paul. *Birds of the Great Plains.* Lincoln: University of Nebraska Press, 1979.

Lame Deer, Archie Fire, and Richard Erdoes. *Gift of Power: The Life and Teachings of a Lakota Medicine Man.* Santa Fe: Bear & Company, 1992.

Landes, Ruth. *The Ojibwa Woman.* New York: Columbia University Press, 1938.

Lawson, Michael Lee. "Reservoir and Reservation: The Oahe Dam and the Cheyenne River Sioux." *South Dakota Historical Collections* 37 (1974): 103–233.

Lazarus, Edward. *Black Hills/White Justice.* New York: HarperCollins, 1991.

Lévi-Strauss, Claude. *The Savage Mind.* Chicago: University of Chicago Press, 1966.

Lewis, Thomas. *The Medicine Men: Oglala Sioux Ceremony and Healing.* Lincoln: University of Nebraska Press, 1990.

Lowenthal, David. *The Past Is a Foreign Country.* Cambridge, England: Cambridge University Press, 1985.

Lowie, Robert H. "The Material Culture of the Crow Indians." *Anthropological Papers of the American Museum of Natural History* (New York) 21, pt. 3 (1922).

———. "Minor Ceremonies of the Crow Indians." *Anthropological Papers of the American Museum of Natural History* (New York) 21, pt. 5 (1924).

———. *The Crow Indians.* New York: Holt, Rinehart and Winston, 1935.

Mails, Thomas E. *Sundancing at Rosebud and Pine Ridge.* Sioux Falls, S.Dak.: The Center for Western Studies, 1978.

———. *Fools Crow.* Lincoln: University of Nebraska Press, 1979.

———. *Fools Crow: Wisdom and Power.* Tulsa, Okla.: Council Oak Books, 1991.

Mallery, Garrick. "Pictographs of the North American Indians: A Preliminary Paper." *Fourth Annual Report of the Bureau of Ethnology for 1882–83,* Washington, D.C.: Smithsonian Institution, 1886.

———. "Picture-Writing of the American Indians." *Tenth Annual Report of the Bureau of Ethnology for 1888–89.* Washington, D.C.: Smithsonian Institution, 1893. Reprint (1 vol. in 2), New York: Dover Publications, 1972.

Markoe, Glenn E., ed. *Vestiges of a Proud Nation: The Ogden B. Read Northern Plains Indian Collection.* Burlington: Robert Hull Fleming Museum and University of Vermont Press, 1986.

Martin, Calvin, ed. *The American Indian and the Problem of History*. New York: Oxford University Press, 1987.

Maurer, Evan. *Visions of the People: A Pictorial History of Plains Life*. Minneapolis: The Minneapolis Institute of Arts; Seattle: University of Washington Press, 1992.

McCoy, Ronald. *Kiowa Memories: Images from Indian Territory, 1880*. Santa Fe: Morning Star Gallery, 1987.

———. "Short Bull: Lakota Visionary, Historian, and Artist." *American Indian Art* 17, no. 3 (1992): 54–65.

———. "Swift Dog: Hunkpapa Warrior, Artist, and Historian." *American Indian Art* 19, no. 3 (1994): 68–75.

McDermott, John F. *Audubon in the West*. Norman: University of Oklahoma Press, 1965.

McHugh, Tom. *The Time of the Buffalo*. Lincoln: University of Nebraska Press, 1972.

Mekeel, Scudder. "A Short History of the Teton-Dakota." *North Dakota Historical Quarterly* 10, no. 1 (1943): 138–205.

Meuli, Jonathan. *Shadow House: Interpretations of Northwest Coast Art*. London: Harwood Academic Publishers, 2000.

Miles, Ray, and John R. Lovett. "The Pictorial Autobiography of Moses Old Bull." *American Indian Art* 19, no. 3 (1994): 48 57.

———. "Deeds That Put a Man among the Famous: The Pictographs of Joseph White Bull." *American Indian Art* 20, no. 2 (1995): 50–59.

Mohr, Charles. *The World of the Bat*. Philadelphia: J. B. Lippincott Co., 1976.

Momaday, N. Scott. *The Names, A Memoir*. Tucson: The University of Arizona Press, 1976.

Mooney, James. *The Ghost Dance Religion and the Sioux Outbreak of 1890*. 1896. Reprint, Chicago: University of Chicago Press, 1965.

Nabhan, Gary Paul. *Gathering the Desert*. Tucson: University of Arizona Press, 1985.

Nabokov, Peter. *Two Leggings: The Making of a Crow Warrior*. New York: Thomas Y. Crowell Company, 1967.

Nagy, Imre. "Cheyenne Shields and Their Cosmological Background." *American Indian Art* 19, no. 3 (1994): 38–47.

———. "Lame Bull: The Cheyenne Medicine Man." *American Indian Art* 23, no. 1 (1997): 70–83.

Neihardt, John G. *Black Elk Speaks: Being the Life Story of a Holy Man of the Oglala Sioux*. 1931. Reprint, New York: Pocket Books, 1972.

Nunley, John, and Judith Bettelheim. *Caribbean Festival Arts*. St. Louis, Mo.: The St. Louis Art Museum; Seattle: University of Washington Press, 1988.

Nunley, John, and Cara McCarty. *Masks: Faces of Culture*. New York: Harry N. Abrams, Inc., 1999.

O'Connor, Nancy Fields. *Fred E. Miller: Photographer of the Crows*. Missoula: University of Montana, 1985.

Paige, Darcy. "George W. Hill's Account of the Sioux Sun Dance of 1866." *Plains Anthropologist* 24 (1979): 99–112.

Parks, Douglas, Margot Liberty, and Andrea Ferenci. "Peoples of the Plains." In *Anthropology on the Great Plains*, edited by W. Raymond Wood and Margot Liberty, 284–95. Lincoln: University of Nebraska Press, 1980.

Penney, David W. *Art of the American Indian Frontier*. Seattle: University of Washington Press, 1992.

Penney, David, and George Longfish. *Native American Art*. New York: Hugh Lauter Levin Associates, 1994.

Peters, Arthur King. *Seven Trails West*. New York: Abbeville Press, 1996.

Petersen, David. *Among the Elk*. Flagstaff, Ariz.: Northland Press, 1988.

Petersen, Karen. *Plains Indian Art from Fort Marion*. Norman: University of Oklahoma Press, 1971.

———. *American Pictographic Images: Historical Works on Paper by the Plains Indians*. Santa Fe: Morning Star Gallery, 1988.

Petroski, Henry. *The Pencil: A History of Design and Circumstance*. New York: Alfred A. Knopf, 1989.

Powell, Peter J. *People of the Sacred Mountain: A History of the Northern Cheyenne Chiefs and Warrior Societies 1830–1879*. 2 vols. San Francisco: Harper and Row, 1981.

———. *To Honor the Crow People: Crow Indian Art from the Goelet and Edith Gallatin Collection of American Indian Art*. Lincoln: University of Nebraska Press, 1988.

———. "Sacrifice Transformed into Victory: Standing Bear Portrays Sitting Bull's Sun Dance and the Final Summer of Lakota Freedom." In *Visions of the People: A Pictorial History of Plains Life*, by Evan Maurer, 81–106. Minneapolis: The Minneapolis Institute of Arts; Seattle: University of Washington Press, 1992.

Powers, Marla. *Oglala Women: Myth, Ritual, and Reality*. Chicago: University of Chicago Press, 1986.

———. "Mistress, Mother, Visionary Spirit: The Lakota Culture Heroine." In *Religion in Native North America*, edited by Christopher Vecsey, 36–48. Moscow, Idaho: University of Idaho Press, 1990.

Powers, William K. *Oglala Religion.* Lincoln: University of Nebraska Press, 1975.

———. *Yuwipi.* Lincoln: University of Nebraska Press, 1982.

———. *Sacred Language: The Nature of Supernatural Discourse in Lakota.* Norman: University of Oklahoma Press, 1986.

Praus, Alexis A. "A New Pictographic Autobiography of Sitting Bull." *Smithsonian Miscellaneous Collections* (Washington, D.C.) 123, no. 6 (1955): 1–4.

Price, Catherine. "Lakotas and Euroamericans: Contrasted Concepts of 'Chieftainship' and Decision-Making Authority." *Ethnohistory* 41, no. 3 (1994): 447–63.

———. *The Oglala People 1841–1879: A Political History.* Lincoln, University of Nebraska Press, 1996.

Rice, Julian. "*Akicita* of the Thunder: Horses in Black Elk's Vision." *Melus* 12, no. 1 (1985): 5–23.

———. *Deer Women and Elk Men: The Lakota Narratives of Ella Deloria.* Albuquerque: University of New Mexico Press, 1992.

———. *Before the Great Spirit: The Many Faces of Sioux Spirituality.* Albuquerque: University of New Mexico Press, 1998.

Ridley, Edward. Catalogue and Price List. New York: Edward Ridley and Sons, fall and winter 1882–83. Advertising circular in the collection of the Strong Museum, Rochester, N.Y.

Ritzenthaler, Robert. "Sioux Indian Drawings." *Primitive Art Series* (Milwaukee Public Museum) 1 (1961). Portfolio and unpaginated brochure.

Roberts, Matt, and Don Etherington. *Bookbinding and the Conservation of Books.* Washington, D.C.: Library of Congress, 1982.

Robertson, William G., J. E. Brown, W. E. Campsey, and S. R. McMean. *Atlas of the Sioux Wars.* Fort Leavenworth, Kans.: Combat Studies Institute of the U.S. Army Command, 1993.

Robinson, Will G., ed. "Digest of the Reports of the Commissioner of Indian Affairs as Pertains to Dakota Indians, 1869–72." *South Dakota Historical Collections* (Pierre, South Dakota Historical Society) 28 (1956): 179–320.

Rogers, Dilwyn. *Lakota Names and Traditional Uses for Native Plants.* St. Francis, S.Dak.: The Rosebud Educational Society, 1980.

Schaeffer, Claude. "Bird Nomenclature and Principles of Avian Taxonomy of the Blackfeet Indians." *Journal of the Washington Academy of Science* 40, no. 2 (1950).

Scott, Hugh. "Notes on the Kado, or Sun Dance of the Kiowa." *American Anthropologist* n.s. 13, no. 3 (1911): 345–79.

Scott, Shirley, ed. *Field Guide to the Birds of North America.* Washington, D.C.: National Geographic Society, 1983.

Smith, J. L. "A Ceremony for the Preparation of the Offering Cloths for Presentation to the Sacred Calf Pipe of the Teton Sioux." *Plains Anthropologist* 9 (1964): 190–96.

———. *Short History of the Sacred Calf Pipe of the Teton Dakota.* Vermillion: South Dakota Museum, 1967.

———. "The Sacred Calf Bundle: Its Effect on the Present Teton Dakota." *Plains Anthropologist* 15 (1970): 87–93.

Sotheby's. *Fine American Indian Art.* Auction catalogue. New York: Sotheby's, October 1994.

Spelman Brothers. Catalogue of Fancy Goods and Notions. New York: Spelman Brothers, summer 1880. Advertising circular in the collection of the Strong Museum, Rochester, N.Y.

Stirling, Matthew W. "Three Pictographic Autobiographies of Sitting Bull." *Smithsonian Miscellaneous Collections* (Washington, D.C.) 97, no. 5 (1938): 1–56.

Streshinsky, Shirley. *Audubon: Life and Art in the American Wilderness.* New York: Villard Books, 1993.

Szabo, Joyce M. *Howling Wolf and the History of Ledger Art.* Albuquerque: University of New Mexico Press, 1994.

Taylor, Colin F. *Buckskin and Buffalo: The Artistry of the Plains Indians.* New York: Rizzoli International, 1998.

Thomas, Sidney. "A Sioux Medicine Bundle." *American Anthropologist* 43 (1941): 605–9.

Torrence, Gaylord. *The American Indian Parfleche: A Tradition of Abstract Painting.* Seattle: University of Washington Press, 1994.

Utley, Robert M. *Last Days of the Sioux Nation.* New Haven: Yale University Press, 1963.

———. *The Lance and the Shield: The Life and Times of Sitting Bull.* New York: Henry Holt and Co., 1993.

Van Wormer, Joe. *The World of the Pronghorn.* Philadelphia: J. B. Lippencott, Co., 1969.

Vanderworth, W. C., ed. *Indian Oratory*. Norman: University of Oklahoma Press, 1971.

Vestal, Stanley. *Warpath: The True Story of the Fighting Sioux Told in a Biography of Chief White Bull*. Boston: Houghton Mifflin Co., 1934.

Vincent, Gilbert, and Janet Catherine Berlo. "Black Hawk's Drawing of a Vision." *The Magazine Antiques* 151, no. 1 (1997): 200.

Vincent, Gilbert, Sherry Brydon, and William Coe, eds. *Art of the North American Indians: The Thaw Collection*. Cooperstown, N.Y.: Fenimore Art Museum, 2000.

Viola, Herman J. *Warrior Artists: Historic Cheyenne and Kiowa Indian Ledger Art Drawn by Making Medicine and Zotom*. Washington, D.C.: National Geographic Society, 1998.

Wade, Edwin. *The Arts of the North American Indian: Native Traditions in Evolution*. New York: Hudson Hills Press, 1986.

Walker, J. R. "The Sun Dance and Other Ceremonies of the Oglala Division of the Teton Dakota." *Anthropological Papers of the American Museum of Natural History* 16, pt. 2 (1917): 52–221.

———. *Lakota Society*. Edited by Raymond J. DeMallie. Lincoln: University of Nebraska Press, 1982.

———. *Lakota Myth*. Edited by Elaine A. Jahner. Lincoln: University of Nebraska Press, 1983.

———. *Lakota Belief and Ritual*. Edited by Raymond J. DeMallie and Elaine A. Jahner. Lincoln: University of Nebraska Press, 1991.

Wardwell, Allen. *Native Paths: American Indian Art from the Collection of Charles and Valerie Diker*. New York: Metropolitan Museum of Art, 1998.

Warner, Christopher, ed. *Ledger Art of the Crow and Gros Ventre Indians: 1879–1897*. Billings, Mont.: Yellowstone Art Center, 1985.

Weeks, Joseph D. "Report on the Statistics and Wages in Manufacturing Industries; With Supplemental Reports on the Average Retail Prices of Necessaries of Life and on Trade Societies, and Strikes and Lockouts." *Tenth Census of the United States* 20 (1880). Washington, D.C.: Government Printing Office, 1886.

Weygold, Friederich. "Das indianische Lederzelt im Koniglichen Museum für Völkerkunde zu Berlin." *Globus: Illustrierte Zeitschrift fur Lander- Und Volkerkunde* 83, no. 1 (1903): 1–7.

White, Richard. "The Winning of the West: The Expansion of the Western Sioux in the Eighteenth and Nineteenth Centuries." *Journal of American History* 65, no. 2 (1978): 319–43.

Wildhage, Wilhelm. "Material on Short Bull." *European Review of Native American Studies* 4, no. 1 (1990): 35–42.

Wildschut, William, and John C. Ewers. *Crow Indian Beadwork: A Descriptive and Historical Study*. New York: Museum of the American Indian, Heye Foundation, 1959.

———. *Crow Indian Medicine Bundles*. New York: Museum of the American Indian, Heye Foundation, 1975.

Wissler, Clark. "Symbolism in the Decorative Art of the Sioux." *Proceedings of the International Congress of Americanists* 13 (1905): 339–45.

———. "The Whirlwind and the Elk in the Mythology of the Dakota." *The Journal of American Folklore* 18, no. 71 (1905): 257–68.

———. "Some Protective Designs of the Dakota." *Anthropological Papers of the American Museum of Natural History* (New York) 1, no. 2 (1907): 19–52.

———. "Societies and Ceremonial Associations in the Oglala Division of the Teton-Dakota." *Anthropological Papers of the American Museum of Natural History* (New York) 11, pt. 1 (1912): 1–99.

———. "Societies of the Plains Indians." *Anthropological Papers of the American Museum of Natural History* (New York) 11 (1916).

Wolf, Eric. *Europe and the People without History*. Berkeley: University of California Press, 1982.

Wong, Hertha. "Pictographs as Autobiography: Plains Indian Sketchbooks of the Late 19th and Early 20th Centuries." *American Literary History* 1, no. 2 (1989): 295–316.

Wooley, David, and Joseph D. Horse Capture. "Joseph No Two Horns, He Nupa Wanica." *American Indian Art* 18, no. 3 (1993): 32–43.

INDEX

ABOUT THE AUTHORS

Janet Catherine Berlo is the Susan B. Anthony Professor of Gender and Women's Studies and professor of art history at the University of Rochester, New York. She received a Ph.D. in pre-Columbian art and archaeology at Yale University in 1980 and has published widely on pre-Columbian art of Mexico as well as North American Indian art.

Berlo's publications include *The Early Years of Native American Art History* (University of Washington Press, 1992), *Plains Indian Drawings 1865–1935: Pages from a Visual History* (Harry N. Abrams, 1996), and *Native North American Art* (with Ruth Phillips, Oxford University Press, 1998). She has been awarded fellowships from the National Endowment for the Humanities, the Getty Foundation, and the John Simon Guggenheim Memorial Foundation for her work on Plains Indian drawing.

Arthur Amiotte, an Oglala Lakota, is an adjunct professor of Native studies at Brandon University in Manitoba, Canada. He is an award-winning artist, art historian, educator, and author.

Eugene V. Thaw, a retired art dealer, donated a large collection of American Indian art, including Black Hawk's drawing book, to the Fenimore Art Museum, Cooperstown, New York. He also donated his impressive collection of European master drawings to The Pierpont Morgan Library, New York.